'Baker is a wonderful writer, careful, intelligent and dry. He also knows his London, and the Spare that emerges in his portrayal is very much an avatar of that unique and ancient town: humble Cockney beginnings, the bright years as a smoldering *wunderkind*, and then a long plunge into poverty, obscurity, and a deep weirdness…'

Erik Davis, author of *Techgnosis* and *High Weirdness*

'[written with] zest and insight… Ever determined to break down the barriers between reality and fantasy, Spare has finally achieved it – not by elaborate psychic exercises, but through biography.'

Matthew Sturgis, *Times Literary Supplement*

'I cannot recommend *Austin Osman Spare* too highly. Phil Baker has done a wonderful job of bringing the complexities and contradictions of Spare's life to the fore, and in making the London of Spare's time come to life vividly and richly.'

Phil Hine, *enfolding.org*

'Phil Baker has written an elegant and comprehensive biography, and his deep sympathy for his subject is nicely balanced by his scepticism towards some of Spare's sources of esoteric thought. There is a wealth of detail here… A stunning tribute to an unjustly neglected artist.'

Noel Rooney, *Fortean Times*

'Phil Baker's book is excellent; it's the one many Spare enthusiasts such as I had been waiting for.'

John Coulthart, *London Society Journal*

'So many of Spare's works look like sketches for a masterwork rather than the finished article. Perhaps the finished article was Spare's life itself, an extraordinary carnival of strange characters and incidents, some of them semi-mythical. It is as good as a novel.'

Reggie Oliver, *Wormwood*

T0354256

AUSTIN OSMAN SPARE

The Life and Legend of London's Lost Artist

Phil Baker

Strange Attractor Press
MMXXIII

First published by Strange Attractor Press 2011; revised edition 2012
This third, expanded paperback edition 2023
Text © Phil Baker 2011, 2012, 2023
Foreword © Alan Moore 2011

ISBN: 978-1-913689-6-50

A CIP catalogue record for this book is available from the British Library.

Unpublished George Bernard Shaw material copyright The Society of Authors, on behalf of the Bernard Shaw Estate.

Strange Attractor Press
BM SAP, London, WC1N 3XX, UK
www.strangeattractor.co.uk

Distributed by the MIT Press, Cambridge, Masschusetts.
And London, England
Printed and bound in Estonia by Tallinna Raamatutrükikoda

CONTENTS

Foreword by Alan Moore

In his relation to both art and occultism, Austin Osman Spare stands out as a strikingly individual and even unique figure in fields that are by their very nature brimming with strikingly individual figures. While his line and sense of composition have at times drawn justifiable comparisons with Aubrey Beardsley or with Albrecht Dürer, if we seek a match with Spare the visionary or with Spare the man, surely the only candidate is his fellow impoverished South London angel-headed nut-job, William Blake. In both men's lives we find the same wilful insistence on creating purely personal cosmologies or systems of belief, fluorescent mappings of the blazing inner territory that each of them clearly had access to. We find the same strangely iconic phantoms and grotesques; the same heroic readiness to embrace lives of poverty; the same tales of erotic drawings either burned or spirited away upon the artist's death; the same sense of unearthly realms of consciousness both actually experienced and lucidly depicted.

The one glaring difference that exists between the two, at least from the perspective of their numerous admirers, is that while both men were equally ignored and marginalised during their respective lives, since Alexander Gilchrist's seminal biography we've at least come to know and understand a great deal about William Blake. Spare, on the other hand, who died within my lifetime, is a presence (or an absence) wreathed in mystery and often in deliberate mystification about whom even his greatest advocates have managed to dig up comparatively little. Until very recently he has remained a liminal and even possibly fictitious character, in jeopardy of vanishing into the selfsame were-they-real-or-weren't-they borderland inhabited by Spring-heeled Jack and Sweeney Todd and Enoch Soames; inhabited by the liquescent hags and chimeras of his own illustrations.

Partly this precarious teetering upon the precipice of myth or historicity, it must be said, is Spare's own fault, or at least an inevitable consequence of seeking in his art, his occultism and sometimes his reminiscences to smudge the line dividing fact from fantasy. Whether in his account of underage initiation into sex and magic by the frankly doubtful Mrs Paterson or in his yarns of frontline horrors and exotic postings during World War I, we're left with the impression of a man for whom material reality and the reality of the imagination were equivalent if not entirely interchangeable. Then, built on this already suspect bedrock of Spare's recollections, we have the accumulated coral of jaw-dropping tales that others tell about him, most significantly those additions to the legend that have been contributed by an engagingly delirious Kenneth Grant, perhaps the last man standing who knew both Spare and Spare's bête noir and former associate, Aleister Crowley.

Grant is obviously a key, albeit problematic, player in the narrative of Austin Osman Spare, both with regard to the uncanny artist while he was alive and, more importantly, to Spare's posterity. I can recall a conversation some ten years ago with my good friend, the similarly half-apocryphal London occult initiate and voodoo campaigner Trooper Marshall, who observed that almost all we knew of Spare had been transmitted through the medium of Kenneth Grant. Given that this included many of the more astonishing manifestations, like the sigil-summoned giant aquatic owl, it's surely tempting to depict Grant as the ludicrously weird distorting lens that has prevented us, for decades, from obtaining a clear picture of this massively important artist and occult philosopher, but that is to misunderstand the shifting and unfixed perspective of the twilight magic worldview that both parties are or were clearly immersed in. It could possibly be argued that the startling and dream-like episodes which Grant's frequently lurid anecdotal writings have attributed to Spare are our best way of apprehending what the world of magic feels like from within the sorcerer's own mindset, and that understanding the mythology surrounding Spare is vital if we are to have a full, inclusive comprehension of the man; of who he was and what he meant. Additionally, it should be stated that without the tireless championing of Kenneth Grant the vast majority of us would, in all likelihood, have never heard of Austin Osman

Spare. That said, it has occasionally been a source of some frustration down the years that we have been unable to view Spare save through the intervening violet curtain of Grant's fascinating and yet sometimes obfuscating prose.

In light of all of the above, the book that you are holding in your hands represents a true watershed in the increasingly enthusiastic and progressively more populous field of Spare scholarship. To my mind, Phil Baker has established himself as among the very best contemporary biographers, especially as one who finds his subjects in the murkier and much less well-regarded tide-pools of twentieth century culture, where the fauna has a tendency to be both livelier and more unusual. Despite having had a strong aversion to the work and politics of Dennis Wheatley ever since a brief infatuation at the age of twelve... perhaps the only age at which it's possible to take that writer seriously... I found myself enthralled by Baker's sympathetic and insightful treatment of this seemingly repellent individual in his earlier biography, *The Devil is a Gentleman*, a work I'd been unable to put down regardless of my lack of previous interest in either Wheatley or his writings. Upon hearing advance word that Austin Spare (someone in whom I have been very interested for many years) was to be focussed on in Baker's next endeavour, I began to eagerly anticipate its publication, although not without a twinge of apprehension that my unrealistically high expectations might not be fulfilled.

As it turns out, they've been surpassed beyond my wildest hopes. Phil Baker shines a light upon the artist and the individual that is at once sufficiently bright to illuminate the foggier and more occluded corners of Spare's life, while at the same time being soft enough to never quite dispel or scare away the ragged phantoms that surround Spare like a robe of ectoplasm and are an intrinsic part of his life; of his art and his mystique. Baker allows us access to Spare as, at least in part, a self-mythologizing fantasist without attempting to diminish the reality of Spare's phenomenal accomplishments as a magician, artist or extraordinary human being. If anything, this emphasis upon Spare's sheer cat-shit and kitchen sink humanity serves only to make his glorious work of self-invention seem both more heroic and more genuinely magical. The thoroughness of the research and of Baker's informed ability to empathise with his unusual subject matter cast a necessary light on aspects of Spare's history and singular

cosmology that will surprise even those devotees who had believed that they were thoroughly acquainted with the artist and his thinking. I myself was equally astonished to discover that Spare was a married man, and to have pointed out the way that Madam Helena Blavatsky's Theosophical ideas had influenced such central aspects of Spare's magical philosophy as his conception of the "kia", his notion of the "neither-neither" and the cryptic and ego-annihilating stance of his Death Posture. Baker's book resolves the many contradictory impressions that we have received of Spare as rampant satyr or shy introvert; as terrifying conjuror of thunderstorms and elementals or compassionate animal lover and humanitarian; as Oswell Blakeston's seedy backstreet black magician and pornographer or the unrecognised progenitor of Pop Art and Surrealism. All of these other selves, these 'atavistic personalities' perhaps, are masterfully woven into a coherent, credible and comprehensive portrait of a real flesh-and-blood character, despite that character's insistence on positioning his life and art upon the shifting opalescent brink of incoherence, of incredibility and the incomprehensible.

What Phil Baker has accomplished here is little short of marvellous. Our previous glimpses of the artist/occultist have been fragmentary and incomplete, compiled from oddball racetrack oracle cards, from the recollections and embroideries of his contemporaries, from privately hoarded copies of *The Golden Hind* or *Form*, a bit like having an array of tantalising and arresting jigsaw pieces which, without connective tissue, are not even obviously part of the same puzzle. Filling in all of those strangely-contoured missing spaces, Baker at last offers us a view of Austin Spare that is complete and has an animating warmth; a human study that neither confirms nor yet conclusively denies the extra-human properties attributed to its astounding and ambiguous subject.

If there's any point at which my own assessment of Spare's life diverges from the one presented here, it is entirely in a minor matter of interpretation: while Baker presents a solid case for the linguistic origins of Spare's cognomen "'Zos", he does not quite dissuade me from own suspicion that the name was probably the alpha of the artist's own initials, AOS, projected into an omega state off at the far end of the alphabet as ZOS, a kind of ultimate and transcendent expression of himself at the extremities of his own being. Whichever reading of this clearly

irresolvable small detail is correct, what's undeniable is that Phil Baker has achieved an integrated and sincere depiction of both AOS the man and Zos the fabulous delinquent demigod, a complete A – Z of this arresting, otherworldly creature. Whether you have been a Spare obsessive since you first set eyes on his unsettling and posthumous *Man, Myth & Magic* debut cover in the 1970s or if you have never previously heard even the faintest word about the glorious and savage Brixton magus, read this book immediately and, in an act of self-love, treat yourself to the unprecedented pleasure to be had from Austin Osman Spare, his life, his legend and his ugly ecstasies.

Prologue: BOY HUNG

One afternoon in May 1904 a recently retired police officer, named Philip Spare, was cycling through the City of London's 'Square Mile' when he noticed a newspaper seller with a placard that said "Boy Hung". This annoyed Mr Spare. He was a stickler for things done properly and he knew perfectly well that it should have said "Boy Hanged", so he crossed the road to put the paper seller right.

There was a shock waiting for him on the other side, where the boy in question turned out to be his own son, Austin Osman Spare.

Seventeen-year-old Austin had not in fact been hanged at all; a drawing of his had been hung at the Royal Academy. He was lauded as the youngest exhibitor ever, and he found himself suddenly borne up on a rising wave of publicity. He was praised by Augustus John, George Frederick Watts, and John Singer Sargent, and described in newspapers as "beyond doubt a genius." He was acclaimed as the new Aubrey Beardsley, and the finest draughtsman in England; journalists even said that he had his sights on the Presidency of the Royal Academy itself.

"There must be few people in London interested in art," said the *Art Journal*, "who do not know the name Austin Osman Spare."

<div align="center">❦</div>

Even allowing for a certain amount of hyperbole, a glittering career seemed to be on the cards. What could possibly go wrong?

One: SEATE OF THE BEASTE

"Thou art the Seate of the Beaste, O Smithfield," Ben Jonson wrote in *Bartholomew Fair*, "and I will leave thee. Idolatry peepeth out of every side...". An unholy mixture of butchery and religion is steeped into the soil of Smithfield. Once a rubbish dump and a cemetery, with an altar to the Roman god Mercury nearby, Smithfield was known to generations of Londoners as a place of meat and slaughter. Vast numbers of animals were herded together, and Dickens remembered that the "ground was covered, nearly ankle-deep, with filth and mire; a thick steam perpetually rising from the reeking bodies of the cattle" with "unwashed, unshaven, squalid and dirty figures constantly running to and fro". Even in the mid-nineteenth century the drainage channels were often choked with offal, the streets were bloody, and goaded cattle would stampede into shops or collide with church congregations.

Smithfield's other stock in trade was religion: the area was home to St. Mary's Nunnery, the Carthusian monastery of Charterhouse, the Priory of St. John of Jerusalem, and the Church, Priory and Hospital of St. Bartholomew. Religion and butchery came together in the successive slaughters between competing religions, and the area had a history of martyrdom. In 1538 the Catholic clergyman John Forest was roasted in a cage at Smithfield for refusing to recognise the King as leader of the Church, before over two hundred Protestants were burned for heresy, facing the church of St. Bartholomew, during the short Catholic reign of Queen Mary. In 1558, Protestantism returned with Elizabeth, and Catholics in turn were hanged, drawn and quartered as traitors.

As late as 1652 John Evelyn saw a woman burned at Smithfield, for poisoning, and the culture of old London was generally brutal. Bear baiting, cock fighting, and bare-knuckle boxing abounded at scenes of entertainment such as Bartholomew Fair, held at Smithfield on the site

of the present meat market. It was founded in the eleventh century by Rahere, the court jester who is also said to have founded the Priory and Hospice of St. Bartholomew. The Fair further catered to the ordinary Londoner's no less important desire for wonderment. Over the years there were dwarves, fire eaters, a glass blower in a glass wig blowing teacups, and crocodiles hatched from eggs by steam. Samuel Pepys marvelled at "the Wonder of Nature", a girl of sixteen who was only a foot tall and would sing and whistle.

Curiosity, credulity and fraud often went hand in hand. Cock Lane, at the south edge of Smithfield, was famous for the Cock Lane Ghost, named Scratching Fanny. Anticipating spiritualism, which began a century later in America, the 1762 haunting involved a luminous figure, an adolescent girl, and some rappings (once for yes, twice for no...). The likely explanation is that the householder, Mr Parsons, was trying to harass and blackmail a former tenant, Mr Kent, by alleging that Kent's dead wife had been poisoned. The ghost communicated with the help of Parsons's young daughter Betty, who was later found to be hiding a piece of wood under her nightdress.

Noblemen and gentleman amateurs gathered nightly around the sleeping form of Betty Parsons, waiting for the knocking to begin. Dr Johnson took an interest, and joined a commission appointed by the Lord Mayor. He spent a night sitting up in St. John's next to a coffin, waiting to hear a spirit rap on the lid, and endured a certain amount of ridicule after the hoax was revealed.

Johnson was unrepentant: there was a great deal at stake with the question of ghosts, including survival after death and the possibility of disembodied intelligence. Boswell records him insisting (with "solemn vehemence"): "This is a question which, after five thousand years, is yet undecided; a question, whether in theology or philosophy, one of the most important that can come before the human understanding."

The Victorians needed to get a grip on the Smithfield area, and they did. Animal slaughtering was moved away in 1855, the same year that Bartholomew Fair was finally suppressed for debauchery and public

disorder, and in 1868 an impressive new meat market was opened at Smithfield as the London Central Meat Market.

One of the many men responsible for upholding the new order of the later Victorian era, a footsoldier in the battle for a more civilised and law-abiding London, was Philip Newton Spare. Born in Yorkshire in 1857, he had come down to London, lodged at 3 Gray's Inn Passage, Red Lion Street, Holborn, and joined the City of London Police in 1878. He worked from Snow Hill Police Station at 5 Snow Hill, built on the site of the Saracen's Head tavern, an ancient criminal centre which survived into Dickens's day. Snow Hill itself was formerly notorious for eighteenth-century 'Mohock' gangs capturing old ladies at the top and rolling them down to the bottom in barrels.

Philip Spare met Eliza Osman, daughter of a Royal Marine from Devonshire, and in December 1879 they were married at the Wren church of St. Bride's, Fleet Street, famous for its 'wedding cake' steeple. They lodged with other police families in a now demolished tenement called Bloomfield House, on Bloomfield Place, King Street (now Smithfield Street) at the Holborn Viaduct end of the market, just next to Cock Lane.

They lost their first child in 1881, but John Newton Spare (b.1882), William Herbert Spare, "Will" (b.1883), and Susan Ann Spare, "Cissy" (b.1885), all survived, and another child was conceived in the spring of 1886. Born within the sound of Bow Bells, Cheapside – qualifying as an authentic Cockney – at shortly after four in the morning on 30th December 1886, this was Austin Osman Spare.

Bloomfield Place was opposite the entrance of the Smithfield Market, just by an imposing building in the style of a Venetian church. There were fifteen or so families in Bloomfield House, sharing two rooms each, with market workers, drivers, and clerks as well as police. The coal shed, lavatories and washing facilities were communal, in the middle of the courtyard, but the flats were otherwise well-equipped with gas and a cold water tap.

Spare's father was a somewhat hard character, laconic and dour, but Spare liked as well as respected him. Spare saw little of his father for

long stretches of his childhood, since he was often working a night shift, and he took on extra work at evenings and weekends as a guard at the meat market. Spare's mother also looks severe in photographs; he would turn against her as he grew older, although he always remembered her abundant hair with pleasure.

The Spare boys would stand up when their father entered the room, and all the Spare children were brought up very respectably; they were not allowed to play in the street. Another tenant of Bloomfield House recalled Spare as a curly-haired child squatting on the family's front step, where he was always busy at his drawing.

Spare went to a small school attached to St. Sepulchre's church, at the top of Snow Hill. The corner where St. Sepulchre stands is now dominated by the Edwardian Old Bailey building, with its dome and its figure of Justice with scales, but this was not there in Spare's childhood: until 1902 it was dominated by the sooty, monolithic, almost windowless bulk of Newgate Prison.

As late as the 1960s and 70s there was an old Cockneyism, "black as Noogit's Knocker" (I heard this and imagined Noogit, whoever he was, to be a figure like Scrooge). Newgate was a place of legendary horror where the conditions of disease, cold, and victimisation now read like accounts of life in the Gulag. It appalled Londoners (Dickens found it a "horrible fascination") and Spare often referred to it in later years.

Walking around the area now, it is striking how very local Spare's childhood world was. The meat market, Cock Lane, St. Sepulchre's church, Spare's father's police station – which young Spare must have passed every day on his way up the hill to school, with Newgate at the top – and the church school are all within a few yards of each other.

St. Sepulchre's is one of the Cockney churches (it figures in the rhyme 'Oranges and Lemons' as "the Bells of Old Bailey"). An early rector of the church, John Rogers, was burned at Smithfield for helping to translate the Bible into English, and it maintained a special relationship with Newgate; a well-meaning Christian named Robert Dowe left money for a handbell to be rung outside the condemned cell at midnight before an execution, to remind the man about to be hanged of God's goodness.

There is a striking oddness about the name "Saint Sepulchre." It doesn't sound like the name of a saint, or a person at all, and it is not: it is a shortening of "Saint Edmund and the Holy Sepulchre." Spare was fascinated by unusual words and he had the Bible drilled into him as a child, so he may well have associated it with Matthew 23:27: those "whited sepulchres, which indeed appear beautiful outward, but are within full of dead bones, and of all uncleanness."

The meat market itself was probably a greater influence on Spare than his first school. It offered the spectacle of thousands of animal carcasses, which arrived under the market by a specially built railway before being displayed and disposed of at ground level. At the same time the ironwork of the new market has an almost ecclesiastical grandeur – the Central Avenue has been described as "like a cathedral nave," with a "nave and screen" effect – as if to hint at the repressed kinship between slaughterhouses and religion.[1]

In his youth Spare would become disenchanted with the Christian faith he was raised in, and evolve a personal religion of his own. It was a religious philosophy that was centrally aware of flesh and death, and had a vulture's head as its major symbol.

Spare hated Smithfield. His family left when he was seven years old, and he made a point of never going back. He loved animals, and his friend Frank Letchford believed that his childhood was "stained by later recollections of the sounds, sights and smells of animals in fear." As an adult he told Letchford about a recurring dream of being held in his mother's arms and carried across a wide space surrounded by the cries of animals in pain. It sounds almost like memory, but livestock was no longer a part of the market by Spare's day. At any rate, Spare seems to have felt that Smithfield had what a later generation might have called a *bad vibe.*

The 'Autumn of Terror' struck in 1888, when Jack the Ripper terrorised London with a series of murders that continued until 1891.

1. Writing in his essay 'Bloody Sundays,' critic Denis Hollier juxtaposes Georges Bataille's sense of "sacred horror" at the Paris slaughterhouses with Zola's words on Christ and the Christian martyrs in fin-de-siècle Catholicism: "What a butcher's stall…".

Spare was a year old, going on two, when the killings began but they seem to have had a lasting effect on him (and a Spare drawing entitled 'Characters for a Murder Plot', featuring several women's heads and a larger male head, is thought to be about the murders). The Ripper case disturbed him, and in later life he would become flustered if it was mentioned and refuse to talk about it: a friend from the Thirties showed him a newspaper with something about the Ripper, thinking it would interest him, only to have Spare snatch the paper away, make a gesture of silence, and put it into the fire.

Spare's father was not directly involved in the case, although he may have known people who were. As a policeman on the eastern fringes of the city, bordering Ripper territory, he must have heard a great deal about it at work, and he may have talked about it with his family. Perhaps he used the Ripper as a bogeyman to frighten his children. Quite what the Ripper meant to Spare, and why, remains a mystery. It is far from being the only one.

Two: The Discovery of Witchcraft

In 1894, when Spare was seven, the family moved away from the ugliness of Smithfield to the fresh pastures of Kennington, south of the river, probably at the insistence of Spare's mother. Kennington gave Spare some of the best days of his life, before he was hit by either fame or obscurity.

In those days it was an exciting area, combining a good standard of living with a touch of radicalism. There was relative poverty nearby – the young Charlie Chaplin was living in it, just a few streets away, although his family did at least have a stuffed pike on their wall – but there was plenty of grass and trees, with squares of well-proportioned houses built for the new middle classes. Spare's father was doing well, buying and letting property as a sideline, and the family lived at 15 Kennington Park Gardens, a leafy enclave off the main thoroughfare by Kennington Park, between a newly-built variety theatre and the Church of St. Agnes, where Spare went to St. Agnes School.

Spare remembered "The Goldfish Man", who would walk the streets with a tank of goldfish on his back, along with a string of jam jars and globe fishbowls, all hanging off a length of bamboo. "Old clo' men" would also barter woollen clothes from children in exchange for goldfish. A haggard man with a top hat covered in bluebottles would demonstrate and sell his flypaper, particularly outside butchers. There were numerous hawkers of one kind or another, and being Kennington – near a theatre – there were variety artistes and one-man-bands. Real poverty was never far away in London, and Geoffrey Fletcher remembers "the shivering men who sold the penny toys" and "the haggard women who sang in the streets or begged for cups of water... they survived until the 1930s, and I recall the depressing effect they had on me..." On a brighter note there was the Jack-in-the-Green, a man covered in leaves and branches who would come out as part of the May Day festivities.

The late Victorian and Edwardian world was a very decorative place. The Kennington Park Gardens area had houses adorned with masks, reptiles and various Art Nouveau embellishments, which Spare probably took for granted, and motifs of Pan's head, foliage, grapes, and so forth were everywhere: on lintels, fireplaces, Wedgwood Doric jugs, 'Sixpenny Novels', and the boxes of board games. Many artists of Spare's generation were to react against this period lushness and reject it; Spare was not one of them.

Perhaps through having a uniformed father, Spare's first ambition was to be a soldier, and then at one point he wanted to go to sea. His father hoped he would join the police. He was a strong, vigorous child and as he grew older he enjoyed boxing, wrestling, and particularly swimming. He liked cycling and on one occasion, when he lay stunned after an accident, he thought he had already died. He also played cricket well, playing with the hackney-carriage drivers on Kennington Park and captaining his school team.

In other respects Spare was not a team player, and there was a more withdrawn side to his character. More than sport, he enjoyed drawing, and it was around this time that he began to work on it more seriously, drawing caricatures for the amusement of his schoolmates but also shutting himself up in the attic to draw at home. His work was noticed and he was encouraged, with a framed picture hung on the wall at his school.

Outwardly stern but in fact a patient and encouraging figure, his father took great pride in Austin's work and it was put up on the walls at number 15. His mother was also encouraging, in her more reserved way, and Spare did a portrait of her showing her great abundance of wavy hair (something Spare inherited) which was usually worn up but reached down to her waist when it was loose.

With his father absent at work, Spare was largely brought up by his mother, and as he later told a friend: "His mother made life a series of rewards if he did right, and punishment for wrong-doing. By all the

canons of psychology he should have been pathological, he said, even criminal, by the quality of his frustration!"

More than that, "His bile rose up from conflicting family relationships during formative years leading later (by his own admission) to an inability to separate fantasy from reality." Spare had a life-long tendency to confabulation and self-mythologising, beginning with the date of his birth, which he claimed was not 30th December but the liminal, Janus-faced moment of midnight on December 31st.

His mother told him that carrying him in pregnancy had been hell, and his relationship with her was unsatisfactory almost from the start. In later life he said that he would never allow her to kiss him, and another friend from the Forties remembered he "often spoke disparagingly" of her, and that "his relations with his mother were strained and his filial affection was transferred to another woman whom he referred to as his second mother."

This was "Witch Paterson," an elderly woman who allegedly seduced the young Spare in some way and changed the course of his life: perhaps he could have said, like Marlowe's Doctor Faustus, "'Tis magic, magic that hath ravished me." Mrs Paterson introduced Spare to fortune-telling with cards, and she had the power to materialise thought-forms to the point where another person could see them; not so very different, perhaps, from what an artist does. She also had the power to transform herself from an aged crone into a sexually alluring and lascivious woman, although some of Spare's art suggests that this was a fluid distinction anyway, as far as he was concerned, and one that fascinated him.

There is, however, very little evidence that this old witch really existed; at least not in the full blown form that some accounts have given her, naming her Yelga Paterson and making her an elder in an ancient witch cult (ancient witch cults themselves being a virtually non-existent phenomenon). A late text, purportedly by Spare, *The Witches' Sabbath*, describes such a figure:

The Witch so engaged is usually old, usually grotesque, libidinously learned and is as sexually attractive as a corpse; yet she becomes the entire vehicle of consummation. This is necessary for transmutation; the personal aesthetic culture is destroyed; perversion is also used to overcome the same kind of moral prejudice or conformity... thus the life force of the Id is free of inhibitions prior to final control. Thus ultimately the Sabbath becomes a deliberate sex orgy for the purpose of exteriorisation, to give reality to autistic wishful thinking by transference.

This is uncharacteristic of Spare's style; whose style it might be we can consider later.

The aged nature of this witch figure is traditional: writing in his sixteenth-century book *The Discoverie of Witchcraft* – in which the central "discovery" is that there are no real witches – Reginald Scot noted the association of witchcraft with old women, "lame, bleareyed, pale, foul and full of wrinkles." As for Mrs Paterson, she seems to be a composite fantasy figure. Spare talked occasionally of an old fortune teller, and in later years, after the Second World War – when the fantasy had already started to germinate elsewhere, in the mind of a friend – one of the few details he gave was that she died aged over a hundred years old.

The nearest real-life candidate for Mrs Paterson is a Ruth Patterson (with two t's) who died at the age of 102 in 1942. In 1900 she was sixty and lived with her husband George, a retired brewery stoker, and their two adult children at 75 Park Street, Southwark; a now vanished location just behind the Globe Theatre. This is not especially close to Kennington, but perhaps its proximity to the route crossing the river makes it seem less remote.

The Spares had another child in 1900, Spare's much-loved little sister Ellen Victoria ("Vicky") Spare, and it is just possible that Ruth Patterson babysat and played card games such as patience, perhaps shading into the milder, tea-leaf styles of fortune telling. Tarot packs and full-blown occult weirdness seem unlikely, however, since she was a devout Christian.

In his more daylight life, meanwhile, away from the doubly shadowy figure of Paterson, Spare was attending the very religious school at nearby St. Agnes Church. Originally a plain, shed-like building that had housed a vitriol works, St. Agnes had been remodelled by Gilbert Scott, the Gothic-revival architect. Larger than some cathedrals, with magnificent stained glass windows, it was a notably "High" Anglo-Catholic church; a place of ritual and incense, which caused violent controversy on its opening because the priest wore a white stole and Mary was hymned. From the Protestant perspective this was all too much, and more than half way to "the drunken bliss of the strumpet kiss of the Jezebel of Rome."

Nuns were a prominent feature of life around the church and school. The drawing of Spare's which was hung on the wall of the classroom seems to have featured robed and cowled figures; this was the distant memory of a neighbour, and she was probably right because these figures were to become a lifelong motif in Spare's work.

Spare was impressed by the ceremonial and ritual side of religion at St. Agnes, and he assisted with it. It was an honour for a young boy like Spare to get up before dawn to lay out hymn books and light oil lamps, and occasionally he would even read the Lesson. As a child he believed in the Bible. It was only a little later that he had second thoughts about the jealous desert God of Judaism, Christianity and Islam; William Blake's "Old Nobodaddy."

Spare's school records, and perhaps even his picture of the cowled figures, perished with St. Agnes in the Blitz: the church and school were wrecked in the same wave of bombing that would destroy his studio. There was an odd postscript to Spare's schooldays in the late Thirties, when an old down-and-out called on him. He had heard that Spare was looking for tramps as models, and after he had made the old man a cup of tea, Spare realised who he was. It was his old headmaster from St. Agnes, who had taken to drink after his retirement and ended up in the gutter.

Or so Spare said, and it may well have been true. He also told a friend in later life that all he learned at St. Agnes was how to masturbate, but this was not true. It made more of an impression on him than that suggests, not least because he had been exposed to High ritual and religiosity, and

given an intensified awareness of religion of the kind that often overlaps with occultism.

Superstition of one sort and another was also rife in working class London. People might attend church, as a one-off event, not because they were Christians but to "change their luck". Lucky horseshoes were widespread, along with elephant charms (still sold by hawkers door to door in the 1960s and perhaps later). Spilling salt was unlucky, along with the colour green, crossing on the stairs, crossed knives and forks, scissors or penknives as gifts, and passing a cross-eyed person – or a black cat – in the street. A picture falling from the wall foretold a death in the household.

A South London historian and journalist, William Harnett Blanch, established a club in affectionate mockery of all this superstition; its higher aim was to raise money to keep the elderly poor of Southwark out of the workhouse. It was called The London Thirteen Club and it first met at the Holborn Restaurant, 218 High Holborn, on 13th January 1894.

A dinner of thirteen courses was served by cross-eyed waiters in room thirteen, where there were thirteen tables each holding thirteen diners. Guests wore bright green ties with little skeletons in their buttonholes, and they all walked under a ladder on the way to the feast. Tables were decorated with "a cornucopia of bad luck" featuring peacock feathers, black cats, and witches' cauldrons. All knives were crossed, the salt spoons were in the shape of gravedigger's spades, and each guest received a penknife as a present. There was a general smashing of mirrors at the end.

Among the club's members was George R Sims, author of the celebrated poem 'Christmas Day in the Workhouse', who was on the board of this worthwhile cause but never actually attended. He feared it might be unlucky.

Also not present was Oscar Wilde. "I love superstitions," he wrote to Mr Blanch,

They are the colour element of thought and imagination. They are the opponents of common sense. Common sense is the enemy of romance. The aim of your society seems to be dreadful. Leave us some unreality.

Three: Boy Genius

Spare had his first romantic disappointment in his teens, when he fell in love with the daughter of a local clergyman; she seems to have been called Bessie Mitchell. As he told it later, her father turned him away from the rectory and shut the door in his face because he wasn't good enough for his daughter; years later Spare had the satisfaction of recognising her in Brixton market, now grown fat and encumbered with screaming children.

Balancing the pain of unrequited love, Spare still had the pleasures and obsessions of his work. From the age of about twelve he had been attending evening classes at Lambeth Art School, where he studied under the artist Philip Connard. Glyn Philpot – later to be a very successful painter – was a fellow pupil and friend. Spare felt he owed his early success to the School, and remembered his teachers – Connard, Mr Shelly the life-drawing tutor, and Mr Macady the principal – with affection. He told a journalist he would always "look back with pleasure and satisfaction to the happy evenings I spent with them."

In 1900, at the age of thirteen, Spare had left St. Agnes school and been apprenticed to the eminent local firm of Sir Joseph Causton and Sons, a printers and poster designers in an industrial-looking flat-roofed iron and glass building on the Clapham Road; they produced lithographs for artists such as James Pryde, one of the "Beggarstaff Brothers" with William Nicholson. Spare earned five shillings a week at Caustons (about twenty pounds today). Resisting an arrangement that would tie him to the firm for seven years, he left after nine months and went to the glassworks of Powell's in Whitefriars Street, possibly through a Masonic connection of his father's, the family had since moved away, south of the river, but Powell's is close to Spare's childhood home and his father's old police station.

Spare was fortunate with Powell's, which had links to the Arts and Crafts movement and William Morris, and was highly regarded as the manufacturer of Whitefriars Glass. Stained glass design left its mark on Spare's early work, and for a while he produced exquisitely coloured drawings with strong linear pen and ink outlines filled in with bright transparent watercolour, giving an almost gem-like or enamelled effect. Spare began by simply tracing designs on to glass, but before long he was transferred to the draughtsman's room. His talents were noticed at the firm, and a more senior employee, Thomas Cowell, asked him to design five stained glass windows for his house; featuring an uplifting design of sunshine and birds, they are very different from Spare's more characteristic work.

Some design work that Spare had been doing in his lunchbreak was noticed by two visitors to the firm, Sir William Blake Richmond and FH Jackson RBA, and they recommended him for a scholarship to the Royal College of Art in South Kensington. The honours were falling thick and fast around this period: he had drawings in the British Art Section of the St. Louis Exposition and one in the Paris International Exhibition, and in 1902 he won a National Mathematics Award with a treatise on solid geometry.

In 1903 Spare was entered by Lambeth for the National Competition of Schools of Art, winning a silver medal. The judges included Walter Crane and Byam Shaw, and they noted his "remarkable sense of colour and great vigour of conception." The art magazine *The Studio* felt that "his designs for figure compositions in colour belong practically to the realm of colour-prints, and as such are quite the best of their kind." Looking back at the report of the competition with hindsight gives an overview of individuals who had not yet met each other, working separately around the country. Along with Spare and Philpot, the report mentions Maggie Richardson from New Cross, with her metalwork, and Herbert Budd, designing fireplace tiles up in Hanley; Spare would get to know both of them at the Royal College of Art, along with the suffragette Sylvia Pankhurst.

Living through the era he did, Spare could hardly escape the influence of Aubrey Beardsley, even if it was largely indirect. Closer influences included Charles Ricketts – who was himself highly influenced by William Morris and the Pre-Raphaelites – and Edmund Sullivan, a Victorian illustrator of the grotesque. The greatest influence of all was probably the Symbolist painter George Frederick Watts, "England's Michelangelo".

Watts aimed to paint ideas rather than objects, and his high-minded if sometimes ponderous allegorical works towered over Victorian art. His much-reproduced picture *Hope* (1885) features a blindfolded female figure sitting on a globe and perseveringly playing on a harp which has only one remaining string: "Once seen this famous picture is never forgotten, which helps to explain why it was regarded for so long as the epitome of all that was most regrettable in Victorian painting."

Spare worked at his drawing until well into the night, then read in bed. He was a keen reader, notably of Homer, and Edward Fitzgerald's exotically Orientalist *Rubaiyat of Omar Khayyam*. More than that, he had discovered Theosophy, in the form of Madame Blavatsky's *Isis Unveiled* (1877) and *The Secret Doctrine* (1888). Cobbled together from numerous sources – one critic found over two thousand passages quoted from other books without any acknowledgement – *Isis Unveiled* was a huge tome, written at great speed and supposedly with the help of spirit guides and secret masters. Anyone reading it would learn about Egyptian occultism, the cult of the Great Mother, and a digest of Eastern philosophy.

As a historian of Theosophy, Peter Washington, has noted,

> *Blavatsky's book answered to deep needs at a time when religious doubt was fuelled by the first great age of mass education. The late nineteenth century produced a large, semi-educated readership with the appetite, the aspirations and the lack of intellectual sophistication necessary to consume such texts. It was the milieu portrayed so vividly in England by Bernard Shaw, HG Wells, George Gissing and Hale White: the world of autodidacts, penny newspapers, weekly encyclopaedias,*

evening classes, public lectures, workers' educational institutes, debating unions, libraries of popular classics, socialist societies and art clubs – that bustling, earnest world where the readers of Ruskin and Edward Carpenter could improve themselves, where middle-class idealists could help them to do so, and where nudism and dietary reform linked arms with universal brotherhood and occult wisdom.

Much of Blavatsky's writing now seems ridiculous, and it did then to many readers, but it must have fascinated the young Spare up in his bed or he would never have persisted with it. There was another world revealed in her books, rich with the consolations of dubious philosophy.

A philosopher named Karl Britton once told his friend Wittgenstein that he had just reviewed a philosophy book by the once-famous intellectual celebrity Professor Joad. They agreed it was a bad book, but Britton mentioned that he had lent it to a friend of his, a policeman, who had read it aloud to his wife from cover to cover, and they had both been completely charmed by it: "It opened up a new world," the man told Britton.

This very much interested Wittgenstein and after a moment he said: "Yes, I understand how that is. Have you ever seen a child make a grotto with leaves and stones and candles — and then creep in and out of the world into a kind of world he has made for himself? It was the grotto that your policeman friend liked to creep into."

Spare would soon be pushing deeper into the grotto, reading books such as Cornelius Agrippa's *Three Books of Occult Philosophy*, the works of the French occultist Eliphas Levi, and more Blavatsky.

Grottoes are fascinating, but there were some genuinely inspirational ideas in Theosophy, and its appeal was not restricted to the semi-educated. Yeats was at one time a Theosophist, and a Blavatsky book – *The Voice of the Silence* – is said to have been on Tennyson's bedside table when he died.

Theosophy offered a synthesis of the world's religions, suggesting that Christ, Buddha, Lao Tzu and the rest were all equally "Masters", and it promoted a fascination with non-western cultures, notably of Egypt, India and Tibet. Along with more dubious ideas – that a body of Himalayan adepts was running the world behind the scenes, for example, and that it was possible to contact them – Theosophy gave a basic introduction to Hindu and Buddhist ideas, including reincarnation and karma, and popular occult ideas such as the astral body and the astral plane, where the astral body can go flying during sleep. The student of theosophy would have learned of the spiritual background to the ordinary world, and that the world of appearances was not the real or ultimate world; an idea found not only in Eastern philosophy but also in Platonism, Gnosticism, the Qabala, Kantian philosophy and German idealism, and Symbolist art.

The Royal College of Art in South Kensington was a great disappointment to Spare, as it was to many of its students. When the young Aubrey Beardsley called on GF Watts, Watts specifically advised him to avoid "South Kensington". Spare was already used to drawing from life in his Lambeth evening classes, but at the RCA he found himself drawing hands and feet from plaster casts. What life drawing there was was taught as lectures, with over two hundred students crammed into an airless room. Spare's lifelong strength was line (highly valued at the Slade art school, where he might have been happier) but at the RCA the emphasis was on shading. There was also no training in black-and-white pen illustration (which had been highly regarded back at Lambeth), despite the fact that many of the students would later have to earn their living from it. Altogether, as Sylvia Pankhurst said, "There is a general depressing feeling in the College. I never was in a place where one felt that so keenly. The students are very miserable about their future..."

Much of this misery was financial and practical. "A great many students do not eat enough," said Pankhurst; "It is not very easy to live on the little money that they get, and they do not look after themselves properly in many instances." Students were often despairing about their careers, knowing that the main prospect would be teaching, or doing

commercial illustration for little money, and Pankhurst said she could count five cases of insanity in students who were at the college or had recently left.

It would be interesting to know if she thought Spare was one of them. He was still living at home with his parents in Kennington, but he indulged a certain 'artistic' flamboyance in his dress, wearing a white shirt with a coloured sash. Herbert Budd (also known as Herbert Ashwin Budd, 1881-1950), who went on to become an art teacher, remembered him four decades later, with some romanticization, as "a fair creature resembling a Greek god, curly haired, proud, self-willed, practising the black arts and taking drugs."

Spare was something of an *enfant terrible* at the College. He was tall, with striking looks, and he had a reputation as rather a dangerous individual, although this was not really the case and his aloofness was largely shyness. He was younger than most of the other students and, according to Sylvia Pankhurst, "the weirdness of his work in those days caused the first year women students to regard him as a rather dangerous person." When he announced a plan to publish his first book of drawings, *Earth: Inferno*, and started taking advance orders, several of the more reserved or cautious women asked Pankhurst to order copies on their behalf.

Although the male students often considered her to be rather haughty, Pankhurst and Spare became great friends – one of her biographers describes him as "perhaps her best friend" at the time – and they stayed in touch in later life; she tried to help him as her star rose and his waned.

Spare's younger sister Ellen became a feminist comrade of Pankhurst, and helped in her campaign against the Italian invasion of Abyssinia (Ethiopia) in the Thirties. Spare himself supported this, and gave her some of his work to sell for the cause; when Pankhurst went to live in Addis Ababa she took three of his pictures with her, and her son Richard Pankhurst remembered "she always spoke of him as one of the finest draughtsmen she had ever known."

Spare's last word on the suffragette milieu, in the Fifties, was less exalted but typical of a certain vein in his later utterances: "The feminist movement were mainly sexual failures or sexually sub-normal – few of them worth going to bed with – I know."

1904, meanwhile, was Spare's *annus mirabilis*. In May 1904 he had his first public showing in the foyer of the Newington Public Library, Walworth Road. The spread of public libraries and galleries was a relatively recent phenomenon, part of a nineteenth-century attempt to take culture to the people. One of the prime movers in bringing art to South London was William Rossiter, a founder of the South London Art Gallery, who found his patience tried by "swearing young monkeys" who threw cabbages at pictures and behaved like savages: "I have been invited by a gentleman of four to go outside and have my head punched."

Now the people were being treated to a show by one of their own: the young Austin Spare. "This is a vitality that comes from the street", said the *Daily Mail*. In some respects it was a strange event for a public library to mount, given the often unhealthy-looking air of Spare's work. One of the drawings on view is said to have been 'Portrait of Hisself Aged 17'. Beneath this distinctly uneducational spelling it features an unshaven Spare, one hand in his pocket, wearing a peculiar vulture motif on his shirt. He is wearing a loose sash like the one Pankhurst remembered, and he is standing over, or perhaps rising up from, a nude woman sitting with her back to him on a kind of upholstered banquette. Neither of them looks very happy.

Spare's trousers end at the knee, and beneath his hairy leg his bare foot is treading on a tube of paint, making it spurt from the tube. Between his name and the date, 1904, is an animal skull, and round the banquette are some obscurely mystic words – something about "Kia", and more in an unknown language – ending "sleep is better than prayer".

The Newington Library is an attractive building, and an imposing venue for a seventeen-year-old. Spare must have found it exciting; perhaps uncomfortably exciting, increasing his self-consciousness as much as his self-esteem. What the locals made of it is not recorded, but one man who was impressed was the popular journalist Hannen Swaffer.

Swaffer was going home to Denmark Hill on a tram when it went past the Library, and he saw the arresting name of Austin Osman

Spare on a poster outside. He broke his journey and went in. "All I can remember of this collection of drawings is their extraordinary rhythm of line and their arresting originality. But the experience, and the artist's name, I never forgot." The man getting off the tram could hardly know that twenty years later he would meet Spare, and in fifty he would offer to pay for his funeral.

The public library show was hardly more than a rehearsal for the wave of attention that was about to break over Spare, after his father submitted two of his drawings to the Royal Academy. One of them, a design for a bookplate, was accepted, and Spare suddenly found himself famous as the youngest exhibitor: the youngest exhibitor ever, in many accounts.[1]

Extraordinary praise seems to have showered down on Spare around this time, although it is often hard to confirm. GF Watts apparently said "Young Spare has already done enough to justify his fame", Augustus John is supposed to have described his draughtsmanship as "unsurpassed", and John Singer Sargent allegedly hailed him as "a genius" and the greatest draughtsman in England.

Whatever was said, there must have been an element of kindness and encouragement as well as absolute praise, and this may not have been clear to Spare and his family. Meanwhile, journalists descended on the house in Kennington. Spare was "beyond doubt a genius." He had been a stained glass designer, but it had become clear he "possessed too brilliant a genius for this work." Now he had "astonished the art world" with works "which are staggering in their profundity." His career was already marked out: "His ambition is to be President of the Royal Academy."

Spare would come home from the Royal College to find journalists already waiting for him, and poking about. "Ah, don't look at that," he said to one, hiding away a frieze designed for a nursery. "I did that in a kid's competition." Far from taking drugs and practising the black arts, the journalists noticed how laboriously he worked, leaving home

1. Which is untrue. Edward and Charles Detmold, for example, had exhibited work at the age of thirteen in 1897.

AN ACADEMY EXHIBITOR AT SEVENTEEN.

Austin Spare Talks about his Life.

DWELLING in a humble home in Kennington is a poor boy who has had the good fortune to win a considerable measure of fame at one fell swoop.

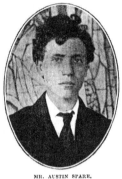

His name is Austin Spare, and he is seventeen years of age. Six months ago no one in the outside world had ever heard of young Spare. Obscurity and a meagre wage seemed to be his permanent lot in life. What he should do to earn money he did not quite know. There was a chance of his becoming a telegraph messenger. It was of the utmost importance that he should contribute towards his own keep, for his father, who had been a constable in the City of London Police Force, was none too well off. Altogether Austin Spare's outlook was not bright.

MR. AUSTIN SPARE.
(*From a Photograph.*)

at eight thirty, returning at nine, and then drawing into the night. In the mornings "I can hardly open my eyes," he said: "It is on waking in the morning that I feel the strain." Why couldn't he play the odd game of cricket, like he used to? "Because I can't. I shall take up sport again when I've time to breathe."

Spare had already sold some work. The first picture he sold, for half a crown, was a watercoloured drawing entitled 'The Spirit of War', inspired by a (misquoted) line from Alexander Pope's mock-epic poem *The Rape of the Lock*, "What dire offences rise from trivial things." Beardsley had already illustrated Pope's poem in 1896.

Spare's modesty was noticed by several interviewers ("when people have bought my drawings," he said, "I have always thought that they did so merely to do me a good turn") but it was in a long interview with the Edwardian boy's paper *Chums* that his discomfort with celebrity really began to manifest itself. *Chums* always liked 'boy makes good' stories, prodigies, and triumphs over adversity, and this was how they wrote Spare's story up ("It has been remarked that Austin Spare is in poor circumstances. As a matter of fact he can indulge in very few of the amusements that are dear to a lad's heart. Compared with him the public schoolboy with his shilling or two a week is a millionaire").

They trumpeted Spare on the cover, but after the usual praise ("The news of the lad's triumph at the phenomenally early age of seventeen at once spread through the length and breadth of the land, and today Austin Spare is regarded as a wonder even by the greatest

of artists") Spare's own words were far from being so positive, and the cracks began to show:

> *I admit that I used to be ambitious, but somehow it has been crushed out of me. I have had to cope with discouragement. The only time I could work with my brush was at night, and then again people seeing me perpetually painting concluded that I was not quite right in the head. When I forsook trade to study as an artist they said that I ought to be out working – perhaps as a telegraph boy.*

And now, "a lot of erroneous statements have been printed concerning me. It has been alleged that I aspire to be President of the Royal Academy. I no more aspire to be President of the Royal Academy than I aspire to be a wastepaper basket."

Chums printed a picture by Spare, apparently done when he was thirteen, featuring a lion-like animal standing on an arabesque of convoluted vines or creepers; it is remarkably like Charles Ricketts's illustrations for Wilde's *The Sphinx*. The similarity passed unnoted, but some journalists thought his work resembled that of Sidney Sime and GF Watts. Watts was also mentioned in interviews: "Of the great names in art he knows but little. Watts has the complete mastery of him."

The society paper *The Tatler* printed a strange photograph of Spare pretending to paint while dressed in what looks like his Sunday best, wearing a tie and sporting a watch chain. The picture on the easel looks like his friend Glyn Philpot. Strangest of all, Spare's eyes are closed: it is not clear if he is blinking in a flash or dreaming in concentration. His father said he used to draw in "a trance," which would turn out to be a very prescient description.

On the floor in the *Tatler* photo is what looks like a picture of his father. Within a few years another portrait of his father led to a family disagreement, when Spare senior complained that it looked as if he only had one ear. Unhappy with criticism, Spare then deliberately changed the colour of his father's eyes from blue to brown.

Spare found his celebrity painful and he became ill with stress, beginning a lifelong tendency to psychosomatic suffering. The following

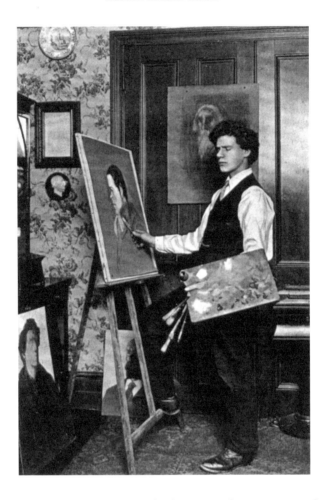

year he was still being hounded. Cycling out to Surrey to visit a female relative who was in domestic service at a house there, and possibly to visit the writer George Meredith, he was in the White Horse Inn at Shere when a journalist called Arthur Ravenscroft recognised him, with his distinctive bushy hair. Yes, said Spare, "I am Austin Spare," but "I do not wish to commune with journalists as I am off to visit George Meredith."

Years later the period of the 1904 journalists, waiting for him to come home and picking up nursery friezes, had mutated in his memory to

something like a bad dream: they "all poked and pushed themselves into private bedrooms and cupboards," he told a friend, who remembered it was all very much "to Austin's disgust and consternation."

Most of the interviewers noticed how very autodidactic and earnest Spare was; possibly more earnest than they would have liked. "His conceptions of men and things are weird in the extreme" said the *Daily Chronicle*; "His figures have faces that suggest nightmares and all the terrors of the *Inferno*. He might have been born to illustrate *The Divine Comedy*. The explanation is not far to seek. Hear this boy of seventeen on religion:

> *I have practically none... All faiths are to me the same. I go to the Church in which I was born – the Established – but without the slightest faith. In fact, I am devising a religion of my own which embodies my conception of what we were, are, and shall be in the future."*

Already Spare was working out his central ideas about what he called the "Zos" and the "Kia" – the word in the public library show – and the interplay between the two. Spare's ideas might seem strange, but perhaps no stranger than the allegorical system of William Blake, with Urizen, Los, and the Four Zoas.

Spare considered "Zos" to be the body as a whole, including the ordinary mind: the whole mortal, fleshly, existential entity of the person. In later life he would refer to himself as Zos. It seems to combine a sense of the biological or animal with the esoteric; animal from the related Greek roots *zoe*, life, and *zoion*, animal or beast, giving rise to words like zoo, zoological, *The Zoist* (the name of a Victorian periodical and a society, the Zoists, to which Spare's friend Victor Neuburg belonged), "zoetic" ('pertaining to life') and so on.

At the same time, due to the rarity of Z in English, it also has a distinctly esoteric ring to it, as in Zeus; *Zanoni*, the famous Victorian occult novel by Bulwer Lytton; Zoretti, the spirit guide of WB Yeats;

the Zohar, one of the sacred Jewish texts; Zoroaster or Zarathustra, the Persian prophet; Zosimos, Azazel, Azrael, and so on. The spiritual world abounds in Zeddy mystic entities, and what have been called "dental sibilant gods."

The word Kia is more complex. Spare sometimes speaks of it like a universal mind or God, but it is less personal, and more like the Hindu Brahman or the Tao of Chinese philosophy. Spare associates it with a vulture, skulls, and evolution, and it is at one and the same time the fertile void behind existence and also a soul-like state of supremely detached, self-sufficient consciousness.

Spare's phrasing when he writes of the Kia seems to borrow from Taoism on the Tao, the "way" which is in and behind everything, and of which nothing can be said: "the Tao that can be expressed in words is not the Tao". It is from this perspective that the Tao makes an uncarved block of stone more sublime than any sculpture, since it already contains all possible carvings in undisturbed potential. Kia is perfect in its formlessness, like the Buddhist idea of *Sunyata*, the absolute void. Again, nothing can be said about *Sunyata*, but it is "the ground of all Wisdom." Louis MacNeice has observed that "'Nothing', in [the] mystical sense, seems to be an essential part of the foundations of religion."

Like Zos the word Kia, again, has a mystic ring to it, resembling esoteric Eastern and cabalistic words Spare might have encountered such as *ki*, *chi*, *khya*, and *chiah*. The most likely inspiration, however, is Blavatsky and *The Secret Doctrine*, where the word Kia figures as a compound (Kia-yu) with an accent over the A like the one Spare tends to give it.[2] Within a year or two he had finished a magical book or grimoire in decorated manuscript form, entitled 'The Arcana of AOS and the Consciousness of Kia-Ra', which surfaced at Sotheby's a few years ago.[3]

It was a book like this 'Arcana of AOS' that was seen by the reporter from *The Daily Chronicle*:

2. After the intrinsic impossibility of defining Kia, it is a relief to say that at least we know how Spare pronounced it: he pronounced it "Keah" or "Keer".
3. *The Book as Art: Modern Illustrated Books and Fine Bindings, Part II*, Sotheby's London 21st November 1995, lot 411.

*And this curious religion is an important factor in the youth's
personality. He is writing it out and illustrating it with glaring
terrible plates, the whole to be contained between two covers of
wood emblazoned with symbols, the one called "Power" – an
elephant head with human arms outstretched on either side, and the
other some crowning deity, after the manner of the Egyptian Isis.*

Writing in a 1907 book, *The Power of Gems and Charms*, George Bratley
noted that "it is not only royalty who believe in the magic of charms," and
then moved from superstitious monarchs to the likes of Haydn, Rider
Haggard, aviator Santos Dumont, and "the clever black-and-white artist
Mr. Austin Osman Spare". Spare, says Bratley,

*once picked up a golden skull, bearing the word "one" in opals.
On the night he picked it up he dreamed that as long as he kept
the trinket, he would be lucky. So far his dream has come true.
It is for this reason that he signs his drawings 'One.'*

Picking up this gold-and-opal object sounds too good to be true,
but in 1904 the man from the *Morning Leader* saw something like it,
minus the gold and the opals: "He signs most of his drawings – 'One,'
and the same word he wears on his jacket in a sort of pin of skull and
cross-keys design." Spare was still wearing this in the Fifties.

Exactly what Spare meant by "One" remains a mystery, but he
does sign his pictures with the word around this period. Spare the
aspiring artist might have felt it had a good individualistic ring to it,
and a certain social dignity. In the words of JP Donleavy:

*Back far enough... we all had to come from the wrong side of the
tracks. And rely on the good example of others who made it over
to the right side of the tracks. Where one refers to oneself as one.*

At the same time he almost certainly meant some form of mystic
oneness (the oneness of the human and divine, for example, sometimes

said to be the central message of Theosophy); or the oneness of the self seen as a world in itself; or the oneness of the Tao, or of the Kia.

In its earliest appearances the Kia seems to be more of an entity rather than a philosophical abstraction, playing its part in the visionary adventures of a persona called AOS, but within a few years Spare started to symbolize the Kia as a vulture's head, and to describe it as the "consumer of religion" (consumer in the sense not of customer but of destroying devourer). This aspect of the Kia is not only a state of mind but – like the Tao – contains something like the idea of 'deep time', setting not just our troubles but our little religions, just a couple of thousand human years old, against the age of the universe.

In that sense the Kia must have been comforting to contemplate, taking the unhappy Spare 'out of himself' and dwarfing even the perspective of the kind of thinking commonly expressed in sentiments such as 'this too shall pass', and 'one day I'll look back on all this and laugh.' As Spare put it, "Revere the Kia and your mind will become tranquil."

1904 was a difficult year for Spare, but his golden age was just about to begin.

Four: A TOUCH OF EVIL

Speaking in the House of Commons early in 1906, Winston Churchill attempted to defend something called the Chinese Labour Contract – the use of indentured Chinese labour in the South African gold mines, under conditions akin to serfdom or worse – which was widely recognised to be a disgrace. "The Chinese Labour Contract," he said, "cannot in the opinion of His Majesty's Government be classified as slavery *in the extreme acceptance of the word* without *some risk* of terminological inexactitude." [my emphases]

This had already been the subject of *The Morning Leader*'s 'Cartoon of the Day', during the period of Spare's Royal Academy celebrity. In the right hand panel, captioned "SLAVERY South Africa", a man of Chinese appearance, with slit eyes and a pigtail, stands bearing a pickaxe before an industrial or mining structure suggestive of a cross. In the left hand panel, captioned "MAMMON Park Lane", a bow-tied plutocrat sits at a candelabra-lit dining table furnished with elaborately designed and faintly sinister vessels of abundance. "This," the paper explained, "is the first political cartoon drawn by Austin Spare, the seventeen year old artist, whose picture at the Royal Academy is attracting the notice of so many visitors."

Profiling him three years later, the paper *The New Age* celebrated Spare as not only "a new Blake" but an artist who "has learnt his art by himself in the hard environment of poverty and opposition," under the heading "A Young Socialist Painter." Although the occult would be associated through the twentieth century with reactionary tendencies, as George Orwell points out in his essay on Yeats, for Spare it was still marked by the progressive politics that were bound up in the nineteenth century with Theosophy, spiritualism, and even phrenology. Before long, though, Spare would declare an even more

radical disaffection that went well beyond anything that is normally called political.

Things were not getting any better for Spare at the Royal College, where GS Sandilands, later to be Registrar of the College, remembered him as the "wonder boy", but where he was now in trouble for cutting his classes. With the College in a state of widely-recognised malaise (Professor WR Lethaby described it as "probably the worst Art College in Europe") Spare preferred to go and study on his own, looking at the designed objects in the nearby Victoria and Albert museum; the Egyptian, Greek and other antiquities at the British Museum; and the animals and birds at Regent's Park Zoo. This would leave more trace in his work than anything he learned at the College.

At some point he was called to account for his truancy. As the years went by his memory of the RCA, like his memory of the poking plague of journalists, became dreamlike: he told Haydn Mackey of being summoned to account for himself in a room with an enormous table:

> *... the longest table he'd ever conceived as possible, even in a dream. An enormous table that stretched in a vast perspective from the end at which, meek and lowly, he and his fellow delinquents stood. The effect of that huge table was all that he seemed to regard as of any significant interest. What decisions were arrived at, affecting his conduct, career or prospects, on that solemn occasion I never learnt from him. The whole incident, apart from the colossal table, had long been dismissed from his mind.*

Spare had been a striking figure at the RCA, and something of a character. He was quite well liked by the other students, if 'odd', and Maggie Richardson, a sculptor, celebrated his looks in a portrait. Spare left the College in 1905. He had acquired no qualifications, but he must have been buoyed up by the sensational publicity of 1904 and his self-publication in February 1905 of the work that Pankhurst and her friends had subscribed to: his first book, *Earth: Inferno*.

Looking back on the 1890s, GK Chesterton remembered "the Decadents and Pessimists who ruled the culture of the age." New realities of economic and sexual discontent were breaking the surface, and the hypocrisies and exaggerated decencies of the Victorian age were being unmasked. In their place came a new morbidity, and an almost glamorously sophisticated sense of evil that radiated from Aubrey Beardsley and the decadent periodical *The Yellow Book*.

Defending Beardsley, the artist and great chronicler of the period William Rothenstein notes his reaction against "a false refinement", a refinement that "forbade the mention of the real nature of man's instincts. His greed, his lust, and his cruelty were no longer spoken of." Beardsley's sister Mabel told Yeats that her brother "hated the people who denied the existence of evil, and being so young filled his pictures with evil." The result was that his exquisitely elegant drawings were widely condemned as "repellent" and "repulsive," and he was described in his *Times* obituary as "morbid."

Morbid itself, one of the key words of the time, was discussed by Vincent O'Sullivan in the Nineties periodical *The Savoy* ('On The Kind Of Fiction Called Morbid') and more penetratingly considered by William James in *Varieties of Religious Experience*. James suggested it was an all too valid way of seeing the underlying realities of existence.

> To... the morbid-minded way, as we might call it, healthy-mindedness pure and simple seems unspeakably blind and shallow... To the healthy-minded way, on the other hand, the way of the sick soul seems unmanly and diseased...

> [But] healthy-mindedness is inadequate as a philosophical doctrine, because the evil facts which it refuses positively to account for are a genuine portion of reality; and they may after all be the best key to life's significance, and possibly the only openers of our eyes to the deepest levels of truth.

> The normal process of life contains moments as bad as any of those which the insane melancholy is filled with, moments in which radical evil gets its innings and takes its solid turn. The

*lunatic's visions of horror are all drawn from the material of
daily fact. Our civilisation is founded on the shambles* [i.e.
slaughterhouse], *and every individual existence goes out in a
lonely spasm of helpless agony. If you protest, my friend, wait
till you arrive there yourself!*

One of the most quintessential characters of the period was the dismal
poet Enoch Soames, habitué of the Café Royal and author of two slim
volumes of verse entitled *Negations* and *Fungoids*. The poems were "Strange
growths," in Soames's own description: "...exquisite, and many-hued, and
full of poisons." "Pale tunes irresolute," ran one,

> *And traceries of old sounds*
> *Blown from a rotted flute*
> *Mingle with noise of cymbals rouged with rust,*
> *Nor not strange forms and epicene,*
> *Lie bleeding in the dust,*
> *Being wounded with wounds.*

Another began "Round and round the shutter'd Square / I stroll'd
with the Devil's arm in mine," while a third was a dialogue between
St. Ursula and Pan. Soames was very slyly depicted by his creator Max
Beerbohm who felt, all things considered, that the Diabolistic side of
Soames was probably his best; indeed, "it seemed to be a cheerful, even a
wholesome influence in his life."

Soames was perfectly in step with his era, but it was not enough
to save him from obscurity; he makes a time-travelling pact with the
Devil, in order to discover his posthumous reputation, but can find
little trace of himself. So much a figure of his day, Soames has all but
vanished from the history of literature, like Spare from the history
of art.

Spare's disenchantment with his fame may have fed into *Earth: Inferno*, which he worked on through 1904 and self-published in February 1905 using the Co-Operative Printing Society in Tudor Street, a stone's throw from the glass factory where he had worked.

The central argument of the book is that this Earth is already hell, expounded in text and drawings arising from a convoluted mixture of Dante, Theosophy (Blavatsky had revealed that this Earth is hell in her 1889 book *Voice of the Silence*), Omar Khayyam, the Bible, and Spare's own nascent mystical system. As "C.H.L." writes in the Foreword, "we cannot fail to see how far removed is the conception of Earth here presented from the accepted theory. ... these pictorial writings in allegory are to convey no morals or sentiments, but are a song of Experience and of the Negative."

"Strange Desires and Morbid Fancies," Spare wrote in the Soames-like dedicatory verse, "Such do I give." He expanded on this in 'Of Myself:'

> *Alas! I am morbid,*
> *And have put a purple colour about my brow.*
> *All men seem eating and drinking the*
> *"Joy of the Round Feast," while I am*
> *Melancholy and silent, as though in a*
> *Gloomy wood, astray.*
>
> *Strange images of myself did I create,*
> *As I gazed into the seeming pit of others,*
> *Losing myself in the thoughtfulness*
> *Of my unreal self, as humanity saw me.*
> *But alas! on entering to the consciousness*
> *Of my real being, to find fostering*
> *"The all-prevailing woman,"*
> *And I strayed with her, into the path direct.*
> *"Hail! The Jewel in the Lotus."*

An awkward, ugly, naked figure, seemingly with two left feet, removes a domino mask from its face with the caption "Blindness Unmasked." Another figure is still wearing such a domino, for the moment, raising a hand to it while a bearded old man stands close

behind with warty growths on his bald scalp below the caption "Youth Unmasks." On the ground beside them is a soda siphon with writing on it: "Read The Yellow Book."

Disappointment and disillusion are key notes:

The Pleasure in Pleasure
Is the expectation of the actual,
But the actual is a crude awakening
From the blindness;

Perhaps Spare felt his minor celebrity was an over-exposure, and yet negligible in the larger scheme of things:

When we gaze into the mirror of our-SELF,
And see our works as others judge them,
Then we realize our insignificance
To the incomprehensible intellect of
The Absolute KIA (the omniscient),
And find how subcutaneous our
Attainments are.
Alas! We are children of EARTH.

This I will call the HELL of Intrinsic Being.

Two figures, a man in a coat and a sexually ambiguous figure in a low-cut dress (a snake rising at the heavy cleavage) with a heavy jaw and a bristly chin, are labelled The Despair, punning on Spare and Pair. Candles burn and a naked woman lies seemingly unconscious while a naked man – with the bathetically footy-looking feet, almost cartoon-like, that are something of an early Spare trademark – crouches nearby, wearing a domino and paying her no attention.

Elsewhere, looking forward to some of Spare's later work, a naked woman lies on a plain architectural curve, with wretched-looking figures below. Perhaps combining the mother-goddess with the feminism of the era, and the contemporary idea of the "New Woman", it is

The desertion of the "Universal Woman," lying barren
On the Parapet of the Subconsciousness in humanity;
And humanity sinking into the pit of conventionality.
Hail! The convention of the age is nearing its limit,
And with it a resurrection of the Primitive Woman.

It is tempting to say the pictures speak for themselves, but even this would hardly be true. Beardsleyesque evil; hermaphroditism and sexual confusion; satisfaction denied and padlocked away; a grotesque carnival of masks and mirrors; a chaos of writhing bodies, like something from Doré; a seedy man leaning his chair on its back legs while 'The Dwellers on the Threshold' occupy his mind – perhaps – and shadowy cats run past his feet; animal-like skulls; and a general air of cracked, off-key evil: it would be a very bold viewer who presumed to say what it all means.

Clearer sense occasionally breaks through: "I myself am Heaven and Hell"; while a youth "exposes the inferno of THE NORMAL" by drawing aside the shielding curtain of "Faith (a token of humanity's LIMITED knowledge)". Elsewhere "DEATH IS ALL." Knowledge as Jester capsizes "the Feast of Illusion" and exposes "The World, The Flesh, and The Being." As for the morbid young author,

My ambition is DEAD,
Died premature and with it the love of care,
Also the Jewel in the Lotus.
The morrow holds nought for me
Save Sin and Death.

Nevertheless it is here that positive notes start to assert themselves:

Yet in despair we begin to see true light.
In weakness we can become strong

And in heavier type, one of the clearer lines in the book: "REVERE the KIA and Your Mind will become TRANQUIL."

What Spare's family made of *Earth: Inferno* is anyone's guess. His mother and father were probably proud, mystified and worried in equal measure. Spare's father may not have had much idea what Zos and Kia meant (let alone Ikkah, Sikkah[1] and the Zod-Kias, which also figured in Spare's complex early system) but he always stuck by Spare and encouraged him. His mother may have been growing less keen on his work.

Someone who wouldn't have liked it at all was his elder sister Susan "Cissy" Spare, who was growing to loathe him. Aggressively sensible, strait-laced, and religious, she regarded Austin as the black sheep of the family, or even as a little Antichrist, and her dislike would have serious consequences for him later.

Spare seems to have kept a visual diary around this period: a few sketchy pages survive, including what looks like a winged figure taking off from a sleeping Spare; a simple home-made shrine; an indistinct or ghostly figure speaking into Spare's ear; and another, with a suggestion of turbulence or radiance before the Spare figure, entitled 'The Reunion with Ellen Osman'.

It is not clear who Ellen Osman was, but it is very possible she was a dead and loved relative on his mother's side; an aunt, perhaps. Given the recycling of names in Victorian and Edwardian families, and the pieties of the time, it may be significant that the Spares' last child, born in 1900, was christened Ellen.

As for reunions with the dead, Spare was definitely aware of spiritualism at this time, and it manifests in his work at both ends of his career, including a picture of a 'Red Indian' 'spirit guide' named Black Eagle, of the sort that were once popular in the British parlour ("Red Eagle, White Owl, Grey Feather, some such name," writes one commentator; "one imagines some enormous squawking empyreal chicken run from which spiritualists draw their guides").

Modern Spiritualism had begun in New York in 1848 with

1. Gavin Semple has suggested that the words "ikkah" and "sikkah" are derived from Sanskrit, indicating Spare's exposure to classical Indian thought via Theosophy. In Spare's early system Ikkah seems to be the body and Sikah consciousness.

the tapping and banging noises around the Fox sisters, Margaretta, Leah and Kate, and it answered such a deep need that even when they confessed to fraud this did nothing to halt the craze. Before long this domesticated necromancy had taken off in Britain, with all its apparatus of flying trumpets, luminous hands, and yards of wet, cheesecloth-like ectoplasm. It fascinated people across the social spectrum: Sir Arthur Conan Doyle was a keen spiritualist, as was Sir Oliver Lodge, one of the foremost scientists of the day. WB Yeats, whose literary career was radically changed by mediumistic phenomena, wrote in 1927 "I am still of [the] opinion that only two topics can be of the least interest to a serious and studious mind – sex and the dead."

Despite that, spiritualism seems doomed to be associated with fraud, ignorance, and supernatural kitsch: "the infinite army of the banal dead", to borrow a phrase from Osbert Sitwell, or more recently "Something about a cardigan, she was saying. A certain class of dead people was always talking about cardigans. The button off it, the pearl button, see if it's dropped behind the dresser drawer, that little drawer, that top drawer...". Speaking distinctly *de haut en bas*, Arthur Machen summed it up as "all the rabble rout of imposture, with their machinery of poor tricks and feeble conjurings, the true back parlour of shabby London streets." The point is made more elegantly by Tim d'Arch Smith, contrasting the "roulette" of ritual magic with Spiritualism as "the bingo of the occult world."

The empyreal chicken run is a comical image, but perhaps all this joking has something nervous about it; something that denies the real experience of darkened parlours, often as strange as it was seedy. The writer and curator James Laver, who knew Spare, remembers paying seven shillings and sixpence to attend "the front parlour of a small house in a back street in Balham." The lights went down and the attendees were requested to sing, "passing without any apparent sense of incongruity, from 'Abide With Me' to 'Roll Out The Barrel', and from 'Angels Hovering Round' to 'Who, Who, Who's Your Lady Friend?'". The medium, a man on this occasion – they were more usually women, contributing to the erotic charge that was often felt at seances – was tied to a chair with a luminous painted trumpet nearby, which duly began to levitate and speak. It was "Dad". "God

bless you, Dad," cried one of the party, "Have you any message for us tonight?", but Dad was playing it safe: "Go on," he said, "as you're going on now."

Laver saw the whole thing was a fraud, and a pretty cheap one ("The medium had earned... the same rate, perhaps, as a conjurer at a children's party").

> *But the interesting thing is that, by the time the foolery was finished, the atmosphere of that little back parlour in Balham was so charged with evil that I fled from the house as quickly as I could. No doubt the Collective Unconscious – whatever that might be – contains all the devils that mankind has ever imagined, and it is only too easy to call them up.*

Spare's few direct comments on spiritualism are not very positive. "These spiritualists are living sepulchres," he wrote at a period when he was disenchanted with almost everything he'd ever known; "What has decayed should perish decently." On another occasion he said that what appeared to be fraud – the word that always recurs with spiritualism – wasn't necessarily simple fraud, but rather an attempt to recapture what the medium had once experienced as real.

Something was happening. "The tables turn. The sleepers speak. This is a fact," writes Jean Cocteau; "It is revolting to deny it." Where James Laver saw something simply fraudulent and yet strangely evil, others witnessed something indeterminate and more precisely *uncanny*. It is this grey area of spiritualism, involving neither the spirits of the dead nor conscious fraud, that was the most thought-provoking for some witnesses, Spare among them. It seemed to point to the uncanny weirdness of the human mind, and strange things happening within it. Spare left little direct record of his early involvement with spiritualism, but his work suggests that it marked him more deeply than anything else.

Spare's work was growing stronger in composition and he had another drawing accepted for the Royal Academy in 1905, *The Resurrection of Zoroaster*, which features serpentine creatures with beaks swirling around an ascending figure. Having left the Royal College, he now began earning money as a bookplate designer and illustrator, with Ethel Wheeler's *Behind The Veil*, published by David Nutt in 1906, as his first book commission.

Containing two works, 'Past Incarnations' and 'Through the Mystic Doors', *Behind the Veil* is a forgettable helping of vaguely mystical prose. "I was exploring the byways of the Docks at Rotherhithe," says the narrator, "for the purpose of catching local colour upon my mental palette, to be afterwards transferred to the pages of the realistic novel I was engaged upon, 'The Submerged Soul,'" when she encounters an old man throwing himself into the Thames, and the title of her book flashes into her mind. "'Bride of the World,' shouts the old man, "supreme Beauty, hidden too long under the tinsel of our earthly show, wait for me! I come!" She never finds the strangely iridescent pool again, nor any trace of the old man, "who had sought to elude again the trammels of the senses, and wed with the submerged soul of the human race."

As well as drawing the suicidal old man, Spare responded to the book with some suitably Symbolist-style pictures, including some nuns beside a crucifix, with a Continental-looking town visible through a round window; a more Nineties-ish composition including a peacock, a candlestick, and a bird with a lock of hair in its beak; and a man by a window with a moonlit landscape beyond.

A second commission from David Nutt, Charles Grindrod's *Songs from the Classics, Second Series* (1907), allowed Spare to indulge a fascination with Greek antiquity. For the most part the illustrations are fairly literal – 'Arachne' has a woman weaving, and 'The Riddle of Oedipus' has a winged sphinx on some Charles Ricketts-style rock or cliffs – but others deviate into the designing of fabulously elaborate antique objects: the cover shows a jug with a multi-breasted woman for a handle, a face for a spout, and masks at its foot. Inside the book there is another curious jug, and at the end of it what looks like an inset illustration inside a box, on a plinth with winged beasts. His old

tutor Philip Connard had commended Spare as a designer as much as an artist, and Spare had a strong sense of 'props' and bric-a-brac. His father had taken him around the East End antique markets as a boy, encouraging and rewarding him if he found anything interesting or valuable, and junk became a lifelong passion.

The David Nutt commissions were bread-and-butter work compared to Spare's new book in preparation, *A Book of Satyrs*, or satires: Spare liked the old spelling because the word evoked the goat-legged animal men, suggestive of lust, who pranced their way through the work of Beardsley and the 1890s in general, overlapping with the era's neo-pagan cult of Pan.

Published in 1907, the book comprised nine satirical pictures – 'The Church', 'Existence', 'Quackery', 'Intemperance', 'Fashion', 'The Connoisseur', 'Politics', 'The Beauty Doctor', and 'Officialism' – framed at each end by an introductory picture and a final 'General Allegory', preceded by another captioned 'Advertisement and the Stock Size'. This gives a clue as to how the book is meant to be read, because it features two figures clearly inspired by GF Watts: a blindfolded figure with a lute (only one string broken this time, but still reminiscent of *Hope*), and a minotaur figure leaning on a thick wall or parapet, reminiscent of Watts's *The Minotaur*.

The likelihood is that these are just borrowings from Watts, rather than allusions to him, but they still suggest his presence in Spare and the relevance of his allegorical method. Watts's picture of *Mammon*, for example, the god of riches, is an allegory of the power of money and it shows a gross, dull figure crowned and enthroned on a Papal-looking chair decorated with skulls. Before him are a naked couple, the kneeling woman bowed down with Mammon's hand resting on her head, and the man lying at his feet, looking all but dead. Watts said he wondered why the Victorians didn't set a giant statue of Mammon up in Hyde Park, so they could worship him openly.

Two of Spare's enthroned figures recall Watts's Mammon in their implacable beefy dullness; the seated figure in 'Officialism,' and the Imperial presence in 'Politics', with naked figures and a skull at his feet. But where the meanings in Watts are easily read, Spare's are half-lost in complicated and obsessional detail.

'The Church' features a great pig or boar and before it a man who seems to be literally bible-thumping, with a cross and a little bag – it is probably meant to be a money bag, although its size makes it look like some kind of pomander – conjoined around his neck. Another man reads a book upheld by a satyr bookstand, while a black serpent comes in from the lower left, and a satyr looks on at the top. A boar's head also figures in 'Politics', mounted on a plinth with the Greek letters for 'Theos' – God – beneath it.

'Intemperance' features two women, perhaps a barmaid or serving wench and her mother or employer, with four little dwarfish men around them, one of them clinging to the barmaid's skirt. 'The Connoisseur' shows a man poring over some sheets of paper, presumably drawings, surrounded by elaborate antique items. Some of these look unsatisfying, such as a draped classical figure with the top half missing, and a small model of a porcine head on its own mount, elegant enough in itself but sitting off centre on a stand far too large for it.

Spare himself seems to be in several pictures. In 'Officialism' Spare, looking like an art student with what may be a sketchbook under his arm, turns away with a rejected air from a bloated-looking man in a chair (possibly relating to his unhappy time at the RCA): there are also a couple of sculpted figures tied to posts and constrained, and a sottish dwarf. The artist-player with the lute in 'Advertisement and the Stock Size' has Spare's distinctive hair, and he has the central role in the 'Introduction', showing the onlooker a mirror. In 'General Allegory' the Spare figure has a woman behind him, holding a mask in her hand, with more empty masks hanging in a suspended bunch beside them.

Overall the book has a period air that seems to combine late Victorianism with the seventeenth and eighteenth century; an era that Beardsley had already delved into. Spare's career was dogged by comparisons with Beardsley, and some of his earlier black and white work does have a Beardsleyish air, but the drawing of *A Book of Satyrs* is very different: Beardsley's pictures are relatively easy to copy, because the genius has already gone into the simplified design, whereas copying the obsessional penwork in *A Book of Satyrs* would be so much work as to be hardly worth the trouble.

One of the book's most distinctive aspects is the filling of the pictures with more fabulous invented bric-a-brac. Masks, strange jugs, unbelievable lamps and candlesticks combining human and animal forms with skulls and multiple breasts, sculpted satyrs, and small demonic forms all abound on the surfaces, until it is like peering into the window of some faintly hellish junk shop.

Spare's work was still strengthening and evolving, and in 1907 he produced an important self-portrait, now in the collection of Led Zeppelin guitarist Jimmy Page, which exemplifies this imaginatively cluttered-up look. Already far more confidently drawn and better finished than the world of the *Satyrs*, it features Spare staring straight at the viewer with his face in his hand – the hand gesture, one finger to each side of his nose, is quite distinctive – and his jacket sleeves rolled back, perhaps for the pleasure of depicting the striped lining. It is a remarkable work of Edwardian black-and-white art, and if only this one work survived people would still say 'Who was that artist...?'

Spare is seated at an idealised desk or table covered in objects, over twenty of them, ranging from a bird and some leather-bound books to more idiosyncratic items of his own design. There is what looks like a lamp, of boat-like form, with a woman standing on it holding a rein-like chain to a stopper, and a horse's head at the prow: a sail-like screen with an eye on it seems to form a kind of shade. Before a couple of ink bottles stands a lantern-like vessel with a grotesque head, along with several figures after the antique – variously winged, broken, tailed, multi-breasted, and verging on the tribal – along with a model horse, a plant-form candlestick, two realistic masks (one, derived from the face of Spare himself, is so fleshily realistic it looks almost butchered, with one eye socket empty) and a handy-sized seal – like a Chinese 'chop' – engraved on the base to stamp a signature image of an animal skull.

The whole tableau has something culturally familiar about it, suggesting among other things the scholar-connoisseur at his desk. The most famous example, unknown to Spare, is probably Freud's desk with his collection of small antiquities arranged in front of him, but a related

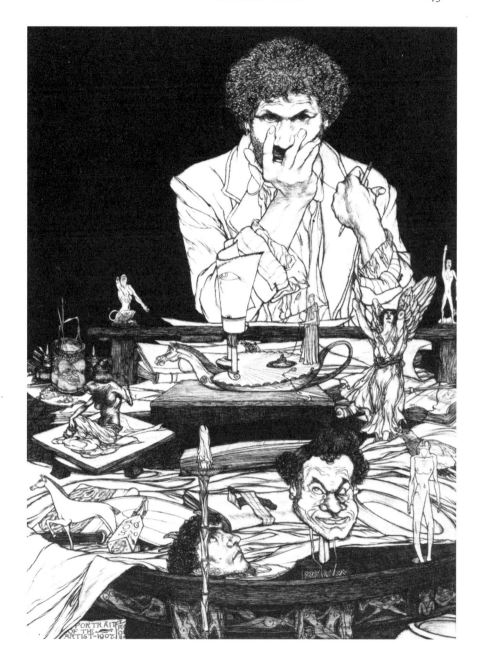

look is widely recognisable elsewhere: it is as distinctive, in its way, as the visual idea of the alchemist's laboratory. An old tome or two, perhaps a skull, some small items suggestive of classical antiquity or foreign gods, something ethnographic or tribal, perhaps a natural history specimen in a bell jar; altogether it only takes a small range of these curious little exhibits and entities to create this distinctive space or look that we might call the 'scholar sanctum' look.

Along with Freud's desk, other examples would include André Breton's studio; in comics and graphic novels Jason Hyde at his desk, and Wilhelmina Murray in her study (inside the British Museum) in *The League of Extraordinary Gentlemen*; and in Victorian and Edwardian occult fiction – the whole look has something Edwardian about it – the room of MP Shiel's psychic detective Prince Zaleski, or even the study in RH Malden's 1909 story 'A Collector's Company.' This is described as a room lined with bookcases, particularly containing Neoplatonic and Orphic literature, while on a table by the window is a collection of Gnostic gems; in the corner is an Egyptian mummy-case, and on a fireside table is Philostratus's *Life* of Apollonius of Tyana. This study belongs, in fact, to a gentleman scholar who is also an occultist, and the story swiftly shifts through mention of pins in dolls, necromancy, and familiar spirits to the death of the man in question, with claw marks on the body suggesting attack by a supernaturally large owl.

In Spare's case one aspect of this look is social, because it has a touch of the gentleman collector about it: this is Spare as amateur of the rare and curious, like a finer version of 'The Connoisseur' in *A Book of Satyrs*. It is tempting to think that he was completely indifferent to social advancement, but when he was young he wasn't; he had quite an ambitious letterhead printed up, for example, describing himself as a "publisher of rare editions".

Be that as it may, in a few years time something like this peculiar tablescape is going to recur in Spare's work, and its significance will become more central.

The *Satyrs* book appeared with a generous and tactful introduction by James Guthrie, implicitly contrasting the "curbed enthusiasm and polite art" of the day with "the remote, and the strange, and the unadaptable."

Not long after *Satyrs*, Spare had his first West End showing at the Bruton Gallery, 13 Bruton Street: 'Black and White Drawings by Austin O Spare.' This attracted widespread notice and somewhat sensational reviews. *The World* liked it:

> *The amazing eccentricities to the perpetration of which that precocious genius, Mr Austin O Spare, applies his rare gifts, will probably be the talk of the London studios for many a day to come. In speaking of his pen and ink work it is difficult to avoid superlatives. His craftsmanship is superb; his management of line has not been equalled since the days of Aubrey Beardsley; his inventive faculty is stupendous and terrifying in its creative flow of impossible horrors.*

Observer critic PG Konody quite liked it too, but only up to a point: Spare's drawings, "in all their repulsiveness... hold an element of extraordinary beauty. Indeed this young man stands unrivalled as regards the power and expressiveness of his pen line...". But for all that, they were drawings "like the terrified howls of a man driven by the Furies, they are unearthly, gruesome, horrible", and ultimately it was a show

*which should prove of equal interest to his fellow artists and
to pathologists. The criticism should be left to the latter, for
Mr. Spare's art is abnormal, unhealthy, wildly fantastic and
unintelligible, and altogether of a kind which will make the
family man hesitate to take his wife or daughter to the gallery.*

Spare must have been more resentful of *The Globe's* notice, which
sounded the same note of pathologising, but this time with a more
patronising twist:

*perhaps the chief excuse for the character of the drawings and
sketches which Mr. A.O. Spare is exhibiting at the Bruton
Galleries is that the artist is very young, and is, in consequence,
afflicted with that inclination for what is horrible and
abnormal which, with other infantile complaints, passes away
after maturity is reached...*

Perhaps the most famous judgement on the early work of Spare
came from George Bernard Shaw, who is widely alleged to have said that
Spare's medicine was too strong for the average man, or that his work was
too strong a meat for the normal.[2]

If the press notices were calculated to put many visitors off, there
was something about them that would prove positively attractive to
a few. Among them was the so-called Wickedest Man in the World,
the self-styled Beast 666; and so it was that Aleister Crowley came
striding through the door of number 13 Bruton Street, grandly
announcing himself to the shy and awkward artist as the "Vicegerent
of God upon Earth".

2. "Spare's work is too strong a meat for the normal; for the magic of the flesh is Spare's
creed and there is no compromise." Cited without source in 'Additional Biographical
Notes,' *Austin Osman Spare (1888-1956) Paintings and Drawings*, Greenwich Gallery,
23rd July to 12th August 1964. There are close variants in the introduction to *A Book
of Automatic Drawings* (Catalpa Press, 1972), *Austin Osman Spare* (Taranman Gallery,
1974) and the chronology of *Austin Osman Spare (1887-1956)* [sic], Oliver Bradbury
and James Birch Fine Art 17th November – 8th December 1984. Kenneth Grant has
"Spare's medicine is too strong for the average man" in *Images and Oracles of Austin
Osman Spare* (Frederick Muller, 1975) p.16.

Five: THE DARLING OF MAYFAIR

References to the work of Spare in fiction are few and far between, but they do exist. In Kyril Bonfiglioli's 1976 novel *Something Nasty in the Woodshed*, the narrator is being ushered into the library of the Lord Dunromin, passing down a long gallery past a phallic figure of Pan in a lit vestibule, "which, as we passed, suddenly became a drinking-fountain in a most dramatic and peculiar way."

> *The butler shunted me into the library, indicated the librarian's desk and left me to my own devices – or solitary vices, as I dare say he thought. I ambled down an alley of shelves crammed with a bewildering accumulation of priceless, richly bound filth and rubbish. Nerciat rubbed shoulders with DH Lawrence, the Large Paper set of de Sade (illustrated by Austin Osman Spare) jostled an incunable Hermes Trismegistus, and ten different editions of L'Histoire d'O were piquant bedfellows to De La Bodin's Demonomanie des Sorciers.*
>
> *The Earl's librarian was a pretty slip of a girl with circles under her eyes. She didn't look as though she got much time for reading.*

There is a more realistic interior depicted in Ethel Archer's novel *The Hieroglyph*, from 1932, when the heroine Iris considers the decor of a man called "Svaroff": "A room, she reflected, betrays the character of its owner and occupant, and this was far from being a common one. ... the semi-ecclesiastical austerity side by side with evidences of strange perversity and barbarity."

The bare floor is painted black, with a leopard skin rug before the fireplace. A large stuffed crocodile grins from the corner of the room. From the ceiling hangs a "wonderful silver lamp or censer" and above

the mantelpiece is a Byzantine crucifix, while on the mantelpiece itself are several images of Buddha, together with Chinese and Egyptian gods. On the wall is a scarlet silk hanging embroidered with gold letters, "the spoil of a Tibetan temple." On the bookshelves are first editions of Verlaine, Baudelaire, Swinburne, and Wilde, with some Rodin busts on top of the bookcases, and on the wall beside the fireplace are "drawings by Beardsley and Osman Spare."

Svaroff is based on Aleister Crowley as Archer remembered him around 1910,[1] and it is quite likely that he did own drawings by Spare. The two men had struck up a relationship after that first inauspicious meeting at the Bruton Gallery, when Crowley had told him he was the Vicegerent of God upon Earth. Spare thought he looked more like "an Italian ponce out of work", or so he told a friend years later. Perhaps with the benefit of four decades of hindsight, he said this was what he had told Crowley at the time.

Crowley apparently told Spare that in their different ways, Crowley in his poetry and Spare in his drawing, they were both messengers of the Divine. It was the beginning of a professional and personal relationship between the two which was ultimately unhappy, and remains a puzzle. There is no question, though, that Crowley admired Spare's work, commissioning illustrations for his journal *The Equinox*, taking artwork in exchange for a ceremonial robe that Spare couldn't afford, and recommending Spare to Holbrook Jackson as an artist. Jackson, now largely remembered for his pioneering study *The Eighteen Nineties*, was involved in editing the journals *The New Age* and *The Beau*, and around 1909 Crowley wrote him a note to say that as an illustrator Spare "would do you as well or better than Sime."[2]

Crowley had joined a growing band of Spare's patrons and champions, and already "a minor cult following that would last his entire life, to a greater or lesser degree" was getting under way. Spare's major patron was probably Pickford Waller, a wealthy property developer who

1. A hatless, curly headed, laughing youth named Newton comes into the room, "faunlike", bursting into "irresponsible laughter that was somehow strangely infectious," and looking younger than his twenty-six years: he is closely based on Victor Neuburg, born in 1883.
2. Sidney Sime (1867-1941), British illustrator of the fantastic.

was himself an accomplished amateur artist, and a keen patron of the arts; he collected Beardsley, Whistler, and Charles Conder. He had taken Spare up after the publicity around the 1904 showings, and also introduced him to James Guthrie, then a well-known figure in the world of design and small magazines, who had provided the introduction to the *Book of Satyrs*.

Other early admirers included writer and collector Desmond Coke, man of letters Ralph Straus, Lord Howard de Walden, and Charles Ricketts. Spare continued to illustrate books, with a further commission for another Charles Grindrod book, *The Shadow of the Raggedstone* (1909) and more notably *On the Oxford Circuit and other Verses* (1909) by a judge, the Honourable Mr Justice Darling. Accompanying Darling's verses are several symbol-laden pictures; in one an Icarus figure falls past a windmill while a man sleeps, a cock crows, and a seedy-looking man in a hat skulks about, while the prop-heavy title page features various objects – an owl, a skull, an old tome, some scrolls – drawn from items bought in junk markets.

One of Spare's major activities was the design of bookplates, in those days extremely popular items, and his work in this field has a distinct strand of Nineties-style evil; this was so much a part of the ambient style of the period that it may simply have looked 'sophisticated' to the contemporary viewer. Certainly Spare's early work is in tune with what Cyril Connolly remembered as "the cult of strangeness... the conception of beauty characteristic of the Aesthetic movement as something akin to disease and evil." Spare had already drawn an exceptionally chilling woman in the manner of Beardsley: above her austere mannish face is an excessively prominent forehead, with the hairline far too high, and beside her hangs a green-gloved hand with overlapping pointy fingers; the effect could hardly be creepier if her sleeve was sprouting tentacles.[3]

Several decades later Spare looked back ruefully on the artistic fashions of his youth, and the appeal of evil: "Evil is more potent than good, promising excitement, gain, and ease of accomplishment..." There is a hint of wickedness with a more pagan slant in an illustration for Grindrod's *Songs from the Classics*, where a winged cherub, half-

3. *Seated Figure in a Japanese Robe*, Christie's South Kensington, 12th May 1994, lot 5.

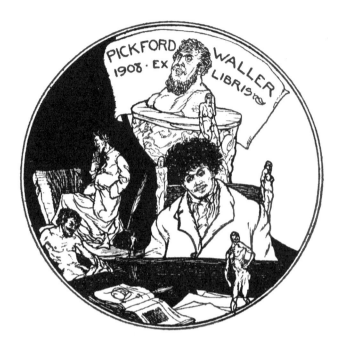

sheltering behind a classical herm, points reproachfully at a grinning
satyr, who looks leeringly in control of the situation, as if accusing him
of theft (perhaps of the musical instruments now under his hooves) or
some other injustice.

A 1907 bookplate for Desmond Coke features an evilly-faced figure
– itself seemingly a statuette or similar representation – among a spread of
bric-a-brac, playing on a Pan pipe, and a 1908 plate for Pickford Waller
features a seated man with statuettes on the surface around him: the man
– who bears some relation to Spare, through his distinctive frizzy hair – is
leaning off-centre in his chair with a doll-like inertia, as if he is a puppet
with loose strings. The effect is slightly uncanny, like a mannikin blurring
the line between the living and the dead.

There is another modified self-portrait in a 1907 plate that Spare
did for himself, this time an uglified portrait with a conspicuously broken
nose. The flesh of the face is twisted and hairy, and it seems to leer at the
viewer with idiot cunning. Far from Beardsley's stylizations towards the
effete, Spare seems to be stylizing his own fancied brutishness, making a

fetish out of it – or equally, perhaps, depicting himself as flawed. Years later he told a friend that a broken nose could damage a person's confidence; particularly a woman's.

Always ambitious for his son, Spare's father went to the Mayfair office of publisher John Lane – just as he had gone to the Royal Academy with Spare's bookplate design in 1904 – with *A Book of Satyrs*, to see if Lane would like to do a new edition. He couldn't have chosen a more appropriate publisher. Lane's imprint, the Bodley Head, was at the centre of *fin de siècle* culture, publishing the likes of Oscar Wilde, Ernest Dowson, Richard Le Gallienne and Aubrey Beardsley, whom Lane had published in *The Yellow Book*.

Like Spare, Lane came from a working class background, but otherwise he could hardly have been more different. He was a smooth operator – he had taken up golf in 1895, not because he particularly liked the game but because it was useful for making contacts – and although he always liked to be associated with the avant-garde (in a slightly later era he would publish Wyndham Lewis's periodical *Blast*) he still had an over-riding concern with profit and respectability. He was said to go over Beardsley's pictures with a magnifying glass checking for indecency. As soon as the Oscar Wilde scandal erupted, with his arrest in 1895, Lane had withdrawn all his books from sale and fired Beardsley from *The Yellow Book*'s art editorship.

Spare's professional association with Lane lasted for a decade or so, but it was difficult. From the start, Spare annoyed Lane with late delivery of work; he had promised extra plates for the new edition of *Satyrs* but couldn't seem to get them done, so it didn't appear until 1909. Nevertheless, the Bodley Head brought various benefits to Spare. He remembered seeing the famous GK Chesterton at Lane's office, and his relationship with the firm seems to have given him entry into a belated Nineties milieu that featured the wealthy dilettante Marc-André Raffalovich and his companion Canon John Gray, author of *Silverpoints* (a book of poems published by Lane) and spread out to include the novelist George Moore and the novelist and priest Robert Hugh Benson.

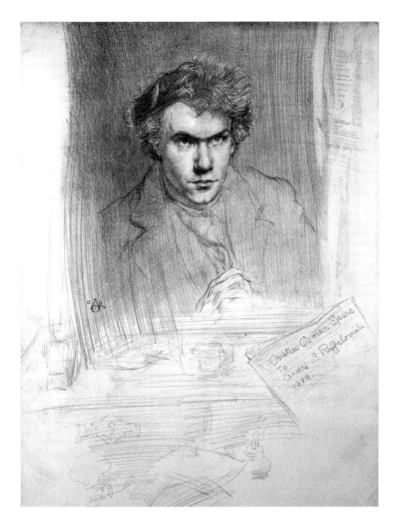

Gray and Raffalovich had both been young friends of Oscar Wilde – Gray was said to have been the model for Dorian in Wilde's *Picture of Dorian Gray* – but they had come to dislike him intensely. Before Spare's day – in fact just around the time he was born – Raffalovich's cultural ambitions had led him to run his house at 72 South Audley Street as a slightly second-rate intellectual salon, of which Wilde famously said he had wanted to run a salon and ended up running a saloon. Showing his

contempt with a cruel and unusually boorish joke, Wilde turned up one day with some friends and said "Table for six, please."

Now Gray and Raffalovich had moved their operations much more successfully to Edinburgh, where young Spare stayed with them. He knew Gray the better of the two, and years later said "He was the most wonderful man I ever met". He drew his portrait, as well as the portrait of their housekeeper Florence Gribble, who seems to have been an essential part of the ménage. For Raffalovich he designed a curious bookplate, showing a columbine-like flower which is actually composed of a ring of dead birds and a mask, and he also gave him a striking self-portrait.

Raffalovich and Gray did their best to help Beardsley's sister Mabel, now in straitened circumstances, and it may have been through them that Spare met her and drew her portrait – if it is actually from life; it has been suggested it might be from a photograph – now in the Victoria and Albert Museum. Spare was moving in these sophisticated circles while still living with his parents, travelling in and out of London to The Old Mill, Chadwell Heath, in Essex. He wanted to leave home, causing a family argument and a temporary rift with his parents, but he soon found his first lodgings; with an uncle of Mabel Beardsley, according to his own account.

There is a vivid picture of Spare at this period in a 1909 interview by Ralph Straus, for whom Spare did a bookplate featuring an ostrich, punning on the German for ostrich, *straus*. Straus invited Spare to his house, and when he arrived "I was irresistibly reminded of the Angel in Mr Wells's *Wonderful Visit.*" It soon became obvious, writes Straus, that Spare looked at life with "what, for want of a better description, I must call the 'odd' point of view... He was obviously one of those rare creatures possessed, like Socrates, of a daemon."

Spare revealed an enthusiasm for Buddhism and Theosophy, along with magic:

> *He had read and dreamed of the occult and the diabolic, and, looking into his deep eyes, I wondered whether I would cast out my commonplace philosophy and begin to believe in reincarnation. We talked, I remember, of tortures and fairies, of*

*tapestries and blood and were-wolfs, of magic and book plates
and religion...*

Spare and Straus then went to call on some Spare collectors to see
more works, including Pickford Waller, and Straus mentions some famous
admirers of Spare: "My dear friend Desmond Coke possesses a water
colour study entitled 'The Sacrifice', painted at the age of fifteen – it called
forth no small eulogy from Watts himself" while Spare's use of colour
reminded Straus of the great artist Frank Brangwyn, "himself, by the way,
to be numbered amongst Spare's admirers."

Straus himself was something of an admirer of Spare, with his
"wonderful hair and the face of a Watts knight." Viewing Spare's
artwork in collections served to convince him, in a revealing turn of
phrase, "that the work was no less interesting than the boy," and it is
noticeable that a large number of Spare's patrons and admirers at this
time were gay.

Straus always liked to encourage young men – thirty years later he
was inviting the young novelist Dennis Wheatley round to his bachelor
apartment for help with spelling and grammar – and RH Benson was
similarly inclined. As for Gray and Raffalovich, they were not simply
homosexual but extremely interested in the theory of the subject (from
what now seems a slightly odd and repressive angle, leading to Raffalovich's
contributions to the *Archives de l'Anthropologie Criminelle*). Desmond
Coke meanwhile came from an old and distinguished English family, but
was very much the last of his line and wrote schoolboy fiction under the
name of Belinda Blinders.

Some of Spare's work does give off peculiar messages, particularly
by Edwardian standards. *Chaos*, from 1904, for example, which probably
figured in the controversial Bruton Galleries show, is an impressively
composed allegory of the chaos of creation, with stars, lizards, snakes and
other animals, an Adam and Eve-like couple, and other human figures,
one minutely dwarfish and another wearing a domino mask across his
eyes – but the central figure is a standing male nude, plain white flesh
standing out against the teeming pen and ink detail all around, with
a harsh aquiline face above a rather emphatic backside with a pair of
teardrop-shaped buttocks. Years later, after Spare's death, two younger

friends, Frank Letchford and Dennis Bardens, were comparing notes on him, and Letchford quoted the opinion of Sir Frank – as he was by then – Brangwyn:

> *He was homosexual strongly but had suppressed it since the 1920s. Before WWI in the company of Raffalovich and Father Gray he had been "one of them" – for at the Salon was a congress of young poets, writers, artists etc., seeking patrons – and patronage then as now goes a little deeper than a man just buying another's pictures – emotion enters into it. To-day to get known in the world of entertainment, or for an artist to be accepted, often he has to play along with the homosexual element just as in Spare's day – at the end of last century this was all too strong and it backwashed over into the new century. Raffalovich and Co. escaped to Edinburgh to start a new life. Spare dived into the tenements of Southwark in the 1920s for the same reason. But he never escaped his own knowledge of his desires but – as I say – suppressed them. For he never approached me all the time I knew him. ... Sir Frank Brangwyn averred that Spare was a flagrant homosexual – but this could only have been pre-1914.*

It all sounds very reasonable. However, in contrast to Letchford, another friend – the occultist and writer Kenneth Grant – thought the reason for Spare's dive into the tenements of Southwark was a desire to have discreet sexual relations with older, elderly, and even crone-like working class women.

Spare recommended Edward Carpenter's book on homosexuality, *The Intermediate Sex*, to Letchford, adding "There but for the grace of the gods go I". His sexuality remains a mystery, and one which plays a part in the further mystery of his relationship with Aleister Crowley, whom he came to remember with loathing and distaste. Crowley was voraciously bisexual, and it is sometimes suggested that he may have

made advances to Spare, which Spare found repellent, or even that they briefly had a physical relationship. The clues, such as they are, are largely to be found in three poems by Crowley, but the two men were clearly associates by 1908, when Spare inscribed a copy of the *Book of Satyrs* to him. Written on the white space of a candle, in the drawing entitled 'General Allegory', Spare's inscription is awkward and unclear. There is no "from", but instead "Aleister Crowley with Austin Osman Spare Kind Wishes 1908."

Spare and Crowley had met before Crowley departed for North Africa with his sidekick and partner Victor Neuburg, where they evoked the demon Choronzon in the desert (Crowley became possessed by Choronzon and tried to grab Neuburg by the throat) and carried out a good deal of sexual magick (as Crowley spelled it). Crowley, who liked to take the passive role, wrote a poem entitled 'The Garden of Janus', which opens "The cloud my bed is tinged with blood and foam...." The second stanza begins "So, he is gone whose giant sword shed flame / Into my bowels...".

It has to be said, this is off-puttingly sodomitical for some tastes. Crowley dedicated 'The Garden of Janus' to Victor Neuburg, but it is more of a mystery why he should have sent a manuscript copy of this poem to Spare. What Spare thought of it we don't know, although he wrote back to say he was pleased to receive it. A few months later Crowley wrote another poem, 'The Priestess of Panormita.'[4] The priestess herself is speaking, addressing her God and praying him to send her a lover. It begins "Hear me, Lord of the Stars!" and continues through to

> *I solemnly sacrifice*
> *This first-fruit flower of wine*
> *For a vehicle of thy vice*
> *As I am Thine to be mine.*
> *For five in the year gone by*
> *I pray Thee to give me one;*

4 Panormita is not a deity or religion: instead it seems to be a reference to the poet Antonio Beccadelli (1394–1471), known as Il Panormita (a version of "The Palermitan", meaning he was from Palermo). Beccadelli was famous for his priapic works, notably *Hermaphroditus* (1425).

A lover stronger than I,
A moon to swallow the sun!
May he be like a lilywhite goat
Crisp as a thicket of thorns,
With a collar of gold for his throat,
A scarlet bow for his horns!

The plot thickens with Crowley's annotation to this in his own copy: "Refers to Austin Osman Spare consciously; but the Gods deemed otherwise, though granting the request made to the full." This seems to suggest that the future lover Crowley had in mind was Spare; the Gods did not grant this, but the more general request for a lover was met elsewhere.

Crowley wrote a third poem – all three were eventually published in his collection *The Winged Beetle*, privately published in 1910 – entitled 'The Twins', this time dedicated to Spare and featuring the Egyptian gods Hoor and Set. The poem is perhaps intended to be seductive:

V
Look! in the polished granite,
Black as thy cartouche is with sins,
I read the searing sentence
That blasts the eyes that scan it:
"HOOR and SET be TWINS!"
[...]

VI
Ay! O son of my mother
That snarled and clawed in her womb
As now we rave in our rapture,
I know thee, I love thee, brother!
Incestuous males that consume
The light and life that we capture.
"Come then, conquer and kiss me!" says the poet, "Come! what
hinders? Believe me..."

IX
See how subtly I writhe!
Strange runes and unknown sigils
I trace in the trance that thrills us.
Death! How lithe, how blithe
Are these male incestuous vigils!
Ah! This is the spasm that kills us!

Whatever was going on, if anything, we can be fairly sure Spare wasn't taking these poems out to Chadwell Heath to show the family.

He could be more open about his relationship with Raffalovich and Gray. Raffalovich was a historian of homosexuality (or *unisexualité*, as he termed it) and in 1896 he published his study *Uranisme et unisexualité: étude sur différentes manifestations de l'instinct sexuel*. However, having converted to Catholicism under the influence of Gray, he seems to have believed that homosexuality was a misfortune best not actively indulged, and Raffalovich and Gray both came to see their former friend Wilde as a pervert, a degenerate, and a corrupter of youth.

Raffalovich thought the responsible homosexual should instead transcend and sublimate his sexuality into the realm of the aesthetic, and spiritual friendship. These ideas were already looking retrograde, and at the time he knew Spare, around 1910, Raffalovich withdrew from public debate. He devoted the remaining quarter century or so of his life to religion, art and letters; aesthetic pursuits such as flower arranging; and the smooth and slightly formal hospitality of his salon.

Over the years, visitors to his salon included Max Beerbohm, Henry James, RH Benson, Herbert Read, Walter Sickert and many others. A guest remembers

> *There was a very fin-de-siecle atmosphere about the house. Beauty only appealed to André if it was in some way curious or exotic, or at least odd. There would always be some beautifully but*

*unexpectedly bound volume laid on a table near to flowers which
had obviously been chosen to give point to its colour. Or it might
be some other object. If you lunched or dined at 9 Whitehouse
Terrace near Christmas you would be given a present which
exactly reflected his rather peculiar taste. It was never a thing you
wanted, but neither did it lack charm, a faintly decadent charm.*

The atmosphere was slightly formal, and Raffalovich would immediately introduce a new guest to another and wait to see if conversation took hold ("waiting for you to begin striking sparks off each other. It was most embarrassing at the age I then was"). If conversation failed, he would step in and separate guests on the pretext of wanting to show one of them a book or an object. "Conversation was brisk – and well regulated. Dangerous topics... were checked by an intonation, or the lightest of glances on the part of the host."

Raffalovich may have had an exquisite side to his character, but this wasn't expected in guests. Comparing his flower arranging to his salon ("the same curious delicacy shown... in his sensitive groupings and arrangements"), Lady Margaret Sackville remembered, "The flowers he chose were always small flowers, and many of his guests were quite 'ordinary' people." Brocard Sewell comments that "people were welcomed for their own sakes; often quite obscure, humble people in whom André detected some characteristic or quality..."

So this was the Raffalovich milieu, in which Spare was neither a sophisticate among sophisticates, nor was he rough trade. Instead he was a young, uneducated guest in a responsible environment of rather correct if kindly Christian hospitality, and it seems to have agreed with him well enough. It is not clear how many times Spare stayed with them in Edinburgh – probably not many – but he writes to Pickford Waller late in 1909 on Chadwell Heath notepaper to say that he has been ill for some weeks and is going to Scotland, and early in 1910 he writes again to say that he is back from Edinburgh and feels "very fit".

Spare kept up a reasonably relaxed correspondence with Gray, telling him about the bric-a-brac he was buying as props for the Justice Darling commission, receiving a throat spray by post – a rather solicitous

gift for Spare's endless minor ailments – and on one occasion sending Gray a piece of Congolese tribal art.

It was apparently Gray who introduced Spare to George Moore, the Irish novelist and once famous man of letters. Spare remembered him looking like a hotelier, and "peering through thick lenses with his gooseberry green eyes" (another witness remembered him looking like a satyr crossed with a codfish). Moore must have been an excitingly worldly companion for Spare, and he would tell him about life in Paris as they sat together in the celebrated Café Royal; the great cafe of the 1890s at the Piccadilly end of Regent Street, modelled on the great Paris cafes of the Second Empire. Spare told a friend he remembered drinking coffee in the Café Royal while looking up the skirts of tarts in the balcony above.

It is an architecturally mysterious image, but it would have suited Moore. A former Decadent poet, with lines like "Poor breasts! Whose nipples sins have fed," Moore had now become a Realist novelist in the manner of Zola, and he still had an obsessive fascination with women. However, his biographer Tony Gray remarks that he seems to have been interested in women only to the extent that he liked to look at them naked as much as possible, and in this he may have been "a typical Irish bachelor of the time". His several volumes of autobiography are filled with tales of his sexual conquests, but it seems he may, in fact, have died a virgin.

It was also in the Café Royal, or so we are told in a recent book, that Spare encountered no less a figure of the age than the poet Enoch Soames. The Café Royal was Soames's natural habitat – Max Beerbohm describes seeing him there drinking his absinthe, "in that exuberant vista of gilding and crimson velvet set amidst all those opposing mirrors and upholding caryatids, with fumes of tobacco ever rising to the painted and pagan ceiling" – and it was there that we are assured Spare caught sight of him, after being treated to some chocolate cake by Raffalovich.

> *...there he saw Soames for the first and last time. So impressed*
> *was the young Austin by his glimpse of Soames – in high spirits,*
> *for once – emerging out of the gloom into the light of Regent*

Street, that in subsequent years he drew him many times. The strange, momentary association of himself, the lost poet and the precocious boy led Raffalovich to make his only recorded mot; with an unusual spark of humour and spontaneity he remarked to the artist, with what John Gray recalled as a hideous gurgling chortle... "So there we all were, the three spare men of our day!"

Recalling this same period to a younger friend years later, Spare painted a vivid picture of erotic excess. Even before he was sixteen, he said, he had been living with a much older woman, who became pregnant: it was only due to a fatally premature birth that he avoided becoming a father. Asked by the friend for a self portrait, he drew a picture of an erect phallus and titled it *Self-Portrait at Age of Eighteen* ("He described it as the only truthful self-portrait I would ever get"). Another drawing, from around 1950, entitled *Hermaphroditism*, shows a naked girl with a vacant stare, her tongue out – it looks as if it might spend a lot of time out, perhaps when she breathes, suggesting feeble-mindedness rather than a momentary gesture – and an over-developed clitoris standing upright, and it is labelled "Drawn from memory of actual person 1910."

Spare told this same young friend – for whom he did the picture – that he had an affair with a hermaphrodite around this time. It was one of several memorable adventures, including a Welsh maid with a violent temper, and a dwarf woman with a snub nose and a protuberant forehead. It is possible he did know these women, of course, although the details are fugitive. Perhaps such things leave little trace by their nature. But it is also in the nature of deviant and abnormal sexual scenarios that they are easy to imagine vividly – picturesque as much as perverse – as if they offer more purchase and texture for the mind's eye to catch on to, like the Marquis de Sade enduring long solitary imprisonment and dreaming up a character who would "embugger none but monsters, or blackamoors, or deformed persons."

It is hard to be sure about Spare's sexual life, and any hermaphrodites and dwarves who might have been part of it, not least because Spare himself is the main witness. But around this time something happened to change it; he met the mother of the woman who would become his wife.

Six: Young Man With Prospects Wanted

The Hermetic Order of the Golden Dawn, high point of the nineteenth century Magical Revival, had been active through the 1890s until its fatal schism in 1900; this involved WB Yeats (who became Imperator of the Outer Order's Isis-Urania Temple) on the one side, and MacGregor Mathers and Aleister Crowley on the other. Now, around the time he knew Spare, Crowley founded a similar order, the Argenteum Astrum or Order of the Silver Star, with a compendious journal to accompany it, *The Equinox*.

At the time *The Equinox* was launched in March 1909 the Order had only three members; Crowley, Victor Neuburg, and Captain JFC Fuller. Spare accepted a commission to provide artwork, and he had two diagrams and two drawings in Volume One, Number Two. He sent this proudly to Pickford Waller with a letter detailing his contribution and saying that he would have a colour plate in the next issue, but this never materialised.

It is possible that Crowley had sent his poem 'The Garden of Janus' to Spare for illustration; if so, this never materialised either. Whatever the details of their relationship, Spare found himself drawn into the Argenteum Astrum – Crowley apparently told him he wanted to recruit famous people in the arts – and on 10th July 1909 Spare took the Oath of a Probationer in the A∴A∴, signing a form to the effect that he pledged

> *To prosecute the Great Work: which is, to obtain a scientific knowledge of the nature and powers of my own being... Reverence, duty, sympathy, devotion, assiduity, trust, do I bring to the A∴A∴, and in one year from this date may I be admitted to the knowledge and conversation of the A∴A∴.*

WILLIAM NORTHAM,

ROBEMAKER,

9, Henrietta Street, Southampton Street, Strand

TELEPHONE—5400 Central.

MR. NORTHAM begs to announce that he has been entrusted with the manufacture of all robes and other ceremonial apparel of members of the A∴ A∴ and its adepts and aspirants.

No.								£	s	d
0.	PROBATIONER'S ROBE		£5	0	0
1.	„	„	superior quality	7	0	0
2.	NEOPHYTE'S	6	0	0
3.	ZELATOR	Symbol added to No. 2	1	0	0	
4.	PRACTICUS	„	„	3	.	.	.	1	0	0
5.	PHILOSOPHUS	„	„	4	.	.	.	1	0	0
6.	DOMINUS LIMINIS	„	„	5	.	.	.	1	0	0
7.	ADEPTUS (without)	„	0 or 1	.	.	.	3	0	0	
8.	„ (within)	10	0	0
9.	ADEPTUS MAJOR	10	0	0
10.	ADEPTUS EXEMPTUS	10	0	0	
11.	MAGISTER TEMPLI	50	0	0

The Probationer's robe is fitted for performance of all general invocations and especially for the I. of the H. G. A.; a white and gold nemmes may be worn. These robes may also be worn by Assistant Magi in all composite rituals of the White.

The Neophyte's robe is fitted for all elemental operations. A black and gold nemmes may be worn. Assistant Magi may wear these in all composite rituals of the Black.

The Zelator's robe is fitted for all rituals involving I O, and for the infernal rites of Luna. In the former case an Uraeus crown and purple nemmes, in the latter a silver nemmes should be worn.

The Practicus' robe is fitted for all rituals involving I I, and for the rites of Mercury. In the former case an Uraeus crown and green nemmes, in the latter a nemyss of shot silk, should be worn.

The Philosophus' robe is fitted for all rituals involving O O, and for the rites of Venus. In the former case an Uraeus crown and azure nemmes, in the latter a green nemmes, should be worn.

The Dominus Liminis' robe is fitted for the infernal rites of Sol, which must never be celebrated.

The Adeptus Minor's robe is fitted for the particular workings of the Adeptus. A golden nemmes may be worn.

The Adeptus' robe is fitted for the rituals of Sol. A golden nemmes may be worn.

The Adeptus Major's Robe is fitted for the Chief Magus in all Rituals and Evocations of the Inferiors, for the performance of the rites of Mars, and for the Postulant at the Second Gate of the City of the Pyramids.

The Adeptus Exemptus' robe is fitted for the Chief Magus in all Rituals and Invocations of the Superiors, for the performance of the rites of Jupiter, and for the Postulant at the Third Gate of the City of the Pyramids.

The Babe of the Abyss has no robe.

For the performance of the rites of Saturn, the Magician may wear a black robe, close-cut, with narrow sleeves, trimmed with white, and the Seal and Square of Saturn marked on breast and back. A conical black cap embroidered with the Sigils of Saturn should be worn.

The Magister Templi Robe is fitted for the great Meditations, for the supernal rites of Luna, and for those rites of Babylon and the Graal. But this robe should be worn by no man, because of that which is written : " Ecclesia abhorret a sanguine."

Any of these robes may be worn by a person of whatever grade on appropriate occasions.

Spare was still only the seventh person to join, although membership eventually reached about forty. Through the A∴A∴ Spare met Victor Neuburg, who became a friend and wrote two poems to him, 'The Artist' and 'Existence (For A Picture)' in his collection *The Triumph of Pan*, published in 1909. Other members included Raffalovich's brother George, psychic researcher Everard Feilding, Ethel Archer (of *The Hieroglyph*) and the model, artist, writer and woman-about-town Nina Hamnett.

The A∴A∴ had its temple at 124 Victoria Street, and members were required to wear hooded robes.[1] These could be had at some expense from the firm of Northam's in Covent Garden, and Spare wrote to Crowley in a letter dated 31st April [sic] 1909 "I cannot afford the Robe (have nothing)

1, One of these is illustrated in Sotheby's London 'English Literature and History' 16th and 17th December 1996, lot 342. It is red, with the Rosicrucian cross embroidered in gold and coloured thread on the chest and the Eye of the Illuminati embroidered in silver thread on the hood.

and it's kind of you to pay off on the work. Do you order it or I?"

Crowley seems to have paid off on some artwork, probably the *Equinox* work, but the rest of Spare's letter is more mysterious:

> *About that other matter – to be certain – we must wait till we meet... Had a try today ... nearly 13-13=2 – but 0=78 – [with a diagram like a pair of scales above 78] ... which is better... all too chaotic though. So tomorrow I make a special [diagram drawing, possibly representing a card being lifted from a pack of cards] anyway their [sic] will be no doubt when we meet...*

He signs it "A", and continues beneath the signature "I did certain things today which will help on..." with a line of dots to the diagram above the 78.

Being a Probationer of the A∴A∴ – before even getting properly on the ladder as a Neophyte, after which there were a further nine Golden Dawn-style grades leading up to Ipsissimus – was hard work. There was a long reading list, beginning with *The Equinox* and Crowley's own collected works, and including the *I Ching*, William James's *Varieties of Religious Experience*, JG Frazer's *The Golden Bough*, Charles Hinton's *The Fourth Dimension*, the works of Kant, Hume and Berkeley, Malory's *Morte d'Arthur*, JK Huysmans's *La-Bas* and *En Route*, Rudyard Kipling's *Kim*, and *Alice in Wonderland*. Neophytes also had to memorise Crowley's 'Liber Cordis Cincti Serpente' ("An account of the relations of the Aspirant with his Holy Guardian Angel") and keep a 'Magical Record' of their lives for a period of one year.

A test for a later student gives a sense of the enlightenment on offer, with questions such as:

> *What is the meaning, & why, of the following numbers: 148, 210, 831*

> *Reconcile the two apparently conflicting series of meanings of the number 65*

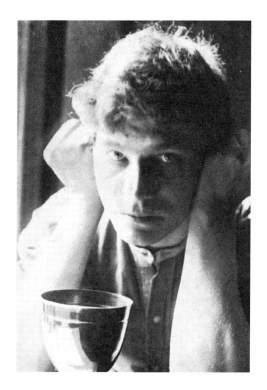

Work out the equation 3=4 especially in relation to the Sephiroth and the Planets

Describe a woman with ♅ ♂ ☋ △ ♀ *rising in 8°*

A friend's cows suffer from some epidemic disease. How would you set to work to discover the cause; if due to bewitchment, how to detect the agent; and how would you proceed to avert the evil?

This might or might not be nonsense, but at the very least it is tricky, complicated, difficult nonsense.

Spare (pictured above, at around this time, in Crowleyan pose) never became a full member of the Argenteum Astrum. In December 1912, by

which time the honeymoon was definitely over, Crowley was looking over the Probationer's oath forms and writing a brief report on each one. When it came to Spare's, he wrote: "An artist. Can't understand organisation or would have passed."

Spare's friend Frank Letchford was sure that Spare never fell for Crowley's seductions. Spare certainly remembered Crowley with a distaste that included his use of cosmetics: his comment on seeing Crowley in Piccadilly one day, made up like a male prostitute, was, "My God, if I had to go to all that effort to attract 'em, I'd give up the ghost."

At other times Crowley liked to think he was magically invisible, and there are several stories of him parading around the Café Royal in full regalia, not catching anyone's eye, until a visitor or tourist asked a waiter who he was. Don't worry, said the waiter; that's just Mr Crowley being invisible. Spare seems to have seen a variant of this, with Crowley walking up Regent Street wearing a cowl and placing his finger to his lips in the Sign of Harpocrates. By his own account, perhaps with the benefit of hindsight, Spare told him straight: "I saw you – so did others!"

Spare also saw Crowley put a dollop of spaghetti on his head, which ran down his collar without anyone paying any attention, but the most elaborate of his tales was about the time he made Crowley some special cakes. Knowing Crowley's taste for exotic foodstuffs and aphrodisiac concoctions, Spare prepared some little sugar-coated cakes of horse dung and dog shit and presented them to the Master at afternoon tea, telling him they were *from an old T'ang dynasty recipe*. Crowley munched away impassively with Spare watching him closely, until Spare blurted out the truth. "Crowley retained his bland impression and said 'I guessed as much.'"

It is generous of Spare to give Crowley the last word. Spare seems to have told this story to Lawrence Bradshaw, the husband of his friend Grace Rogers: whether they believed it we don't know.

Spare was a self-willed, anarchic character who not only couldn't understand organisation but distrusted it on principle. There is no evidence he was particularly interested in the equation 3=4 in relation to the Sephiroth and the planets, or the conflicting meanings of the number 65, or for that matter the bewitchment of cattle. The things Spare believed in were at once much simpler and much greater, notably the unconscious and the Self.

"What is there to believe in," he wrote, "but in Self?" It sounds off-puttingly egocentric, but perhaps it is not. If William Blake had said it, it would seem true, reasonable, and perhaps even brave. One reasonable meaning of Spare's deceptively straightforward rhetorical question would be to read "self" as mind, or consciousness (like the Cartesian cogito, "I think therefore I am"). But there are reasons to think it also means something more specific, and there is a clue to this in one of Spare's small, stained-glass-like mystical watercolours from around 1905 entitled 'I and my self in Yoga'.

Yoga was still an unusual word in Spare's day, keeping close to its original meaning – from the same Sanskrit root as the word 'yoke' – of yoking together the ordinary self with the higher self: 'myself and my Self,' in effect. Spare would have been acquainted with this from Theosophy, and this is the Self that Spare believed in: the higher Self, essentially the *atman* of Hindu philosophy.

This is the self which transcends and loses ordinary self-consciousness in the bliss of pure consciousness. Within Spare's own peculiar terminology it is an aspect of the Kia, not only as mystical void but as the higher self which partakes of that void in the consciousness of subject without object: the blissful void in which everything else has its transient being, like the clear sky in which clouds come and go.

It is a state sometimes reached through meditation or mystical experience, particularly if we leave an imaginary Jehovistic God out of the equation. When the surrealist and visionary Georges Bataille considered mysticism, he did so under the radically stripped down and a-religious title of *Inner Experience*, and Spare encapsulated this approach to the subject when he wrote "A mystic is one who experiences more of himself than he can articulate."

The other great thing Spare believed in was the power of the unconscious mind: the unconscious, if you could only tap into it properly, could do almost anything. This was widely believed in the twentieth century ("Conscious thinking is the weakest", says novelist Patricia Highsmith, "how I believe this!") but Spare believed it very early. The work of Freud had not yet been translated into English, so Spare must have arrived at these ideas by a different route.

William James, writing in *Varieties of Religious Experience*, dates the great discovery to 1886, although it is not completely clear what he is referring to: it is probably the work of Frederic Myers, who found a whole consciousness existing "subliminally", as he termed it, under normal consciousness (it has also been suggested that James might have been thinking of the work of Pierre Janet on *"automatisme psychologique"*). Between them, Myers, Janet and their followers ushered in what has been called "the golden age of the subconscious," from around 1886 to 1910. Appropriately enough 1886 is the year of Stevenson's *Dr Jekyll and Mr Hyde*, and of Spare's birth.

The word "subconscious" has long been replaced in serious psychoanalytic usage by the Freudian "unconscious", but the early researchers preferred "subconscious," and this was the word Spare used. They discovered this subconscious largely by studying trance states in hysterics (Janet was a pupil of Charcot, who specialised in hysteria) and in mediums: Myers was a founder of the Society for Psychical Research and wrote *The Human Personality and its Survival After Death*.

The work of Théodore Flournoy on the medium Hélène Smith, published in 1900 as *From India to the Planet Mars*, is particularly important here. Hélène was not only possessed by Marie Antoinette and an Indian Princess, but she was also a regular visitor to Mars, where she seemed to have picked up a surprisingly plausible grasp of the Martian language. Since she wasn't consciously fraudulent, Flournoy concluded that if we dispose of occult belief and 'spirits' then her inventions, well beyond the abilities of her ordinary self, must come from her "sub-conscious".

André Breton comments in 'The Automatic Message':

In spite of unfortunately widespread ignorance of his work, we remain more indebted than we generally believe to what William James so aptly called the gothic psychiatry of FWH Myers, and the ensuing admirable explorations made by Théodore Flournoy, of a completely new and passionately interesting world.

The discoveries of these early explorers all tended to agree that the phenomenon revealed by mediums and hysterics wasn't just an alternation of a normal self with an unusual self, but rather that the two co-existed all along, like simultaneous but separate streams, with the "subliminal" region only breaking through occasionally. It might do this (to use Janet's terminology) in "sensory automatisms" – such as visions or hallucinations – or "motor automatisms", such as automatic drawing, writing, and 'possessed' speaking.

The results of mediums – when they think they are possessed by Shakespeare or Beethoven – are famously mediocre, and the genius of unconscious thinking or "the subconscious" is more impressive in everyday life. Almost everyone occasionally has extraordinary dreams, where the dreamer wakes to feel almost humbled by this extraordinarily awesome cinema that has simply flowed through them, without them being able to take any real credit for it.

Dreams of the dead are a notable sub-category, in which they occasionally appear as such a complete working analogue of themselves that they seem to be autonomously there, with a reality that approaches new knowledge of them, and far exceeds anything we could do by conscious impersonation. Similarly, people under hypnosis often show an extraordinary talent for mimicry, again far exceeding anything they could do consciously.

William James looked at the prevalence of 'automatistic' phenomena among the founders of religions, in conjunction with their tendency to mystical or cosmic consciousness. He believed this all came in through the "subliminal" regions of the mind, whether higher or lower, and he went as far as to say:

... if there be higher spiritual agencies that can directly touch us, the psychological condition of their doing so might be our

*possession of a subconscious region which alone should yield access
to them. The hubbub of the waking life might close a door which
in the dreamy Subliminal might remain ajar or open.*

Having considered religious experience in more detail, and the
"automatisms" involved, he comments, "The great field for this sense of
being an instrument of a higher power is of course 'inspiration.'"

The inspired believer achieves union with what James shorthands
simply as the "more" – filtered through whatever the person's religious
frame of reference might happen to be – and James suggests that this
"more" is in fact "the subconscious self." He adds that this is "nowadays" –
circa 1900 – "a well-accredited psychological entity."

One aspect of this is the methodical cultivation of this mystical
subconscious, and James quotes Vivekananda's book *Raja Yoga,* from 1896,
on the state of *samadhi* (a super-consciousness) as the goal of yoga. The
further implication of this – not quite spelled out by James (although it is,
in slightly vulgarized form, by his keen reader Aleister Crowley)[2] – is the
possibility of a tapping into states of genius at will.

This sense of creative powers is a great difference between the loosely
defined "subconscious," considered as a romantic or occult unconscious
full of extraordinary untapped mental powers, and the strictly Freudian
unconscious. The Freudian unconscious is more about the repression
of disturbing (usually sexual) material out of consciousness, and Freud
warned against an excessive respect for a "mysterious unconscious." Talking
to Jung, when their ideas were already diverging, Freud made him promise
to keep to the sexual theory of repression and therefore of the unconscious:
the alternative, he said, was to let in "the black tide of mud of occultism".

2. Crowley writes in his *Confessions* of "employing the methods of yoga to produce
genius at will" and claims to have met the great psychiatrist Henry Maudsley on an
ocean voyage: "one of our fellow passengers was Dr Henry Maudsley... one of the
three greatest alienists in England... a profound philosopher of the school which went
rather further than [Herbert] Spencer in the direction of mechanical automatism... We
talked about *Dhyana.* I was quite sure that the attainment of this state, and *a fortiori* of
Samadhi, meant that they remove the inhibitions which repress the manifestations of
genius, or (practically the same thing in other words) enable one to tap the energy of the
universe." Crowley decided that the best way to do this without "the whole discarded
humbug of the supernatural" was through drugs.

But if this was what Freud rejected, it was exactly what Spare embraced. "MAGICAL obsession," wrote Spare, "is that state when the mind is illuminated by *sub-conscious activity evoked voluntarily...* for inspiration. It is the condition of Genius." [italics mine]

One of the earliest methods that Spare evolved for communicating with this all-powerful unconscious or "subconscious" was his method of "sigils." The word sigil, from the Latin for "little sign," has a long history in Western magic. The members of the Golden Dawn were perfectly familiar with it ("combining the letters, the colours, the attributions and their Synthesis, thou mayest build up a telesmatic Image of a Force. The Sigil shall then serve thee for the tracing of a Current which shall call into action a certain Elemental Force") and it was used in the making of talismans. The sigil was like a signature or sign of an occult entity.

The traditional sigil, as in the Renaissance magic of Cornelius Agrippa, was often codified by tracing the Greek or Hebrew letters of an entity's name on to a square or circle of letters, to produce a geometrical shape, meanwhile taking all manner of cabalistical and astrological considerations into account. The big difference with Spare's method was that he dispensed with pre-existing esoterica and external beliefs, so the sigils were no longer for controlling traditional demons, angels and what-have-you, but instead for controlling forces in the unconscious psyche of the individual operator.

Spare's sigillization was a mode of simplification, paring an idea down into a condensed graphic formula. Taking a desire in a short phrase, the phrase would be written down at its simplest and then duplicate letters would be knocked out, before combining the remaining letters into a kind of ornamental cipher. The idea was that this jumble of letters would mean nothing to the conscious mind, thereby bypassing it and allowing the sigil to work in the unconscious, where the sigil might take on a life of its own.

This kind of combination is closely akin to the artist's monogram, (as above) like the AD of Albrecht Durer and the AOS of Spare. These

were once everywhere in the arts;[3] the same volume of *The Studio* that reported on the National Competition of Art Schools, featuring Spare, also had the results of a national competition for designing monograms. So in short, in Spare's own words, "Sigils are monograms of thought, for the government of energy."

Psychical research was all the rage in the late nineteenth and early twentieth centuries, and the "subconscious" was being credited not just with feats of memory but with telepathy, clairvoyance and poltergeists, all of which seemed to be within its special dominion. This can only have made it more attractive to Spare.

One of the youthful Spare's earliest companions in research was his patron, Desmond Coke, with whom he carried out a lengthy series of experiments involving cards (probably not Tarot cards, but perhaps ordinary playing cards or cards of Spare's own devising). As Spare remembered it four decades later "I described unknown people in psychical and other detail of such nature as could only be known to the persons concerned, in addition to future events relating to them. The enquirer had no contact with me or the cards, an essential part of this test."

Around 1910 Spare went to stay with the highly-strung clergyman and novelist Robert Hugh Benson – author of *The Necromancers*, convert to Catholicism, and friend of Frederick Rolfe, the self-styled Baron Corvo – at his house in Buntingford, Hertfordshire.

Benson's house on Hare Street was said to be haunted; he had been

3. See, for example, *Monograms of Victorian and Edwardian Artists* by Peter Nahum (Victoria Square Press, 1976). The monograms above are William Reynolds-Stephens, Beatrice Thomson, Edward Poynter, Walter Francis Tiffin and James Burrell Smith.

able to buy it cheaply because no one would live in it, and it had fallen into a dilapidated state. Benson had artistic interests and his brother remembered the small front hall, "bright with pictures – oil paintings and engravings." The furniture was old and solid, and there were "a few curiosities about – carvings, weapons, horns of beasts." There were large Tudor stone fireplaces and some "curious" tapestries; one of the rooms upstairs, with a four-poster bed, also had a "rather terrible tapestry, representing a dance of death."

Spare was staying for several days, and one night he went to bed early and lay awake reading. The window seems to have been open. The door of his room opened as if blown by a draught, and he closed it. A few minutes later it opened again, and Spare felt the approach of something cold; possibly the draught, or (in this particular telling) possibly not:

> *Whatever it was passed right through him and out of the window. He had the feeling that had the room been in darkness he would have seen the presence he had merely sensed, for he was conscious of a peculiarly negative radiance that seemed to drain or lessen the light of his bedside lamp.*

In another version, he would have seen it but for the light of his candle, but still managed to have a short conversation with it, and in yet another he was woken with the words "Are you there?" He told Benson about this the following morning, and Benson wanted him to push things further. With the aid of a sigil on a card Spare succeeded in materialising the ghost and communicating with it. "What he later told Benson convinced his host that Spare had entertained the haunter of his house."

Benson was interested in subjects such as mesmerism and spiritualism, and while they were out for a walk one clear day the conversation turned to rain-making. Spare drew a sigil on the back of a used envelope, held it to his forehead – an old Golden Dawn method – and stood still while he concentrated. Within ten minutes or so some small clouds appeared above them, and they were soon drenched by a brief downpour.

Spare was being entertained by overlapping social sets at this

period: Benson knew Raffalovich and Gray, and he is also said to have introduced Spare to the Hon. Everard Feilding, a barrister with a keen interest in psychic research (he was Secretary of the Society for Psychical Research from 1903-1920) whom Spare could in any case have met independently, since Feilding was a friend of Crowley and a member of the Argenteum Astrum.

Feilding wanted his slippers, which were in a room downstairs, to appear in the room where he and Spare were sitting (probably in his house at 5 John Street, now Waverton Street, off Berkeley Square): Feilding's manservant would bring them in at eleven o'clock but it was now only six. Spare later claimed to have thought it was "a bloody silly thing to get by magic what could be got more effortlessly by going downstairs and bringing the slippers up in the normal fashion" but he nevertheless encapsulated the wish in another sigil. Hardly had he done so than the door opened, and the servant appeared five hours early with the slippers. He was unable to explain why he had done so, and Feilding thought there must have been a touch of senility involved.[4]

There are numerous mysteries in Spare's life, but we do know what he was doing on Monday 15th May 1911 from 11.30 in the morning. Morale at the Royal College of Art had been so bad that in 1909 the Board of Education had begun an inquiry into the College. When a group of past students requested to give evidence – Sylvia Pankhurst was probably the organiser – their request was accepted, and a deputation of former students with grievances was selected to appear before the Departmental Committee of the Board of Education. The deputation was eventually narrowed down to three: Miss Sylvia Pankhurst, Mr John S Currie, and Mr Austin O Spare.

Pankhurst complained about poor teaching, financial hardship and even malnutrition among the students, combined with lack of prospects,

4. This version of the story dates from 1954, but there are others: in another variant, published in 1972, Spare is to materialise an object visualised by Feilding but unknown to Spare, and he does so with the help of a sigil which functions as the ideogram of a familiar spirit.

and the lowering expectation that students would just go on to teach, rather than work as designers; let alone artists. Spare suggested that lectures on chemistry and colour would be useful, and pointed out that although most of his work since leaving the College had been in black and white drawing, this particular skill was not taught at the college.

Spare had a particular grievance in that he had no diploma, despite the fact that the principal had allegedly promised him one after six months. All three students, in fact, had left without qualifications: Pankhurst was not awarded a scholarship for a further year to get her diploma, and neither was Currie, who had left on bad terms with the Principal and therefore had no written recommendation from the College. Pankhurst commented that anyone who had been to the College knew "that the scholarships are not given so much on the question of merit, but on the question of conduct and general friendship with the principal."

The old story, in other words. The students gave their evidence before a panel consisting of Sir Kenneth Anderson, Professor Brown, Mr Chambers, Mr Cockerell, Mr Ricardo, Mr Warner, and Mr Sedgwick. Spare probably found the experience more intimidating than his friend Pankhurst, who was by now a hardened suffragette campaigner and a veteran of prison. It may even be the occasion of the enormous dreamlike table that he remembered.

Spare was something of a man about town by now, after his fashion. After leaving home he had lived at several addresses including 73 Denbigh Street, in Pimlico, where he had an Egyptian-style bed and even a telephone (Victoria 3709), and 107 St George's Road (now St George's Drive) where his patron Pickford Waller lived just up the road at 117. Spare had romantic ambitions towards his patron's daughter, Sybil, and gave her a little Buddha, but his feelings were unrequited. More than Sibyl, around 1910 he was in love with a younger girl called Constance (Connie) Smith, but it ended in sadness and frustration

One version of Spare's life would have it that he was "well known for his heterosexual excesses in his youth". His friend Frank

Letchford veers to the other extreme, describing the young Spare, circa 1910 as "unworldly, naive, and perhaps virginal." He several times told Letchford about the apparition of a seventeen-year-old girl "who haunted his thoughts and appeared to him in ghostly form; he had actually drawn her several times down the years." She seems to have come into his life quite early and stayed with him. As for real girls, Letchford suggests "the thought of a permanent alliance with a lady, despite the physical aspect which attracted him moderately, only crossed his mind fleetingly."

He had continuing dealings with John Lane and the former Bruton Gallery (by now renamed the Baillie Gallery), and it was one night in a Mayfair pub near the Baillie that Spare got talking to a middle-aged woman, one Mrs Shaw, sitting on the next bar stool.

As Letchford recreates the scene, she was striking if somewhat overdressed – and the fact that she was sitting at the bar in a public house strikes a very dubious note by the social mores of the time – and Spare could have no idea that she was soon to become his mother-in-law. Hearing Spare talk of his success as an up-and-coming artist, with his wealthy patrons, she evidently felt that he was a bit of a gent and a man with prospects; just the sort of man, in fact, who would suit her daughter Eily, a chorus girl.

Mrs Shaw was concerned by the comings and goings of young men to see Eily, and in fact she was already looking after Eily's baby daughter at her house in Brixton. The child had been born in 1908 and her father, a Mr Bernstein, had quickly removed himself from the scene.

Mrs Shaw lost no time in bringing Spare and Eily together. Eily Shaw was three years older than Spare, twenty eight to his twenty five, and she was the daughter of Mrs Shaw's deceased husband, Harry Shaw, who had been a keen amateur naturalist.

Spare was smitten with Eily. He gave her a self-portrait in oils – an unusual medium for Spare – sitting at a table with a GF Watts-style mountain landscape behind him. Another pencil drawing, from 1910, shows the face of Eily surrounded by little heads of Spare; such variant heads are not uncommon in artist 'studies', but the thought here seems to be magical, particularly since the picture contains several sigil clusters, as

if Spare is either orbiting around her or trying to cast a charm over her by surrounding her face with a constellation of his own.[5]

Eily seems to have pushed things forward by the more down-to-earth expedient of pretending to be pregnant, and on 4th September 1911 they were married. According to one of Spare's letters to Pickford Waller[6] it was a very grand wedding indeed, complete with carriages, at the fashionable church of St. George's, Hanover Square, where Shelley had been married before them, and Alfred Doolittle in George Bernard Shaw's *Pygmalion*. This may not be true, however, and there are reasons to think it was at St. George's Registry Office. Spare was nervous and choked on his cake, sending Eily "into hysterics."

Spare and Eily set up home together at 8b Golders Green Parade, next door to Sylvia Pankhurst who had found the flat for them. Spare helped her out with some amateur carpentry, and the Spares had their windows broken by mistake for Pankhurst's during the Suffragette struggles.

Golders Green, only recently suburbanized, was already a Jewish neighbourhood, and in order to understand his neighbours and perhaps impress them Spare started delving into Jewish literature. Always a keen reader and autodidact, Spare read The Song of Solomon and The Zohar, and years later he remembered a quotation, "Men fall only in order to rise."

Spare still seemed to be a rising star, and he was something of a dandy. He had several embroidered waistcoats, and he would go to parties in a white suit with a crimson silk sash. He also liked to buy antiques for the house. It was quite a prosperous area and he might have thought it would be a good ground for portrait commissions, but these never materialised. He did a striking portrait of his wife around this time, now in the Victoria and Albert Museum, and he made a number of animal studies and bird studies, some on silk[7] including a Pekinese dog – perhaps Eily's – and his own pet rabbit.

5. Christies South Kensington, *Twentieth Century British Art* 26th July 2001, Lot 49 (catalogued as 'Head Studies'), formerly in the collection of Thomas Lumsden.
6. This letter is one of a batch of thirty or so bound in a peacock-feather album; the album is believed to have gone to Iceland in the 1970s and has not been traced.
7. E.g. *An Exotic Menagerie*, lot 13, Sotheby's 30th Sept 1998, illustrated in colour.

Eily and Austin seem not to have been very compatible. She was unintellectual and materialistic, and she liked Austin to spend his money bringing their groceries back from Fortnum and Mason in an open carriage. Spare had given an inscribed copy of *A Book of Satyrs* to Mrs Shaw in August 1911, but her daughter seems not to have appreciated that she was living with a genius; Frank Letchford suggests she may even have wanted him to get a job. He was still in touch with Father Gray, and the various ailments he complains about in his letters suggest a man who wasn't entirely happy; as Letchford says, they were "a sure sign that he was under tension."

Spare did a self-portrait of himself with Eily: his own face is fleshed and finished in gleaming detail, while hers is like a faint sketchy ghost to one side, less definite even than the totemic charm in the corner. We don't know very much about her. Spare and Eily had little in common, they moved in different circles, and she was jealous of his friends, some of whom she wanted him to drop. She complained about him spending too much time with younger men. As for Spare, he wanted to run off with their maid, a buxom country girl, or so he claimed later; it is not certain that they had such a maid.

Years later he discussed marriage with a younger friend, and said he liked the idea of a plain or even ugly woman with a good body. If he married again, he said, that was the sort of woman he might choose, as long as she had an easy-going, tolerant disposition and good healthy hair. Meanwhile, marriage to Eily seems to have been conducive enough to working and even to writing a book, begun during courtship and published in 1913. This was *The Book of Pleasure (Self Love)*; a more fertile work than the title might suggest.

Seven: NECROMANTIC SIGNS

Spare was still working as an illustrator, and around 1910 he illustrated *The Starlit Mire*, a book of cynical and self-consciously worldly epigrams by two doctors, James Bertram and F Russell.[1] It was published by John Lane in 1911 with ten drawings.

Spare seems to have chosen which epigrams to illustrate, because they echo his own interests. "Self-love is immoral – it is the love of the ugly" inspired the book's frontispiece, 'A Gutter Love'. Still showing the influence of the grotesque illustrator Edmund Sullivan, it features a woman looking in a mirror to confront a strange, ugly hermaphrodite. "If it were not for their garments we should neither fear Death nor love Woman" was illustrated by a picture entitled 'Whited Sepulchres', with a finely dressed woman on the one hand and a skull and lightning bolt on the other; all quite straightforward but for the object in the centre, like a tribal art fetish of Spare's own invention.

For "The Model Family. The World, the Flesh, and the Devil... for they never quarrel" Spare drew 'The Peace of the Wicked'. It is again fairly literal, and the figure representing Flesh is a young man with a stylized resemblance to Spare himself. There is another idealised self portrait for "An objection to an empty mind... the Seven Devils that enter are of a stupidity," but the illustration, 'The Senseless Seven', seems less about stupidity than kinship with the animal kingdom. The Spare figure, eyes closed, is surrounded by seven horned and tusked creatures, from a boar and a ram to a devilish grotesque, and their horns are echoed by the two separate beards on either side of his chin.

1. In reality Bertram James Collingwood, a nephew of Lewis Carroll who became a professor of physiology, and Russell Wilkinson.

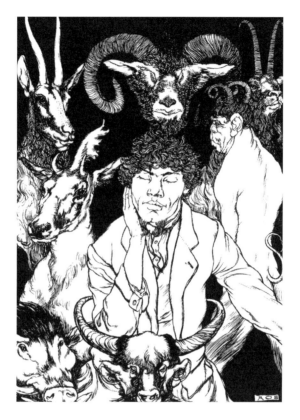

Horned creatures figure in other works of the period, notably a magnificent large sketch from 1910 of two figures: a handsome youth resembling Spare gazes out of the picture and a devilish figure with horns, wings and breasts – like Eliphas Levi's 'Goat of Mendes' – rears up beside him.[2] It would have made Gray and Raffalovich shudder. The youth has a blandly handsome animaloid face – like eighteenth-century physiognomy drawings showing animal types in human faces – and a fine pair of ram's horns curling down from his head. Below his face is a sketchy study of an idealized Grecian face, while beside and behind him stands the hermaphroditic devilish figure, with a

2. *Vague Familiars* (1910). Now [2023] in plate section. See List of Illustrations, Item 17, p.272.

more austere and severe countenance. It is stretching oddly-shaped wings upwards, their shape seemingly due to the fact that they are simultaneously represented as unfurling, with a sideways movement, and at full vertical stretch.

The pencil work has a rapid energy and an intensity that Spare could never have indulged with pen-and-ink. The act of drawing the curling ram's horns has inspired a dancing squiggle that continues over one of them, looking like whorls of smoke from a joss stick, where the local energy of the hand has taken off into a further flourish like a musical extemporisation in jazz. At the bottom of the picture is a cloudy scribbled density of 'automatic' line – still some years before the surrealists took it up – with animal heads taking shape within it.

Most twentieth-century representations of the devil belong in what has been called the "comic inferno," but the devilish figure here has a hieratic dignity that completely avoids it. The picture as a whole has a number of key Spare elements that will later come into their own, including animal kinship, the Grecian face, and automatic drawing. The composition of the two figures, with the winged one standing higher, is like a devilish parody of the Annunciations familiar in early Renaissance art, with Mary and the winged angel. The whole thing has the gravity of a statement about a chosen destiny; although quite what that destiny was would be hard to say, even with hindsight.

Spare was still riding high. He was at the Baillie Gallery in October 1911, in a show called *The Modern World*. Once again it was controversial, and the *Observer* critic wrote

> *Of Mr Austin O Spare's drawings... in the end room, it is difficult to speak without dragging in questions which are beyond the range of legitimate art criticism. Blake's most fantastic inventions are sane, normal and bourgeois beside these irresponsible wanderings of an over-heated imagination.*

At the same time,

> *Every scribble of his pencil is informed with style. And the pen-work of the highly-finished 'The Psychology of Ecstasy' is a marvel of incisive clearness, crispness, suppleness and richness. To find the equal of its line one has to fall back upon Durer's etchings.*

Spare followed this with *Pleasure and Obsession: drawings by Austin O Spare* at the Ryder Gallery in April 1912, which attracted less notice. He told Pickford Waller that the press invitations had not been sent out, and in any case it was badly overshadowed by the Titanic disaster, two days before the show opened. It left Spare with plenty of unsold work for another show at the Baillie Gallery in October.

Pleasure, obsession and the psychology of ecstasy were all part of Spare's *magnum opus*, his great work in progress that he was trying to interest John Lane in publishing. Spare wasn't in favour with Lane at this time – the pictures for *The Starlit Mire* had been delivered late, and were felt not to have helped it with the public – and the new book itself, "the pleasure book" as he referred to it in their continuing correspondence, was just too off-puttingly strange for Lane to take a chance on. Spare went ahead and self-published it from 8b Golders Green Parade, printing it once more with the Co-Operative Printing Society.

According to a note in *The Book of Pleasure*, the work as we have it is missing whole sections. There was to be an introduction by a Daniel Phaer, and the following unknown chapters, all with their corresponding illustrations: The Feast of the Supersensualists; Modus Operandi at the Joy of the Round Feast; Prophecy, Omens, etc; The Book of Revelation; Definitions; Dreams; Mental States in Relation to Suggestion; Description of Sensations and Emotions; Controlling the Elements; Black Magic with Protection; The Black Mass; Vampirism; Sorcery; Oracles, etc.; Use of Spells and Incantations on Men, Animals, etc.; and Invoking Elementals, Nature Spirits for Glamour and Power, etc. "These may subsequently

appear in a fuller edition," says the note. They never did, but the book we have is formidable in every sense.

For one thing, it is almost unreadable by normal standards. It has been ingeniously suggested that Spare was trying to create a grotesque artwork in words, a counterpart to his grotesque drawings, but it might equally be compared to a Heath Robinson machine.

Spare's genius was graphic and conceptual, and his tortuous struggles to express his ideas in writing can be ponderous, awkward, and disjointed. The effect can be vexing to read, like being told a boring dream.

> *The symbol of justice known to the Romans is not symbolic of Divine, or our justice, at least not necessarily or usually. The vitality is not exactly like water – nor are we trees; more like ourselves, which might incidentally include trees somewhere unlearnt – much more obvious in our workings at present.*

There is no clue provided as to what this symbol of justice might be.

Given the style of the book it is almost ironic that there was no obfuscation intended, but this already puts it on a different level from books pretending to bogus traditions or superhuman messages, like Gerald Gardner's witchcraft writing and Aleister Crowley's *Book of the Law.* In contrast *The Book of Pleasure* is simply a man speaking to his readers, without pretensions to leadership, aiming for an engineer-like practicality.

If the point of experiencing *samadhi* might be to produce genius at will, as people were beginning to think in the Edwardian period, then Spare must have been tapping into it in abundance: he was firing on all cylinders. Half-hidden in *The Book of Pleasure* are radical ideas about the unconscious, the nature and functions of belief, the "Kia", the "Self" and "self-love", and something called "the Death Posture", not to mention the concepts of "inbetweeness" and the "neither-neither".

One of the main themes of the book is the unbinding and wilful re-direction of free mental energy: "The words God, religions, faith, morals, woman, etc. (they being forms of belief), are used as expressing different "means" as controlling and expressing desire: an idea of unity by fear in some form or other which must spell bondage."

"Virtue" equals "Pure Art", writes Spare, whereas "Vice" involves the imprisoning of energy in "Fear, belief, faith, control, science and the like." Throughout *The Book of Pleasure* there is a stress on a psychic disinvestment from the external world and its objects, or the mental representations we have of them – from love objects, to religions, to what normally passes for reality – undoing emotional investments and un-binding mental energy to free it for new ends, or simply for the sheer Blakean pleasure of liberating it. Freud saw this kind of energy in sexual terms, as so-called 'libido'; and since Spare also seems to see it in sexualized terms this might be an appropriate comparison. Psychoanalysis coined its own jargon for this investment and disinvestment, as "cathexis" and "decathexis", of which Charles Rycroft comments "Most statements using the word 'cathexis' can be reformulated in terms of 'interest', 'MEANING', or 'REALITY'."[3]

When it came to reality, Spare saw the extent to which it was constructed from belief. We know the importance of belief from the sometimes dramatic results of placebos and 'nocebos' (negative placebos, like the pointing of the witch-doctor's stick that kills aborigines who believe in it) but there is a larger sense in which reality is the embodiment of lived belief.

Spare was less interested in promoting this reality or that reality, and more interested in the way people confined themselves to whichever one they had: he was less interested in what to believe than in how to believe. He saw belief as something free-floating, which could be channelled and re-directed to different objects (again like Freud's descriptions of "libido", which often sound like something out of hydraulic engineering). Spare, in other words, sought to conjure with belief itself.

Disappointment could play into this sorcery of belief, and it often plays a role in this kind of thinking: a Buddhist in pre-war China told the writer John Blofeld "You must be disappointed before Wisdom can root itself in your mind." "Hence let him wait for a belief to be subtracted," writes Spare; "that period when disillusionment has taken place... disappointment is his chance." On a kind of rebound, it was a chance

3. Charles Rycroft, *A Critical Dictionary of Psychoanalysis*, p.16; Rycroft isn't shouting with his block capitals, which are meant to cross-reference with other entries in the dictionary.

to channel this free-floating capacity for belief into a new desire and a new purpose. As simple examples of a usable disappointment, he gives "the loss of faith in a friend, or a union that did not fulfil expectations."

Among the many things that Spare didn't believe in was ceremonial magic, as promoted by his former friend Crowley. Crowley was in touch again just a couple of months before *The Book of Pleasure* was published: "If you have any illustrations that you think would do for No.10 of *The Equinox* please let me see them this week. I should like to have something of yours in our last number."

Spare didn't have anything for him; nor, indeed, did he want anything more to do with him, or so it seems from *The Book of Pleasure*: "These Magicians," he wrote, "whose insincerity is their safety, are but the unemployed dandies of the Brothels" (a description clearly related to the "ponce out of work")

> *I know them well and their creed of learning that teaches the fear of their own light. Vampires, they are as the very lice in attraction. Their practices prove their incapacity, they have no magic to intensify the normal, the joy of a child or a healthy person...*

Instead,

> *Self condemned in their disgusting fatness, their emptiness of power, without even the magic of personal charm or beauty, they are offensive in their bad taste and mongering for advertisement.*

This little diatribe is part of a larger attack on so-called ritual magic, and the Golden Dawn-style use of symbolism (as in the GD practice of "the assumption of god-forms", temporarily identifying the practitioner with this or that Greek or Egyptian deity).

Our asylums are crowded, the stage is over-run! Is it by symbolising we become the symbolised? Were I to crown myself King, should I be King? Rather should I be an object of disgust or pity.

Spare also distrusted this kind of symbolism as belonging too much to the conscious mind. What he actually put his faith in, as we have seen, was the unconscious, or "subconscious", as the fount of genius and inspiration, and in *The Book of Pleasure* he elaborates on this. Conscious desire is all but useless, serving largely to reinforce our sense of separateness from the thing we want but don't have. Conscious desire is like the watched kettle that never boils.

Unconscious desire, on the other hand, especially when it becomes unconscious taken-for-granted belief, is the stuff that makes reality what it is: one aspect of this is the way that 'character is destiny,' and some people seem consistently lucky or unlucky in certain directions. Spare has a memorable image for this:

A bat first grew wings and of the proper kind, by its desire being organic enough to reach the sub-consciousness. If its desire to fly had been conscious, it would have had to wait till it could have done so by the same means as ourselves, i.e. by machinery.

It is a beautiful image, and it brings us to another strand in Spare's thought. Although this is far from orthodox Darwinism, which supposedly works by natural selection following completely random mutations, Spare was greatly inspired by Darwin; in fact he was interested enough to make a special visit, years later, to see the village of Downe in Kent, where Darwin had lived and wrote *The Origin of Species*.

Spare's sense of Darwinism was eccentric. Spare believed in the kinship of humanity with the whole of life, so he thought we carry within us deep organic memories of being mice or whales or tigers. In reality we have only come down one branch of the evolutionary tree – we may have been amoebas and lizards and tree shrews and ape-like creatures, but we have never been elephants or birds – but for Spare

this was combined with the idea of karma, as in reincarnation, so that we might have, for example, "bird karmas" deep within us waiting to be evoked like spirits.

Spare later theorized this as what he called "atavistic resurgence", and it is central to his thinking; already in *The Book of Pleasure* he writes that the "soul" is really "the ancestral animals". Ideas of atavism – a throwback to something ancestral and remote, instead of one's parents – were well known in Spare's day, particularly with Ernst Haeckel's influential idea that "ontogeny recapitulates phylogeny". The history of the individual's (ontogenetic) growth supposedly goes through the stages of the species's (phylogenetic) evolution, so a foetus in the womb, for example, was thought to go through a fish-like stage.

As well as taking Spare far beyond the Biblical faith he was raised in, the sheer mind-expanding weirdness of evolution – the idea, for example, that humans are kin to the tree shrew and the flying squirrel, and that whales are descended from a small pig-like or deer-like creature that once trotted along beaches and occasionally swam – must have excited him.

Evolution confirmed his deep feeling that human and animal life was one, feeding into his horned figures, adding another strand to his Nineties-style satyr imagery of goat-men, and driving his beliefs about the real meaning of the Sphinx:

> *The Egyptians... were a sub-conscious race, Artistic as opposed to our scientific. To them the Darwinian was no new theory, they were already in possession of the "vital" knowledge that Man had evolved from animals, from the lower forms of life. They symbolised this knowledge in one great symbol the Sphinx (hence its importance) which is pictorially Man evolving from animal existence.*

Spare believed that the difficulty in accessing these earlier ancestral strata, just like the difficulty in tapping into those FWH Myers-style subliminal

levels of the mind, lay in too much conscious thinking. The conscious mind had to be distracted and bypassed, which was why Spare thought geniuses often had hobbies: "ALL geniuses have active sub-consciousness, and the less they are aware of the fact, the greater their accomplishments." The role of a hobby was that it served "to restrain and occupy the conscious mind, to prevent its interference with spontaneous expression." Spare's example was Leonardo's interest in mathematics.

This was the point of his sigils, Spare's radical system for communicating with the unconscious; they bypassed the conscious mind. Unlike the showmanship of holding them against the forehead, the great knack with sigils lay in consciously forgetting them after they were made and charged, so they could germinate in deeper strata. This (along with the fact that, unlike symbols, they meant nothing to the conscious mind) was what supposedly did the trick.

"Sigils are made by combining the letters of the alphabet simplified," Spare writes, and he elaborates on this simplicity in *The Book of Pleasure*:

> *Sigils are the means of guiding and uniting the partially free belief with an organic desire... Sigils are monograms of thought, for the government of energy (all heraldry, crests, monograms, are Sigils and the Karmas they govern), relating to Karma; a mathematical means of symbolising desire and giving it form that has the virtue of preventing any thought and association on that particular desire...escaping the detection of the Ego, so that it does not restrain or attach such desire to its own transitory images, memories and worries, but allows it free passage to the sub-consciousness.*

This, in effect, was how all magic worked, said Spare, when it did – by unconscious suggestion.

> *This being the only system, any result other than by it is accidental. Also you do not have to dress up as a traditional magician, wizard or priest, build expensive temples, obtain virgin parchment, black goat's blood, etc., etc., in fact no theatricals or humbug.*

Further to sigils, Spare devised another graphic system he called the Sacred (or Atavistic) Alphabet, or the Alphabet of Desire, where each character supposedly corresponded to a "sex principle".

The idea of a primordially-rooted language, where signs would correspond more fully to the nature of things, is perennial: Giordano Bruno writes in *De Magia* of a "language of the gods", last glimpsed by mankind in the form of Egyptian hieroglyphics (still undeciphered in Bruno's day) and Ezra Pound put his faith in the pictorial basis of Chinese ideograms. In the 1960s Ted Hughes and Peter Brook attempted to develop a language called Orghast, effectively a magical language where words would have "a more inevitable relationship to reality." For example, the Orghast for "darkness opens its womb" ("staple of any phrasebook," as a cynic writes) is BULLORGA OMBOLOM FROR. Deep onomatopoeias of feeling are also palpable in many ordinary words like the Sanskrit *guru*, meaning "heavy", from which we get the modern word.

Spare's complex and still undeciphered system, a would-be script of dreams, has little or no precedent within fine art (which he was part of – he wasn't an outsider artist but a trained professional who never came to the attention of psychiatrists) but it is familiar in the lettering systems of outsider art, along with mediumism (like Hélène Smith's "Martian script", left) and occultism, where a fascination with magical languages and scripts is almost an obsession in its own right. In the words of Dr Faustus:

These metaphysics of magicians
And necromantic books are heavenly.
Lines, circles, scenes, letters, and characters:

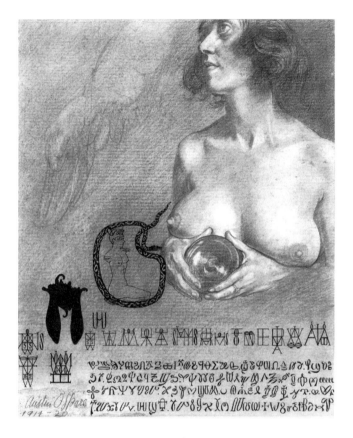

Ay, these are those that Faustus most desires.[4]

The fascination of writing within magic goes back a long way: sometimes based on degraded Greek, Latin or Hebrew, it was suggestive of secret learning for the very few. More than that, the deeper fascination in magic scripts and signs is the way that undecipherable asemic script seems to offer a way into the unconscious, like doodling or glossolalia. Within contemporary art, this effect has been used by Susan Hiller in

4. Marlowe, *Dr Faustus*, Scene 1, lines 78-81: the word "scenes" is generally felt to be wrong, and it has been suggested that "sayings" – as in spells or incantations – or indeed "signs" might be correct. "Necromantic" has also been explained as a corruption of "nigromantic", i.e. not about raising the dead but black magic in general.

Midnight Baker Street, scribbling over her own photo-booth image with cryptic, shorthand-style marks. Also within twentieth-century fine art, Isidore Isou and the French "Lettrists" and post-Lettrists, of the Fifties and onwards, unknowingly followed Spare in their "hypergraphics", such as Noel Arnaud's *Towards a Sexualization of the Alphabet*, of which Spare's Alphabet of Desire is an early instance.[5]

Spare's Sacred Alphabet will never be deciphered completely, because it doesn't fully add up; he claimed in the Fifties to have forgotten the key, and it is likely that many of the characters were invented simply out of graphic pleasure. It would, in any case, be personal to Spare himself, as he always stressed: he wrote in a later book that each of us has our "*own* arcana" [my emphasis] – our own symbol system, memories, reference points – possibly borrowing the word arcana from tarot cards (which don't otherwise seem to have interested the mature Spare very much). As one of his best commentators puts it, there is for every individual "the sacred alphabet of the mysteries that each one of us contains."

A psychoanalyst, Serge Leclaire, also catches this idea when he suggests that for each person there is an encoded core fragment unique to them, a "jubilatory formula",

> *...the inaccessible text of the elementary unconscious. It consists of a sort of secret ejaculation, a jubilatory formula, an onomatopoeia... The articulation of this formula, either out loud or in a whisper, connotes a jubilatory movement of the body, such as curling up and then stretching, taking pleasure in the result obtained and then starting again.*

It is rare, Leclaire continues, for an analyst to arrive at these secret formulae, "since admitting them is, as it were, a violation of modesty. In general they are obscene or grotesque." And, considered as personal arcana, rather magical.

5 See for example *Potlatch pour Noel Arnaud* (Toulouse, Palais des Arts, Nov-Dec 1997) e.g. Gabriel Pomerand, *Aphorisme Onze* and Jean-Louis Brau, *Sans titre*; and Noel Arnaud's *Vers une sexualisation de l'alphabet*, with Jean Dubuffet (Paris, Editions du Limon, 1996).

Spare's writing overlaps with psychoanalysis, as he knew: this gave him a certain resentment towards the famous Freud and Jung (or "Fraud and Junk" as he called them, with their "psycho-anal" "pathopsychology"). He later wrote to a friend that he was "born and bred among the founders of 'modern' schools":

> *Friendship with H[avelock] Ellis all my life. Freud, Krafft Ebing, Adler, Whitehead – many others to this day have sorted me out.[6] Why? Freud used one of my thesis. Worked 18 months with Ebing.*

Sometimes the overlap is real, like his ideas about the therapeutic power of automatic drawing:

> *Automatic drawing is a cure for insanity because it exposes the wounded sentiment allowing the consciousness to recognise what is obsessing and thus reason (control) begins afresh.*

Spare's ideas about the importance of deliberately forgetting desires, as a way of getting them into the "subconscious" and thereby giving them power, also goes beyond the fin-de-siècle romantic subconscious and approaches a more Freudian-style model of an unconscious that is created by repression: it is in this sense that (in Kenneth Tynan's neat formulation) "a neurosis is a secret you don't know you're keeping."

Spare believed that because these wishes, pushed out of the conscious mind, were in effect repressed, they would therefore bounce back (like the Freudian "return of the repressed" within the mind) with vital effects on real life. It was really a matter of engineering artificial, purpose-built complexes and neuroses, charged with an unconscious energy of their own, and then setting them loose, like useful little demons, into the mind-stuff of which the occult world is made.

6. *Sic*: sought me out?

At other times Spare's overlap with psychoanalysis sounds more real than it is, particularly when he writes about "obsession".

> *Obsession known as or related to insanity is an experience that is dissociated from the personality (Ego) by some sort of rejection.*

This all sounds quite psychoanalytic, but Spare's thoughts on obsession have at least as much to do with spiritualism:

> *Magical obsession is that state when the mind is illuminated by sub-conscious activity evoked voluntarily by formula at our own time, etc., for inspiration. It is the condition of Genius.*

This deliberate evocation and use of obsessions, almost like spirits, is central to the way Spare thought the mind worked and could be worked with, and he draws pictures of "obsessions incarnating" and "the instant of obsession."

Spiritualists talked about obsession as a state where the mind was 'obsessed' or besieged by an intrusive force, like an intrusive thought, as opposed to 'possession' where the mind was completely taken over. There is a struggle with this kind of obsession in RH Benson's 1909 novel *The Necromancers*:

> *"[you must] fight on his side against this thing that is obsessing him... whatever you see – little tricks of speech or movement – you must not for one instant yield to the thought that the creature that is obsessing him is what he thinks it is... It is not Possession yet: he is still partly conscious..."*

Interestingly enough, when Spare stayed with Benson around the same time as the novel, Benson seems to have thought Spare was being obsessed by "evil spirits".

Spare's theorising about this kind of obsession also has a slightly ironic ring to it, because he could also be deeply obsessional in the ordinary Freudian sense, with little rituals and personal superstitions (in the way that

it might be unlucky to tread on the cracks on the pavement, for example, or that such-and-such might happen if you can hold your breath until you reach the next lamp-post, or if the next bus is a number 23). Further obsessional traits in Spare include the sense that you might get what you want but only if you don't think about it (not easy); the experience of thoughts as independent dynamic things; and the belief that thoughts themselves work directly on reality. This sense of the 'omnipotence of thoughts' is central to obsessionality, to the 'magical thinking' of so-called primitive people and some psychotics, and to occultism.

Freud's idea of obsessionality was central to his work and it produces some of his most interesting writing, like his idea that even the ordinary obsessional, with his mental tricks and personal rituals, unintentionally produces a parody of a religion.

Eight: STRANGE PLEASURES

Central to Spare's religion was the idea of the Zos and the Kia, as we have seen: the ordinary bodily self of the Zos and "the intrinsic non-existence at the heart of entity" of the Kia, which could be experienced as a kind of transcendent and ecstatic higher self, tuning into or partaking of the great Kia-void behind existence known to Mahayana Buddhists as Sunyata.

This uniting of the Zos and the Kia could be brought about by several methods, notably what Spare called the Death Posture (the term probably comes from the yoga term Shavasana, "the corpse pose"). Spare would gaze into a mirror until his ordinary sense of self was blurred and unseated, then close his eyes, looking into the "third eye" of meditation. He would then tense himself – for greater relaxation later – clasping his hands behind his back and stretching his chin upwards, and begin to hyperventilate (known in yogic circles as "breath of fire") before falling on to a bed with a sense of totally self-sufficient relaxation and contentment, which he described as including the "emotion of yawning" and the "emotion of laughter". In effect he had brought about a kind of swoon, using a brutal shortcut to states otherwise achieved through yoga and meditation.

Spare found great things in the Death Posture, including *samadhi* at will; ecstatic pleasure; and a stepping off-point for so-called astral projection (one of his illustrations is inscribed "The Whole Body Becoming a 'Ka' in the Death Posture", Ka being an Egyptian astral body). He may also have found something akin to what Pierre Janet termed an *abaissement du niveau mental*, a lowering of the threshold of consciousness supposedly characterised by a proliferation of "rich... and grotesque profundity."

It was also in the Death Posture that he could undertake his adjustments to the fabric of reality, getting behind the scenes and

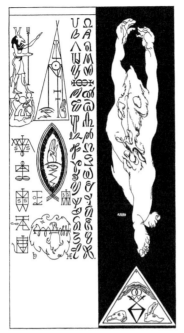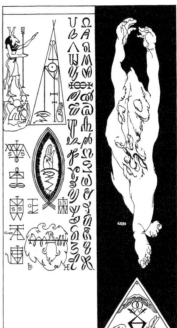

engineering changes through the use of sigils. Lying in the Death Posture was an ideal moment to drop a sigil into the unconscious and then deliberately forget about it, so that it would germinate later.

This use of sigils was facilitated by the attainment of an all-important vacuity, and Spare suggests numerous methods for achieving a pleasant blankness of mind. "There are many means of attaining this state of vacuity: I mention the most simple, there is no need for crucifixion."

> *Vacuity is obtained by exhausting the mind and body by some means or another. A personal or traditional means serves equally well, depending on temperament; choose the most pleasant; these should be held in favour, Mantras and Posture, Women and Wine, Tennis, and the playing of Patience, or by walking and concentration on the Sigil, etc., etc.*

The playing of patience is an unexpected example. Many readers, George Bernard Shaw seemingly one them,[1] have noticed that far from being concerned with the playing of patience, *The Book Of Pleasure (Self-Love)* in fact has a strongly onanistic subtext, running alongside the higher-minded union of the Zos and the Kia.

Even the union of the Zos and the Kia itself is like the strange new vice suggested by fin-de-siècle writer Richard Le Gallienne in his poem 'The Decadent to his Soul,' which seems to have begun as a satire on the tendencies of the 1890s. The "Decadent" of the poem has

> *...dreamed of a new sin:*
> *An incest 'twixt the body and the soul.*

The term narcissism ("morbid self-love" according to the OED) was still quite new in Spare's day, being coined with reference to a book by Havelock Ellis – whom Spare seems to have known slightly – in which Ellis drew on the myth of Narcissus loving his own reflection.

The "Self-Love" described in Spare's title goes well beyond the merely masturbatory to describe deep narcissistic pleasure. This shouldn't be confused with the arrogant or preening senses of the word. It can take many forms, from the practise of meditation to the taking of opiate drugs, or simply the exquisite pleasure of staying in bed when you have to get up; similarly, the French philosopher Montaigne "found the silk-smooth slide into unconsciousness so rewarding that he asked his valet to wake him early so that, realising it was still early, he could repeat the experience." A cellmate remembered that the spy George Blake, when he was in prison, used to "practise being dead. He would lie on the bed with a bandage over his eyes and say 'I'm being dead'. He said it was like black velvet."

This fantasy idealisation of death as a kind of mystical state involving subject without object is not uncommon, and neither is the deeper phantasy of death as a mystical union, but there is a less morbid example of narcissistic pleasure in Marvell's poem 'The Garden':

1. Chapter IX.

Meanwhile the mind, from pleasures less
Withdraws into its happiness;
The mind, that ocean where each kind
Does straight its own resemblance find;
Yet it creates, transcending these,
Far other worlds, and other Seas;
Annihilating all that's made
To a green thought in a green shade.

This is mind pleasure, the bliss of pure consciousness, or what Spare would have called 'self-love.'

In one of his early novels Samuel Beckett describes a tragi-comic character called Murphy who leaves the outer world behind and perfects deep narcissistic states by tying himself blindfolded to a rocking chair. Beckett adapts Spinoza's description of God for the "Amor intellectualis quo Murphy se ipsum amat" (the intellectual love with which Murphy loves himself)[2] and tells us the result was "So pleasant that pleasant was not the word."

In an earlier book Beckett describes another character who likes to reach what he calls a "wombtomb" state of mind and become a "twilight mummyfoetus"

> *He lay lapped in a beatitude of indolence that was smoother than oil... dead to the dark pangs of the sons of Adam, asking nothing of the insubordinate mind. He moved with the shades of the dead and the dead-born and the unborn and the never-to-be-born, in a Limbo purged of desire...*
>
> *If that is what is meant by going back into one's heart, could anything be better, in this world and the next... not sleep, not yet, nor dream, with its sweats and terrors, but a waking ultra-cerebral obscurity, thronged with grey angels; there is nothing*

2. Contrast *Amor intellectualis quo Deus se ipsum amat* : the intellectual Love with which God loves himself.

*left of him but the umbra of the grave and womb where it
is fitting that the spirits of his dead and his unborn should
come abroad.*

Psychoanalysts used to think in terms of primary narcissism (the supposedly happy self-sufficiency of an infant in the womb, for example) and secondary narcissism (when, for example, disturbed individuals take themselves as their own self-sufficient love object, including variants such as finding themselves in the image of another), but it is now more widely thought that there is no primary narcissism, and that narcissism is "always already" a union with a phantasised object[3] (or 'other') inside the self: "Falling asleep is not a simple narcissistic regression," writes an analyst, but involves a phantasy object: "the sleeper is not truly alone, but 'sleeps with' his introjected good object... sleep is not a phenomenon of primary but rather of secondary narcissism, at least after early infancy, and the sleeper shares his slumbers with an introjected object"; a kind of beneficent succubus.

Analyst Michael Balint, writing in *The Basic Fault*, relates these self-sufficient states to early frustrations and "insoluble resentment against the mother." Freud, writing about the related area of the "oceanic feeling" – a feeling of mystical oneness with everything – describes it with less anger and blame, and with further-reaching implications:

> *the oceanic feeling... might seek something like the restoration
> of limitless narcissism... I can imagine that the oceanic
> feeling became connected with narcissism later on... Another
> friend of mine [tells me]... by withdrawing from the world,
> by fixing the attention on bodily functions and by peculiar
> methods of breathing, one can in fact evoke new sensations
> and coenaesthesia in oneself, which he regards as regressions to
> primordial states of mind which have long ago been overlaid.*

3. When psychoanalysis talks about "objects" it usually means other people, entities, or parts of people (like the breast); it doesn't, by and large, mean "things".

He sees in them the physiological basis, as it were, of much of the
wisdom of mysticism.

More could be said about Spare's "mystic book", as he described it to
a friend, but it will soon be time to move on. He also writes about
Automatic Drawing; art as "Need-Not-Be" ("The Vital Religion");
and the "Neither-Neither." Possibly from the Sanskrit term *neti-neti*
("neither this nor that", an important idea in Advaita Vedanta[4] and
Budddhism) "Neither-Neither" was another key concept for Spare: given
a polarity of two states, think of a point between them which is neither;
then think of a point which negates that in turn. Spare's example was
"Man implies Woman, I transcend these by the Hermaphrodite, this
again implies a Eunuch;[5] all these conditions I transcend by a "Neither"
principle": finally he reached an exquisite detachment, and a sense of an
"atmospheric 'I'".

This transcendence involves a disinvestment in the objects of the
outside world for a perfect midpoint of equilibrium within, and the
discovery of luxurious pleasures beyond it. Something like this is familiar
in the world's religions: Christians are told "The Kingdom of Heaven lies
within," and Buddhists are known in Tibet as "nangpas", "nangpa" meaning
"inside-er". There may be an element of this in the magical name Spare
chose when he joined the Argenteum Astrum, "Yihoveaum". Combining
Jehovah and the Aum or Om of mantra meditation it suggests at the
very least a fusion of Western and Eastern religion, but in view of Spare's
developing philosophy it perhaps also suggests, more mystically and
narcissistically, that "God is Om".

"Poor though I be," writes Spare towards the end of his Pleasure
book, "my contentment is beyond your understanding." He had united

4. Advaita Vedanta is a major school of Hindu philosophy, *Advaita* meaning "non-
duality" and specifically the identity of the higher Self (Atman) with Wholeness
(Brahman). For Buddhists *neti-neti* leads to the point where conceptual thought ends
and the void of Sunyata begins.
5. Known in Buddhist logic as 'fourfold negation' (not A or B or both or neither), and
too close to be coincidence; but Spare's use of sexual identity as an example seems to
be his own.

"the Ego and Absolute", drunk "the nectar of all-beneficent and gratuitous ecstasy" ("The most pleasurable nourishment that harms no one") and consumed a "syllabub of sun and moon". Strange pleasures were everywhere: on the subject of automatic drawing, for example, he writes:

> *When the mind is oblivious, great success is assured. Looking at the thumb in the light of a moonbeam, till it is opalescent and suggests a fantastic reflection of yourself is a means to great perfection and extraordinary results are obtained.*

The Book of Pleasure is a very idiosyncratic and at first glance seemingly *sui generis* work, but there are important sidelights cast on it by books such as *Yoga: A Study of the Mystical Philosophy of the Brahmins and the Buddhists* (1925) by Spare's near-contemporary and probable acquaintance Major-General JFC Fuller, an old Argenteum Astrum member who had meanwhile pioneered tank warfare and laid the tactical foundations for what would become blitzkrieg.

Some of the pleasures in Spare's book (hearing internal music, for example) are mentioned by Fuller, along with the transferring of attention and consciousness to a single part of the body in *dharana*. Fuller is strong throughout on the Hindu atman, which is essentially the Self that Spare believed in: "identification with this Atman (Emerson's 'Oversoul') is, therefore, the end of religion and philosophy alike," says Fuller. "God, immortality, freedom, are appearances and not realities, they are Maya [illusion] and not Atman; space, time and causality are appearances and not realities, they also are Maya and not Atman. All that is not Atman is Maya"; "super-consciousness (Samadhi)... will consume him back into the Atman from which he came"; "Yoga consists in withdrawing the organs of sense from the objects of sense, and concentrating them on the Atman".

Fuller is also illuminating on the Atman-equivalents in various other religious and mystical systems: Taoists have the Tao, Platonists have the Augoeides, Gnostics have the Logos, Sufis the Beloved; Abramelin the Holy Guardian Angel, Theosophists the Higher Self or silent Watcher.

Spare's concepts of the "Self" and "Kia"[6] belong to this family.

Buddhism fits less readily: it parted company with Hinduism by virtue of its disavowal of any individual soul or Atman, and in this Spare was ultimately more Hindu than Buddhist, because he chose to stay with the idea of his own higher Self, and its pleasures.

Spare must have had every expectation of having his genius recognised after he self-published his book in 1913 (alongside the fact that he was, as he thought, providing a genuine service to mankind). Readers were slow in coming, however, and he still had some unsold copies left in the 1930s.

We know Gray and Raffalovich had a copy (it went to the Dominican Library in Edinburgh, from where it was later bought by young art dealer Anthony D'Offay), and we know Crowley had a copy and read it, because he annotated it:

> *Spare was at one time a pupil of Fra.P. [i.e. Frater Perdurabo; Crowley himself] but was kept back by Him on account of his tendency to Black Magic. This tendency is seen in its development in this book.*

Given Crowley's popular image this sounds like the pot and the kettle, but it has a more specific meaning. Golden Dawn-type magicians were wont to talk of "Black Magic" and "Black Brothers", and Crowley puts an explanation in *Magick in Theory and Practice*: firstly, he says, anything but mystical self-development tends to become black magic, notably "the use of spiritual force to material ends" (as in sorcery or Christian Science, one of his slightly mischievous examples). More culpable still, in a sense, are "Brothers of the Left-Hand Path"; "These are they who 'shut themselves up', who refuse their blood to the Cup" and who generally cut themselves off from the stream of humanity in

6. Overlapping to some extent with each other (Kia perhaps being the higher [non-] manifestation that the Self partakes in, as the relatively individual Atman partakes in the more universal Brahman).

developing their egotism and their sense of separateness. This criticism, fair or not, is his objection to Spare: it comes back to his apparent self-absorption and narcissism.

Another of the book's readers, according to Spare, was none other than Sigmund Freud. Spare told a friend that Freud had written to him "to congratulate him on his original thought" (more than that, "Austin maintained that Freud used some of his ideas"). Another friend remembered that Freud's letter had, according to Spare, apparently described *The Book of Pleasure* as "one of the most significant revelations of subconscious mechanisms that had appeared in modern times."

Sadly this letter has not been found.

The *Times Literary Supplement* reviewer was not so impressed. Describing the book as "symbolical drawings and expositions of his creed, by the artist of the curious *Earth: Inferno* (1905) and *Book of Satyrs* (1907)" he gave readers the flavour of it:

> *Here is the opening sentence – a typical one – of a paper on 'The Cloudy Enemies Born of Stagnant Self Hypnotism,' which seems to be illustrative of a drawing consisting of a half-nude but armless woman apparently in a faint; a face winking the left eye; a guttering candle and a shadowy animal head with four human hands where its ears should be: – "Natural belief is the intuition that compels belief through that which is experienced reacting, and dominating in turns; everything has to associate itself through its definite emotion, stimulated by those in harmony; those discordant, lose cogency and inhibit." This, we admit, gave us the first twinges of dyspepsia, but we would not dissuade adventurous spirits from the full meal.*

He did concede that "Mr Spare, we need hardly say, when he is depicting a recognisable object, shows much technical mastery"; a mollifying conclusion that hardly touches the art of *The Book of Pleasure*.

Spare's extraordinary attempts to "visualize sensation" in *The Book of Pleasure* (see page 99) are unlike anything else in the art of his day. The nearest comparison, and it is slight, might be with the foetus motif in Beardsley. But the entity representing the death posture – its face sometimes in its chest, its lips thick and its tongue out, its outlines and extremities taking flight into animal skulls or automatic drawing – stands alone. This creature resembles almost nothing in art until at least the surrealists, and perhaps the description of Francis Bacon's art as being like feeling your face with your hand in a dark room.

The more conventional artwork in the book is often a labour-intensive Symbolist art of women, wings, skulls, and human-animal fusions, caught up in finely scrolling and unfurling plant-like detail. It has undergone a change from Spare's earlier work, and it shows his move away from simple pen and ink to the silverpoint-like effects and cloudy nuances possible from pencil.

There is nevertheless a remarkable continuity between the frontispiece, entitled 'The Death Posture' and dated 1912, and the 1907 *Portrait of the Artist* that showed Spare at a table covered in curious connoisseurial bric-a-brac. Spare now has a snake curling around him and a winged skull above his head, suggestive of sexuality, death and transcendence, but his hand posture on his face is virtually the same.[7] The composition of the rounded table is also unmistakably similar, this time with figurines, masks, a fabulous candlestick with entwining fish (possibly inspired by the entwined dolphins on Thames-side lamp posts, along the Lambeth bank) and various entities, some from the antique and classical world and some invented out of Spare's own head.

It is not immediately clear why the 'Death Posture' title should connect what I have termed the 'scholar sanctum' look with the more yoga-like aspect of the other death posture depictions. However, if Spare

7. It has sometimes been suggested that this shows some form of breath control or auto-asphyxiation, closing the nose, which further relates it to the 1906 picture of Spare riding a dragon-like entity, formerly in the collections of Pickford Waller (Christie's South Kensington 12th November 1965 lot 55) and Paul Getty (sold as *Self Portrait with a Dragon* Christie's King Street, 24th November 2004 lot 17). However, there are further variants of this in Spare without the nose closed, and it might equally relate to a stylized, face-grasping gesture of thoughtfulness or melancholy; the dark side of narcissism.

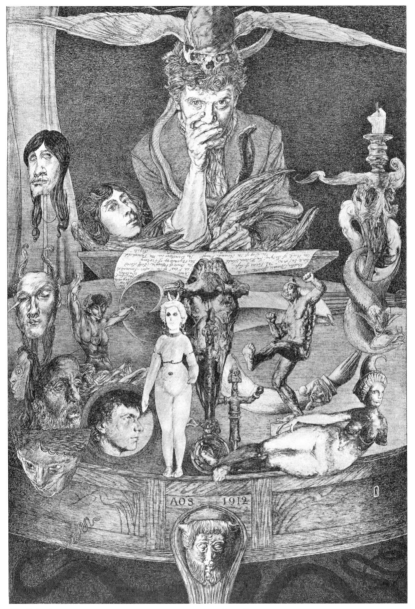

 THE DEATH POSTURE

at his table and the Death Posture have a common denominator, it is
surely a sense of mental plenitude. He is brooding over the table like a
mental domain: a kind of psychic work-space, and place of private power.
Spare believed that the various dynamic thought-entities, complexes and
obsessions in his mind were alive, and the various objects and entities on
his idealised desk are like the contents of that mind. This goes beyond
the normal realm of writerly bric-a-brac (although even in the case of
Freud's desk, he said his little objects helped him to think; "He said his
little statues and images helped stabilise the evanescent idea, or keep it
from escaping altogether"). Without pushing the point to suggest any
intentional or allegorical aspect, this strange depiction of the death
posture – reasonable as a foetus-like yogic figure, but unexpected as a
plenitude of objects at a desk – is like an image of mental objects and
thought-entities,[8] perhaps even of thoughts thinking themselves; the
kind of quasi-autonomous thoughts Spare saw as "automata", elementals
and familiar spirits.

In this connection we could consider a third picture, related to these
1907 and 1912 compositions, 'The Senseless Seven' from *The Starlit Mire*
of 1911. Again it figures Spare as the single protagonist, hand to face,
sleeve rolled, this time with his eyes closed: his attention is now clearly
inward, and he is surrounded in the picture by his mental inhabitants or
intruders ("the… devils that enter…").

Elementals and familiars fascinated Spare, and we can look at them
in more detail later, but for the moment we might consider the words
of the nineteenth-century French occultist Eliphas Levi on elemental

8. Considering philosophy, the early analyst Victor Tausk wrote in a 1914 paper
that the philosopher turned away from external objects and displaced his freed or
disinvested libidinal energies on to thinking itself: "The reality of a thought takes the
place of objective reality and, because of its emotional charge, assumes the characteristic
of a material object. This characteristic classifies the philosopher with the obsessional
neurotic" (Victor Tausk, 'Psychoanalysis of Philosophy and Psychoanalytic Philosophy'
in *Sexuality, War and Schizophrenia* ed. Paul Roazen, 1991). Tausk's ideas are relevant to
demons, immaterial pets, and the fantastic machines beloved of some outsider artists.
For a graphic depiction of a thought-object in a very different key, see the entity on
Freud's desk in Ralph Steadman's *Sigmund Freud*: this has a crazed smile, one arm fallen
off, a flower up its backside, and some noughts and crosses on its flank, while a curly tail
seems to double as a chimney or exhaust pipe. It is "a joke", and Freud is peering at it
intently to try to understand how it works.

spirits and the danger of indulging them: "The love of such beings by a Magus is insensate and may destroy him."[9]

9. *The Magical Ritual of the Sanctum Regnum* (London, George Redway, 1896) p.35. I take this to be at least in part about the dangers of excessive interiority.

Nine: "What Dire Offences Rise..."

Professionally Spare still seemed to be doing well, with his first one-man show at the Baillie Gallery in July 1914, including some large animal studies. He was also involved with a new popular art magazine called *Colour*, edited from Victoria Street: contributors included Frank Brangwyn, Ernest Collings, Mark Gertler, Nina Hamnett, Haydn Mackey, Ricketts and Shannon, Glyn Philpot, Frederick Carter and others, including the photographer EO Hoppé. Spare's early contributions included a full page colour 'Decorative Bird and Animal Composition', and he was able to use his feel for designed objects in drawing some decorative adverts for a furniture firm, Herbert E Wheeler at 55 Victoria Street.

Spare was still in touch with John Lane and wrote to suggest a new art journal, as a successor to *The Yellow Book*. Lane agreed, and Spare was appointed as editor of *Form* along with Frederick Carter, who used the pseudonym Francis Marsden. Carter was a talented etcher from Bradford who combined an interest in the supernatural with a rejection of what he thought of as "bourgeois" art forms such as conventional theatre. Instead he explored idiosyncratic fields such as the *commedia dell'arte*, often given a macabre twist. In a 1916 catalogue of his work he defined his subjects, in addition to the *commedia*, as fairytale images, giants, enchanters, witches, strange seas, fantastic gods, gondolas on dark Venetian canals with secret meetings, romantic triumphs and disappointments, wild moons, castles and Rosicrucian sects, passwords and searchers of the Kabala.

Altogether Carter should have been a good colleague for Spare. His biographer, Richard Grenville Clark, connects his work to the Edwardian fascination with "automatic writing, hysteria, dowsing rods, poltergeists, extra sensory perception, multiple personality and other areas of psychical research. Spiritualist, esoteric and occult alternatives to religion were actively pursued. Clearly, science was not regarded as the sole means to

achieve human happiness and Carter's etchings drew successfully on these contemporary interests." Clark quotes Samuel Hynes on the art of the time as showing elements of "religious instincts detached from the forms and dogma of established religion... a debased or sentimentalised supernaturalism."

Carter joined an esoteric Christian group called The Order of the Corporate Reunion, later leaving it behind him for a developing interest in Freud and Jung, along with hermeticism and Neo-Platonism. He knew a wide range of people including Crowley, Yeats, Arthur Machen, Edmund J Sullivan, James Guthrie, Raffalovich and DH Lawrence. Lawrence wrote an introduction for Carter's *Dragon of the Apocalypse*, and Arthur Machen wrote one for his *Dragon of the Alchemists*. Carter later tried to make some overall sense of his esoteric interests in an unpublished memoir, 'Tower and Chapel or Zeitgeist and Anima Mundi: Symbol and Spell'.

It has been suggested that Spare was inspired in *The Book of Pleasure* by his love for Eily and this may be true, although it seems a surprising book to result, with its peculiar personal asides such as "May the idea of God perish and with it women; have they not both made me appear clownish?"

Spare and Eily were still together, and had now moved to the ground floor flat at 298 Kennington Park Road, a handsome address very suitable for the editing of *Form*, with a Regency-style bow front, a pillared portico over the door, and decorative plaster ceilings. Spare and Carter managed to get the first issue of *Form* out in the summer of 1916. It was strikingly designed, with an unusual high rectangular format, and contributors included Walter de la Mare, Frank Brangwyn, WH Davies, JC Squire, Ricketts and Shannon, and even WB Yeats, but two contributions now stand out: EJ Sullivan's large feature on 'The Grotesque', and Spare and Carter on 'Automatic Drawing'.

"The study of the Grotesque in Art is bound up with the study of Demonology, and so indirectly of Theology," argued Sullivan,

whose graphic work had been such a major influence on the younger Spare. He proceeded to consider the grotesque in various guises such as the animal kingdom ("it is hard to imagine the planning of the mandrill, except by a malignant fiend"), "savage races, among whom demonology develops earlier apparently than theology," and medicine, from which he cited elephantiasis, a man with two penises and a baby with two faces.

Artistically Sullivan was something of a specialist in the grotesque, but in his article he took a rather condemnatory stance, arguing that while conventional beauty is good, the grotesque is evil. It is a banal polarity, and Spare's thinking on the grotesque would go far beyond it.

Carter had already published a piece on automatic writing in 1914. Now, writing on automatism in *Form*, Spare and Carter restated some of the ideas which had been in *The Book of Pleasure*, arguing that the unconscious would shine through if only the artist could clear his mind of inessentials, permitting "through a clear and transparent medium, without prepossessions [i.e. preconceptions] of any kind the most definite and simple forms and ideas to attain expression." Starting with a scribble, the germ of an idea might appear, and then be "selected and trained" by the artist so that the "profoundest depths of memory" were drawn upon, "and the springs of instinct tapped," capturing "obsessions":

> *Automatism being the manifestation of latent desires (or wishes) the significance of the forms (the ideas) obtained represent the previously unrecorded obsessions.*

Instead of recording the outer world,

> *Art becomes, by this illuminism or ecstatic power, a functional activity expressing in a symbolical language the desire towards joy unmodified – the sense of the Mother of all things – not of experience.*

Spare and Carter knew they had precursors in religion and mysticism ("Renounce thine own will that the law of God may be within

thee") and in the work of Leonardo da Vinci, whom they quote on a "a new method of assisting the invention" and "opening the mind" (which moves from automatism proper into what Salvador Dalí would explore as the "paranoiac-critical method"):

> *if you look at some old wall covered with dirt, or the odd*
> *appearance of some streaked stones, you may discover several*
> *things like landscapes, battles, clouds, uncommon attitudes,*
> *draperies, etc. Out of this confused mass of objects the mind*
> *will be furnished with abundance of designs and subjects,*
> *perfectly new.*

Spare's strong identification of himself with strictly automatic methods – living up to his father's early observation that he drew "in a trance" – seems to make him a precursor of the Surrealists, and this angle was later exploited in Thirties newspaper articles about him.

The early Surrealists also identified themselves with automatism, to the extent that André Breton could write in the *First Surrealist Manifesto* (1924) that "Surrealism" was simply a noun that meant

> *pure psychic automatism by which is intended to express...*
> *the true function of thought. Thought dictated in the absence*
> *of the control exerted by reason, and outside all aesthetic or*
> *moral preoccupations... Surrealism is based on the belief in*
> *the superior reality of certain forms of association heretofore*
> *neglected, in the omnipotence of the dream.*

The earliest surrealist experiments with automatism were verbal and literary rather than graphic and they date to around 1919, giving rise to the publication of *The Magnetic Fields* in 1920. When Spare discusses automatic drawing in the *Book of Pleasure* he claims to have experimented with it as far back as 1901, and even with *Form* in 1916, and the *Book of Pleasure* in 1913, the dates do make him look like a precursor of surrealism.

It is not so simple. What makes it more complicated is Spare's rootedness in an alternative and longer tradition springing from

Spiritualism and the early explorers of "subconsciousness." A Mrs Alaric Watts, for example, was producing so-called "automatic" drawings in the 1870s, and *The Occult Review* published a substantial article on 'Automatic Drawing' in 1910. "Here I must leave the subject with my readers," it ended, asking whether it was "Menthes" (a spirit) "or the subconscious self?"

Automatic writing had been popular since WT Stead had published his spiritualistic *Letters from Julia* ("received by automatic writing") in 1898, and William James had instructed Gertrude Stein in automatic writing (without the spirits) in 1903. It makes WB Yeats and his wife Georgie Hyde-Lees seem almost belated when they started receiving automatic messages through Georgie in 1917, although they were still earlier than the Surrealists.

Spare's spiritualistic background – entailing his view of practical genius as an "obsession" to be harnessed or ridden like a wave – shows through the wording of his piece on Automatic Drawing. The odd word "prepossessions" ("without prepossessions of any kind") suggests pre-conceptions as prior possessions. Instead the mind should be clear, without already being possessed: it should be, as he puts it, a transparent *medium*.

The *Times Literary Supplement* reviewer of *Form* was not over-interested in automatism, and more interested in making a connection between Spare and Beardsley: "Mr John Lane gave us the *Yellow Book* and Aubrey Beardsley; Mr John Lane now gives us *Form*, with Mr Austin Osman Spare."

After praising the poetry in the issue and noting a few artworks, such as "a noble lithograph by Mr Charles Ricketts", he was nevertheless in no doubt that "Mr Austin Osman Spare is clearly the kernel of the thing, for Mr Frederick Carter's clever drawings and even the powerful work of Mr Herbert Cole are, as it were, but runners-up for Mr Spare. Perhaps, too, Mr EJ Sullivan is little more, on this occasion, than Mr Spare's prophet."

Noting that Sullivan's essay on the grotesque was fascinatingly horrible, and that the gist of it seemed to be that evil and loveliness could

enhance each other by contrast, the reviewer found this to be his lead-in
to Spare:

> *And Mr Spare... is here to show us the evil enhancing the*
> *lovely. Together, Mr Spare and Mr Carter tell us something*
> *about "Automatic Drawing" in which the mind and body are*
> *at rest, and the subconscious guides the apparently aimless*
> *pencil. Out of the results, we do not doubt, come some of the*
> *most loathsome of Mr Spare's creations. Loathsome they are.*
> *The mandrill, elephantiasis, and the other pleasant things of*
> *which Mr Sullivan tells us are sweet compared to some of Mr*
> *Spare's grotesques, and then, in two drawings, Holocaust and*
> *Bacchae, and one lithograph, Nemesis, Mr Spare goes straight*
> *to the lovely, and gives us the lovely to our heart's desire.*[1]

"There is little question of his great ability," said the reviewer, but "Whither
these theories and practices of his are going to lead him and art is
another matter."

Overall it seems *Form* was not well liked by the critics or public, and in due
course a waggish letter arrived from George Bernard Shaw. His wife had
been going through his papers, he said, and she had found three copies of
Form, two of which he was returning.

"*Form* is a very horrible publication," said Shaw. This was not
because of its grotesques but because of Shaw's "ancient Morrisian" – i.e.
William Morris-style – views on book design. His main complaint was
that the vertical format and space were not being put to any good use
(with compositions failing to fill the space, or alternatively being cut off by

1. 'Nemesis' features a female figure and a skull; 'Bacchae' a standing woman in
a style that looks forward to Spare's next book, *The Focus of Life*; and 'Holocaust'
a crucified man between two crucified women, with several faces below them
including what looks like a pre-Columbian mask. It was in the collection of Thomas
Lumsden and sold at Christie's South Kensington, *Twentieth Century British Art*,
26th July 2001, lot 48, where it was titled 'Crucifixion.'

the edge) and the worst offender was Spare himself: "you have produced sections of wall paper or bill poster that make one ask where on earth the other squares are." Moreover, "You have not written on your studio wall 'The design of Michelangelo and the colouring of Titian': rather, I should imagine, 'The drawing of James Barry and imagination of David Scott', a strange and melancholy aspiration these days" (and today obscure even as an insult).[2]

After lecturing Spare on composition and framing ("Did they never teach you that the frame is the most important part of the picture...?") Shaw gave him an avuncular ticking-off for artiness: "Be sober, honest, industrious and clean; cut your hair; eschew velveteen jackets and silk blouses, [and] knock down any man who calls you an artist." Then he struck a more peculiar note: whereas the man "who makes revelations and interpretations for other people is quite a useful person", Spare had to remember that "the man who draws to please himself is a wretched – well, what do you call a man who makes love to himself? – "

It sounds as if Shaw was thinking of the masturbatory subtext, or at least the subtitle, of *The Book of Pleasure (Self-Love)*.

Any annoyance that Shaw's vaguely insulting letter might have given Spare must have paled beside the troubles he had with WB Yeats. Spare's extended circle of acquaintance seems to have included an introduction to the great aesthetes Charles Ricketts and Charles Shannon ("Ricketts and Shannon"), who were widely respected as arbiters of taste: they founded the highly influential periodical *The Dial*, designed almost all of Wilde's books, and Ricketts was offered the Directorship of the National Gallery, which he declined. It seems to have been through Ricketts (who at one stage admired Spare and described him to Yeats as "a clever draughtsman") that Yeats donated eight poems to *Form*, an action he came to regret.

2. James Barry (1741-1806); David Scott (1806-1849). Both history painters in the would-be grand manner.

The first problem was that *Form* was running late, and Yeats needed to have his poems published in Britain before they were published in America, in order to secure his copyright. To overcome this, the poems were printed ahead of *Form* in a pamphlet, *Eight Poems by WB Yeats* (dated January 1916, *Form* in turn being dated April, although it wasn't ready until June).

The second problem was that Yeats loathed the design of the poems, reproduced in hand-written calligraphy by a man named Edward Pay and ornamented with a female nude by Spare. "I think this picture vulgar," Yeats wrote in one copy, and in another "I don't like the work. The red woman is a brute."

Spare's work may already have been dating and démodé (it has strong links with Art Nouveau, for example, a style which the architect Edwin Lutyens by now felt had become "common") and Yeats wrote inside a copy belonging to Lady Gregory "I am not responsible for this pretentious publication", while in yet another copy he wrote

> *I am not responsible for this foolish picture or anything else in this book but the writing. A foolish or intrepid young man got them to publish [this] pamphlet of poems to secure the copyright for me as his magazine was postponed and my poems were coming out in America.*

Spare was already short of money, which bears on the next turn of the story. Yeats wanted only a few copies bound to secure so-called "technical publication" and he tried to stop Spare publishing more. "A man," he wrote to Lady Gregory,

> *has issued, by mistake he says, by design I suspect, a pirated edition of some of my recent poems. He had proposed to make technical publication as his magazine* Form *was delayed and the poems were coming out in America. I got in a rage and limited him to fifty copies. He wrote this would ruin him and that he had not enough to eat.*

Ricketts then interceded, offering to make good any loss that Spare suffered. As he wrote to a friend, "I know next to nothing about *Form* to which I have merely promised to subscribe and contribute: I gather that they are short of cash and propose a sort of *Dial*, which was run on 'from hand-to-mouth' principles by a small clique." He then added "Spare never turned up, and I rather fear he may be ill again. He is a queer youngster, but he has talent."

Rather than let Ricketts lose money, Yeats relented and reluctantly allowed Spare to print two hundred copies. It looks as if he managed to print more. Ricketts seems to have grown tired of Spare, and his references to *Form* change from "a sort of *Dial*" to "poor Spare's beastly paper".

Yeats was far from the only person not to like Spare's work. In a 1918 letter which touches on mysticism and the current vogue for automatism, the composer Peter Warlock (Philip Heseltine), whose own magical interests might have made him sympathetic to Spare, writes that mysticism in art is a two-edged sword: "in proportion as it enables the good artist to attain to greater conceptions than he would otherwise be capable of, even so does it cause the inferior man to make a far, far bigger fool of himself than he would be able to do by any other method." But mysticism is not entirely to blame:

> *Do you imagine that Austin Spare is a bad artist because he stupefies himself with drugs, drink, or women – or mysticism? This is verily Post-hoc etc. We have two propositions: – Austin Spare is a bad artist. Austin Spare stupefies himself. Neither proposition is the cause of the other: both spring from the central fact that: – Spare is Spare – which would not be so without the bad art or the stupefaction.*

One of the figures around *Form* was JC Squire (later knighted), for whom Spare illustrated a couple of books of poetry. Very influential in his day,

Squire was the literary editor of the *New Statesman* at the time he knew Spare. He was an old-style man of letters and famously middlebrow, "associated with everything that an intellectual of the day was liable to wince at most – cricketing week-ends, foaming tankards, Sussex-by-the-sea, pale green pastorals, thigh-slapping joviality." His parodies have lasted better than anything else, like his take on Gray's *Elegy in a Country Churchyard*:

> *Full many a vice is born to thrive unseen*
> *Full many a crime the world does not discuss,*
> *Full many a pervert lives to reach a green*
> *Replete old age, and so it was with us.*

Spare illustrated and decorated Squire's 1916 *Twelve Poems*, and Squire seems to have liked it well enough to ask him to do his 1917 *The Gold Tree*. Spare has recently been accused of plagiarism with these initial letters, mostly of mediaeval and Renaissance letters, but they are so obviously not the original work of an early twentieth-century artist that it seems clear Spare thought he was borrowing them as a designer.

Allegations of unoriginality always dogged Spare, along with inflated comparisons: he supposedly started out "aping Beardsley" and imitating Ricketts; then he was said to draw like Leonardo, Dürer, Michelangelo, Blake, Rembrandt and the rest. In reality styles and influences were among the spirits that possessed him, just as they possess everyone. There is something intensely Nineties about some of his early work and its concern with sin and hypocrisy, something very Thirties about his Deco stylizations, and even something Fifties about his "original flying saucers", his jokey name for painting on plates.

It is all oddly in tune with William James's observations on spirit mediums and the Zeitgeist. The curious thing about trance utterances, said James, was how similar they were in different individuals. It was either a lot of phoney 'Red Indian' stuff or, if it had higher intellectual pretensions, it tended to vague and optimistic "philosophy and-water, in which phrases about spirit, harmony, beauty, law, progression, development, etc., keep recurring…"

Whether all subconscious selves are peculiarly susceptible to a
certain stratum of the Zeitgeist and get their inspiration from
it, I know not...

Spare and Squire, along with Frederick Carter and a man named Synett, even seem to have planned a journal featuring lettering and design, advertised as *Typographia*. It never appeared. *Form* itself managed a second issue (far from being quarterly it appeared a year later, in April 1917), which had less of Spare in it.

 Form was a trial to all concerned. Correspondence survives between Spare and Frederick Carter detailing the various negotiations and disagreements leading to the resignation of both Carter and James Guthrie, who had also been involved.[3] Finding an old piece of *Form* letterheaded paper, years later, James Guthrie wrote to Pickford Waller's daughter Sybil "This bit of paper recalls Spare, a hopeless man to work with. You may remember him? Clever in a nasty way, rough without any principle..."

 Someone else who knew Spare at this time, a neighbour named Benjamin Clemens, remembered him quite differently, noting his kindness to other people and to animals: "His goodness and practical sympathy was shown not only in times of stress, but also in quieter days." As *Form* was slowly foundering, Spare was planning another spin-off publication, illustrated by Spare and Frank Brangwyn. Surprisingly, given Spare's image as a Satanic occultist,[4] this was *The Little Flowers of St. Francis*, a book about St. Francis of Assisi. As Spare told a friend, "He's the saint I like best."

3.　Thirty four letters from Spare, item no. 152 in Roy Davids Ltd. *Catalogue IV: The Artist as Portrait* (2000).

4.　"Another English satanic occultist is Austin Osman Spare, who wrote *The Book of Pleasure (Self-Love)*, *The Psychology of Ecstasy* (London, published by the author, 1913), with curious symbolic illustrations." Mario Praz, *The Romantic Agony* (Oxford University Press, 1933) n.59 p.396.

The First World War was now heavily under way, but Spare had no interest in killing Germans, and he would hardly have wanted his own genius snuffed out in its prime either.

Early enthusiasm for the War had died after the long attrition of the Somme. Conscription had been introduced, and the casualty rate was such that while the early recruits had needed to be tall, Bantam regiments had now been formed for men under five feet. The Military Service Act (Conscription) of January 1916 called for all unmarried men between the ages of eighteen and forty-one, but fortunately Spare was married. A few months later the Military Service Act II came in, and this covered married men as well.

Spare still had a couple of chances: he was hoping John Lane could get him on to the Reserved Occupation list, and he thought flat feet would keep him out (whether he really had flat feet is unclear). Meanwhile the net was tightening: the Military Service Act III re-examined men previously rejected on health and fitness grounds, and shrank the list of Reserved Occupations. On 16th May 1917 – just after managing to get the second issue of *Form* out – Spare was conscripted into the Royal Army Medical Corps.

People are sometimes said to have had "a good war". Spare didn't have a very good war but he certainly had an interesting one, at least by his own account. A posting to Egypt allowed him to study Egyptian hieroglyphics at first hand; back on the Western Front he spent all night under a pile of corpses in No-Man's Land; and when he was on a troopship bound for Africa and a torpedo struck, he remained calmly on the deck while everyone else jumped overboard at the cry of "Abandon Ship!" (as an older man he still dreamed about being the only survivor).

Spare's friend Frank Letchford, who seems to have been a rather loveable individual, later remembered "the small occasional white lies I noticed in Austin's company."

In fact Spare didn't get as far as Egypt, although he did get to Blackpool. Private Spare, 117935, was sent to the Blackpool Depot of the RAMC, and hated it. He disliked discipline and Church Parade, he

was reprimanded for scruffiness, and he hated having a portion of his pay swindled out of him by NCOs for the so-called "sports fund", which he made a complaint about. In his leisure moments he would take a rowing boat out to sea until he could look back at the town, which he said offered a view as fine as Naples.

Spare seems to have become a medical orderly, inoculating troops against tetanus before they were posted abroad; he later recalled that when one fainted before an injection, the rest fell down like a row of dominoes. It has also been suggested that he worked in the fledgling Camouflage Section, headed by Colonel Solomon Solomon. This sounds plausible, since someone might have noticed his artistic background and decided to make use of it, but there seems to be no evidence that it is true.

It is true that Spare was posted back to London towards the end of 1918, and based at the King George's Hospital Barracks, Stamford Street. His artistic talents were noticed at the end of the war, and he was put to work (now with the specialist's rank of Acting Staff-Sergeant) with a dozen or so other artists in a studio at 76 Fulham Road under a Lieutenant-Colonel Brereton, illustrating a historical record of the conflict.

The war wrecked what was left of Spare's marriage to Eily. Austin and Eily were never formally divorced, which was expensive and uncommon in those days, but Eily met a Mr Chignell and took up with him. Spare still hoped that they might patch things up, and in 1920 he heard that she was working at the Strand Palace Hotel and rushed to see her, but there was no reconciliation. They nevertheless remained on amicable terms, and exchanged Christmas cards.

Always prone to nervous strain and mystery ailments, Spare was for a while devastated by the marriage break-up and found it difficult to work. With the flat at Kennington Park Road gone, he also needed somewhere to live; there is a story of him hiding a bed in his studio, where he was only supposed to be working in the daytime. At the end of the war he was living in "a miserable room" at 8 Gilbert Place, near the British Museum.

Spare made new friends among the artists he worked with in the army, notably Walter Spradbery and Haydn Mackey; the latter would

eventually write his *Times* obituary. Working together in the studio, they would use each other as models for wounded soldiers, posing in bandages. Around this time he also met the artists John Austen and Alan Odle, with whom he would collaborate on group shows in the Twenties.

Spare's work on the medical history of the War finally took him to the continent, after the war had ended, from 13th May to 6th June 1919. His pictures from this period are now in the Imperial War Museum, and include subjects such as *Stretcher Bearer Rescuing the Wounded*, *Air Raid*, *The Receiving Tent in a Dressing Station*, *Motor Ambulances at Ypres*, *Dressing the Wounded During a Gas Attack*, *Air Raid in a Dressing Station* and *Wimereux Cemetery*.

Based in straightforward illustration – in some ways not unlike the artwork that once filled children's weekly educational papers, as late as the Sixties and Seventies – Spare's works bring a heightened drama and a sense of macabre detail. The war scenes sometimes include creeping mist, smoke or gas, with an uncanny air about it, while their humanity looks forward to his cockney portraits of the Thirties.

It may have been retrospective, but it is likely that Spare found his war work harrowing. Even years later his pictures would often include distinctively skeletal trees, like the bare blasted trees of the Western Front. Writing of his war art, Frank Letchford goes as far as to suggest

> *To my mind these pictures represent the death of his own soul. It is a possibility that such a traumatic experience within the imaginative mind can affect sex-life to such an extent as to force a man to live inwardly and to practice celibacy thereafter.*

Spare's last major project was a series of pictures for the Women's Work Committee and the Women's Hospital Corps. Commissions included portraits of some of the more senior women involved, such as Dame Rachel Crowdy, Dame Maud McCarthy, and Miss Sidney Browne; more work of the sort he had done in France such as 'Inside a hospital train, showing wounded'; and most notably 'Operating Theatre, Endell Street, London', a picture he came to regret ever doing.

Portrait work had been an early ambition, but Spare had developed misgivings about it, and these must have been reinforced by the reception of his first commissions: Sidney Browne's picture was well-received, but Rachel Crowdy disliked hers intensely, and as he worked on Maud McCarthy he was told "We are most anxious that this should be as completed a piece of work as your charming study of Miss Sidney Browne."

This was nothing compared to the trials that attended his pastel picture of women working at the Endell Street Military Hospital in Covent Garden. This featured seven women carrying out an operation, and was apparently drawn from life. Spare's close attention to the drapery of their smocks and headscarves gives the picture a certain Pre-Raphaelite doominess, but this was not the problem.

After it was shown at the Royal Academy in a December 1919 exhibition, *The Nation's War Paintings and other Records*, Flora Murray, the senior doctor at Endell Street, wrote to Colonel Brereton requesting that it should be destroyed. Since this had no result, she wrote again to Lady Norman, responsible for the women's section of the Imperial War Museum, to say it was

> *a misrepresentation of the work of professional women. It is full of errors which, though they may not strike the lay person, make it an object of ridicule to all those who have some professional knowledge... We would rather have no record of our work than false record; and Dr Garrett Anderson and I must earnestly ask you to do all you can to have this picture destroyed... The credit of women surgeons is at stake.*

The objection was to the presence of a couch, sterilising drums, a discarded splint, and a nurse kneeling at her work. Lady Norman in turn wrote to Spare, asking him to alter the picture before the *Great Victory Exhibition* at Crystal Palace or not have it exhibited:

> *... Dr Flora Murray and Dr Garrett Anderson... would prefer not to have the picture shown at all than as it is at*

> *present, which they say makes their work look ludicrous to the*
> *technical mind.*
> *[...] What we would ask you to do would be to cut the floor off*
> *the picture so as to remove the various things so out of place in*
> *an operating room...*
>
> *There is so much good work in the heads that I should very*
> *much regret not being able to show your picture which I still*
> *think is your best piece of work.*

Spare was furious: he was "astonished," he said, and "had fondly imagined that what good there might be in the picture was not confined to the heads... I *cannot* consent to the mutilation of my picture."

There was ample opportunity for Dr Flora Murray or Dr Garrett Anderson to offer suggestion or criticisms while the work was in process, he said, "which I should have been only too glad to receive, providing always, that my conception as an artist was not infringed thereby: – but I wish to state very clearly that I actually saw at Endell Street *everything* I have put into my picture."

Spare's defence includes a characteristic dig at Modernism, when he answers the charge that the picture might be ludicrous to the technical mind:

> *Doubtless many soldiers will feel that their work in the Great*
> *War has been made to appear 'ludicrous' by certain modern*
> *artists; but that is no valid reason for banning such works from*
> *the honourable positions they will eventually receive in the*
> *Imperial War Museum.*

A surprisingly sympathetic recent study of the affair in the *Burlington Magazine* considers the evidence and sides largely with Spare ("it is unlikely that Spare would have invented the presence of sterilising drums") but the stakes were high for the medics who, as women, had battled to have their work taken seriously in the First War, and they prevailed.

We know what the picture looked like because a member of the public, seeing it at the Royal Academy, was impressed enough to request a photograph, but the original picture has since disappeared.

Years later Spare denigrated his war work ("I am hoping that all my work is dead and buried *as there is nothing worth seeing...*") and his experience continued to rankle: Letchford remembered "He became disillusioned... with the Generals, the Church and Society women holding high rank in the Women's Forces, Red Cross etc." But for now he was back in civilian life, and returning to the struggle for artistic recognition.

Ten: A Swine with Swine

Talking about the break-up of his marriage, Spare had a story that he'd been in bed with a model one day, at Kennington Park Road, when the servant girl opened the door and unexpectedly let a friend of his wife in. A variant says it was Eily herself, or that he was in bed at the house of the girl, who was a friend of Eily's, when the servant let Eily in. It sounds like a scene from a farce.

Whatever happened, by 1920 he was thirty-four, separated from his wife, and he had no adequate home, studio or full-time employment. He writes from his wretched room in Gilbert Place to Pickford Waller, thanking him for a cheque: "It means great things to me... I assure you I shall not have a kipper for dinner today!"

Creatively Spare was at the height of his powers, and in 1919 he drew a magnificent picture inscribed "The negation of unity is wisdom". Given Spare's taste for the profound, not to mention the obscurity of his syntax, it might be tempting to interpret this as an ambiguous philosophical statement, but it is probably just about the splitting of his marriage. Other inscriptions on the same drawing, perhaps suggesting confusion or mental distress, are "Write to parents for £5... pawn watch" and

They are all gone out of this
and away, they are altogether become unprofitable:
there is none that please, no, not one

and I cried
for the body
of an aged
woman

Drawn in Spare's finest pencil (and illustrated overleaf), with a nod to Albrecht Dürer, it features a tired-looking nude woman, probably Eily, at the base of the picture; a new girl's face – somewhat boss-eyed but superbly realised – ascendant at the top of the picture; and a sketchier but perhaps more crazed and lascivious-looking female face to the mid-left. On the right is a less distinct ascending column of bodies, faces, snakes, bauble-like forms, and skulls.

The ascendant girl also seems to figure in 'Spiritual Study' of 1920,[1] reworked over a 1914 picture from the *Book of Pleasure*, and in another picture from 1920 mysteriously inscribed "Freda Spare".[2] Spare had no sister called Freda, and it seems unlikely this girl is a cousin; instead, it is possible that he thought or dreamed of his model Freda as the new Mrs Spare.

Freda seems to figure in his 1921 book *The Focus of Life*, which he had been working on for several years; it has numerous female nudes, but none of them is Eily. Published by the highly respected Morland Press in Ebury Street, and edited and introduced by Frederick Carter, *The Focus of Life* contains some of Spare's finest drawing, accompanying a heartfelt and tortuous text that seems to take up where *The Book of Pleasure* left off.

It is well sprinkled with words and phrases such as "thou," "verily," and "oft times"; an archaic style that was known in its day as "Wardour Street English", after the Soho street then associated with reproduction antique furniture (the writings of Crowley are similar in this respect, making twentieth-century occultism seem like a sort of nature reserve for words that no longer flourish in the wild). The central vision is once again a mystic plenitude, this time involving the "New Sexuality". Pansexual but perhaps celibate, this seems to be an ecstatic sexualized relation that embraces both the self and the whole of life, but at the same time avoids the tribulations and limitations of an ordinary sexual relationship with another person, which in Spare's view would be "a partial sexuality entangled in the morass of sensual law."

"The degenerate need women," says Spare, "dispense with that part of thyself." Romantic desire involves a frustrating separateness:

1. Christie's South Kensington, 12th May 1994, lot 23 [see page 93 above].
2. Christie's South Kensington 3rd August 1988, lot 138, catalogued as 'Portrait of Freda Spare'.

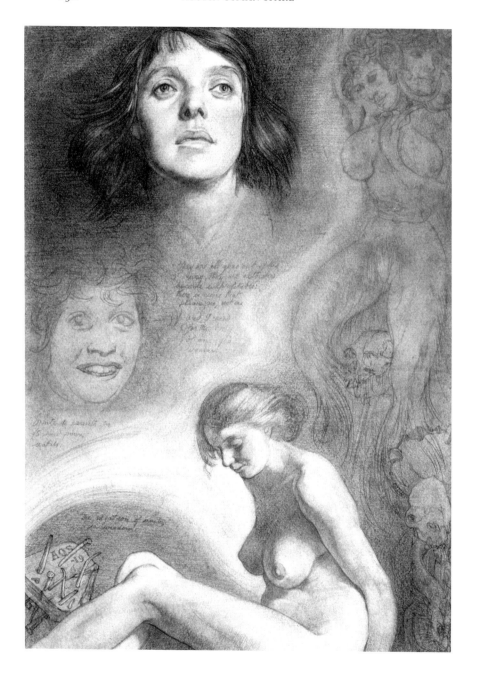

Desire is the conception I and induces Thou.
There is neither thou nor I nor a third person – loosing this
consciousness by unity of I and Self; there would be no limit to
consciousness in sexuality.
Isolation in ecstasy, the final inducement, is enough...

So, preferring an unlimited ideal over a limited real, it combines narcissistic self-pleasure with a sense of oceanic oneness. It also bypasses the ordinarily sexual, despite Spare's quasi-mystical sense that *everything* is sexual ("There is only one sense – the sexual") in a kind of oceanic sexuality, "becoming one with all sensation".

Verily a new sexuality shall be mine, – unnecessary to degenerate
or surpass.
To give it a name, I call it the Unmodified sexuality; without
a name it shall be conscious of all desire; thus no ecstasy shall
escape me.

It was a kind of 'negative capability' (to borrow Keats's phrase for Shakespeare's apparent ability to become anyone, in his work) and back in *The Book of Pleasure* Spare relates "a secret of great import", known even in his childhood: "by sedulously striving for a vacuity of belief, one is cosmic enough to dwell in the innermost of others and enjoy them." Empathetic but vicarious, it was a way of having all the sex in the world while not necessarily having any.

It bears some comparison to the having-by-not-having of St. Augustine, which has been cited in relation to the masturbatory sexuality of Salvador Dalí ("in the zone of the imaginary presence of the other... Dalí explores the mystical paradox... of having by not having, in sexual terms"). A little later there was a peculiar coda to *The Focus of Life*, offering further insight into it, in the form of an unpublished and very private album of erotic drawings.[3]

The published book, meanwhile, is dedicated to an L.C.O'C.S, who has never been identified. Spare's friends suggested it might stand for something like London General Omnibus Company, but he never gave

3. Chapter XII.

the secret away. L.C.O'C.S also figures in the text ("O, L.C.O'C.S!! thou insatiable thirst of my self-love, with none but thee will I procreate!"). Frank Letchford has suggested that it is "a lady friend who married a patron," but this hint of private information is dispelled when he later wonders if it might have been a "young man." The initials suggest an Irish name such as O'Connor Sullivan or similar, and there was no shortage of Celts in London's occult and artistic circles. Spare had also been unhappily in love with Connie Smith, now the first wife – they were to split in the early Twenties – of sculptor Charles Sergeant Jagger, and her name is highly suggestive of the last two letters. It is nevertheless just possible that it might not be a person at all, and instead a private acronym ending in Self or Spare.

With slightly creaky Freudian-style symbolism, Spare tells us that Aaos [sic], protagonist of *The Focus of Life*, found that "Frequently, fragments of dreams haunted him for many a day, but *they* were of his marriage bed. After his divorce he slept alone with his sword."

Two dreams of particular interest are recorded. Walking from a tavern, he finds himself looking into a well-lit undertaker's shop at night, when a group of drunken undertakers drag him in and set upon him: "that drunken fight among the dead and funeral furniture was hopeless for me. I was robbed, stripped, spat upon, kicked and bound – what abuse did I not suffer?"

> *And I was told they had recently finished making my wife's coffin. They then forced me to view her dead body. Even in my pitiable state, I thought of the beauty of her corpse. Again, they reviled me because of her: she who, if I had not neglected her, would still be living. I, the whoremonger, betrayer of women, and arch-abnormalist. After much other insult; they told me – my fate. I was given the choice of being burnt to death or buried alive with her! Naturally my choice was to be alone. But no such chance was to be mine. I was buried alive with her corpse.*

The other dream is about map-making, after exploring an unknown country: "He was surprised how fresh was his memory, at the ease with which his hand drew the mountains and contours of that unknown country. His dexterity became too pleasing and threatened an event long ceased and then forgotten" – in other words, a wet dream. "Then he spoke to himself thus:"

> ...*Verily, to be alone and map drawing is now an unsafe art! Sleep? – This sexual excitement still obtains. Procreation is with more things than women. The function of the sexuality is not entirely procreation: stranger experiences are promised than ever imagination conceived!*

The dreaming Spare, in other words, found the graphic activity of drawing exciting in its own right.

Frederick Carter almost signed his own name to the introduction of *The Focus of Life*, but whether it was the sentiments ("For I love thee, O Self! For I love thee, O mine I!") or the writing ("O truth, where is thy mispronunciation?") or the drawings, or simply because he and Spare had fallen out over *Form*, he decided at the very last moment that he no longer wanted his name on it, and it appeared under his old pseudonym "Francis Marsden." Copies survive with pasted labels showing the last-minute switch.

The Imagist poet TE Hulme had written in 1912 that "Life" had become the new buzz word: "all the best people take off their hats and lower their voices when they speak of Life", while in *The Edwardian Temperament 1895-1919* Jonathan Rose notes "a monotonous Edwardian obsession" with this "Life," seen as a kind of vitalism. In that sense *The Focus of Life* was in harmony with its period.

It was well received, less for the text than the pictures. These figure naked women, largely in swirling mist but occasionally in landscapes with animals: the stylistically related work that Spare was doing around

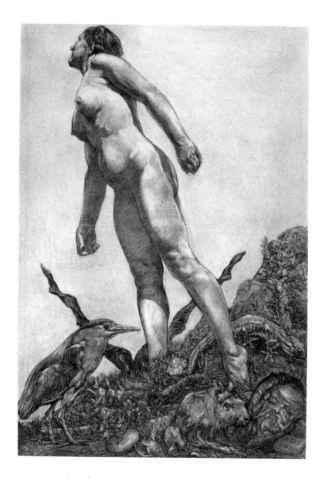

the same time also figures an exquisitely teeming organic world, with a coral reef-like density of closely packed detail. Spare was to a great extent a Symbolist, and these works are heavily infused with that turn-of-the-century sense of "Life" and less concerned with GF Watts-style moral allegories. This strand of Spare is more like those Continental works of a few years earlier where, typically, an Austrian artist might paint a meadow or mountainscape featuring an aardvark and a nude woman.

Symbolist rat – a typing error that deserves to stay – was well-suited to Spare's fascination with evolution. "The soul," he wrote, "is the ancestral animals." Some of the recurrent animals in Spare's pictures probably have

a totemic significance, notably the rat or perhaps large shrew on the table before him in the 1911 self portrait that he gave to Eily, and the marmot-like creature in his 1924 *Self Portrait with Rodent*.[4] Spare's eccentric Darwinism gives a new depth of meaning to the idea of totem animals, familiar in tribal life and beautifully described by the anthropologist Levi-Strauss: "Some animals are good to eat," he writes, while others – like the bat, the mole and the toad, perhaps – "are good to think."

Related to Pre-Raphaelitism and Art Nouveau, Symbolism had its epicentre in the Europe of the Nineties – with artists such as Gauguin, Munch, Max Klinger, Fernand Khnopff, Odilon Redon and Ferdinand Hodler – so Spare's Symbolism left him doubly isolated, belated in time and cut off in place. Combined with a certain misogyny in his writing, the idealisation of the female in his art and thinking is also very much of a piece with Symbolism. The clean and strapping women of *The Focus of Life*, such as Tzula the Huntress or The Primogenial, seem to fulfil the promised resurrection of the "Primitive Woman" in *Earth: Inferno*, which accompanied its erotically mystic-sounding observation that "with her" – this time the "all-prevailing woman" – "I strayed into the path direct."

Spare loved the flesh, perfect and imperfect, and among the idealised nudes there are other women who are more realistically naked. This was a lifelong tendency, increasing as he grew older and started to use elderly local women for models, and it must have contributed to the reputation he developed as an indecently erotic artist. His friend Dennis Bardens remarks that "His nudes were sometimes idyllic, sometimes earthy," and remembered giving one of the latter to a recently married friend:

> *I remarked on a visit to him that I saw the picture, a splendid one, nowhere displayed. His wife, it seems, had objected to it, saying it was 'too nude'. It was therefore relegated to the basement, where someone of better judgement stole it.*

4. Christie's South Kensington, 12th May 1994 lot 76, reproduced as a tipped-in frontispiece to *The Book of Ugly Ecstasy* (Fulgur, 1996). Something very like this creature is already in the 1906 *Arcana of AOS*.

Frank Letchford remembered Spare telling him that at one of his exhibitions he left a sketch-book of erotic drawings on a small table in a side room, "which he entered, only to find a couple playing with each other – he was shocked." Shocked, or perhaps gratified.

Encouraged by the good reception of *Focus*, Spare wrote to John Lane offering to revive *Form*. Lane agreed, and the new, smaller format *Form* launched its first issue in October 1921, edited by Spare and his friend WH Davies, the poet and author of the best-selling *Autobiography of a Supertramp*. Davies lived in Great Russell Street while Spare was living in Gilbert Place, which may be how they knew each other. Some years older than Spare, Davies had been in trouble with the law when young and lived the hard life of a genuine tramp, losing a leg while jumping a train in America. He wrote poems from the rustic-sounding 'Farmhouse' – in fact a doss-house in Southwark – and sent some to George Bernard Shaw, who championed his work. It was Shaw, author of *Man and Superman*, who suggested the *über*-tramping title of Davies's autobiography.

They must have made a strange double-act, Spare the hulking cockney and Davies the one-legged, five-foot tall Welshman, united by their lack of formal education. One of the most obvious things to be said about *The Book of Pleasure* is that it is an extraordinary feat for a young man who left school at thirteen, and so it is; but at the same time, it is the sort of book only a man with no schooling could write. As for Davies, "Like all autodidacts he considered his self-found talent unique. Robert Frost found his conceit 'asinine', Rupert Brooke thought him a talkative bore, and DH Lawrence" – who had initially liked him – "changed his opinion, [saying] 'I think one ought to be downright cruel to him'."

The new editors promised that in the new *Form*, "Satire and the psychology of the arts will be given greater consideration than is ordinarily the case in magazines dealing with Fine Arts." Its tastes were populist: "If art is not for the people then for whom can it be? The heresy of the Highbrow has lasted too long. Let us leave them to their Mist and their

Morrow without a Dawn. Art, like life, is common. And for and by the common people does it live."

Contributors included Sidney Sime, Robert Graves, the critic Herbert Furst, Laura Knight, Frank Brangwyn, Glyn Philpot, Edith Sitwell, Walter de la Mare, Havelock Ellis (on Spanish folk songs) and many others. In later life Spare said he knew Havelock Ellis (Letchford remembered Spare saying "*The Psychology of Sex* by his friend Havelock Ellis contained all that one might desire to know on the subject") and since Ellis was a contributor to *Form* and lived in South London it is likely that he did. But when the expert on "Self-Love" met the man who virtually coined the concept of "Narcissism," they didn't find much to talk about: by Spare's account Ellis was "as shy as himself", and "They sat facing one another for three hours with hardly a word spoken until Mrs Ellis entered with the tea, saying not a word!"

Another contributor was JFC Fuller, the old A∴A∴ member and blitzkrieg theorist, who wrote in his piece on 'The Black Arts' that "Freud and Jung and a host of followers have invented psycho-analysis, which to-day is still pure black magic, the anatomization of mind by thought potentized by theories in place of pantacles, mantras and spells".

George Bernard Shaw was still in touch, and wrote to say that the new *Form* was "a horrible but fascinating magazine" (this was better than the old *Form*, which had just been "very horrible"). Fascinating or not, after only three issues, the last in January 1922, Spare abandoned it. His new acquaintanceship with the writer Clifford Bax opened up the possibility of a new artistic and literary periodical to be published by Chapman and Hall, and Spare jumped ship.

Clifford Bax already knew Spare's work ("queer amalgams of primitive magic and primitive sexuality. And I had greatly admired the power and the distinction of his draughtsmanship"). When he met Spare in person, in a Lyons tea shop, he liked him at once: "what an odd and charming person... I noticed and liked his pale eyes which were always honest and

often humorous. I realised at once that he was a shrewd though unworldly fellow who knew many aspects of London life which I had known only by hearsay." They decided to call their journal *The Golden Hind*, after Drake's ship: it went with the Tudorbethan tastes of the era, and suggests a vessel with treasure on board.

Spare had recently moved down to South London, into a council flat at 52 Becket House, Tabard Street, Borough SE1. It was "a high bleak barrack-like tenement block," as Bax remembered it, and he was now living among people "to whom a penny and ha'penny are very different coins". Spare had to ask him not to put "Esq." on his letters; "We've only one other esquire in my block, and they think we're giving ourselves airs."

Bax had Spare to lunch one day with a mutual friend, a woman called Norah Rowan-Hamilton, and Spare treated them to a little discourse on method. A man's conditions were caused by his "subconscious desires", he said, and "Whatever you really want, you can get":

> *The want rises first in the conscious mind, but you have to make the subconscious desire it too. And you can do this by inventing a symbol of the thing you want – wealth, a woman, fame or a country cottage, it's all alike. The symbol drops down into the subconscious. You have to forget all about it. In fact, you must play at hide-and-seek with yourself. And while you're wanting that particular thing or person, you must resolutely starve all your lesser desires. By doing that, you'll make the whole self, conscious and subconscious, flow towards your main object. And you'll obtain it.*

At least, that was how Bax remembered it (it seems to have changed slightly from the method in Spare's writing, perhaps in the interests of clarity)[5] but there was surely nothing wrong with Bax's memory when he remembered the way Spare smiled as he said "I suppose my own subconscious desire is to be poor!"

5. Spare stressed that sigils should not be symbolic, because symbolism was too conscious.

Radio had recently begun, with Radio 2LO coming on air in 1922, and Spare's lifelong interest in radio had begun, building valve sets from kits. He had already been interested in the gramophone (before the Great War he had owned a collection of Negro Spirituals on 78rpm discs) and visitors would often find him tinkering about, inventing gadgets to improve the reproduction and sticking his head inside the speaker horn as he experimented.

He brought a home-made wireless set for Bax when he came round to lunch, and afterwards he climbed on to the roof of Bax's garage and fixed the aerial up on a telephone pole, not realising this was a dangerous thing to do.

Some time later the composer Gustav Holst was visiting Bax during a thunder storm. Suddenly there was a tremendous explosion, as a bolt of lightning caught the telegraph pole and ran down the aerial to hit the set in the room. Holst lay on the floor to recover from his terror, and had to be sent home in a taxi.

The first issue of *The Golden Hind* appeared in October 1922, and included a large lithograph by Spare entitled 'The New Eden': Spare's head, bat-winged, appeared in the sky over a realistically fleshy Freda, crouching naked near a coiled snake. It is drawn in mind-space rather than any real perspective, and a crescent moon appears down in the corner, lower than Freda. The *TLS* reviewer took a distinctly end- of-term tone: the merits and faults of Spare's work were pretty well known by now, he said, and "he will never do himself justice until he has learned to trust himself more and assert himself less."

As Bax remembered it, Spare "innocently filled our first number with ... backviews of massive nude females", and this caused their journal to be nicknamed The Golden Behind. The Cambridge bookseller Heffers refused to stock it, and letters of complaint were received, according to Letchford ("concerning the muscular female nudes... some with their behinds somewhat prominent"). Still, *clunes portae musarum*, as the old Latin tag has it: the buttocks are the gateway of the muses.

As the journal continued its other art contributors included John Austen, Alan Odle, the belated Decadent Alastair (Hans Henning Voigt), Laurence Bradshaw, Grace Rogers, Haydn Mackey, and Frank Brangwyn, all of whom were or became friends of Spare (Brangwyn was a lifelong

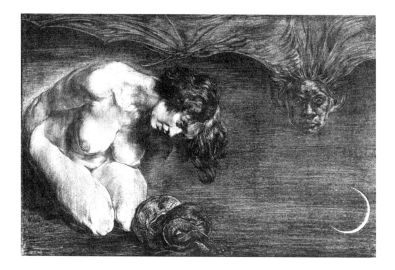

supporter but nevertheless liked to keep a certain distance, and referred
to him as "a queer fish"). Spare was keeping very busy in his shambolic
way, his trousers held up with an old tie (a JC Squire trick), and wealthy
patrons still came to visit Becket House.

In June 1924 Spare exhibited with the Society of Independent
Artists, newly formed under the presidency of Frank Brangwyn, at a store
in Oxford Street – Thomas Parsons and Sons at 315-317 – which aimed
to reach a larger public than attended the Bond Street galleries, and *The
Studio* noted him as "an artist whose work attracted much attention some
years ago by its almost uncanny originality, but who has since been seen
less frequently."

Spare got to know Frank Brangwyn's assistant Lawrence Bradshaw
– later to sculpt the head of Karl Marx in Highgate Cemetery – and
his friend Grace Rogers, and he went with her to the 1924 British
Empire Exhibition at Wembley. Spare found this inspiring, and Rogers
remembered him "bubbling over with excitement" at having seen witch
doctors and tribal dancers from Sikkim, Tibet and Burma. She also
remembered going into Liberty's famous department store on Regent
Street with him; its artistic roots in Art Nouveau and the Arts and Crafts
movement were related to Spare's own, but he was nevertheless trailed
by a store detective who clearly didn't like the look of him. Worse still,

visiting Gloucester with Grace and her sister, they all separated for a while and the sisters then found Spare very angry and upset in the street, having been thrown out of a shop.

The Golden Hind was still limping on, now reduced in size from folio to quarto. The penultimate issue had an "elaborately disgusting" Alan Odle picture, said a reviewer: "We have seen sounder and livelier numbers of the Golden Hind than this". The writing was on the wall. In the words of Bax, "We ought... to have realised that quarterly magazines of art and literature belonged to the age of silk hats, hansom-cabs, drawing rooms and permanent marriages." *The Golden Hind* folded in 1924 after eight issues.

No longer would Spare turn up at the editorial office in Henrietta Street, Covent Garden, browsing the nearby book and junk stalls in his free time. He had lost touch with many of his old friends, patrons and supporters such as Gray, Raffalovich and Ricketts, and Freda seems to have gone too. Bax remembered Spare with affection ("a charming companion" and "a staunch friend... all his instincts are generous"); but while Bax sailed on happily enough, kept afloat by his class and his contacts, the failure of *The Golden Hind* hit Spare very hard.

Bax remembered that Spare's "attractive simplicity" came out in the friendly way he'd once said to him "If you are ever passing my place, do drop in." The trouble was – as Bax adds – "it is seldom that anybody happens to be passing the Borough unless he lives there."

Isolated, rejected, almost defeated, the second half of Spare's life was now beginning, down among the inhabitants of Borough: living, as he told Grace Rogers, "as a swine with swine."

Eleven: NEVER ALONE

Spare was living in a grimly Dickensian location (Little Dorrit Park and Quilp Street are now nearby) but Becket House was no slum: only recently built, it was good quality housing offering "homes fit for heroes" after the First War. Spare's flat had a good view of the green lawn in front of the block, but the neighbours were not so pleasant; bottles of milk would disappear, and he constantly suffered from petty thieving.

Seven people lived in the small flat beside Spare's, and the two grandparents would hide when the council rent collector called. In the flat above, the tenants took in washing, and the mangle could be heard grinding into the night, along with sounds of sex coming through the wall from next door. Nearby was a rat-catcher, who would bite the heads off rats as a stunt. Becket House was cramped but Spare did a great deal of work there, using a nearby framer called Bunnett in Great Dover Street.

Grace Rogers remembered visiting Spare at Becket House one afternoon with Lawrence Bradshaw, crossing the yard with its clothes lines, big dustbins and teeming children. Up the steps they went, and past the public lavatory-style tiling on the walls, peered at by the neighbours, until they reached number 52 and rang the bell:

> *almost immediately the dingy Nottingham lace curtain was abruptly pulled aside and two eyes, beneath a mass of tousled, dirty hair, literally glared through the glass, resenting the intrusion. Spare opened the door and we were led into one of the two rooms he called the studio, a small overcrowded place mostly occupied by a double divan bed which served as a table, a model's throne and work-bench for making wireless sets by which he seemed to make a precarious living.*

The walls of the studio were hung with a variety of pictures, many of them of blowsy women of middle age, a few heads of chocolate-box beauty, slightly distorted and done in coloured chalk. Spare brought out a large portfolio, neatly kept and well-preserved from the surrounding chaos and dirt — grotesque and arabesque designs, rather obscene in nature but exquisite in execution...

Spare had two small rooms and he had put draperies on the walls to give a vaguely Eastern and exotic atmosphere, but Rogers noticed the absence of the candlesticks, Italian mirrors, tribal masks and sculptures that he used to have, back in the days of his marriage. They'd been sold, although Spare bought more tribal pieces as time went by.

On glancing up and towards a black cabinet with a sateen curtain drawn across a corner of the next room, was another satanic mystery which seemed to portend more obscurities; Spare hinted at Black Mass... [and] a skull reposed on the mantelpiece beneath another mystery shrouded in a green curtain. We were told we would be overwhelmed by some appalling disaster if we approached too near!

Looking through Spare's stacks of pictures and drawings, they were reminded of Doré, Beardsley (Rogers remembered Spare would talk of Beardsley, and of having known his sister) and others: "Amongst the pencil drawings to be seen at Becket House there were many to equal old Master drawings but, unfortunately, they were drawn in penny exercise books or on postcards". Fascinated, they stayed until it started to grow dark. Finally they left for Borough underground station, after helping Spare out with twopence for the gas meter.

Spare shared something of his philosophy with Rogers. The dream life was the only real life, he told her, because in the dream world we could tap into the unconscious and get "the unadulterated truth, not the tissue

of lies as in the conscious world." The conscious self was a divided self, a badly mixed combination of reality and dream.

As their friendship grew, Rogers helped Spare to edit his newest writing, *The Anathema of Zos: The Sermon to the Hypocrites*. Described as a "diabolic automatic writing", this was a bitter Nietzschean rant against conventional society, something in the manner of *Thus Spake Zarathustra*.

In addition to archaism ("verily") the *Anathema* shows a growing relish for polysyllabic words, which would increase as Spare grew older. Characteristic lines include "What! I to aid your self-deception, ameliorate your decaying bodies, preserve your lamentable apotheosis of self?" and "Further, to ventilate my own health, I scoff at your puerile dignitaries' absurd moral clothes and ovine faith in a fortuitous and gluttonous future!" Elaborate words are a famously autodidactic taste, almost like the rhodomontade of an old-time music hall compere.

Otherwise it was a continuation of earlier themes, but with a newer emphasis on the hypocrisy, timidity and stupidity of ordinary life. Followers of any kind are despised ("For me, there is no way but my way. Therefore, go ye your way") and organised religion is rejected ("I say unto ye, I live by bread alone. Sleep is competent prayer.") The kingdom of heaven remains within ("Shall I speak of that unique intensity without form? Know ye the ecstasy within? The pleasures between ego and self?"). Desire is still a key concept, along with evolution:

> *Fools! Ye have made vital the belief the Ego is eternal, fulfilling*
> *a purpose now lost to you.*
> *All things become of desire; the legs to the fish; the wings to the*
> *reptile. Thus was your soul begotten.*
> *Hear, O, vermin!*
> *MAN HAS WILLED MAN!*

Out of the same crisis, during the summer of 1924, came the extraordinary sketchbook of "automatic drawings" entitled *The Book of Ugly Ecstasy* (image opposite). Finely drawn and truly, disturbingly hideous, it is a riot of warty, dripping, hairy flesh, spewed frogs,

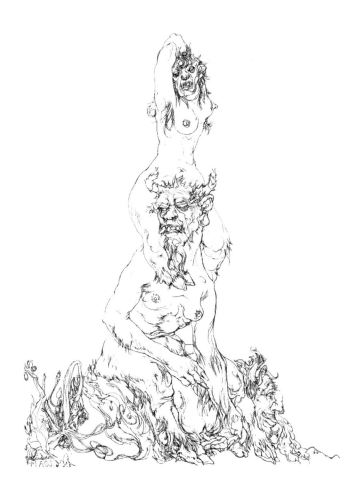

scaled and rotting teeth, splitting faces and noses with a root-like life of their own. It goes far beyond Edmund Sullivan's easy equation of the grotesque with evil, and instead seems to accept it almost lovingly on its own terms.

It contains some of the greatest grotesque art since the Middle Ages and it was bought by the eccentric art historian Gerald Reitlinger, a friend of the novelist Anthony Powell. A trained but amateur artist himself, Reitlinger went on to write *The Economics of Taste*, a magisterial study charting the rise and fall of art values in three

volumes.[1] Reitlinger believed there had been a decline of artistic taste, due to a redistribution of wealth and an inflated price put on individual reputations. He also collected Chinese, Persian, and Moghul art, and he told Frank Letchford that although he happily sold his Matisse prints, he would never sell his Spare drawings.

Reitlinger's brother Henry "Scipio" Reitlinger, an authority on Old Master drawings, also bought works from Spare in the Twenties. They dealt with Spare direct and remembered him as extremely shy, although Gerald did persuade him to come and see more of their collections.

Not long after *Ugly Ecstasy*, in the spring of 1925, Spare completed a related series of drawings entitled *A Book of Automatic Drawings*. Less finely detailed, this additionally features a more calligraphic line in places, related to the figurative calligraphy of the Renaissance; Spare called this his "sine curves" line. It remained unpublished until 1972, when Ian Law wrote that it might be "daemonic doodling", but it nevertheless has "an urgency that compels the belief that Spare really did have insights into a different reality outside the world of common sense." A further suite of pictures, *The Valley of Fear*, sets the figures from *Automatic Drawings* into a rocky landscape.

Gentler than *Ugly Ecstasy*, occasionally almost winsome in comparison, *A Book of Automatic Drawings* contains pages with titles such as 'Alternating Personality,' 'Astral Body,' 'Idiotcy' [sic], 'Obsession,' 'The Complex,' and 'The New Eden'. The latter was a title that meant a lot to Spare, and he'd previously used it for his picture featuring Freda and himself. Now it was applied to a grotesquely ugly couple trudging along companionably.

It would be sentimental to say that the figures in *Ugly Ecstasy* and *Automatic Drawings* are happy despite their hideous appearances. Some don't look happy at all. It would perhaps be more realistic to say it takes us – in the words of WH Auden's poem, 'In Memory of Sigmund Freud' –

1. *The Rise and Fall of Picture Prices, 1760–1960* (1961); *The Rise and Fall of Objets d'Art Prices since 1750* (1963); and *The Art Market in the 1960s* (1970).

Down among the lost people like Dante, down
To the stinking fosse where the injured
Lead the ugly life of the rejected.

Nevertheless, Spare signed off *Automatic Drawing* on a defiant and innuendo-laden note: "Great is he who pleasures this difficult life," he wrote, and "He has found wisdom who knows how to spend."[2]

Some of Spare's straighter work is classically beautiful, but conventional beauty was something he felt he could take or leave.

Talking to Grace Rogers about his neighbours, Spare told her about the girl next door. Life's real tragedies were not all dramatic, he said, and this girl was a case in point. When he first saw her, "she was courting and she had all the charm of a healthy girl of eighteen, in the flush of adolescence, when good looks seem to descend upon the most commonplace. Probably she had the average girl's attitude to the man of her choice and the usual dreams of the formation of a home to care about; just human and simple." But now, she was a mother: "she had a child and it nearly killed her. She is an utter wreck physically, a haggard faced woman with an undersized infant and living in the same house with a quarrelsome stepmother, and she has to work to keep the bloody lot, with nothing to look forward to but a long life of dreary toil."

When he'd first seen her, "I seemed to see in her the symbolic woman of all time — I seem to have seen her a million times before." This was a quintessentially Spare note, and there was a further one when he pointed out another girl whose life he felt was, again, "a tragedy." She was waddling along like a swan on land, and Spare said that the world of jazz music and men must all be closed to her; "the library must be her only hope of salvation." No man could fall in love with her, he said, and yet "my opinion is that such women as this have as fine thoughts on the matter of love as anyone and must suffer from much mental

2. Victorian euphemism for ejaculation.

repression... Only I, who have deliberately stamped on the aesthetic idea of love, might find in her some sort of sex mate."

Late in his life, Spare wrote that "a culturally accepted criterion [of attractiveness] has destroyed more affective affinity than any other belief; but he who transmutes the ugly into a new aesthetic has something beyond fear." It was an idea taken much further in paraphrase by his young friend Kenneth Grant (who went some way towards creating his own version of Spare): "By taking the ugly, the deformed, the aged, and, overcoming revulsion by uniting with it aesthetically – sometimes even physically – a rare ecstasy results which generates great magical potential."

A writer on the Chinese philosopher Mencius comments that "The Christian and Chinese traditions of asceticism seem to differ; many Taoist ascetics retiring to the wilderness perhaps rather to develop sex than to deny it."

It is a moot point how much sex, if any, Spare was having down in the Borough, and how he was developing it. People who have taken an interest in Spare vary on this, from saying "I bet there are Spare bastards all over London" to answering, in response to the question of when Spare last had anything like normal sex, "Probably around the middle of his marriage."

Spare told Frank Letchford a story that he had once been picked up by a loose woman or prostitute who took him back to her room for a good time, buying some fish and chips on the way. Having been to the lavatory and, Spare noticed, failed to wash her hands, she then started digging into their supper with her fingers, "which somehow sickened Spare and he fled." He told Kenneth Grant a similar story: a "nice prostitute" told him they'd have a little supper first, before pissing into a chamberpot in his presence, wiping herself with her hand, "and with the same wet hand placing sandwiches on his plate." Spare was disgusted, and on the pretence of going to the lavatory he left the room and once again fled.

Whether this suggests that Spare regularly frequented prostitutes, whether it is two versions of the same incident, and whether it happened

at all, we don't know; it may be a confabulated story airing an underlying sexual reluctance and disgust.

Sometimes said to be the greatest artwork of the twentieth century, Marcel Duchamp's *The Bride Stripped Bare By Her Bachelors, Even* (*The Large Glass*) features, within its complex machinery, the Bachelors who are eternally separated from the Bride and have to "grind their own chocolate", as Duchamp put it. The indications are that Spare may have been a keen chocolate grinder himself. Short circuits of pleasure were never far from his thoughts: "Seduce thyself to pleasure," and "Let this be thy one excuse: I pleasured myself." Perhaps he enjoyed inner sabbats with what have been nicely called "the Dionysian repertory company of the mind."

It was also Duchamp who said that the great artist of the future would go underground, and in this respect Spare was ahead of his time, living in obscurity down in Borough. Living alone, he said, he had made great introspective discoveries, and he wrote "In our solitariness, great depths are sometimes sounded: Truth hideth in company." He was living increasingly outside of consensus reality, and he told an interviewer: "I have lived for months a hermit's life. Poverty has made me live alone. It has been partly choice, partly compulsion. The result has been psychic development."

The psychoanalyst Donald Meltzer has made the important point that paradoxically Freud *under*-valued dreams, seeing them only as diagnostic material, debris for forensic investigation, and not as experiences in their own right – even though, as Meltzer argues, some of Freud's major dreams were really existential events in his own life. There is reason to think that Spare's dreams were events in his life. The nineteenth-century French romantic Gerard de Nerval coined the idea that our dreams are "a second life", an idea that would wait for the surrealists to explore it more fully, and this is what they were for Spare. Around the mid-Twenties he was working on a lost book entitled *Dreams and Adventures in Sleep*.

Biography can only follow its subject so far, especially a character like Spare, whose real life was internal. The life of an occultist is very different from

the life of a tycoon or a general, and Spare was a hidden figure whose life was lived largely on the inner planes: years later he wrote on a Christmas card "I thank the Gods that be – I see myself as no other seeth me."

As Spare said, everyone has their "own arcana", like the "jubilatory formula" of each individual unconscious, suggested by Serge Leclaire. Yeats once wrote that "there is for every man some one scene, some one adventure, some one picture, that is the image of his secret life" (he was thinking of Shelley, in whose case "a single vision would have come to him again and again, a vision of a boat drifting down a broad river..."). What that scene would be for Spare we can only conjecture from his pictures: something involving young and elderly women, perhaps, and satyrs; perhaps some woodland, and a moon; and the whole image "like a page torn from some necromancer's dreambook."

Spare spent much of his time alone, and yet not. "I have only to turn my head," he said, "to see the whole gang of familiars, elementals and alter-egos that make up my being."

"Towards the end of his life," says one of his main chroniclers, Kenneth Grant,

> ...when Spare lived more or less reclusively in a Dickensian South London slum, he was asked whether he regretted his lonely existence. "Lonely!" he exclaimed, and with a sweep of his arm he indicated the host of unseen elementals and familiar spirits that were his constant companions; he had but to turn his head to catch a fleeting glimpse of their subtle presences.

The frontispiece to Matthew Hopkins's *Discovery of Witches* (1644)[3] has a witch disclosing her familiars around her. Announcing "My Imps names are" in a speech-bubble scroll, she indicates such entities as Ilemauzar, Griezell Greedigutt and Pyewackett. Things have changed

3. A widely reproduced woodcut, figuring as e.g. Plate 12 in Sax Rohmer's *The Romance of Sorcery.*

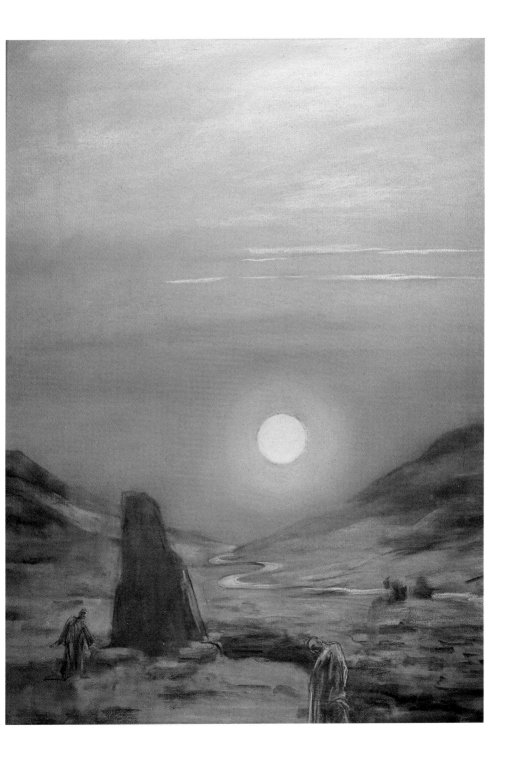

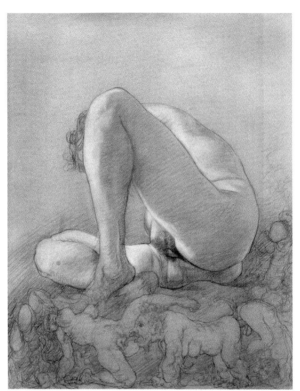

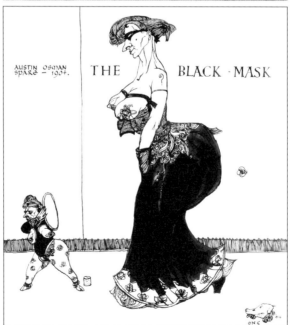

AUSTIN OSMAN
SPARE — 1904.

THE BLACK · MASK

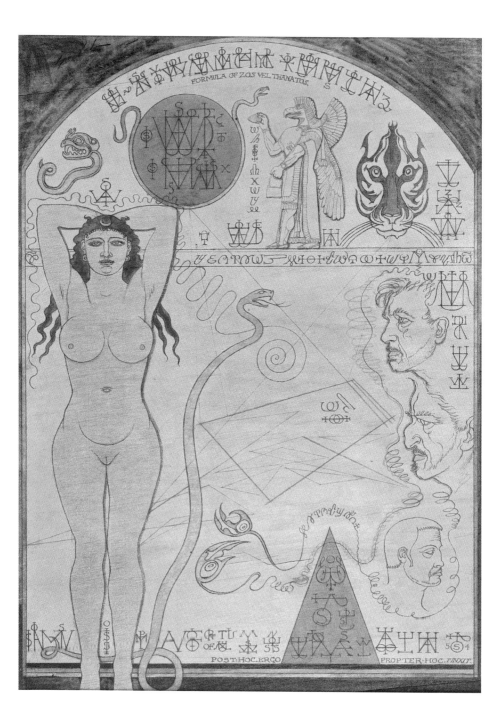

FORMULA OF Z.O.S. VEL THANATOS.

POST·HOC·ERGO

PROPTER·HOC·FINXIT

an 37
John Teed.

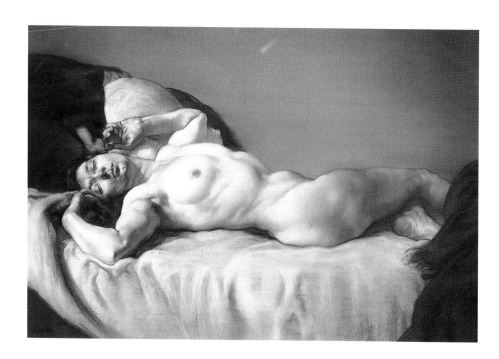

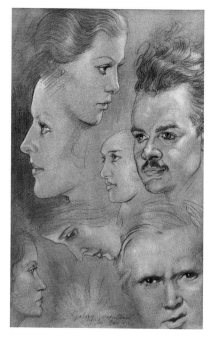

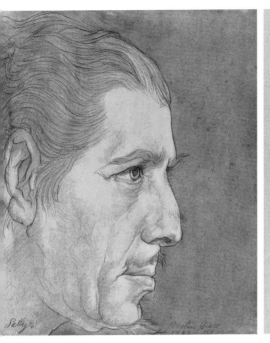
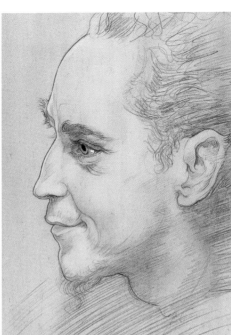
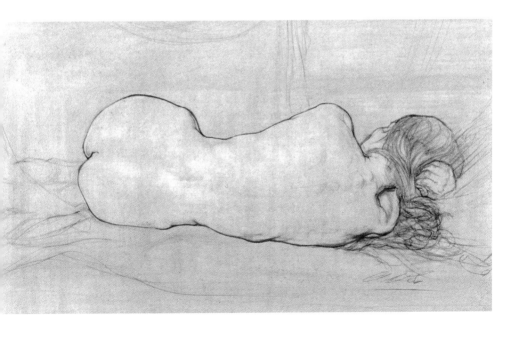

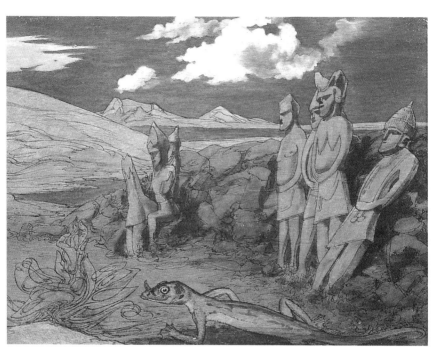

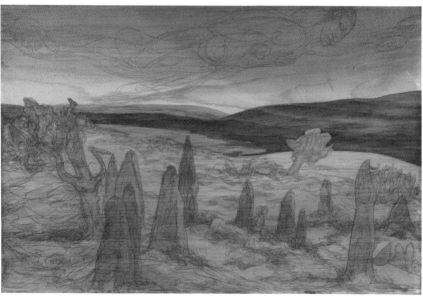

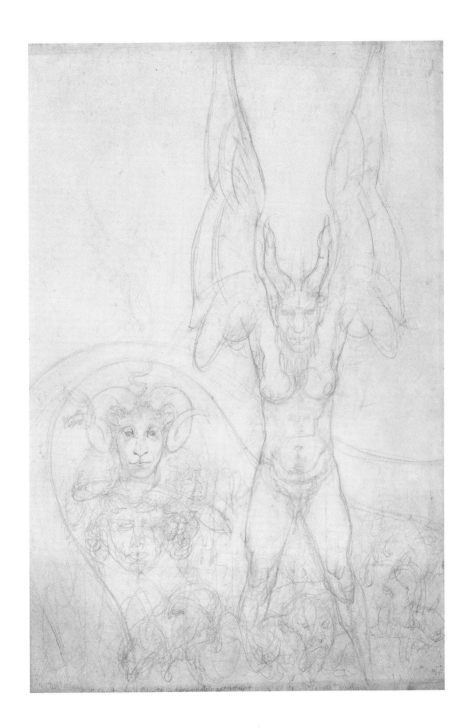

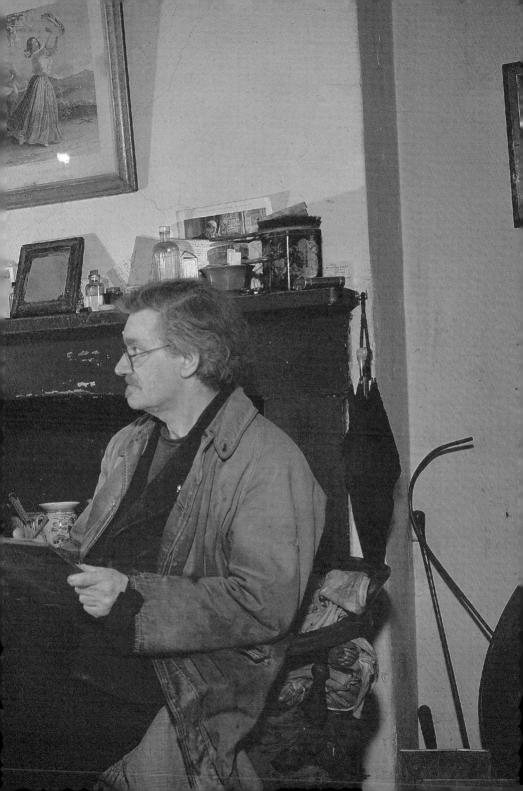

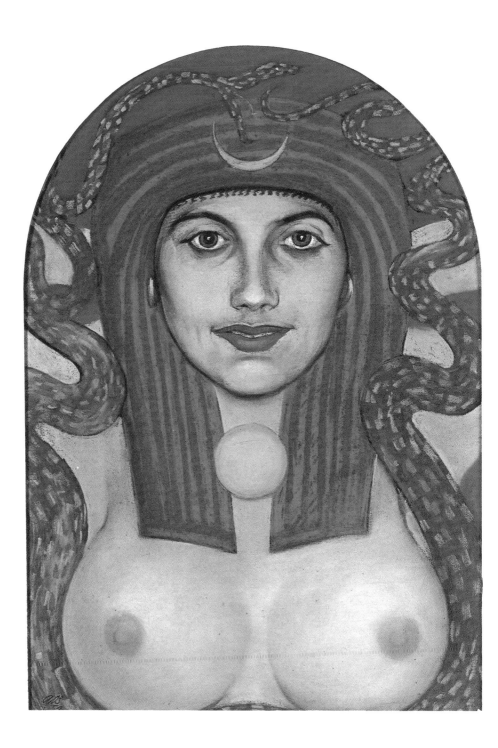

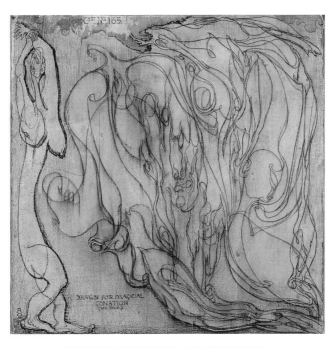

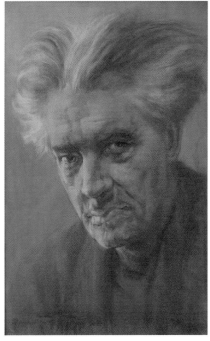

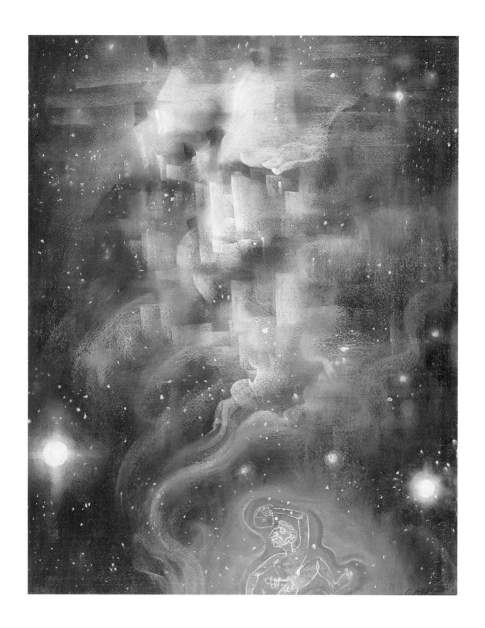

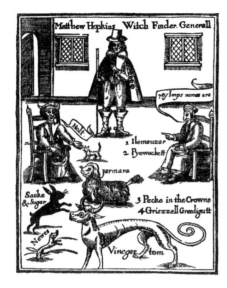

since Pyewackett's day, and Spare was more likely to see his familiars in psychic terms, like his "obsessions" and "automata."

There was already quite a tradition of this. Writing about "unconscious cerebration", a term from around 1870 coined by Victorian neurologist William Carpenter, a largely forgotten Victorian woman called Frances Power Cobbe describes unconscious creativity as the work of a "familiar." As well as waking us at the right hour and searching for forgotten words, "our Familiar is a great deal more than a walking dictionary, a housemaid, a *valet de place* or a barrel-organ man... He is a novelist who can spin more romances than Dumas".

This was what Robert Louis Stevenson found. In 'A Chapter on Dreams' he recounts the genesis of *Dr Jekyll and Mr Hyde* as the work of dream automata who laboured away on his behalf, coming up with plots and scenarios while he was asleep, whom he called his "little People" or "Brownies." Perhaps he was no story-teller at all, he said, and the whole of his published fiction was "The single-handed product of some Brownie, some Familiar, some unseen collaborator, whom I keep locked in a back garret, while I get all the praise."

Spare had an idea about what he called intrusive familiars (anxiety, perhaps, in the case of someone who was a worrier; more supernaturally, he might also feel an "intrusive" manifesting in something like a chain of coincidences). More recently theorists of Artificial Intelligence have worked with the concept of "agents": "these are little mental homunculi with specialised jobs: one agent is for hunger, another agent is for curiosity, another is for fear, and so on. Weave enough of these agents together and you have a fairly crude

model of a consciousness, but one which leads to surprisingly complex sets of behaviour..."

This whole area of thought – demons, spirits, elementals, and so on; a kind of gremlin paradigm – reaches its most rationalised expression in the work of Jung, who was more than half way towards the occult world view himself. Jung believed in "autonomous complexes" within the psyche, their autonomy meaning that "complexes behave like independent beings."

For Jung they are "autonomous partial systems" and "necessarily have the character of persons," manifesting sometimes in mental illness "and also, quite commonly, in mediumistic phenomena." Therefore "daemons" are "nothing... external" but instead "naïve awareness of the powerful inner effect of autonomous partial systems."[4]

Spare did a number of doodled face-forms on cards around this time, in which a looping calligraphic outline became a cloudlike face. He used these cards in personal forms of divination, and he considered them to have some of the attributes of autonomous living entities. He also believed his sigils could take on a kind of life of their own as "sentient" sigils which, once created and properly charged, might continue to burrow around in mental reality and have an effect on it. This takes us into realms where we might well ask if it would be possible to keep an idea as a pet. At which point it might be a good idea to get out more.

In 1929, in the depths of his most solitary period, Spare did a picture which summarises his dealing with elementals. Entitled 'Theurgy' (broadly, ritual magic with spirits) and now in the South London Gallery, it includes a realistic woman's face, a number of sine-curve lines becoming faces and entities, a collaged word ("REFRACTION", which seems to have been stuck on the picture from advertising or packaging) and a list entitled 'Modus Operandi,' or "way of working".

This list runs:

4. See particularly Jung's 'Commentary' to *The Secret of the Golden Flower* ed. Richard Wilhelm (Kegan Paul, Trench, Trubner and Co, 1938) pp.108-113. The original *Secret of the Golden Flower* is a Chinese text, Taoist with Buddhist influences.

Suggestions
Repressions
Obsessions
Fixations
Elementals manifest
Reactions
Will obeys original impulse

It is never easy to make complete sense of Spare's writing, but a plausible paraphrase of this might involve something like: *Suggestion* as the original desired idea, being suggested to the mind by the sigil. *Repressions* as the more Freudian stage of the process; a deliberate forgetting of the idea to put it out of consciousness and (Spare thought) repress it into the unconscious. *Obsessions* and *fixations* as the working and solidifying of the idea in the unconscious. *Fixation* is from the jargon of psychoanalysis, where strictly it means something slightly different (fixated at a developmental stage) but in common parlance it sounds like an obsession solidified or pegged: fixated on something, or on an idea (and there might also be an echo of photo developing).

Elementals manifest – as if the formless materialising obsessions and fixations, or perhaps the now-fixed obsessions, have reified a stage further into living elementals. *Reactions* is one of the hardest parts of the sequence to understand. Perhaps these are reactions in reality, like initial results, or the reactions of the sorcerer-artist or operator (who might respond to these entities, like a person feeling a fish on a line, or playing with a dog). Finally, *Will obeys original impulse*. This must mean the success of the original suggestion, whether as the control of one's own will, or the tapping into and harnessing of a kind of universal world-will.

Spare's star had fallen considerably – he was now written off by some as a "degenerate and crank" – but he was still not completely unknown. In 1925 Evelyn Waugh had written to Harold Acton from North Wales, where he was teaching at a dismal prep school, and reported

"I got very drunk all alone a little time back and was sick among some gooseberry bushes. I also found a hairdresser in a tiny town called Rhyl who collected Austin Spare's drawings and was writing a book about Cabbalism." (Waugh probably knew about Spare because he'd had some work published – art, not writing, so it would have been Spare he dealt with – in *The Golden Hind*.)[5]

Along with their thrill-seeking visits to Chinatown, a visit to Spare might even be on the itinerary for the more daring of the Bright Young Things, or at least it was for bohemian socialite Viola Bankes, whose hectic life in the Twenties also included dressing as a sailor for the Chelsea Arts Ball and going to Nancy Cunard's "negro" parties. Studying art, she writes that "I seldom purchased the work of present-day artists,"

> *as I found it difficult to live with after spending a quarter of a century amongst some of the finest old masters in the world. Nevertheless, I was moved, for many reasons, to acquire a strange little panel in tempera by a weird man called Austin Spare.*

Bankes and her husband visited him in his "squalid rooms in a tenement house," where she thought he looked like "the Angel Gabriel fallen from grace into Hell." They found him intensely shy and very polite, and Bankes noticed his rather grey pallor: "I do not know what form of nourishment he took to keep him alive, but I suspect it was unwholesome."

Bankes saw him as one of the finest draughtsmen of her time, and believed that after his death his work would be sold for inflated prices. Comparing him to Beardsley, Felicien Rops, and Toulouse-Lautrec, she felt his work was "inspired by genius, but has a streak of fantasy in it which comes very near to madness."

> *One felt that if he were sufficiently interested in a person to wish to draw him, his uncanny perception would probably*

5. Vol.2 nos.6,7,8; Waugh's father worked for the publishers, Chapman and Hall.

*lead to his making, not a sensitive portrait, but a caricature, of
the unfortunate sitter.*

Bankes had an interest in sexual perversity – she mentions in
her book that she recognised sadistic traits in herself – and Spare told
her that Richard von Krafft-Ebing (author of the famous collection of
case histories, *Psychopathia Sexualis*) "purchased many of his drawings,
of a rather special nature, for the research department of a museum in
Berlin." He must have spotted Spare very young, because he'd been dead
since 1902.

The Anathema of Zos was finally published in 1927, from Spare's sister's
house at 58 Blythswood Road, Goodmayes, Essex. People interested in
Spare sometimes talk as if, by publishing his *Anathema*, he burned his
boats with the art world and the smart set, but it is more likely that hardly
anyone noticed.

Another book appeared a little later, and attracted only marginally
more attention. This was *The Youth and The Sage* by Warren Retlaw,
"A Philosophic Poem of 95 Quatrains", and it was published from 41
Maplethorpe Road, Thornton Heath, Surrey. Warren Retlaw, or Walter
Warren, to give him his real name, was a sporting gun engraver, cutting
the curlicue decoration into the sides of expensive shotguns.

As he explains in the Foreword, "I left school at 13 to work at the
bench, with a very small margin of time for self-education," but he had
been greatly troubled – "spiritually stranded and nigh wrecked" – by seeing
through the spurious authority of "all so-called revealed religious systems."
The result was his poem, something in the manner of Fitzgerald's *Omar
Khayyam*, "although I hope I offer something more than the idealised
Despair which seems to dominate Omar's thought."

It attracted encouraging words from George Bernard Shaw,
among others, and Shaw must have been interested to see Spare
cropping up again. Warren was a former neighbour of Spare's, and
Spare drew the frontispiece for the book and generally helped with
it: "For the decorations of this first book, and for much advice and

assistance, I am under great obligation to that extraordinary genius Austin Osman Spare."

Spare did a very fine portrait of Warren, dignified by a Holbein or Dürer-like care with the drawing. Before Warren's eyes some loose automatistic scribbling has tightened to produce an ascending column of indistinct heads, and an extraordinary automatistic humanoid is taking form in the bottom corner. The small beard and absolutely formal profile give Warren a somewhat hierophantic quality, like the profile of Ezra Pound. The scribbling and the emerging creature may just be from the exuberance of the hand, let off the leash outside the careful discipline of rendering Warren's face, but at the same time they have an air of being Warren's thought forms, accompanying his blank gaze, and the whole composition has an air of 'Everyman his own Magus' about it.

Spare was producing some of his finest drawing at this period in the late Twenties, like a belated Pre-Raphaelite: there is a particularly good group of drawings all on the same batch of green-tinted paper (a colour that had connotations of Nineties-style decadence and aestheticism: "What a little duck of a room," says a character in Robert Hichens's 1902 novel, *Felix*, "just what I like, all green and idols.").

A 1927 study of six female heads – three girls with two expressions each – could almost be the work of a Pre-Raphaelite, except for the models. Whereas the Pre-Raphaelite woman had a long, statuesque face with a heavy jaw and large, well-cut lips (the face of Rossetti's model Lizzie Siddal and her type, going through the works of Rossetti, Burne-Jones and Millais until it reaches something more like parody with Simeon Solomon) Spare's models in this study look like twentieth-century working-class girls, shop-girls perhaps, with smaller, rounder faces of the kind seen in Peter Blake.

Spare combined this nineteenth-century style, academic standard of drawing with graphic effusions all his own, as in the Walter Warren picture. Some of the pencil work from this time is obsessively detailed, like hallucinations in incense smoke or rockwork, and similarly the iconography accompanying female portrait studies sometimes includes

swirls of subsidiary faces, thought forms, or little bric-a-brac idols at the bottom of the picture.

Spare had a show at the St. George's Gallery in 1927, his first for some years, but it was too introspective and it flopped. "It is difficult," said *The Times*, "to know quite how to take the 'Psychic Drawings and Others of Magical and Occult Manifestations' by Mr Austin O Spare, now on view at the St. George's Gallery, 32a George Street, Hanover Square; whether as works of art or as material for the psycho-analyst."

Herbert Furst, writing in *Apollo*, is even more supercilious, although he does mention that he saw Sir Arthur Conan Doyle poring over Spare's drawings, and that "others who think likewise" – by which he meant people interested in psychic phenomena of one sort and another, because Conan Doyle was a keen spiritualist – would enjoy it.

And this was probably true. The main consequence of the show for Spare was that in the course of promoting it he met Hannen Swaffer, who would become an important champion and friend. The young reporter who had jumped off the bus for Spare's 1904 show was now a major figure in Fleet Street, writing as many as a million words a year as a gossip columnist, theatre critic, editor, and all-round pontificator. Sometimes known as the Pope of Fleet Street, Swaffer dressed more like an old-style actor than a journalist. He was a rather ugly man, sensitive about his large nose, and he affected a wide brimmed black hat, high collar and black stock (press baron Lord Northcliffe called him "the Poet" for his appearance).

Swaffer was a man of the people, and liked to say that his flat overlooking Trafalgar Square would be an ideal place to view the revolution. Hugh Massingham, exploring working-class London in his book *I Took Off My Tie*, reports on men in the East End going to work:

> *As far as I could judge, they all read the* Daily Herald... *and the topic of conversation was the article by Mr Swaffer. All of them seemed to admire Mr Swaffer. He wasn't afraid of anybody, they said, and the men remarked how uncomfortable the Capitalists would feel when they read Mr Swaffer over toast and muffins, and eggs and kidneys, and coffee. They had been to the pictures, and they all knew how the rich lived.*

Swaffer was no intellectual. Aldous Huxley wrote to a friend complaining about the stupidity of the masses: "The imbecility of the 99.5% is appalling – but after all, what else can you expect? Swaffer is their prophet – but if it weren't Swaffer it would be someone else very nearly if not quite as Swafferish."

In middle age Swaffer became a Spiritualist, regularly went to seances, and became honorary president of the Spiritualists National Union, so he was very receptive to Spare's spiel about automatism and mediumistic art. Writing Spare up in the *Express*, Swaffer told his readers that Spare had "confessed" ("openly") that many of his drawings were "merely" automatic, and that although he was the "medium" through which they were made, "Who or what the communicating force was he did not know."

Swaffer visited Spare in Becket House ("a slum"), where apart from drawings there was just a rough bed, some wireless apparatus scattered around the floor, and a few books; it was quite a contrast from the days when "before the war, he lived in Mayfair." Spare played up the psychic aspect, telling Swaffer that he would go to sleep in his bed only to find himself waking up in a chair with an unknown drawing in progress, and doing fine drawings that he couldn't see, in total darkness. These may be simplifications and exaggerations of real experiences, like Spare's account of being unable to work for three months, although he wanted to, and on another occasion producing fifty pages of drawing in twenty-four hours.

Many artists, he said, worked from the "subconscious", unknown to themselves: "the development of these powers will open up a new world", and "all significant art" came from that source. He was now studying the subconscious and trying to perfect his automatic drawing. Given the right conditions, he told Swaffer, "prophecy and revelation" were as possible today as ever.

Meanwhile, like the one-man bands and goldfish sellers of his Kennington childhood, Spare was increasingly concerned with bare economic survival. His next gallery show at the Alex, Reid and Lefevre

Gallery in 1929, with a catalogue essay by Grace Rogers, again attracted little attention, but he managed some alternative showing with the so-called Grub Group on the walls of Leoni's restaurant in Soho. He also began selling direct to the public with shows in his flat, and with the help of a friend he produced a typed flyer: 'PRICES, – And Reasons for a Guinea Exhibition.'

Prices ranged from one guinea to five guineas (about £50 to £250 today) and the flyer explained "This is an effort by the artist to sell to a shy and new public"; people of "limited incomes" who dislike being "'caught'". In the West End, said the flyer, an artist netted about a quarter of the gallery prices, after the gallery had taken fifty per cent commission "(it is often as much as that)" and another quarter or so went on miscellaneous costs and expenses. Even then he had to wait for his money.

> *The great difficulty of the artist is to get in touch with his public. He cannot afford to advertise. The press pays little attention to him except as a "stunt". He hates pleading poverty. But he hates starvation still more. He asks – with some justification – why in a world drunken with wealth and populated by hosts of people who would be glad to acquire his work, he has a difficulty in making a living.*

So here he was, trying to sell direct. "This exhibition is organised by AUSTIN OSMAN SPARE to circumvent some of these difficulties. It is an attempt to give value for money."

It wasn't that Spare had offended the world with the *Anathema*, or deliberately rejected West End success, but that art had changed gear. Modernism and more formalist art values had come in, whereas Edwardian-style occultism, personal eccentricity, Symbolism, 'literary' art and academic drawing were none of them in great demand. Sidney Sime became reclusive around 1927, as did Frederick Carter, while Spare's old hero GF Watts (who had died in 1904, Spare's *annus mirabilis*) had become a figure of fun in Virginia Woolf's play *Freshwater*,

taking six months to draw a big toe and consulting a book of ancient Egyptian symbolism.

Spare was hardly the first or the last artist to be caught out by changing fashions. Four decades later Keith Vaughan wrote of The New Generation exhibition at the Whitechapel Gallery:

> *After all one's thought and search and effort to make some sort of image which would embody the life of our time, it turns out that all that was really significant were toffee wrappers, liquorice allsorts and ton-up motorbikes. So one could have saved oneself the trouble. I understand how the dinosaurs felt.*

Spare took it hard. A dislike of Modernism, already in place during the First War, became increasingly obsessive. Spare was now in something like the position of a classically-trained busker in the Sixties or Seventies, playing a violin on the pavement while pop stars made millions.

Financially, two major props went around this time with the death of Spare's father in 1928 (after which the family affairs were increasingly in the hands of Cissie, the elder sister who disliked him) and the death of Pickford Waller (a loyal, steady enthusiast who is said to have owned some three hundred Spare pictures) in 1930.

Spare had been "an overlooked genius since 1922!", as he later told Frank Letchford (he may have been thinking of 1924 and the collapse of *The Golden Hind*; he was always a couple of years out with dates) and to Hannen Swaffer he confessed he'd been thinking of putting his head in the gas oven; a very popular method of suicide in the days of coal gas, with a pillow in the oven and a chair in front of it.

Despite the earlier ecstasies, it seems that "Self-love" was no longer enough.

Twelve: EXPERIMENTS IN RELATIVITY

Spare once told a friend that there were eight years in his life when nothing at all happened – it's not clear exactly which eight – and on another occasion he said there were as many as twenty of these empty years. He must have meant the years between the Wars, but he was keeping busy, still making "deep incursions into psychic realms", and his flat at Becket House was still littered with drawings, as well as odd bits of tribal art and valve radio parts.

Wireless was an appropriate medium for Spare to play with, because he believed that the "aether" not only carried radio waves but occult vibrations. He wasn't alone in this: Sir Oliver Lodge, the physicist, inventor, radio pioneer and spiritualist, transmitted radio waves in August 1894, a year before Marconi, but he did so believing that they went through this same "aether"; a wave-bearing medium that filled all space. He even wrote an *Encyclopaedia Britannica* article on it, but it is now relegated to the same museum of dead ideas as Eliphas Levi's "astral light". Wireless was widely felt to border on the supernatural; Marconi and Thomas Edison were both interested in radio communication with the dead, and in 1930 the American novelist Upton Sinclair wrote a book on telepathy called *Mental Radio*.

Spare produced many landscapes at Becket House, and his landscapes are distinctive. Some were derived from the Jenolan caves in Australia, seen in a geography book; the cave theme seems to have been associated in Spare's mind with primeval cults, and – as Robert Ansell has suggested – the "subconscious and its denizens." Spare's caves and grottoes sometimes figure robed and cowled figures. Other landscapes were derived from the backgrounds in ethnographic books, notably *The Living Races of Mankind* by HN Hutchinson et al, from 1900, or simply invented, with a great misty sun hanging low in the sky over a winding river through hilly moorland, or dancers high-kicking their way past trees under the moon.

These ecstatic dancers in the trees recall the scenes that WB Yeats envisaged for his ideal community of adepts; people who "worshipped nature and the abundance of nature, and had always, as it seems, for a supreme ritual the tumultuous dance among the hills or in the depths of the woods, where unearthly ecstasy fell upon the dancers, until they seemed the gods or the godlike beasts, and felt their souls overtopping the moon."

Yeats would no doubt have found Spare's pictures "vulgar", but Spare's several distinct modes of fantasy landscape are solidly consistent in themselves, and it is very possible he saw them as akin to real but 'elsewhere' places. The backgrounds of certain Renaissance pictures are remarkably consistent in a similar way – Piero di Cosimo's *Satyr Mourning a Nymph* and Filippino Lippi's *Wounded Centaur*, for example, seem to witness the same land – and Spare would have had enough occult theory from his younger days to see such mindscapes in terms of the 'astral plane'.

After the failure of Spare's show at Alex, Reid and Lefevre, he had decided to go back to a more realistic style. Then suddenly, when things were looking bleak, he came up with an altogether new line in his work: this consisted of elegantly distorted heads, usually female, that he termed 'Experiments in Relativity', catching the Einsteinian jargon of the day.

The Experiments in Relativity were a type of anamorph, an artistic curiosity with a long history. The first anamorphs are usually taken to be the child's face and widened eye in Leonardo da Vinci's *Codex Atlanticus*, and one of the most extreme and famous examples is the elongated skull that falls like a beam across Holbein's *The Ambassadors*. The idea of magic is recurrent in discussions of anamorphs: they were theorised by Jean-François Niceron in his *La perspective curieuse ou magie artificiele des effects merveilleux* or *Thaumaturgus opticus* (1637), and the word anamorph itself first appears in Gaspar Schott's *Magia universalis naturae et artis* (1657) where he again considers anamorphic distortion as a kind of magic.

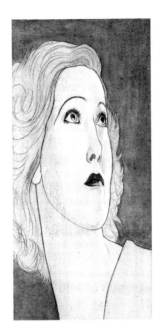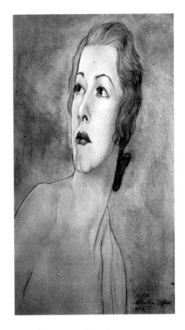

Anamorphosis has been variously considered as uncanny, hallucinatory, phantomatic and demonic, and as a conjuring-type trick demonstrating the extreme virtuosity of artists like Leonardo ("The anamorphic game is thus directly associated with a genius and with artists of the top flight," says George Baltrusaitis in his definitive history of the subject; "The value of such testimony cannot be over-emphasised"). It has also been seen as one of the many precursors of Surrealism.[1]

Spare stops well short of the full-blown anamorphosis that effectively encodes a picture, so that the image has to be decoded with a special mirror or a dramatic shift in the viewer's position. His effect is, nevertheless, sometimes uncanny, and in some of the more extreme cases seems to locate the viewer in an impossible space. Like painting his father's eyes a different colour or confabulating his life, they are also an instance of the perverse power of art, bending reality and making it malleable.

1. G Hugnet *Quelques ancêtres du Surrealisme* (Paris, Bibliotheque Nationale, 1965) pp.70-81. Dalí was experimenting with anamorphs around 1928.

Spare's anamorphs are a mannerist stylisation, often lending women's heads an aristocratic elegance that was at a premium in the class-conscious Thirties; he very rarely attempts horizontal distortion but instead goes for a vertical lengthening, like El Greco and Modigliani. Spare found Modigliani laughable, although he admired El Greco. He seems to have made some of his anamorphs using a camera, and photographers such as Bill Brandt and Andre Kertesz were also experimenting with distortion around this time (there is an elongated Kertesz face illustrated in Amedée Ozenfant's roughly contemporary *Foundations of Modern Art*; it is a portrait of Austen Chamberlain in a distorting mirror which bears some resemblance to Spare's own picture of minor Thirties actor John Teed).

Further to all that, Spare probably had his own inspirations. In *The Anathema of Zos* he had written of elemental spirits that appeared as "distortions of space", and back in 1904, when he was photographed for the *Tatler*, the photographer unwittingly created an anamorph out of Spare's picture of Glyn Philpot by catching it side-on.

Spare first showed his Experiments in Relativity at the Godfrey Phillips Galleries, 43 Duke Street, St. James, in November 1930. The show as a whole was not a great success and it was to be his last outing in the West End, although the anamorphs were his most beautiful and commercial work for some time; perhaps ever. The *Times* critic, condescending but with flashes of insight, told readers

> *A new departure for Mr Spare is a series of water colours, mostly of heads, under the general title of 'Experiments in Relativity' – whatever that may mean. Actually these water-colours work out rather like Japanese colour prints of actors, except that the heads are distorted – rather as if they had been drawn from reflections in a curved mirror. Perhaps this is where 'relativity' – on the principle of space-bending – comes in. No.21 is rather beautiful, and nos. 7, 12, and 15 have their interest.*

"Relativity – on the principle of space bending" also tapped into contemporary artistic interest in the Fourth Dimension, most famously in the work of Marcel Duchamp. The Fourth Dimension is usually taken to be time, but it also figured as an elusive spatial dimension, offering

new perspectives, which could have mystical or 'sublime' implications. Different artists and writers saw it variously as a higher plane of perception, as something akin to the aether, as the unconscious, and as 'nonsense' in the Lewis Carroll sense; the philosopher Hans Vaihinger, who later figures in the Spare story, suggested nonsense was the Fourth Dimension of literature.

Spare would later term his anamorphs "siderealism",[2] and use them particularly for portraits of film stars. The Elephant and Castle had the biggest cinema in Europe, the art deco Trocadero ("a huge ferro-concrete refuge from the cares and troubles of modern life, complete with a marble fountain in the forecourt"), and there were plenty of other cinemas nearby, with queues outside every night. Spare seems to have been interested in film stars as something like the new gods and goddesses, living in the minds of thousands (like Robert Jordan in Hemingway's novel *For Whom the Bell Tolls*):

> *Maybe it never did happen, he thought. Maybe you dreamed it or made it up and it never did happen. Maybe it is like the dreams you have when someone you have seen in the cinema comes to your bed at night and is so kind and lovely. He'd slept with them all that way when he was asleep in bed. He could remember Garbo still, and Harlow. Yes, Harlow many times. Maybe it was like those dreams.*

Becket House was a bad address for Spare because the council objected, under the terms of his lease, to any hanging of pictures on the walls. He longed to move, and in 1932 he moved to 148 York Road, SE1, for a couple of years.

The York Road flat was over a night shelter for 'down and outs', where Spare was able to find models: around this time he also drafted some 'Rules for Sitters', including the statement that "people with no

2. The word also occurs in Ozenfant's book: "What becomes of the sidereal dust, the shooting stars of light?" [p.xi].

claim to beauty, or over forty years of age, are preferred, the artist being an exponent of character and not of beauty."

Spare was able to hold selling shows at York Road. GS Sandilands, from the Royal College of Art, helped to promote these and suggested George Bernard Shaw might like to attend, but received a negative reply: "I shall not go to the Spare show because I am not a buyer of works of art," said Shaw, "and I share the general reluctance to disappoint a shopkeeper by walking out without buying anything."

Shaw nevertheless approved of Spare selling his works cheaply and democratically, because it fitted what he called his "Woolworth" idea ("I am glad that Mr Spare has joined the body of artists who have taken up my Woolworth suggestion"). This was an *idée fixe* with Shaw: he had several times suggested a "Woolworthized £5 exhibition" and also a "Woolworth theatre (all seats 6d)" with no plays by men who had been to school after they were thirteen, or seen a five pound note before they were thirty. It was all of a piece with his encouraging Spare's friends WH Davies and Walter Warren. For Spare, however, he held out less hope:

> ...all the work of his that I have seen is unsuited for domestic decoration. People want pictures that are pleasant to live with. I have not yet met any normal British householders who would care to live with Mr Spare's drawings, or bring up their families on daily contemplation of them. Therefore I rather doubt if the Woolworth plan will benefit him much...

Spare also moved to Lambeth for a while, before finding a more permanent base in 1936 at 56a Walworth Road, Elephant and Castle, coincidentally above the loading bay of Woolworth's.

This was the best studio he had ever had, with plenty of space for storing and exhibiting work. Spare found it through an old friend named Ada Millicent Pain, who now worked for an estate agent. He had known her during his schooldays, when she had been 'walking out' with his brother Will, and re-establishing contact with her was an important point in Spare's life.

Among his visitors at Walworth Road was a young man of about twenty-five named Dennis Bardens, who had quit his job as a milliner's

delivery boy to become a journalist; he worked for a number of papers in the Thirties and was later involved in setting up the BBC television programme *Panorama*. In those days there was a paper called the *Sunday Referee*, which had a 'poetry corner' run by Victor Neuburg, erstwhile friend of Crowley and still a friend of Spare. Neuburg had put the Beast behind him and was now living happily in Boundary Road, Hampstead, with a woman named Runia Tharp. Neuburg had "discovered" Dylan Thomas through his poetry corner, and another of his poetry prize-winners was Bardens, through which he and Neuburg came to know each other.

Bardens was working for the *Daily Express*, in its gleaming black Art Deco building on Fleet Street. This was near Neuburg's office at the *Daily Referee*, and the two of them were drinking coffee in a Fleet Street restaurant named Anderton's Hotel when Neuburg said "You should come and see Austin Osman Spare – he's the best artist alive today..."

They took a double-decker bus down to Walworth Road, where they found Spare's flat above Woolworth's. Bardens was struck by the Spartan quality of the place, with bare floorboards and just a few sticks of furniture, some of it home made, and by Spare himself: "Tall, rugged, relaxed, his eyes glowing with an impressive intensity." Spare had an air of great confidence and self-assurance that day, as if he was indifferent to criticism or praise: "I suppose that to anyone hailed as a genius in his early youth that was hardly surprising."

Bardens was equally impressed by the work itself, which was all over the walls and stacked in folios. Neuburg was well-known for his high-pitched laugh and his nervy, neurotic manner, and the pictures set him off "into extravagant squeaky fits of laughter":

> *the sexual extravagances of the witches, demons, familiars and the rest in their wild and freakish cavortings had obviously a special appeal to him. I was more impressed, I think, by the confident and faultless draughtsmanship, wondering how imaginings so amorphous and outrageous could be translated graphically and realistically.*

It further turned out that Spare seemed to be indifferent to material things, and was selling his pictures at prices that barely paid for the frames: "In the course of time," says Bardens, "I was to discover that certain art connoisseurs such as the artist Frank Brangwyn and Lord Howard De Walden, would insist on paying him a bit more than his price, but this was exceptional as Austin would generally refuse it." Bardens would visit Spare again, gradually coming to see him as a "deeply humanitarian" character and a man "incapable of a mean act".

He also liked his sense of humour, admired his struggle to exist, and came to know something of his deeper preoccupations: "His technique of implanting symbols of wishes and desires into the subconscious mind" and "personally devised cryptology he kept a secret except for a few trusted friends." Bardens would become an important promoter and champion of Spare's work: "This first encounter was to begin a friendship," he says, "that lasted until an hour before he died".

Often said to be reclusive, Spare was far from unvisited. William Smith, a violin maker who was a friend of his sister Ellen, remembered how surprisingly well-informed Spare was, and that he seemed to know more about violins than Smith himself. Changing the subject in conversation, Spare would say "Shall we put another record on?", an expression of the time. Smith helped Spare with some of his exhibitions and he remembered him as a kindly, down-to-earth man, taking milk upstairs for elderly neighbours and building a bird table outside his window.

The young artist Edward Carrick also befriended him, visiting him at Becket House on one occasion and waiting several minutes for the door to open. "Ah, it's you," said Spare when he finally opened it, "I'm bloody well DYING." He was only a few feet from his bed, and he collapsed back on to it. He cheered up a little as they talked, and Carrick suggested he might help him by tidying up the chaotic flat, "a kindness Spare gratefully accepted."

Having first rescued a loaf of bread from its imminent precipitation into the piss-pot, itself cheek-by-jowl with the saucepan, Carrick soon discovered that a number of curiously illustrated cards were strewn amongst the chaos, which he

presumed must be some sort of Tarot. "What's this one then?"
he asked, holding a card up... "Turn it round so I can see,"
said Spare, "Oh – that brings on thunderstorms." Carrick
was still musing on this a few minutes later, when a sudden
and magnificent clap of thunder rattled against the ironwork
balconies... and rain began to lash against the grimy windows.

This seems to have been a 'routine' of Spare's, received by friends with varying degrees of amusement and scepticism.

Spare had a handful of stock topics when he talked about his life in South London, often involving the poverty and brutality of the area. "There was a streak of sadism in the Borough clans that Spare could never fathom." Surreptitiously tying a vehicle to a street coffee stall was a recognised practical joke, so that when the vehicle drove off the stall was pulled down. Fights were common, and Spare had told Clifford Bax how to handle himself if he was caught up in a fight with a gang: hit the biggest one first, he said, and run – advice Bax is unlikely to have needed.

He also talked of the local cruelty to animals, which weighed on his mind. Spare had found a cat that local boys had thrown off the roof, and took it to be put down. Nearby was an alley nicknamed Cat Killer's Alley. Cat fur was saleable, and cat skinners would rip it off the animals, sometimes without making sure they had properly killed them first.

One of Spare's most articulate and vociferous young friends was the somewhat eccentric Oswell Blakeston (1907-85; born Henry Hasslacher, he apparently coined the name Oswell from his admiration for Osbert Sitwell). Blakeston was an art critic, prolific writer - poetry, crime fiction, cookery books, peculiar camp novels - and experimental film maker who was a friend of Dylan Thomas. His tastes were summed up by his partner, Max Chapman, as "a quick eye for the bizarre and the outrageous."

He was at one stage a great fan of Spare's art, although he seems to have taken Spare less seriously as time went on. In Blakeston's 1933 piece 'An Initiate Speaks,' the unnamed initiate has definite flashes of Spare, which grow stronger in his 1950 piece 'Magicians in London':

And it was in London, not Istanbul, that I met my best black
magician. People had told me about him. They said, "He's
an old man now, but his hair is still black and wild. He
lives in a tenement. You'd never dream what a lot of magic
is practised there. Why! He can remember when there was a
cage of skinned live cats on exhibition in the street, and there
was a boy who bit the heads off live rats for sixpence. It's
atmosphere, isn't it?"

On the magician's mantelpiece is a "strange little card": "That!" he says
with a shrug when asked, "That's nothing much. Just a sigil to make it
hail tomorrow."

This weather magic is very powerful, although the magician does
sometimes have to wait a few days before it takes effect. And then, when it
does rain, he finds "I had underrated my own power. I had to will for days
before the rain actually stopped. Think of that!"

"I thought about it," says Blakeston, "and he watched me with
burning eyes to see if I was impressed." He clearly wasn't, and he gives the
knife a few more twists in his 1969 novel *For Crying Out Shroud*, when
the narrator and his friend decide to call on "Old Nick" because he is a bit
of a 'character'.

"The black-magic stuff is pretty off, though, isn't it?"
"It's patter to help him unload his dirty pictures..."
"You laughed at that sigil he had on his mantelpiece."
"He said it was something to make it rain next day."

Old Nick can't help them with the sort of pictures they are looking for;
there has been a police raid. Still, his neighbourhood is on the up and up,
and now it is almost respectable: "He says that a woman will look round
now if she's looking out of a window and someone takes advantage. In the
old days, she wouldn't."

Old Nick has some little spiels about walking in thick London fog
to encourage unconscious guidance, trying to light cigarettes by will power,
and rigging up a camera to scare away a demon by taking its photograph.
He also has a familiar in the form of a pet mouse called Death Posture,

or D.P. for short. Blakeston and Spare seem to have worn each other down a little, if their fictionalised chats are anything to go by, but at least 'Magicians in London' ends on a conciliatory note:

> *"Come back one day," he invited, "and I'll show you all your future in a vision on the wall. You'll like that, won't you? All your future spread out like a map before you... Yes, do come back. I think D.P. has taken a fancy to you."*

Blakeston's idea that his magician had "patter to unload his dirty pictures", and that the police had been round, connects to another mystery about Spare's work. There has always been talk of Spare as a purveyor of erotica, and it has been said that a friend visited his studio within hours of his death and swiftly destroyed the more obscene items ("Spare had earned a small but regular income from such works, finding a ready market amongst certain friends and in the local pubs."). The mystery about this work, until very recently, is why – if it really existed – almost nothing very eyebrow-raising by modern standards has ever been seen again, apart from some informal late drawings at the time he knew Kenneth Grant.

Spare's work for sale and publication, although it is often fleshy and sensual, usually takes great care to conceal male genitals: a thigh, a fig-leaf, even a book in *The Focus of Life*; anything will do. However, an extraordinary album has recently surfaced (in 2009) in which Spare more than redresses the balance, with erections, penetration, and an almost unquantifiable mass of polysexual activity taking place all over the pages.

Thighs seem to grow their own licking faces, a bearded man with breasts gives it to a six-breasted woman while another grotesque figure has him from behind in turn, and disembodied penises sprout in mushroom-like profusion. The most finely finished and unquestionably central figure is a woman on her back (her face never appears) whom we first see vagina-on, with her legs up, as a phallus hovers in the air; she is then bleeding from the vagina, as if deflowered; then seemingly recovered and vaguely beckoning another penis – almost a creature in its own right – with her hand, while rays of light seem to flow out from her buttocks and vagina.

This central woman has strong, heavy hands and forearms, and there is something peculiarly male about her legs: it is particularly obvious below the knee that there is something hard, hairy, and tendony about them. They are, in fact, essentially man's legs, and the short, bristly, curly hair on her head (very distinctive, and almost conventionalized from endless self-portraits) suggests who this man-woman is: it is Spare himself.

The album purports to be a version of *The Focus of Life*, with a similar title page, no text, and most of the other drawing left unfinished, but it is probably not an earlier prototype: stylistically the main suite of drawings seems to date from around the mid-Twenties. It would have been illegal in its day: in 1929 the police closed DH Lawrence's show of his pictures at the Warren Gallery, and they are innocence and health itself compared to Spare's album, which would surely have been described as appealing only to the sickest of minds.

It is particularly interesting, in view of that, to know it was owned by the novelist EM Forster O.M., C.H. (Order of Merit and Companion of Honour, author of *Howard's End* and *A Passage to India*, doyen of the English liberal humanist tradition). Forster may simply have bought it as an isolated piece of erotica from a dealer – he quite liked what he called "smut" – but he owned at least one other Spare and may have had a more general feeling for his work: the god Pan figures in one of Forster's earliest fictions, 'The Story of a Panic' written around 1900, resonating with Spare's satyr imagery.[3]

Changing the record back to Oswell Blakeston for a moment, his Spare-figure is keen on ancient Egypt, as occultists were: "Does not every initiate take the flight into Egypt," writes Blakeston, "even if he does not leave the sofa in his sitting room?".

3. It is not even impossible that Forster and Spare met, although it is hard to say whom they could have known in common; perhaps a figure like the eccentric, gay, Anglo-Indian composer Kaikhosru Sorabji (1892-1988), who was a Spare collector – however, I am not aware that he knew Forster.

Spare showed a Thirties visitor a panel he had painted with Egyptian deities, and explained that he made requests to them:

I do not merely make the request and leave it at that. When I ask for a thing — which I do by placing a note in front of the panel – I deliberately make some sacrifice. I give up smoking — which is a great hardship — or something like that until the request has been granted.

He had already described this "starving of lesser desires" to Bax, and Blakeston's understanding was that the use of sigils was "related to a denial so that the strength of the frustration joins with the summing up of desired achievement."[4]

At the Walworth Road studio, Spare had a lacquered cabinet standing on top of a bureau. It was about two feet square, with double doors. Opening the doors revealed a Buddha, sitting cross-legged on a lotus base, and it was Spare's "superstitious practice" (as remembered by a less superstitious friend) to place a folded note inside the cabinet "and hope that his prayer for a successful exhibition would be answered."

Art has long been bound up with magic – from cave paintings, which seem to have had a magical purpose, to William Burroughs's dictum that "writing is about making it happen" – and this was more than usually the case with Spare. Around the mid-Thirties he found a new patron in a man named William Argent, apparently through a shared interest in electronics. Argent acquired a collection of Spare's work[5] and Spare annotated Argent's copy of Wilde's *The Picture of Dorian Gray*. In the front is a hand-drawn 'Ex-libris William S Argent', but inside the back cover is what must be Spare's reply to Wilde's famous "Art for Art's Sake" dictum at the end of the Preface, when Wilde writes "All art is quite useless."

4. Or in a more sophisticated account: "All habits and behavioural automatisms function as sentient familiars, and, once recognised and isolated, may therefore be induced to set themselves to new tasks." Semple, *Zos-Kia* p.37 n.14.
5. Sold after his death by Lawrence's Auctioneers, Crewkerne, 15th February 2001, *Fine Art and Antiques* lots 361-375.

Spare's refutation of Wilde has some obscure and demanding writing ("Art is essentially ethical being 'graphic' evidence of our harmonic effort by *selective* alignment") but the overall gist is quite clear, blending occultism with Darwinism:

> *All art is of paramount purpose.*
> *If we fail to define its utility that is*
> *a measure of our ignorance and not*
> *the absence of virtue in art. ...*
> *Art is form showing utility*
> *'Aesthetics' is that balance whatsoever the*
> *requirement. The magical colouration*
> *of a butterfly serves its sex and survival*
> *and much more that is occult.*
> *... Nothing survives that is useless.*

Spare was surviving, but the early Thirties had not been good years for him; he had lost direction, he was barely exhibiting, and much of the time he was depressed and drinking. In 1936 it all came together again, when along with the new flat he found a new muse and a new identity.

Thirteen: FATHER OF SURREALISM

Surrealism reached London in the summer of 1936. Salvador Dalí had a show at the Alex, Reid and Lefevre gallery through June and July, and on 11th June the International Surrealist Exhibition opened to a crowd of about two thousand at the New Burlington Gallery, and went on to attract a thousand visitors a day. Dalí gave a lecture wearing a deep-sea diving suit, from which he had to be rescued with a spanner when he began to suffocate. He said he had worn it "To show that I was plunging down deeply into the human mind."

Spare had been doing this for the last couple of decades, and it had done him little good, but suddenly surrealism was all the rage, with its talk of automatism and the unconscious. Writing in the exhibition catalogue, Herbert Read related it to earlier English traditions, and Dalí said "Surrealism is catching on wonderfully in London... awakening the hidden atavisms latent in the English tradition of William Blake, Lewis Carroll, Pre-Raphaelitism, etc."

The English artist Paul Nash also expounded surrealism in *Country Life*, of all places, with particular reference to the surrealist *objet trouvé* or "found object." He went beyond the English scene and related this more interestingly to the animism of primitive peoples, supernatural belief, and even "the idea of giving life to inanimate objects".

Spare was not very impressed with surrealism, but now he had a new identity. Friends rallied to champion him as the great British surrealist, and in autumn 1936 he had an exhibition at his Walworth Road studio with a catalogue essay by Oswell Blakeston (who was also the subject of an exceptional portrait).[1] "Surrealists," said Blakeston,

1. It resurfaced at Christie's South Kensington, 12th May 1994, lot 88.

> *are subtle to marshal under their banner names of the famous*
> *English who displayed treasures of their world before the*
> *surrealist state of mind and art became a movement. Swift is*
> *hailed as surrealist in malice, Mrs Radcliffe in the landscape,*
> *Carroll in nonsense, etc. But none who has written on the*
> *development of surrealism has added to the list: Austin Osman*
> *Spare, Surrealist in Surrealism.*

Blakeston was pulling out all the stops:

> *At his best, Spare's draughtsmanship is on a level with the*
> *masters – the level of Leonardo da Vinci and Holbein. And*
> *those who know Spare's work intimately would willingly give*
> *him the title of a great creator of original forms of expression.*
> *The number of fresh ideas he has introduced into the world of*
> *art must run into thousands.*

Spare was now embarking on a late throw for public recognition, and privately he was enamoured – at least in his way – with Ada Pain: his surrealism was also a romantic joke that he liked to play up in courting her affection, and that year he sent her a birthday card with love from "your surrealist AO Spare."

Spare and Ada Pain also shared an interest in gambling on horses, which had the extra frisson of being illegal except on the race course itself, leading to a shady world of unofficial off-course bookies and bookies' runners.

Back in the days when he was editing *Form* Spare used to pick winners in the office by sticking a pin into a newspaper, but his methods had since become more complicated. Ada would place bets for him (in one letter he tells her that the bookie he knows is undesirable – "hangs about different pubs and I should have to trail him about" – so "you had better get the address of the one you know in the London Road") and he would discuss his methods with her. In one instance he writes her a letter discussing horses with propitious associations in their names, such

as heaven and God (a selection to be refined by attention to the odds). On another occasion he mentions passing a cross-eyed woman in the street, after which he knew his bets would be unlucky.

Gambling is a form of oracle, which is one of the reasons why it is so addictive: over and above the stake, every bet says 'I am/am not lucky', and 'things are/are not going well'. Art critic and one-time gambling addict Peter Fuller discusses this aspect in his essay 'Gambling: A Secular "Religion" for the Obsessional Neurotic'.

Item 176 in Spare's 1936 exhibition catalogue is an oddity: it is a set of "OBEAH CARDS for forecasting race results", available at three guineas, hand drawn, or five shillings printed. The word "Obeah" (a West African and Caribbean magic) is seemingly used here just to mean supernatural, but it wasn't long before these cards were re-christened into one of his most peculiar works, his "Surrealist Racing Forecast Cards".

The cards were numbered from 25 to 50 and each one bore an identical face drawn in Spare's 'automatic' style of looping or flame-like calligraphy, including a wing, a subsidiary face and a couple of animaloid heads.[2] They came in a small brown manila envelope stamped 'SURREALIST Racing Forecast Cards: Read instructions carefully.' These instructions had a further instruction within, marked "After memorising the portion in pencil please obliterate." No copies of this portion seem to survive, if it was ever there.

The use of the cards is obscure, although they may be related to Spare's earlier Arena of Anon, the divinatory card system announced at the back of *The Anathema of Zos* (Arena, in the days of hand-written copy for printers, is very possibly a misprint or misunderstanding of Arcana). It is likely that Spare saw the cards themselves as entities or familiars. Dennis Bardens helped him to sell them with a charmingly reasonable small advert in the *Exchange and Mart*, and according to Bardens they were "a roaring success".

Spare's Surrealist Racing Forecast Cards are an artwork based on gambling; a rare combination. In that sense their only real comparison in the art history canon – conceptual, slightly jokey, but supposedly

2. Re-using the drawing 'Realization of Karma' from *The Book of Pleasure*.

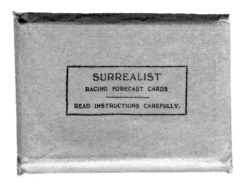

UNLUCKY AT GAMBLING ?
If so why not experiment by buying a pack of
Surrealist Forecast Cards? Designed by a famous
mystic artist and author, they were originally
intended as a joke, but he found that they picked
the winners in his case, and in many others.
Can be used for any race, anywhere, any year,
and the same pack will last for years. These
cards are not guaranteed, as they re-act differ-
ently in the case of each individual, but they do
enable you to conduct an interesting and perhaps
profitable experiment with luck. Obviously, if
they were infallible we should be so rich that we
wouldn't need to advertise them. So we make
this very fair offer. Buy a pack with full instruc-
tions, for 5/-. If you find them to be of no use
to you your money will be refunded without
question or argument.
 SURREALIST FORECAST CARDS,
 261, Lauderdale Mansions, London, W.9

practical – has to be Marcel Duchamp's roulette system. In the early 1920s
Duchamp became interested in "the secret truth of numbers", culminating
in a plan for a roulette system where "one neither wins nor loses". In 1924
he launched a bond for investors in his roulette scheme; the celebrated
Monte Carlo Bond. Thirty of these were issued at five hundred francs apiece,
and promised investors an annual dividend of twenty percent. Each bond
featured a photograph of Duchamp against a roulette wheel, with his
soapy hair pulled up to make two horns on his head, to represent Hermes,
and they were signed by Duchamp and his female alter ego Rrose Sélavy.
The roulette system failed, but the bonds have nevertheless proved to be a
very sound investment.

Spare may never have heard of Marcel Duchamp, but in the end they were both gamblers in the same lottery, the lottery of artistic posterity. In the words of Duchamp,

> *Artists throughout history are like the gamblers of Monte Carlo, and this blind lottery allows some to succeed and ruins others. In my opinion, neither the winners nor the losers are worth worrying about. Everything happens through pure luck. Posterity is a real bitch who cheats some, reinstates others (El Greco) and reserves the right to change her mind every fifty years.*

Fate dealt Spare a wild card for posterity around 1936, when Adolf Hitler apparently contacted him to ask for a portrait. It seems a member of the German Embassy staff bought a portrait by Spare and sent it to Hitler as a present. Hitler was sufficiently impressed, so the story goes, to offer to fly Spare to Berlin to paint his portrait, but Spare refused. In response to Hitler's request he wrote "Only from negations can I wholesomely conceive you. For I know of no courage sufficient to stomach your aspirations and ultimates. If you are superman let me be forever animal." It is far from clear if this reply was ever sent, or even composed before the War.

This story has been told a number of times and the details vary, but there does seem to be something behind it. The picture the Embassy man bought was either a portrait, a self-portrait of Spare, or a self-portrait of Spare "as" Hitler, merging their features: "a marvellous *dual* likeness in one face." Spare did have a small moustache at the time. Whatever the original picture was, Spare did do a later portrait of himself looking like Hitler, with his "reply" written on the picture, and it was at one time owned by Hannen Swaffer.[3]

Wary, resolute and defiant, Spare's self portrait has a neurotic, 'put upon' look about the eyes that chimes with Hitler himself, at least in Orwell's unexpected description of him with his "pathetic, dog-like

3. Probably the picture – depending how many Spare did on this theme – *Self re Hitler*, catalogued as *Self as Hitler*, Bonhams Knightsbridge *Modern Pictures*, 18th March 2008 lot 63, illustrated with text visible.

face, the face of a man suffering under innumerable wrongs. In a rather
more manly way it reproduces the expression of innumerable pictures of
Christ Crucified."

Spare also attempted to photograph himself naked as
Christ on the cross, or so he told a friend: "He set up the camera
and flood lights and jumped into position, but the magnesium
exploded in his face and singed off his eyebrows." Perhaps it
did. But whether Spare depicted himself as Hitler and Christ, or
simply as Hitler, this kind of posing as others is almost without
parallel at the time, oddly anticipating the work of the American
artist Cindy Sherman; a definite winner in the art lottery.

A new friend arrived on the scene in 1937. Aged twenty-one and a native
of Brixton, Frank Letchford was a draper's clerk with an interest in art;
he had already been putting together scrapbooks on Picasso. Modern art
was related to Letchford's larger passion for the exotic, which (in a rather
English way, perhaps) he tended to follow in a mild, vicarious fashion
through books and cigarette cards.

On 13th October 1937 Letchford read a piece in the *Daily Herald*
by the once celebrated journalist HV Morton, entitled 'H.V. MORTON
FINDS A GENIUS!' The genius was none other than Spare, "Alley
artist who prefers painting to money", and he was quoted saying "I don't
like food, I don't want a motor car, I don't want a house or what people
call pleasure."

Letchford was intrigued and he plucked up his courage to visit the
genius, going down to the Elephant and Castle and looking for the alley.
There was a pub called the Elephant, a railway bridge, and a Woolworth's
("Nothing over Sixpence"):

> *The approach to the doorway lay up a cul-de-sac leading to a*
> *Woolworth's loading bay. Pinned to the door lintel was a piece of*
> *fluttering paper with the curt command 'Exhibition, Upstairs,*
> *turn left'... I knocked, and down the stairs tumbled an unkempt*
> *figure dressed in a crumpled suit and muffler. Austin gazed at*

me quizzically, turned away and belted upstairs again, two
steps at a time.

Spare waved Letchford into the only piece of furniture, a horsehair armchair, and began to hold forth: "every aspect of philosophy, psychology, art, literature, architecture, sculpture, music, the occult and the shocking price of meat." Spare told him about tapping into animal ancestry through "atavism", explained the correct way to use French polish, and mentioned that he had met his old headmaster from Kennington Church School, who had become an alcoholic tramp.

He also told Letchford about the local underworld, including the Elephant Gang, who had recently pulled off a jewellery raid in Bond Street, and about boys he had been at school with who were now "smash-and-grab raiders, coppers narks, bookies runners, old clothes dealers, etc." Letchford was fascinated, and in due course he would become probably Spare's most loyal friend and our most reliable witness to his life, setting himself up as Boswell to the man he remembered as "wonderful old Austin."

Or "wonderful old Aw-stin", which was how Letchford and many of the other people in this book, including Spare himself, pronounced his name, rather than "Ostin". This erroneous-sounding pronunciation should be heard less as an error and more as part of the London speech of the time, like the consistent pronunciations of "vayz" for vase, "inter-*rest*-in" with the stress on the third syllable, and "kayf" for café.

Germany may have approached Spare in 1936, but around 1938 and 1939 Spare revisited the story. This time he had flown to Germany, he had painted Hitler's portrait, and now – having somehow brought it back with him – he was going to incorporate it into an anti-Nazi artwork, perhaps even a magical one, or a work of surrealistic propaganda. 'Hitler Posed For Anti-Nazi Poster' said the headline in the *South London Observer*, a story also run by the *Daily Mirror* with the more circumspect addition "... claims Austin Osman Spare."

Spare told Letchford that he had been naive until 1936, by which he seems to have meant that it was only then that he had really learned the value of publicity, and the need to promote himself as a character. Certainly his 1936, 1937 and 1938 shows at Walworth Road were all successful, helped along by catalogue essays from friends, and newspaper reports noted the Rolls-Royces and Bentleys parked among the costermongers' barrows.

Spare had meanwhile opened the Austin Spare School of Draughtsmanship in his studio (where he was, by all accounts, a highly effective and sympathetic teacher of basic skills) and was sometimes said to have a number of 'top people' among his pupils;[4] a story he may have started himself.

The surrealism angle was also revived in 1938, coinciding with the International Surrealist Exhibition in Paris. Organised by Duchamp and featuring Salvador Dalí's *Rainy Taxi*, which included a blonde mannikin crawling with live snails, it was widely mentioned in the British press. Cub reporter Hubert Nicholson was looking for a human interest feature and called on a "poet in Golders Green" (possibly Victor Neuburg) who was ill in bed. His wife, however, suggested Spare: "He's a story," she said, "Look at this book"

> *...and she showed me a book of fantastic automatic and unconscious drawings – all done before the last war.*

4. Including "two cabinet ministers, the head of the BBC and two foreign diplomats", according to the 1964 Greenwich Gallery catalogue.

Sidebar (advertisement):

56A, 56, 58 Walworth Road, S.E.17, is over "Harrison & Morris."

The following high class shops within the vicinity of the Studio will courteously oblige with direction:

"Harrison & Morris" (Consulate Shirts), 58 Walworth Road.

John Newton (Tailors), Ltd. 40 Walworth Road.

"Broadlands," 22 Walworth Road (Tobacco and Confectionery).

Mr. Ingram, "Black Prince," 29 Walworth Road (Nearest Barclay House).

G. Baldwin & Co., 77 Walworth Road (Herbalists).

"Collier's Furniture Stores," 46 Walworth Road.

"Woolworth's," Newington Butts.

W. Love, 61 Newington Butts (Picture Framer).

"Barnes' Pianos," 56 and 59 Walworth Road.

Dales' (Tailoring Dept.), 99 Walworth Road.

Dales' (Gent's Headwear, etc.), 271 Walworth Road (under personal supervision of Mr. Dale).

64559 GILLETT BROS. LTD., PRINTERS (T.U.), LONDON, E.17

It was a pre-surrealism; and when I learned that the artist would have nothing to do with Bond Street, but lived in Walworth Road near the Elephant and Castle, I began to see a daily-newspaper story in it. The inventor of surrealism, a Cockney, living among the fruit-barrows of the Walworth Road! There was a surrealist exhibition in Paris just then and it had had sensational publicity.

There was just one thing, she said:

"Don't try to bait him with the idea that the publicity will do him good or anything of that sort; otherwise he'll shut up like an oyster. Appeal to him to help you and there's nothing he won't do."

Around midnight Nicholson and a friend found the alley, and banged on a door which had crowbar marks around the lock. Spare appeared, holding a lamp, and led them up several unlit staircases "into his great bare echoing rooms, which were evidently galleries as well as studios. We sat in a small circle of lamplight."

It was midnight, and I was a stranger, but this rugged solitary artist opened up his mind to me, showed me every picture he had, told me his methods of work and the history of his development. Long before the Freudian fashion, he had based himself on the assumption that the subconscious mind and its emotional sources were the main fountains of art...

He talked very eloquently about this, and a lot of other astonishing things as well...

And how when he had a show of some hundreds of pictures, all cheapish, in these same rooms, every year, he sold out – mostly to dealers, who believed there would be posthumous fame for him (he was tickled by this grim gambling of theirs).

Spare told Nicholson that John Singer Sargent had called him a genius in his youth, but now, writes Nicholson, "his woolly hair was greying and he goggled through glasses and he had never become a big celebrity; but he seemed to have philosophic satisfactions of his own." Nicholson had his story, which duly appeared under the memorable headline "Father of Surrealism – He's a Cockney!"[5] It was not a new idea – Blakeston and others had been there in 1936 – and as we have seen, Spare's apparent resemblance to surrealism had roots of its own, chiefly in occultism and spiritualism.

Having said that, these same roots were also under surrealism; late surrealism converged with occultism, but early surrealism was already entwined with it, as in Breton's essay 'Enter the Mediums' in 1922, Aragon's 'Enter the Succubi' in 1925, and Breton's 'The Automatic Message' (again about mediumism, and featuring Myers and Flournoy) in 1933. Surrealism, said Breton, took over "what remained of mediumistic communication once we had freed it from the insane metaphysical implications it had once entailed."

Spare, similarly, had a largely 'psychological' and internal approach to spirits and mediumism, describing the passivity of the medium as the "opening out of the Ego to (*what is called*) any external influence" [my emphasis] and using psychological jargon in his piece on Automatic Drawing, leading up to his own credo that "Genius is obsession."

His automatic drawing was also in harmony with surrealistic automatism. Whereas a good deal of spiritualistic automatism involved fantastically laborious elaboration, suggestive of someone's tongue sticking out with concentration (like the work of East London spiritualist Madge Gill (1882-1961), built up from closely patterned geometric detail in the manner of outsider art) Spare's automatism is whipped up from the same kind of rapid and flowing line that Breton writes about ("What is Art Nouveau if not an attempt to generalise and adapt mediumistic drawing...?")

Even Oswell Blakeston's excitable description of *The Book of Self-Love* [sic] as "the first text-book on how to be a surrealist and why" can be related to Breton on surrealism and what Breton says "following Bleuler,

5. *Daily Sketch*, 25th Feb, 1938.

has been called autism (egocentricity)." Breton elaborates by saying that surrealism is ultimately interested (like Spare in his Death Posture) only in "the conversion of the being into a jewel, internal and unseeing, with a soul which is neither of ice nor of fire."

So despite Spare's main artistic affiliation – as an eccentric English Symbolist – he did anticipate surrealism in several respects, and an initially naive-sounding comparison like the Nicholson headline "Father of Surrealism – He's a Cockney!" can be made more plausibly. Perhaps there was something in it after all.

Around 1934 Spare had launched another line in his output, with 'straight' portraits and character studies of local South Londoners; "spivs, higglers, tapsters, billiard-cue markers and taxi drivers" as HV Morton described them, in their flat caps and trilbies. Morton admired a nude of Spare's old charlady, the mother of five rickety children, and other models included female shop assistants from the Woolworth's below, where Spare also found pastel crayons. Spare's models were often elderly; he told Frank Letchford that all his old women were over seventy, and Letchford remembered "These remarkably lively ladies would creep shyly upstairs during the course of his exhibitions to gaze with glee at themselves and their cronies lining the walls."

Spare felt an admiration and sympathy for these women, and he remembered a washerwoman who used to walk from London Bridge to St. George's Road and back again, about four miles in all, with a quarter hundredweight of washing on her back. Pointing out a picture of a woman aged ninety-three, he said "They patiently put up with all kinds of worry, overwork and illness, but they live long because they are wanted"; if only as "charwomen and cleaners." He was also aware of the large number of elderly women living alone, and the fact that when they died, "surrounded by years of accumulated rubbish", (in Letchford's paraphrase) "the police had the odious task of digging them out of their hovels."

Spare planned a series of old-time London newspaper sellers, already thought to be "fast disappearing", and tramps were always welcome, like his old headmaster. Spare liked old-style tramps, and in

1939 he told Letchford that he had thought of opening a hostel for them, little knowing he would one day be in such a hostel himself.

The germ of all Spare's Cockney portraits was already there in his youth, at the time of his 1904 interviews. "I look about for character," he told a journalist. "That picture on the wall is the picture of a costermonger whom I came across in the streets."

People looked different then; not just more heavily and formally dressed, but often older for their ages, and with more of that elusive thing called 'character' (anyone who doubts this should watch the 1964 documentary with James Mason, *The London Nobody Knows*, after Geoffrey Fletcher's book, filled with a dying breed of poor Londoners who seem to be only just surviving from Spare portraits). As one of Spare's most informed champions has written:

> *his compassion for the difficult lives of those who surrounded*
> *him revealed the pathos and stoicism of the British working*
> *class. His body of portraiture of 'local types' between 1934 and*
> *1955 must rank as one of the most important social documents*
> *of London life on the cusp of a period of enormous change.*

It was these Cockneys, more than almost any other group, who were to be swept away by the Second World War and its aftermath.

Spare and Letchford had now become great friends, and they would often go for evening walks visiting pubs in the City and Bankside districts, around Blackfriars and Southwark Bridges. Like much of London, these areas were still illuminated by gas-lamps, lit by a man who would come walking round with a long pole. They visited largely vanished pubs including the Tabard, the Cock, the Skinner's Arms, the Hole in the Wall, the Giraffe, the World's End, the Men of the World, the World Turned Upside Down, and the White Horse, and Spare also liked the galleried coaching inn The George on Borough High Street. At one stage he dreamed of building a house at Bankside, on a derelict patch by Cardinal Cap Alley, looking across to St. Paul's.

The possibility of conflict with Germany was on everyone's mind. WH Auden was sure there would be no war, having been told as much by a fortune teller, and Osbert Sitwell remembered the reassurance given out at a spiritualist séance: "I see white doves," said the medium, "fluttering over Europe, 'undreds and 'undreds of 'em." Spare was under no such illusions. He suddenly stopped walking as he and Letchford were going down Pudding Lane, where the Great Fire of London had begun, and he seemed lost in thought for a few moments. "Well, Frank," he said at last, "wars come and go, but Art lives on for ever."

Fourteen: HITLER'S REVENGE

Spare had wanted to stay out of the First War, but he was keen to play a part in the Second. He tried to enlist in some capacity but – not surprisingly, as a man of fifty-two with a good spread of physical and mental problems – he was graded C3 and rejected.

He turned his attentions to camouflage, and claimed experience of designing it in the First War. There is little evidence that he had any,[1] but his ideas were sound. He based much of his thinking on camouflage in the animal kingdom, partly researched from a set of cigarette cards, and his main idea was that camouflage should be based on different tonal values – a disruption of lighter and darker, losing the outline of the object – rather than on different colours. Greens and browns with the same tonal value, for example, were indistinguishable from each other at a distance and left the object looking solidly visible.

Amateurs up and down the country were sending their ideas to the War Office. Spare seems to have gone to the War Office, the Admiralty, and the Air Ministry, but he was treated with respect only in the *News Chronicle*, by journalist Lionel Hale. In a piece headed 'The Invisible Man (and A New Theory for Camouflage)' Hale recounted his visit to Spare's studio: he had found him in an untidy unheated room where Spare, with a coat over his shoulders, talked animatedly about his theories and his luck with them: he'd been "humbugged about", he said, and would have done better selling carpet sweepers.

1. Spare's claim is probably the origin of Letchford's belief that Spare worked with Colonel Solomon J Solomon in the First War. Spare claimed experience of camouflage; Letchford, researching after his death, would have discovered that Solomon was in charge of camouflage, so – if Spare *had* worked with it – Solomon would have been his superior.

His pictures look down from the walls. Faces of London charwomen; heads of costers; and nudes ("a girl from Woolworth's sat for that one"); and among them sits Mr Spare, with 200 careful designs, and a new theory for camouflage, pretty angry that the authorities treat him lackadaisically.

The piece was accompanied by photographs of Spare ("camouflage artist in the last war") putting the finishing touches to a commando uniform.

At last, despite all his frustrations, Spare still conjured up a clutch of success stories, not unlike the revived Hitler portrait story. The commandos adopted his uniform and the War Office gave him ten pounds; a firm of motor manufacturers gave him a further five pounds; a gasometer was painted to his designs; and he designed a portable aircraft hangar, an improved plan for aeroplane wings, a plan for streamlined aircraft, and a slotted wing (later patented by Handley-Page). Sadly "he found it impossible to exploit all his ideas", as Frank Letchford tactfully put it, although at least he "had been appointed an Official War Artist, or so he said."

Not all Londoners were behind the war effort, particularly in East and South London. Black marketeers and spivs were suddenly in the ascendant (and later recorded by Spare in pictures such as *Spiv Rex*). Crime and even sabotage swept through Southwark, with unknown hands dropping heavy bolts into tramway grooves. A few of these people might have been Nazi sympathisers and Fifth Columnists, much feared at the time, but most were just vandals, excited by the black-out and the air of impending anarchy. Reckless behaviour in general, and promiscuity in particular, famously increased in London during the Second World War, and Letchford remembered that during the black-out, "tarts, hiding in West End shop doorways, shone small hand torches upon bare white breasts."

Letchford joined the RAF, where he was nicknamed The Prof, and went to India, where he caught tuberculosis but saw exotic sights – "bazaars, Jain temples, crematory ghats, Shaivite sadhus" – that far exceeded the 1924 Empire Exhibition (which he and Spare had both been

to see, unaware of each other). He survived his tuberculosis; luckier than Victor Neuburg, who died of it in 1940. Shortly before Neuburg died he suggested that one of his death-bed visitors – a woman named Vera Wainwright, who was interested in art – should go and see Spare in his studio, and she became a close friend.

Dennis Bardens, who was now working at the *Daily Mirror*, joined the Royal Artillery, but before he went to war he and his wife visited Spare in his studio. The Blitz had already begun but they found Spare quite untroubled by it, except for an experience he said he'd had when walking by an undertaker's shop: he saw numerous people coming out of it towards him – dead people, as it turned out – and this "so confused him that in trying to avoid them he bumped into living people, who were unconvinced by his apologies."

Spare was working as a fire watcher, and had embarked on a series of portraits of ARP wardens. In the winter of 1940 a bomb crashed through Spare's roof and went through the floor without exploding, leaving the studio looking more chaotic than usual (this really happened; the debris and the hole in the floor were seen by Spare's policeman friend John "Smithy" Smith, among others). Spare stayed on in the building, and seems to have taken in it in his stride.

He experienced some bad omens, nevertheless. One day in a pub he noticed that the wet beer spilt on the bar counter took the form of a vulture, and not long afterwards he was lighting a Swan match when the entire box caught fire, exploded in his hand, and burnt him.

The night of the tenth of May 1941 was the worst of the Blitz, devastating the Elephant and Castle. Spurgeon's Tabernacle church, a landmark then as now, was left with only its pillared facade standing, smoke blackened, with the church behind it gone and the area around it largely razed. Spare was out on fire-watching duty, on Collier's department store further along the Walworth Road, when a bomb completely destroyed his studio. A bleak new era in his life had begun.

Spare lost everything: his Buddha was gone (subsequently described as "Shrine in Cabinet" and valued at £4/10/– in a War Damage claim) and with it some two or three hundred pictures; Letchford comments that the loss of Spare's wartime portraits in particular, which he had seen, was a tragedy "not only for art but also for the social history of Southwark."

Spare was now homeless. The landlord of the nearby King's Arms pub, Victor Rosati ("Mr Vic"), offered to take him in, but Spare found a bed in a working men's hostel on Walworth Road ("really just a doss house of the Rowton House variety"). He had written to Letchford saying he was sick of being "pushed around by that man" (i.e. Hitler, as in the wartime comedy show ITMA; "It's That Man Again"). Letchford visited as soon as he could, and found Spare playing dominoes with a group of other men in a large smoky room. "Sheer bad luck, Frank," he said, adding "It was Hitler's revenge."

Spare had picked up fleas, and he was dressed like a sailor in a merchant seaman's jumper and reefer jacket, both charitable handouts; his clothes had gone with everything else on the night of the tenth. He had suffered cuts, bruises, and an injured arm, but his real injuries went deeper. He seems to have suffered a loss of memory and some degree of paralysis to his hands, leaving him unable to draw.

Spare and Letchford went for a walk around the Walworth area, but almost everything had disappeared into rubble. "A large department store had dissolved into air-space," says Letchford; "my eyes automatically had sought its illuminated clock." Letchford could barely tell where he was, looking at a map to pick out the pattern of the roads, but for some people it was business as usual, and Spare pointed out the places where looted and black market goods were sold.

Bardens and particularly Letchford did what they could to help Spare, along with one of his former drawing pupils named Donald Bowen. Later to become an African art specialist and a curator at the Commonwealth Institute, Bowen had warm memories of Spare from happier days before the War: "I remember one day leaving his flat with him and his saying, 'That's one of my models'. I looked around only to realize that he meant an elderly woman standing by her barrow of fruit."

Bowen had a stroke of collector's luck with Spare during the war. Ever since being a student he had wanted to own a Spare self-portrait and, walking down the Charing Cross Road while he was on leave in 1941, he found an old copy of *Form* in a bookshop: "and there, between the pages and in pristine condition, was a self-portrait in pastel. Fortunately I was no longer a poor art student but an affluent lance-corporal and I bought my first work of art. I recounted the incident to Spare; apparently he had often inserted a drawing between the pages of the publication."

In due course Spare found a shared work space in a sculptor's studio at 17 Leyden Street, Spitalfields, but he disliked it, and never went back to the East End. He tried to keep his 'School of Draughtsmanship' going there, and said he was working with plasticine or clay figures, lit by candlelight, to create miniature scenarios which he would then photograph. It may have been an alternative to drawing, which he was finding difficult. One of his sketch books from 1942 is inscribed "In search of a new aesthetic: effort to recover memory."

Spare now turned to Ada "Millie" Pain for help and shelter. Her mother had recently died and she had a house to herself at 5 Wynne Road, Brixton, although it was in a bad state, with rain coming into the upstairs rooms. Miss Pain remembered returning home from work one day after being told by an air raid warden that there was a man on her doorstep waiting for her. It was Spare, who had been waiting a long time, "silent, dazed, almost a ghost". He hugged her in the hallway, which she noticed was a little out of character: "Not that Austin was *demonstrative*, as you know," she said to Letchford after his death.

She found a space for Spare in the dark, damp basement, where the front window was boarded over. It was far from ideal as a studio – not only was the light bad, but it was too cramped to stand back from work in progress and look at it properly – but he moved in thinking it would only be temporary.

Spare's friendship with Vera Wainwright was also blossoming around this time, after Neuburg sent her to his studio. Born in 1893, Wainwright

was a poet, artist and woman of letters. After a fairly unhappy childhood, suffering from a curvature of the spine and boarding at a Catholic convent school, which she disliked, she studied art on the continent and knew a number of literary figures including Victor Neuburg, Walter de la Mare, Algernon Blackwood and the Powys brothers.

Spare was unreliable, and sometimes failed to turn up for assignations; Vera was understandably annoyed by this, and her letters alternate between "Dearest Austin" and "Dear Mr A Spare". He was probably nervous and absent-minded rather than indifferent, because he at least went to the trouble of getting a suit to meet her in, bartering some pictures with a tailor while he was still living in the hostel.

Spare went to see her in Surrey and Cornwall, and together they planned to produce a new literary and artistic monthly magazine, to be entitled 'Art and Letters,' or 'Word and Sign'. Spare hoped to have the first copy out, priced sixpence, by November 1944, using the Co-Operative Printing Society: the same firm that had produced *The Book of Pleasure* in his youth.

Nothing came of it, but Spare's projected "contributors" – several already dead – give an interesting glimpse of his tastes and prejudices, as well as Vera's contacts. Defiantly unfashionable and non-modernist (Vera's poetry was also of a traditional kind), the magazine was to feature Clifford Bax, JC Squire, Walter de la Mare, Algernon Blackwood, John Austen, Alan Odle, Ethelbert White, Osbert Sitwell "and his sister" (he was thinking of Edith), Bernard Shaw "perhaps," and John Nash "but not Paul."[2] Paul and John Nash were brothers; Paul modernist-surrealist and John more traditionalist.

Spare also sought Vera's advice on possible subjects for his work, such as "dramatic subjects that can be expressed in the head and hands mainly." Spare suggested Caesar's expression while being stabbed, and Christ's head ("overdone of course – but might succeed"), noting that his favourite figure was St. Francis, but that he didn't lend himself to the sort of work he had in mind; so "suggestions would help – the more terrible the better."

2. Bloomsbury Book Auctions 20th June 2005, lot 182, a collection of Spare and Wainwright material including sketches, letters and photographs.

Vera wrote to Spare at one point, "I conclude that you are on the threshold of sainthood but have not yet crossed it! You still face darkness often, but you could turn towards the light – as it is there at your elbow. You could be quite a wonderful person, but... there is still a little devil at your coat-tail!"

Spare was no ladykiller at this stage, if he ever had been, and Vera was amused by the way he produced his dentures from a box at tea-time. Nevertheless she had hopes they might live together, and signs off one of her letters

> *With my love, dear Austin*
> *Vera*
> *PS supposing it does not go beyond "very close friendship", will*
> *you find that still worth having?*

Her hopes of a shared life led to an unfortunate misunderstanding over money. Vera seems to have thought she was sending Spare money to save up for a deposit on a flat, while he seems to have thought that she was giving it to him for art lessons.

In the event their collaboration was not to bear fruit until they were both dead: Wainwright's slim volume of poetry *Poems and Masks* appeared in 1967, shortly after her death, with drawings by Spare. "Finally," she writes in the acknowledgements, "I would like to express my admiration and affection for Austin O Spare, who, when he was in dire poverty, drew these designs for my book."

Spare remembered Vera in his will, but he wasn't very demonstrative, as Ada Pain had said; or in the words of Vera herself, appositely cited by Letchford, "Human relationships are very mysterious."

Spare's mother had died in 1940, in Wales. He seems to have been virtually estranged from her by now, and the administration of the estate was in the hands of Cissy, the elder sister who disliked him· this was another nail in his coffin financially. Around 1943 a local journalist visited him in the basement, and wrote his situation up as a human interest story:

FAMOUS ARTIST, BLITZ VICTIM, BLAMES FATE. There he was, once a great artist, but now "living in extreme poverty. His is no story of artistic temperament getting the better of common sense. It is simply a tragedy of the war. Spare bears it philosophically. 'Sheer bad luck,' he says."

Still not back to drawing, with his injured right arm, and unable to run his draughtsmanship school in the basement, Spare had received six pounds from the authorities to buy clothing, followed by another £87 in compensation six months later. A further claim was still pending. Meanwhile,

> Now 56 years old, this friendly man with the mop of grey hair, wearing an old Army shirt, tattered tweed jacket, shabby trousers and broken, patched shoes, remains cheerful.

> If better times come he will still refuse to become a fashionable painter. He will do his inimitable portraits of ordinary people – the charwoman, the newsboy, the barman – the studies that were making him famous. [...]

> On Spare's battered old table was a little tin box of coloured pencils and a few postcards, the only equipment this great "artist of the people" possesses.

Spare had no bed and slept on two chairs. He was now surrounded by cats, like familiar spirits, due to the large number of strays that had gone wild and bred in London during the Blitz; hordes of them materialised regularly at a bomb site where Spare fed them once a day. Photographs of the period show him with cats all around, and with a new air about him: like the degenerate look of Antonin Artaud or Chet Baker in their later years, a 'touched' look has now crept into Spare's face, largely due to malnutrition and toothlessness in combination with the intensity of his eyes.

When Bardens first tracked him down to Wynne Road in 1942 he had found him in a very bad way: depressed, half-mad, unable to work, confabulating about his Blitz experience and talking of a broken leg. "He

seems to have lost interest in things," Bardens wrote in his diary, but "offered to kill Hitler by Black Magic."

Bardens later recalled Spare around the end of the war as being in

*one of the saddest and most distressing periods of his life. He...
slept on an old wheelback chair on newspapers which had
shaped themselves to the pressure of his body and formed a
rudimentary mattress. There were hordes of cats, all of which
got fed somehow. His face was gaunt, but his eyes glowed with
the same deep spiritual intensity which gave his features such
strength, in health or sickness.*

Spare may have put on a brave face for the journalist, but Bardens found him "badly traumatised" (as Letchford had: "near to being a nervous wreck; he returned again and again to the indelible memories of the blitz") and with his hands paralysed: "Laboriously, painfully, he was trying to regain the use of his muscles by exercises, day and night; he wrote as a child might, but, amazingly, towards the end of the war he was drawing and painting again."

By the end of the War, Spare was filling sketchbooks with work, including one of 1944-45 entitled 'Adventures in Limbo'. Pyramids rise over a bare landscape which includes standing stones with faces, while an occasional plant-like form with an Art Nouveau luxuriance rises in the foreground. Here and there are human figures, drawn with great attention to the drapery of their clothing. Wherever this place is, it has distinct affinities to the landscapes drawn around 1930; another difficult period. There are similar draped figures in another sketchbook from the end of the war entitled 'Enthosthorasis', while another called 'The Static Alignments'[3] seems to concentrate on faces, and 'A Book of Satyrs', re-using his old title, on satyrized male faces.

Spare seems to have had a crisis of confidence around this period.

3. Four sketchbooks at Bonhams, *Twentieth Century British Art*, 11th July 2006, lots 11-13.

Writing to Letchford about art students, but perhaps thinking of himself, he went on to produce story after story of individuals who had once been inspired but lost their talent. A ship's captain had shown Spare an extraordinary "psychic picture" of the ship's cat, but it was his only work; a young titled woman had produced beautiful watercolours for seven months then dried up altogether; his doctor's wife had painted three pictures and stopped for good; and he said he had read in a newspaper about a working-class lad, a barrow boy, who had produced extraordinary pictures up until the age of fifteen and then stopped, unable to draw another line.

Young people were often like that, said Spare, because they were "fine mediums for the obsession... the difficulty being to get the *right* obsession and to retain it." In fact, he said, he was a case in point himself: he had been praised for his genius by Watts, Sargent, Augustus John, and Brangwyn between the ages of eleven and sixteen, but then somehow lost it on account of laziness. Encouraging Letchford to persevere with his own drawing the following year, Spare explained that art wasn't just about flashes of inspiration, but was more a matter of sticking at it: it was, he wrote, really about "moral courage".

And as Letchford and Bardens both noticed around the end of the war, Spare himself was now working "like a demon" (Letchford); "with demoniac energy" (Bardens). The time had arrived for the great post-war comeback.

Fifteen: THE COMEBACK

London was a changed place after the War. Some of the social changes were almost too late for Spare, although he noticed them; one of his post-war pictures is entitled *Docker with National Teeth,* or NHS dentures. Among his usually contrarian beliefs he thought that in the post-war world there was "Never more talk of democracy and actually less." He disliked party politics, paid tax reluctantly when he did, and considered himself an "Individualist." He believed nobody should earn more than two thousand pounds a year (about £50,000 today) and that society needed a return to craftsmanship.

The quality of the material world was declining, with plywood and veneer replacing real wood; Spare complained to Letchford about the way that softwood pine, with a grain pattern brushed on, was being passed off as oak. Small old-fashioned shops were already disappearing, or not being replaced after war damage; Spare remembered that in pre-war Kennington there had been clog-makers, a taxidermist, and shops selling home-made jam and cheese.

Like the slightly later belief that freak bad weather was somehow caused by the Russians, Spare held a number of odd views characteristic of his day. A rise in lung cancer had been noticed but not yet attributed to smoking, and Spare believed it was caused by the use of tarmac on roads. Silver coinage was no longer made of real silver (it was nickel after 1947), because they were keeping the silver back for building nuclear power stations. And space travel was, of course, impossible; after all, how could you steer in a vacuum?

Things were more expensive than they had been, and less honest. A pre-war tram fare of a penny-halfpenny – Brixton to Blackfriars – had become a bus fare of fivepence. A pub that had sold proper food like pies and saveloys and black pudding now served up an imitation middle-class meal of three small courses, beginning with a splosh of soup. Typical of the follies of the day was the antique dealer's trick of selling old bedside chamber-pot cupboards as drink cupboards or "cocktail cabinets."

Spare noticed that kind of thing because he was still dealing himself, in a small way, trying to scratch a living. He made old parchment deeds into lampshades, cleaned oil paintings, and did what he could with batches of old prints and job lots of frames. He offered Letchford a blackened silver-plate boat race trophy, eventually getting a couple of pounds for it from a local grocer.

According to Hannen Swaffer, Spare lived for several months around this time on nine shillings a week. Things were tight. It was his practice to cash a cheque for five pounds at the bank and make it last; banks would return used cheques in those days and a number of these survive, naturally enough (but still resonantly, in Spare's case, given his earlier writing) made out to "Self."

An official from the War Damage Commission described Spare in his basement as looking and living like a tramp. He used newspaper in place of tablecloth and sometimes plates, eating pie or cake off the *Evening Standard*. He wore his raincoat indoors and he was increasingly neglecting to eat properly; his meat ration was given to the cats, and a

nephew remembered him living out of tins. Boiled white fish was another staple and, more than that, he was beginning to rely on milk in place of food.

This might suggest he was trying to treat himself for gastric trouble such as ulcers, or the "indigestion" he complained of. Spare had long suffered from poor health, and now he had "anaemia," possibly from internal bleeding, along with his old troubles such as exhaustion, piles, and ear problems. Letchford noticed a row of medicine bottles under the dresser when he visited, and remembered Spare peering closely at their labels; "It was his habit to take the largest to the chemist after altering the doctor's prescription."

To cheer Spare up, Letchford took him in June 1946 to a matinee performance of Javanese gamelan music and dancing at the Garrick Theatre on Charing Cross Road, which they enjoyed. No longer "the Darling of Mayfair," Spare hadn't been to a theatre for thirty years. He wore his same old tramp-like clothes, but fortunately it was a far from exclusive crowd in the theatre – that day it seemed to be mostly a party of schoolgirls – and Spare was happy. Opinionated as ever, he praised the roots of Hindu dance to Letchford as going back thousands of years in a "beautiful expression of life-form", whereas the dance spectacles of Bali he thought were already the stuff of tourism.

It must have suited Letchford's taste for the exotic. He had come back from the East with a great deal that he was keen to tell Spare, when he could get a word in. In Bombay he had found himself dragged into an incense-filled, romantically-lit lounge, where a group of beautiful creatures, with jasmine flowers tucked behind their ears, sat around a gramophone and "turned large, kohl-lined eyes upon me." Sadly they all turned out to be men (although "a delicious thought flashed through my mind," says Letchford – "hermaphrodites!"). He hoped this story might appeal to Spare, and it did.

All this time, Spare was working hard: when Bardens saw the massed pictures he had put together he thought "such an output seemed superhuman." Spare had his come-back show arranged for November 1947 at the Archer Gallery, a slightly eccentric space at 303 Westbourne Grove.

The Archer was the brainchild of Dr Ethel Morris, née Remfry, an Australian doctor a few years older than Spare. She seems to have been widely known as Miss Morris, although she was married. She had qualified as a woman doctor and surgeon, despite stiff family disapproval, and had practised in remote parts of Australia, trekking out to visit patients in the outback. An interest in mental illness, art therapy, and the work of Rudolf Steiner had led to her leaving conventional medicine and turning to art, and she had become a sculptor, exhibiting at the Royal Academy in 1933.

She had been an Air Raid Warden in Kensington during the War, and like Spare she had suffered in the Blitz. She was in her studio at St. Mary Abbot's when it was hit: two friends who were with her were killed and she was left trapped under the rubble, permanently damaging her lungs. Later in the war she had started the Archer Gallery, which was said to charge the lowest commission in London (twenty-five percent, instead of the more usual thirty-five or fifty), "and the rest of her life was centred and ended there."

Old Miss Morris was never seen without her old coat, a man's shabby overcoat. The window of the Archer had been blown in by a "V1" flying bomb and still not replaced by the time of Spare's show, so the front of the building had a tarpaulin over it, and Miss Morris slept in the gallery on a camp bed to guard the pictures.

The show opened on 3rd November and it was a great success, with a substantial queue of buyers already outside waiting when the door was unlocked. Letchford was unable to be there, having been sent back to Malta with the RAF, but his father attended: Walter Letchford had never been to an art exhibition before but found it very stimulating, buying three pictures and beginning an interest in art.

Dennis Bardens wrote a catalogue essay, and the show received good press coverage. The word "genius" was used here and there, but inevitably much of the coverage was 'human interest' and emphasised Spare's

poverty, somewhat to his annoyance. A food parcel arrived from as far away as Bulawayo, and a well-meaning woman in Streatham sent him a tin of salmon.

Foremost among the human interest accounts was probably *The Leader* magazine of 3 January 1948. Noting Spare's background and recent Archer show, the writer didn't try for any great insight or profundity ("Spare's hobby is the occult", readers were told, as if it was model engineering or racing pigeons) but the piece was illustrated with photographs showing 'The Painter's Bed' (two chairs beside a dresser), 'The Painter's Pets', 'The Painter's Washing' (hanging on a line in the kitchen) and 'The Painter's Studio': "Austin Spare occupies a Brixton basement. His studio is six feet square, filled with canvas, easels and assorted litter." This article was to have unforeseen and major consequences for Spare.

The Studio ran a brief notice in 'London Commentary', a regular round-up piece by Cora Gordon. After noting a debut show by artist Ronald Searle, she wrote that "After years of ill health Austin Spare has reappeared,"

> *this time at the Archer. I remember his work in 1913; a fine draughtsman subconsciously so sensitive that he reflected the curious atmosphere dubbed "decadent" before the last [sic] war. Now he appears to have retired into a curious hinterland of his own, giving us a strange awareness of undercurrents.*

Retired wasn't quite the word; Spare had suddenly bounced back at the height of his powers. A few subjects in the Archer show might have suggested self-doubt or a certain bereftness, like the nevertheless beautiful picture *Redundancy Isle*,[1] with its lizard and its seemingly abandoned statues, but many were as good as anything Spare had ever done, like the

1. Number 92 at six guineas; reappeared in 1994, Christies South Kensington 12th May, lot 40, illustrated in colour.

gracefully stylized woman entitled *Charmante*.[2] Spare's own favourite picture was number 115, *Priestess and her God* at eighteen guineas, showing a Cleopatra-like figure with emphatic breasts.

Spare's earlier interest in spiritualism seemed to have returned for this show, perhaps because he sensed a renewed potential for patronage and publicity. Maurice Barbanell, founder of *Psychic News*, bought a picture entitled *Dreamscape*, and Spare talked to journalists of ghosts. There were several works on spiritualist themes, a clutch of portraits of prominent spiritualists such as Arthur Conan Doyle and Kate Fox-Jencken, and a couple of pictures of the late Sir Oliver Lodge. Before he died, in 1940, Lodge had famously declared that he would prove the existence of the afterlife by coming back, allowing Spare to claim that his portrait was done from life or something very like it.

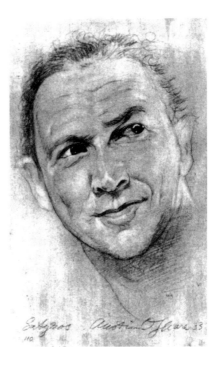

Spare had also formalised his mode of 'Satyrization' as a treatment he could give any male portrait, giving it a faun-like, Pan-ic twist: the underlying idea, surviving directly from the 1890s, was eroticism, lust and in Robert Ansell's words "a latent suggestion of sexual mischief." Along with "paganism" itself, the idea of Pan – half-man, half-goat, later borrowed for representations of the devil – had been sexually encoded for many years. Spare's old friend Glyn Philpot, who had gone on to be a far more successful artist, caused a great scandal at the Royal Academy in

2. Number 145 at ten guineas; reappeared in 1997, Sotheby's London 5th March, lot 116, illustrated in mono.

1933 with his picture *The Great Pan*, which made this aspect too explicit and had to be removed from exhibition.

Earlier 'Experiments with Relativity' and 'Conic Sections'[3] had now consolidated themselves under Spare's coinage of "siderealism", a word – sidereal – which originally meant astral or pertaining to the stars, but which in Spare's case perhaps also had a nod or dig towards surrealism; as if he wasn't claiming an over-realism but something more marginal, a sideways glimpse from strange spaces.

There is also something oddly appropriate, perhaps even punning, in the fact that many of Spare's sidereal subjects were stars in the Hollywood sense. "Dreamer of dreams or observer of film stars, Spare never seems quite to belong to the same world as the rest of us," critic John Russell Taylor has written, going on to write of his "Dorian Gray versions of film stars" that

> ... at least one of the distorted faces, resembling as it does Norma Shearer, raises the question of whether the characteristic curve and vertical elongation of the image was not a result of seeing the screen from somewhere to the left end in the front row of the ninepennies.

3. As in *Constance Bennett and her Conic Section* (1932), Christies South Kensington 12 May 1994, lot 95, illustrated in colour.

In fact Spare didn't go to the cinema much – nor did he have any use for television or the telephone – and he seems to have worked his pictures up from movie magazines (as in the earlier example, opposite) and a scrapbook of film star photographs lent to him by Frank Letchford's sister.

It is a commonplace to point out that this or that figure had lived from the age of the horse and cart to the first jet planes, or some similar contrast, while overlooking the fact that this is true of millions of other people born into the same generation. In Spare's case, though, it is worth noticing that he spans the dog-end of the Beardsley era and the heyday of Hollywood Babylon in a quite distinctive way, neatly encapsulated in a picture such as *Satyrization of Clark Gable*.

Hollywood is equally present across a whole swathe of his film star pictures featuring the likes of Greta Garbo, Bette Davis, Ginger Rogers and the rest, including a dynamic sketch of the young Judy Garland, then

still chiefly associated with *The Wizard of Oz* (like one of those Z words so popular in occultism; Crowley had written a *Liber Oz* in 1941). Spare gives Garland's hair a suggestion of horns and infuses her pigtailed innocence with a certain demonic vitality, as if she is off to see the wonderful wizard of Zos.

Spare met a real film star around 1949, when he was standing at the bar in a pub near London Bridge and James Mason walked in; nearly forty and already a well known face, he was just about to leave for America to make his first Hollywood film, *Caught*. Spare recognised him and struck up a conversation, which left him so excited and distracted, after Mason said he had actually heard of him, that he then went into the Ladies by mistake.

Spare's film star pictures show an engagement with modern Transatlantic popular culture that was unusual in the art of the time, some years before Peter Blake. In 1964 the critic Mario Amaya went as far as to suggest that Spare's work ("sleazy, vulgar... tawdry") in fact makes him the first British Pop artist:

> *... he obsessively explored with a fetishist's fascination the Body-Building hero and the Strip-Tease heroine, in a group of works of the late thirties and forties that can lay claim to being the first examples of Pop art in this country.*

Letchford was still convalescing from tuberculosis, encouraged by Spare, who told him about his elder brother Will surviving it even in the days before modern treatment. Letchford helped Spare with his writing, typing up his "Para-automatecismus" thesis, which suggested that great writers and geniuses in general are far more 'automatic' than they realise: as ever, Spare believed genius was obsession, akin to obsession by a spirit.

Spare was also working on his "Fragmenta", intended as a kind of autobiography but soon fragmenting into aphoristic thoughts on art and life. Faced with Spare's baroque inarticulacy, Letchford's task was to guess at his meanings and try to re-write accordingly. Unlike their art lessons, Spare told Letchford "You are the Master, I the pupil in this." Letchford found it a great tonic: gradually he felt "my confidence, health and strength seeped back."

Spare hated modern art in general and abstract art in particular, whereas Letchford was more enthusiastic. Around this time they planned to take up a project begun before Spare was blitzed, a dialogue (or "back-chat" as Letchford called it, in a phrase of the day) arguing about 'Modern Art Versus Classicism,' which they thought they might publish somewhere.

Nothing came of it, but another acquaintance around this time shared Spare's dislike of modern art, as he told the writer Francis King.[4]

4. Francis X King (1939-1994), writer on the occult, not to be confused with the novelist.

King's unknown friend – evidently older, and "then an art student, now a Chartered Accountant" – had met Spare, and the two of them had got on well. For one thing, they both hated the fashionability of modern art. On the other hand, they disagreed over the occult, which King's friend had no time for, and he wasn't impressed when Spare said that he was sometimes possessed by the spirit of William Blake. This provoked Spare into showing his hand: he completely believed in magic, he said, and he had actually been doing it all his life. More than that, he would give the friend a real demonstration of it next time they met.

It was in Spare's basement that the art student had his appointment with magic, and he found it a bit grim down there. It was cramped and dank and it didn't smell too good. It could be noisy too, with waste pipes gurgling in the ceiling and buses driving past at street level. The friend wasn't feeling quite as phlegmatic as he had the week before. He had done some reading in the meantime and it had made him nervous. Nevertheless, King says, he felt his "firm adherence to the linguistic philosophy of AJ Ayer would save him from being gobbled up by the demon Asmodeus or, indeed, any other unpleasantness".

The first thing the friend noticed was a marked absence of cloaks, incense, magic pentagrams, and general Dennis Wheatley-style paraphernalia. Spare was eating a piece of pie off a newspaper, and when he had finished it the demonstration could begin. In place of any mystic bric-a-brac were some drawings and papers covered with letters and graphic symbols. Spare announced that he was going to attempt an "apportation", i.e. to produce a material object from thin air: apports were very much part of the lore of spiritualism, and they were quite widely known in the late nineteenth century. Spare was going to produce living, freshly cut roses out of the atmosphere. Working in silence, Spare waved a drawing in the air for a minute or two before putting it back on the table. Spare was clearly concentrating very hard, and the strain was visibly showing in his face as he finally pronounced the word "Roses". There was a moment of tense, pregnant silence before the pipe in the ceiling burst, bringing down a deluge of sewage on their heads.

It is within the realm of coincidence but, like a lot of Spare stories, this neat tale has the air of being slightly too good to be true. It is interesting that it seems to originate from the second party, the witness,

and not from Spare himself. The friend's narrative often seems to have a ring of circumstantial truth, and King's own writing has a notably reasonable tone to it, perhaps deceptively; an acquaintance remembers him having "an inclination to fantasy."

Soon, however, tales of Spare are going to move on to a whole new level, a level that is going to make run-down, post-war London seem like HP Lovecraft's Arkham County. Spare is going to make another young friend, a man whose taste for confabulation matches his own.

Sixteen: "Intercourse with a vampire"

Among the people who read about Spare in the *Leader*, some time after the Archer show, was an attractive and recently married young woman named Steffi Grant. She was modelling for the artist Herbert Budd, a tutor at St. Martin's School of Art, and she mentioned the article. It turned out that Budd had been at the Royal College with Spare, and he remembered him: "a god-like figure of whom the other students stood in awe," he said, "a fair creature like a Greek God, curly headed, proud, self-willed, practising the black arts, taking drugs, disdainfully apart from the crowd." This description fascinated Steffi, more than the tramp-like figure surrounded by cats in the *Leader*, and she wrote to him care of the magazine.

In due course she arrived at Spare's basement, one day in the spring of 1949, and was "literally speechless" when he opened the door. Here was an old man, decrepit and bent, wearing clothes he must have slept in, and she noticed there was a tremor to his hands. "D'you know," said Steffi, "I imagined you to look like a Greek god!"

He smiled sweetly, without a trace of offence or irritation, passed his hand across his face in a gesture I later found to be very characteristic of him, and merely said "that was a long time ago..."

Spare showed her his work, stacked around the little basement, and she noticed it fell into groups. There were pastel portraits of local people; 'sidereal' distortions of faces; more formal masks, like old Mexican art (Spare was interested in pre-Columbian art, along with North American

Haida tribal art), some of them with odd magical lettering; and then there were strange astral landscapes, which she liked best of all, "lit by baleful moons and suns, and peopled by strange creatures."

She bought a couple of pieces as birthday presents for her husband, Kenneth, who was almost twenty five. He already knew something of Spare – he owned a copy of *The Book of Pleasure* – and he would soon know much more. Born in Warwick Gardens, Ilford, the son of a bank clerk, Kenneth Grant was a rather strange young man. He was absorbed in occultism in general and the more esoteric side of Hinduism in particular, and he had joined the Army during the War, not long before the D-Day landings and the battle to re-take Europe, hoping to get a quiet posting to India so he could study yoga.

In the event, the Army decided they could dispense with his services. It would be unfair to speculate on why Grant left the Army, although he would have provided a challenging subject for the trick-cyclist, as psychiatrists were known in the Forces. Discharged from the Army, Kenneth took the audacious step of writing to the now elderly Aleister Crowley, whose *Magick in Theory in Practice* he had found on the Charing Cross Road at the age of fifteen. In due course he became apprenticed to Crowley as a student and all-round factotum ("Being watery and Luna," said Crowley, "the bulk of the help asked of you would be Washing Up, the perfect preliminary Lustration in your initiation...").

Crowley was very keen that young Kenneth should come to stay with him at the boarding house where he lodged in Hastings, claiming it would be good for him to get away from the "foul London and Ilford atmosphere," and for a while he did. Grant went on to become an authority on Crowley's work, although some people in the field find his views unorthodox. Even more influential than the time spent as tea boy to the Beast, however, was Grant's reading of visionary and pulp fiction by writers such as Arthur Machen, Sax Rohmer, and particularly HP Lovecraft: Grant developed an unusual and darkly mystical take on Lovecraft, which was that his tales of monstrously trans-aeonic and intergalactic entities, such as Cthulhu the squid god, were in fact essentially true, unknown to Lovecraft himself. These writers would eventually shape Grant's own depiction of Spare.

Steffi took Kenneth to meet Spare, and they all got on like the proverbial house on fire. Spare talked about the architecture of London and how it was being criminally destroyed by the London County Council, who were demolishing beautiful old buildings to make room for their ugly, soulless blocks of flats. Spare seems to have deferred to his new friends socially because, while he and Letchford drank tea out of chipped and tannin-stained old mugs, for Steffi and Ken he produced a special tea set of blue porcelain with a butterfly motif.

As well as appreciating "one of the greatest living draughtsmen" Ken and Steffi enjoyed Spare's extravagant and far-fetched stories and his uneducated speech – Ken captured it in his diary, with Spare saying "'len o'clock" for eleven, and telling them he knew "all them symbols" – and generally found him to be a terrific character, if sometimes a bit "mental", as Grant puts it.

The three of them, often with other members of the Grants' extended circle such as the alcoholic writer John Gawsworth, 'King of Redonda', would go out drinking regularly in pubs. Spare had no telephone, but with several deliveries of post every day, as there were in Forties London, they could make their arrangements for the evening by postcard.

Pubs often had pianists, and the 'Harry Lime Theme,' from the 1949 film *The Third Man*, was extremely popular, played over and over again: "it seemed the signature tune of Spare at that period," says Steffi Grant, "and hearing it now fills me with nostalgia."

Spare would sometimes come up into the West End – the Grants liked the Wheatsheaf in Fitzrovia, or the quieter Shelley's and Old White Goat, both in Mayfair – or they would go South of the river to the pubs on his stamping ground around the Elephant and Castle, including the Alfred's Head, the Waggon and Horses, and the Elephant and Castle itself. Spare was a great drinker of ordinary beer, but his favourite drink, when he could get it, was Imperial Russian Stout.

As he got to know the Grants a new Spare emerged; Spare the ageing satyr. "She's the dirtiest bitch I know," Spare said of one of his models, the local grocer's wife; "likes my work 'cause she thinks it's dirty." It seemed many of Spare's models were 'goers,' and 'well up for it'; having said he'd like to "do her" nude, one of them misunderstood, "Suddenly stripped, threw herself on his sofa, opened her legs and got him on the job

at once!!" A charlady, too, had sat on his couch and instantly lifted up her skirt, "expecting it." Old women in general were a pretty lascivious bunch: women of eighty loved pornography, he said, and he'd met a woman of seventy-eight with a virgin's body, "so tight that it was impossible to fuck her from the front".

Like a lot of things, sex was better in the old days, according to Spare: "a wank used to be less than a penny and you could very often have a 'bunk up' for nothing". He'd had a lot of experience: before he was even sixteen he had been living with an older woman and made her pregnant; "it was due only to a fatally premature birth that he avoided the consequences." Then there was the Welsh maid; and the dwarf; and the hermaphrodite. He'd been married twice (and prosecuted for adultery by a millionaire husband, defended by the famous barrister Norman Birkett, and won) but apart from that he told them about the "hundreds of women he has ridden".

Just occasionally, though – like his stories about fleeing from the unhygienic prostitutes – his tales had a sadder and more anxious quality, including a dreamlike episode involving a blind girl who was in love with him:

> *A blind girl hunted for him everywhere – happened to mention him to man helping her across road; he knew Spare – and so they re-met, but he would have no love of the sort she sought. A tragic story...*

Grant had asked Spare for a self-portrait of himself when young, and a couple of days later it arrived in the post: it came in the form of a picture of an erect penis, entitled "Self-portrait at 18 years" (the same piece of writing paper has a hideous drawing of a "bearded lady"; to all intents and purposes a Roman-looking man with a jutting forehead, broken nose, breasts and a vagina). Spare had recently been meditating on his penis in a semi-lighted room, he said, for magical purposes, while he imagined a girl "tongueing it, like."

Writing to them both, he mentioned an experiment he had once carried out on this penis of his. It was, he told them modestly, only a "large average" in size, but

...as pure magical experiment – I desired a really "grandiose one". It happened in a very short time. It was such a 'mighty organ' that no woman I knew was large enough... rather defeated itself! Simply could not get it in anyone – many famous old whores (for them large vents) at the Elephant remember. It took me over three days to find out how to reduce... And by the way, it takes three days to grow and *I can have* reproduced *this act whenever I so wish. Which proves* not only psycho-somatic interaction as abstract but as concrete. *[sic; Spare's emphasis]*

Spare also made a surprising discovery about Ovaltine: it was an aphrodisiac. He discovered this, reports Grant, when he found it induced erotic or "'wet dreams' in himself, even when at a low ebb of health."

Spare might sometimes have spoken as if his sexual life was in the past, but it was still going strong, one way or another. "Many men seek virgins for pleasuring," he wrote in his persona of Zos, "whereas I am oft content with an old bitch – sound practice if you have imagination." If you had enough imagination you could dispense with the old bitch as well, and be content with "copulating the ether" as Spare put it.

One night in the Elephant and Castle pub they were served by (in Grant's appraisal) a "fat, ugly barmaid". Nothing in her demeanour suggested that she had recently asked Spare to give her a good seeing-to, right there on the pub stairs (but he declined: "he was in a hurry and he liked her ol' man!!"). It may have been in the same pub that he told Ken and Steffi that he'd like to have Mary, the middle-aged barmaid there (possibly the same woman), saying "she's got a nice fat arse."

Along with sex, Spare's interest in magic was undergoing a considerable renaissance under Steffi and Ken's influence. He explained sigils to them (and "word-symbols", like his Alphabet of Desire) and went into more detail in one of his writings from the period, the 'Grimoire of Zos'. As an instance of "Desire for Pleasure," for example (a request "to realize Ideal tactually"), he gave "I desire a large-bottomed woman for

social [sic] congress"; first in word symbols, then as a sigil. As an instance of "Altruistic desire" he similarly gave both forms of "I wish for the death of Stalin."

Another example, easier to understand by sight, was an instance of "Desire for unique experience"; in this case "I desire intercourse with a vampire" (pressed for more detail on this by Ken, Spare explained that by Vampire he meant a succubus).[1] Using the Alphabet of Desire it could be symbolized thus:

(or in sigil form:)

With the encouragement and close co-operation of the Grants, Spare went on to produce a number of manuscripts including the 'Logomachy of Zos' and the 'Zoetic Grimoire of Zos'. Kenneth had a lifelong fascination with the sinister, and some of Spare's work from this post-war period is almost stereotypically black-magical in a way that wouldn't be too far out of place in the writings of Dennis Wheatley. The 'Doctrine and Credo' from the Zoetic Grimoire, for example, runs

> *"Fornicatus benedictus! Almighty Ashmodeus, existent of Chaos, ominous be thy name, thy kingdom come through me on earth. Lead me into all temptations of my flesh so I may trespass greatly into thy ways by my desires: for thou art all sex-seeking*

1. "I'll just say this," Spare wrote, "of course it's possible to have relations with Vampires etc – I have. Proof is that after the event, you accept it just the same as any *real* event & simply could only swear either way it did happen," In response to Grant's suggestion that he might mean succubi he wrote "Of course I meant 'Succubi' – just my loose way of writing...! I'll have something for you re 'dream continuum' later... It certainly may be magically induced".

unity, thou mighty genitalia of creation that knoweth no satiation—grant thou my wish, for thou art all power, ecstasy and actuality. Amen!"

After that,

> *A small talisman arabesque of the major erotic zones is passed around and kissed by all. Then follows a short perverse communion, then a symposium with suggestive exhibitionism, libidinous stories and abreaction of sexual fantasies—developing into the real thing.*

This is unusually fluent for Spare, and may be in part the work of Kenneth Grant. Spare's verbal style is more characteristically represented by a Christmas card he sent to Letchford: annotating a self-portrait sketch "Arabesque of a 'thing' in thought thinking", he provided a sigil and translated it "(Dilemma) (antilogism) (Triadic definition)", further explaining "Whatever is asserted (i.e. derived) of anything as a whole is linear, tautologic evidence that it is partitative of an unpredictable multiple untotality of the thing."

One of Spare's most distinctive inventions at this period was what he called "the Formula of Plotinus" or "Giving Life to the Autistic by Virgin Earthenware". This involved masturbating into a tight ceramic vessel, properly consecrated, and burying the results at midnight – but only at certain phases of the moon.

"The autotelic wish into heterotelic conception is by consummation," writes Spare. Stylistically that does sound more like the man himself, continuing in Grant's version

> *At the moment of orgasm the wish must be imperatively stated. After ejaculation seal the vase with your sigil and with the secret formula of your desire. Bury same at midnight, the moon being quartered. When the moon wanes, disinter and pour contents*

as libation into earth with suitable incantation, and re-bury
same. This is the most formidable formula known, never fails
and is dangerous. Hence what is not written must be guessed.
From this formula was derived the legend of the Genii of the
Brazen Vessel as related by Solomon.

Spare initially vouchsafed this piece of information to the Grants one
evening in October 1949, after they visited him in his basement. Regarding
this vessel or urn, Grant wrote in his diary that Spare had told them "the
secret of the real meaning of the word Urning". The more usual meaning
of the word, chiefly from German sexologists such as Krafft-Ebing, is a
male homosexual.

A number of women had already figured in Spare's life as
inspirational muses – Eily, Connie, Grace, Ada, Vera, perhaps Freda – and
now certainly Steffi. It is not far-fetched to think that Spare felt something
like love for Steffi, and perhaps Ken as well. And if Ken and Steffi wanted
to hear about magic, then Spare wanted to tell them about it.

However interested Spare might have been in the occult, it would
be naïve to overlook this more interpersonal aspect. André Breton noticed
that the celebrated medium Hélène Smith produced her greatest effects,
including interplanetary travel, in an attempt to win the affection of the
psychologist studying her, Flournoy, "who was caring for her, and whose
love she had not managed to win." Breton felt this situation could be
seen in others, like Nadja, another of the iconic madwomen of surrealism.
The magic that she surrounded herself with, said Breton, "was the mind's
compensation for the heart's defeat."

Kenneth started to help Spare title his paintings: titles like *Choronzonic*
Caesar, *Yantra of Yearning* and *Corybantic Ennui* all show the Grant
influence. Words were like objects for Spare, and he was often groping
after them and bending them: the Grants were unable to decipher his
word "sedientesquely", but Spare explained it was actually a slip for
"sentientesquely". Then there were words like "enormon," "stectatorially,"

and "precention" ("meaning 'anticipated perception' or I've imagined it!!").[2]
Spare had always loved words – "Enthosthorasis" was a favourite long
before he met the Grants – but his grasp of them could be wobbly: "By
the way" he asks in a letter, "what exactly does the word 'ambivalent' mean,
'Touch & go'?"

Certainly he had a very idiosyncratic way with them. Thinking about
publishing a book of his philosophy and knowing the value of advance
quotes, Spare wrote to Ken and Steffi

> *A certain famous writer to whom I showed a page or so, of the*
> *best abstract stuff – stated that "I'm on my own unequalled in*
> *such expressionism." A few such opinions – written from like*
> *people will help – make a good jacket.*

With all this in mind the Grants gave Spare a book, *Jarrold's Dictionary
of Difficult Words*. This had some excellent words in it, including
"logomachy" ("battle of words; dispute about words"); "zoetic" ("living;
vital"); "ophidian", ("belonging to order of reptiles including snakes");
and "retromingent" ("urinating rearwards", and usually applied to species
of animals, although Ken had an idea that retromingent women were
particularly suited to certain types of magickal activity).

Spare was impressed by the Grants' library, particularly their
Egyptian *Book of the Dead* – the greatest book in the world, Spare said
– in the monumental edition published by the British Museum in 1899.
Kenneth was also pleased when Spare quite independently mentioned Sax
Rohmer's *The Romance of Sorcery*.

The Grants urged Spare to read a number of books, and among the
works they pressed on him was one by Hans Vaihinger, *The Philosophy of 'As
If'*. Vaihinger (1852-1933) was a Kantian philosopher, remembered for his
idea of "fictionalism" (a.k.a. the "As If" principle). He suggests that human
thought proceeds by the use of unreal fictions, since the truth – following
Kant's idea of the unknowable noumenon, and Schopenhauer's pessimism
about how much we can really know – is impossible to reach.

2. He had (the last OED mention is from 1656, where it means a flourish before a
song); he may have been thinking along the lines of prescient or presentiment.

Vaihinger went further than other neo-Kantians by stressing the usefulness – as tools for living – even of fictions that are actually known to be false. Although it had already been argued that the human mind needs to supplement reality by an ideal world of its own creation, Vaihinger pushed this line of thinking into science, theology, and social morality, recognising the role of fictions that were "beautiful, suggestive and useful" but nonetheless emphatically fictions. Going beyond propositions and hypotheses, Vaihinger was interested in demonstrably untrue fictions, and the way that "something can work *as if* true, even though false and recognised as false."

Whether Spare read the whole book we don't know, but the phrase "as if" begins to appear in his writing, particularly his writing for the Grants. In the hands of Spare and Grant it becomes an extreme point in the tradition of romantic epistemology, and they took it into regions where Vaihinger might well have feared to tread. In Grant's paraphrase it becomes a definition of Spare's magic: "By Belief in a concept, either true or false (objectively speaking) wonders may be wrought and reality realized *in the flesh*." At the very least it became a manifesto for creative confabulation, something at which both men were adepts.

Grant was a very receptive ear for Spare's stories. Forty or fifty years earlier, Spare said, he had been staying in the country with some friends when he had gone out for a walk on his own. He became lost and it started to snow, and as night came down he realised he was in trouble. He was overcome with cold and exhaustion by the time a pony cart appeared, and a man helped him on board and took him to an inn. The door opened, and another man beckoned him to enter.

Once inside, he was given the finest wine he had ever tasted. The snow stopped, the innkeeper showed him the way home, and it was only later that he began to wonder at the man's old-fashioned clothing. He thought perhaps this was how they dressed in the country. His friends had meanwhile been worried about him, and they insisted there was no inn where he described it. He could show them, he said, and next day they followed the tracks of the pony cart to a snow-covered mound; all that

remained of a building which had been demolished outside of living memory. And, as Spare's later investigations disclosed, there had been an inn on that very spot some three hundred years earlier.

And yet the wine had been real enough, he could be sure about that. "Who knows," he said, "but that at some time in my youth, whilst fooling about with sigils, I did not at some time desire to taste wine such as the gods savoured?" Grant is able to add a reasonably-toned, rationalising comment: "The wish had been materialised at a time when Spare's mundane consciousness had been nullified by fatigue and cold, yielding one of the most vivid occult experiences of his life."

As the old cliché has it, you have to be careful what you wish for; a point which emerges more clearly from the Two Dabblers story, which takes place in the same dread basement as the story of the apportation and the bursting pipe in the ceiling. Spare was occasionally bothered by dilettantes and thrill seekers of one kind or another, and on one occasion two dabblers asked him to evoke an "elemental" to visible appearance. A couple of ectoplasm junkies looking for stronger kicks, they had seen the spirits of the human dead materialised at seances, but now they were on a psychic safari after rarer game. They wanted to see a non-human spirit. Spare tried to dissuade them, explaining that these entities embody atavistic forces from deep in the unconscious, and that it is better not to bring them up to the surface. But the dabblers insisted.

Spare drew a graphic symbol of his own devising on a piece of paper, and pressed it to his forehead. Nothing happened for a while. Then the poor light seemed to thicken. A greenish mist now definitely seemed to be in the room, congealing into flitting, seaweed-like fingers and beginning to constitute "a definite, organised shape" with a nightmarish quality of absolute evil; "It entered into their midst, gaining more solidity with each successive moment. The atmosphere grew miasmic with its presence and an overpowering stench accompanied it; and in the massive cloud of horror that enveloped them, two pinpoints of fire glowed like eyes, blinking in an idiot face which suddenly seemed to fill all space." The dabblers panicked and begged Spare to send it away again, which he managed to do, but they were badly shaken by the experience. One of them was dead within a few weeks; the other was in a psychiatric hospital. Grant is so good at telling these stories – inflected as they are

with echoes of Machen, Rohmer, and Lovecraft – you can't help feeling he could make them up himself, if he tried.

He excelled himself when he revealed Spare's involvement with the sinister Chinese cult known as the Cult of Ku. It was Spare's friendship with Thomas Burke, the author of *Limehouse Nights*, that enabled him to gain access to this most secret of secret societies, sometime in the Thirties, when the Cult met at an address in the Stockwell area of South London.

The word *Ku* relates to the eighteenth Hexagram of the I Ching, denoting worms in a bowl, and *Ku* originally seems to have been a form of evil magic in ancient China. Snakes, certain insects and other venomous creatures were placed in a bowl until only one survived. This survivor was the *Ku*, and it was then killed and used to prepare a poison which could be administered with fatal results to the sorcerer's victim, either for revenge or to magically acquire the victim's wealth.

Over the centuries the idea of *Ku* acquired further meanings. One variety of Ku was a love potion, but generally the word slipped towards notions of evil spirits and nocturnal visitations. A certain kind of *Ku*, known as "flitting *Ku*", would fly about at night, and could produce a shadow. As the shadow grew more definite, this type of *Ku* was even able to have intercourse with sleeping women.

It was with something akin to this in mind that the Oriental adepts of the Stockwell cult met, in order to worship a serpent goddess. Coiling incense smoke rose into the room and a special gong was struck, vibrating at a curious resonance calculated to bring about peculiar changes in consciousness. Then, during the working of a strange ritual, a beautiful Chinese woman dedicated to the Cult would slip into a trance and become possessed by the deity. As she undulated about the half-lit room, her shadows would take on lives of their own and become living emanations of the goddess: "sentient shadows endowed with all the charms possessed by her human representative."

Opium may have been smoked. At any rate, these flitting shadow-women would then gravitate towards the adepts who sat around the priestess, now in a drowsy state: "Sexual congress with these shadows then occurred and it was the beginning of a sinister form of dream-control, involving journeys and encounters in infernal regions."

And Austin Osman Spare may have been the only white man who ever penetrated this extraordinary cult. We're not told why Thomas Burke wasn't there as well; perhaps he had just made the requisite introductions and then pressed on home for his tea. But it is a nice touch to credit Thomas Burke rather than the more obvious Sax Rohmer, and to put the cult in Stockwell rather than old Limehouse.

Grant's basic information on the more ancient forms of *Ku* is claimed to come from two authors with the marvellously sinister names of Shryock and Feng, in their celebrated article 'The Black Magic in China Known as *ku*', which appeared in *The Journal of the American Oriental Society* in 1935. It sounds like a piece which might be found in the Library of HP Lovecraft's University of Miskatonic, and a reader might be forgiven for thinking Grant had made the whole thing up.

But no; it is an entirely real article, with entirely real authors.[3] That much, at least, is true.

In their very different ways, Grant and Letchford both pressed Spare for information about his previous career, but by now he had simply forgotten much of it. Always prone to confusion, he was convinced that the book he had illustrated for James Bertram and F Russell was a book by Bertrand Russell.

Grant (who had started signing himself "Thy son, Kenneth") pressed him for more details on the Alphabet of Desire. How was it pronounced, for example? "The vowel sounds as in Sanskrit," said Spare. And what did the individual letters mean? "Can't help you now re Sacred Alpha," Spare wrote: "Key to it and over 300 letters and words... was *all* destroyed in the Blitz...". He tried to remember, but it wouldn't come back: "Of course, it all had significance for me at the time & could still guess a good deal but not much more than yourself." In short, "the whole thing now, could be by another person."

3. It was written by HY Feng and JK Shryock, and it appeared in the *Journal of the American Oriental Society*, Vol. 55, No. 1 (Mar., 1935), pp.1-30. It can be found in the British Library.

And in some ways Spare was another person. After the plenitudes of self-love and the immense inner richness of the Death Posture and so on (like "a syllabub of sun and moon", as it had been, back then) one of his later catalogue notes – typically contrarian, annoyed by contemporary buzzwords about "self-expression" and "looking within" – says "personally, my experience of 'looking within' has been exactly like looking into an empty bucket!"

Letchford, meanwhile, had been asking Spare about sigils. Spare suggested Frank could write a book on them himself if he wanted, and offered to help him. Along with a hint of "psycho-maths-astro factors" and old heraldry, Spare observed in a letter that they might be "touching a reality greater than we know and only badly expressed, so far, in ancient Fairy Tales"; or at the same time they might be "bollocks." Like a teenager scratching 'AS 4 FL' on a tree, Spare then sigillized their initials together in a spread of variations on the envelope, writing on it "This is the only work on Sigils!"

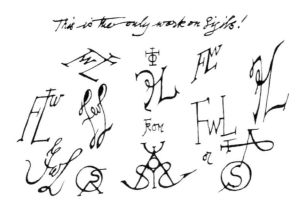

"I'm coming to believe that 'Behaviour' is the whole thing in every direction," he wrote to Letchford; "to self and others equally in all things." Despite the yogic nature of the Death Posture, and how much it had meant to him, Spare told Letchford in later life that yoga was no good because it wasn't *"social"*[4]

4. Spare was generally out of sympathy with yoga late in life. "Bollocks to Yoga", he writes in item 615 of the Logomachy of Zos, "'concentration' on one object is another 'illusion'. I've never managed it for a minute; perhaps morons are more successful."

In his late work 'The Logomachy of Zos' Spare wrote "The disaster of love is that it gives us occasion to love in one person what we should love in all." Perhaps he had mellowed. One thing, though, remained the same. There is a Japanese proverb that says "The Gods only laugh when we ask them for money", and Spare was still chronically short of it. And so, in 1949, he started doing something with which his reputation will always be associated, although it came late in his career; he began holding exhibitions in South London pubs.

Seventeen: THE STOIC

Sylvia Pankhurst was among those who tried to get Spare a Civil List pension, but nothing came of it. Letchford writes that the chance of a grant from the Artists' Benevolent Fund, or a Cozens Annuity from the Royal Academy, was lost because Spare put his date of birth down incorrectly. He was often a couple of years out, and may have put 1888.[1]

The main reason for Spare's near-poverty – although he could still afford to get his round of drinks in, and much of his money was spent in public houses – was his reluctance to do commercial portraits. Spare had been so angry when his father queried his portrait that he changed the colour of his eyes in revenge, and he hadn't enjoyed his experience of working to order for the medical women after the First War. Looking back, he appears to have been a prolific portrait artist, but for the most part his portraits fall into four uncomplaining categories: himself; famous people done from pictures; friends; and local Cockneys (the latter also unlikely to complain, particularly since he tended to take a photo of them and work from that). What are singularly scarce are portraits of paying, middle-class clients done from life.

Spare was desperate to get out of the basement and find better premises, as he wrote to Vera Wainwright:

> *What I really want is somewhere to work – if you can think of any magic which will get me the place above me here – miracles would happen. I'm only rotting away in this dismal basement [...] Miss Pain will not make more room for me and in a way I can't blame her.*

1. He had given his birth as 1888 even as far back as the 1911 Census. Quite separate from his practice of mis-dating works for collectors who wanted earlier pieces, something akin to dyslexia also made him date works clearly from the same batch as e.g. 1954 and 1945.

Letchford was keen to loan him his life savings if it would help, and Spare even had an idea that they could rent a double-fronted shop with living quarters above it, and go into business together; while he worked in one half, Letchford (who could learn picture framing and portrait photography) could deal with those difficult portrait customers in the other.

Spare's first pub show opened on 28th October 1949 at the Temple Bar, 286 Walworth Road, only a stone's throw from the library where he had his celebrated show in 1904. Tom Driberg – old friend of Aleister Crowley and Dennis Wheatley, later an associate of the Kray twins and Chairman of the Labour party – was invited to the press view and may well have attended (Spare "knows Tom Driberg intimately," Grant wrote in his diary, "not as a bugger-boy but as an old acquaintance").[2] Augustus John was among those who turned up for the opening night, Spare's sister Ellen brought a party of friends from Ilford Art Club, and altogether the show was well-attended and a great success.

The first picture was entitled *The metamorphosis of Autoego: Sisyphus Pygmalion (Constant rectification of self-misconceptions)* and Spare wrote a similarly convoluted catalogue essay. John Smith wrote a humane and lucid piece on Spare and Southwark, which Kenneth Grant felt pandered too much to "normal people", while Grant's own essay stressed Spare's work as "a window of weird wonder and terror... a vision that has driven other great men mad with fear":

> *Some would describe him, perhaps, as one who has come face to face with all Evil, dipped his brush and pen into its venomous rivers, and, with unerring skill traced patterns of sin and madness on the face of humankind. I would prefer to say that he has seen the power of Form, of Matter Herself, throbbing with a deadly lust, blind and fatal, at the very Heart of All.*

2. Spare may have known him through Hannen Swaffer, of whom Driberg wrote a biography. Driberg put a plug for the Temple Bar pub into his 'Tom Driberg's Column', *Reynolds News*, 7th August 1949, mentioning Austin Osmund Spare [sic] as an animal lover and artist of local characters.

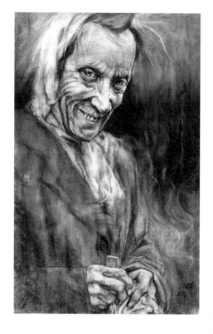

Shortly after the show Letchford bought a picture of an old woman who went from pub to pub selling boxes of matches on a little tray, known as Lambeth Liz or The Mumper, but found he couldn't live with it: "The sensual leer and bleary eyes of this woman depressed me so much that I exchanged the work for another."

Other pictures included *Atavistic Nostalgia*, *Spiv*, *Psychic Labyrinth*, *Obsession*, *Catharsis (Bette Davis)*, *Autotelic Theurgy*, *Self-re-Hitler*, *Paranoid Pleasure*, *Luna on the Bash*, and *Moonbeam*. Spare also did three pictures of broken down horses at the local horse auction, The Elephant and Castle Horse Repository on the New Kent Road.[3] It appalled him that these horses were worth more dead than alive – bound for the knacker's yard, for glue and pet food – and he donated the money to an animal charity. Together with the horses was a picture of the celebrated auctioneer there, Alfred Harris, who never conducted an auction without his yellow gloves and top hat.

Letchford believed that Spare turned down about forty requests for portraits arising from the show. Gerald Yorke, a Crowley collector and brother of the novelist Henry Green, asked Spare to come to his house in Montague Square for a sitting, but Spare declined. He could no more go to Montague Square than he could go to Hitler's Germany. He explained to the Grants "I can only do portraits in the quiet of my own rooms... with the best intentions I don't know how I should get a drawing

3. Pictures 21-23, *Ex-hunter*, *Railway Horse*, and *Van Horse*; auctioneer Alfred Harris was picture 16. There was an almost contemporary depiction of this auction and its distinctively dressed crowd by Ronald Searle in the *News Chronicle*, reprinted in *Looking at London* (News Chronicle Publications, 1953) pp.35-36.

board and easel to any particular place and at a certain time. Which is the reason why I have never troubled to do portraits for a living – but tramps, charwomen etc. ...Studies of heads – yes! But with no thought of sale – that would kill me at once."

Around this time Spare seems to have met another collector named Gavin Todhunter, possibly through Yorke (Todhunter also seems to have been acquainted with the remnants of the old magickal crowd; Ethel Archer signed a copy of her novel *The Whirlpool* for him in 1956). Todhunter collected carved Roman gems[4] of the kind known as Gnostic gems, Basilidian gems, or *Abraxas*, which often figure monstrosities.[5] Robert Ansell has related one of these gems to the "ugly aesthetic" in Spare. According to Todhunter, he showed the gem to Spare, whereupon Spare entered a "deep nostalgia" on seeing it, "and proclaimed a great affinity with the object."

Altogether Spare took around two hundred and fifty guineas on the Temple Bar show. One picture was lost to theft, but later turned up on Spare's doorstep with an anonymous note saying simply "Sorry."

4. His collection came up at Christies South Kensington: *Antiquities, including an English private collection of ancient gems Parts I and II*, 13th May and 29th October 2003.

5. Georges Bataille's highly idiosyncratic reading of Gnosticism sees these gems as figuring a revenge of base matter in the face of idealism, like a victory of the monstrous flesh: "it is possible to see as a leitmotiv of Gnosticism the conception of matter as an active principle having its own eternal autonomous existence as darkness (which would not be simply the absence of light, but the monstrous *archontes* revealed by this absence), and as evil... indicated both by heresiological controversies and by carvings on stones, the despotic and bestial obsession with outlawed and evil forces seems irrefutable, as much in its metaphysical speculation as in its mythological nightmare... It is difficult to believe that on the whole Gnosticism does not manifest above all a sinister love of darkness, a monstrous taste for obscene and lawless archontes... The existence of a sect of licentious Gnostics and of certain sexual rites fulfils this obscure demand for a baseness that would not be reducible, which would be owed the most indecent respect: black magic has continued this tradition to the present day." Completely reversing what Gnosticism is more usually thought to be about, it is a reading that would have gladdened the heart of Kenneth Grant. See Bataille, 'Base Materialism and Gnosticism', in *Visions of Excess: Selected Writings 1927-1939* (Manchester University Press, 1985).

Among the crowd at the Temple Bar show was a man named Michael Hall, who was in the process of putting together the first issue of an ambitious new periodical, *The London Mystery Magazine*, edited – with a little postal legerdemain – from Sherlock Holmes's old address at 221b Baker Street. This ran a whole range of thrills from the criminal to the supernatural, and Hall immediately saw Spare as an appropriate illustrator. It was the beginning of a relationship with a high-quality commercial magazine that would, almost inevitably, end in a fiasco.

The first issue, in 1950, with a cover by the highly respected woodcut artist Joan Hassall, included writing by Hannen Swaffer and Algernon Blackwood, and art by Mervyn Peake, Ronald Searle, and Spare, who provided a couple of decorative heads for a piece called 'Lucifer Over London' by Lewis Spence. Spare would do similar bread-and-butter work in a couple of later issues,[6] but issue five, for August-September 1950, had a piece about Spare himself, 'The Mystery of An Artist' by Hannen Swaffer, which offered a slice of Spare's routine about automatism and psychic inspiration:

> *During the automatic period, I am obsessed or possessed by the spirit of some artist, perhaps a dead artist. I don't exactly know. The only evidence I may have is that it's like Durer or Blake, or like someone I've never heard of.*

This was well suited to the *Mystery Magazine*, because it took an interest in the nature of inspiration. The following issue had a piece by Algernon Blackwood, 'The Birth of an Idea', appropriately illustrated by Spare the celebrated automatist. Blackwood visited Spare in the basement around this time, and his piece gave a good airing to the idea of the unconscious and mediumism, even drawing on Hitler as an example:

> *... Hitler, himself a neurotic, above all a medium, provided the voice. Yes, Hitler was a medium as definitely as anyone of low*

6. 'The Horrible Horns' by Martin Gardner Vol.1 no.7, and 'The Dagger of the Mind' by Dorothy Edwards Vol.1 no.12.

intellectual type who runs a seance room. Hitler provided the
voice for the entire German unconscious...

Blackwood discussed "sudden ideas leaping out from that underground storehouse which is the unconscious" and remembered how he had woken one morning with a meaningless phrase in his head – "You will drown, yet will not know you drown" – and written a story to fit it. Spare in turn did a line illustration.

The magazine had, meanwhile, run an article on the mind by Kenneth Walker, a consultant surgeon and former professor with an interest in Eastern philosophy.[7] Illustrated by Ronald Searle, this introduced readers to FWH Myers and the Subliminal Self, as well as William Blake and Morton Prince. This was followed by a second article by Walker in the next issue, 'Mind to Mind', now moving circumspectly on to consider questions of telepathy and ESP.

Unexpectedly, this was followed by a third piece by Banesh Hoffman, a professor of theoretical physics at Princeton, who had co-authored a paper with Einstein on 'The Gravitational Equations and the Problem of Motion'. His article, 'Mind to Mind: But How?'[8] jumped lightly over the question of whether telepathy and ESP existed, and instead considered how they might work if they did. "It may be physical, or it may be something strange, obeying laws of propagation transcending space and time and behaving in a way absolutely new to science." Kenneth Walker was shown a copy of this and replied in the same issue, clarifying his ideas in yet another piece, entitled 'How Indeed?' and moving away from physics into philosophy and cybernetics.

But really, what did these people know about it? It was time for the man in the basement to have his say, in a piece entitled 'Mind to Mind and How' and by-lined "by a Sorcerer", which initially declared itself to be "rendered in an idiom other than for scientists." And it was, right from Spare's opening quibble with abstractions such as thought, mind and intellect: "Should I, as a God, fall into this cesspit of inexactitude?"

7. 'What's in a Mind?', Kenneth Walker, Vol.1 no.2.
8. Vol.1 no.7.

Thought may be looked upon as a dynamic, ever-present like the
Ether – we are inescapably in and of it.
[...]
If mind has any 'seat' it is in the whole body, rather than a part.
[...]
So, identity is an obsession, a composite of personalities, all
counterfeiting... a faveolated ego: a resurging catacomb where
the phantom-like demiurguses seek in us *their reality.*
[...]
The nexus between cause and effect is medianimity [sic].
There is a Grimorium of graphic symbology and vague phonic
nuances that conjoin all thought and is the language of the
psychic world.

And so it went on; powerful stuff, but needing to be met more than
half-way, and the *London Mystery Magazine* was not the journal to do it.
They rejected Spare's piece, adding insult to injury with an attempt to
rewrite it for him. Spare bore no grudge against Hall and continued to
illustrate, but said he was aware that Hall was slightly "mental"; he could
tell, because of the way he heard Hall giggling on the telephone whenever
he rang up.

Spare went back to art college in 1950 for a life drawing course in the
company of Steffi, largely avoided by the tutor and the other students
as a tramp-like figure. His own art had taken on several new lines and
directions, and he had taken to decorating valve wireless sets, drawing on
the 'baffle boards' or speaker fronts.

This was in harmony with his idea that the 'aether' carried not
only radio waves but occult and telepathic vibrations; as a posthumous
catalogue put it, "Spare's belief in the occult persuaded him that it was
necessary to construct a shrine for the reception of radio waves." Letchford
bought a radio – not only decorated but built by Spare – for his mother
as a Christmas present and was relieved to find it worked, "though the

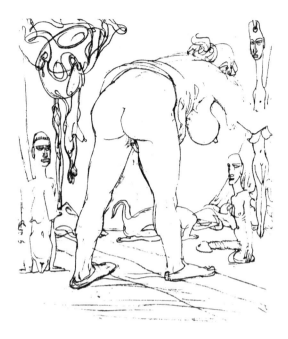

Medusine masque looming in the corner of the room gave her a certain sense of unease as she toiled at the sink."

The wireless decorations, sometimes featuring Egyptian gods, were often outlined in pencil and then filled in with coloured inks. Spare developed a related line in Egyptian-style stelae (a stele, pronounced "steely", plural stelae, is a plaque-like wooden tablet of roughly headstone form, usually with a curved top). Steffi had a picture of a particular stele called the Stele of Revealing, which had been important to Crowley, and Spare had probably seen them not only in books but in the British Museum. Again, his stelae were generally plywood worked with pen or pencil and coloured in, and they are among his most distinctive works. Magically intended, usually as charms of one sort or another, Spare's stelae are like circuit diagrams of thought.

Along with wireless sets, Spare still had his liking for tribal art. Bits of both, radio valves and little tribal figures, had been lying around his various dwellings since the early Twenties. Imagining them now, they seem to go well together, creating a realm of entities and aether.

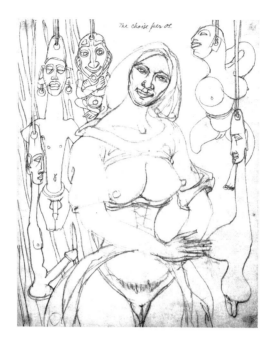

Spare was dealing in a small way, buying tribal odds and ends at London Bridge Auctions, where he knew one of the porters, and selling them on to Letchford or the Grants. Kenneth liked tribal art, as befitted his fascination with voodoo and obeah, and the larger fascination with tribal artworks as tokens of primitive sexuality, dark pagan rites, and the unconscious (Picasso, talking about primitive art and his own work, immediately moves by association to say "spirits, the unconscious… they are all the same thing.") Altogether, as André Malraux put it, tribal or primitive art has been about "the night side of man," and this was a particular interest of Grant's.

There was a strongly tribal aspect to a group of works that Spare did around this time – we could call it his Grant period – such as *Fetish Familiars* (fetish in the tribal sense, and familiars in the witchcraft or sorcery sense.) In *Fetish Familiars* itself (previous page), a woman bends forward with her entities around her: variously elongated and truncated, they comprise a couple of female figures, one of them paired with a grossly ithyphallic male figure; a dog or cat-like quadruped with a tail; and an

automatistic art nouveau thought-form. Coiling in the air like a swirl of incense smoke, solidifying like a half-tumescent balloon, this contains further suggestions of phallic and breast-like forms.

Witch Mother, another of the group, features an old bearded witch with one of these familiar entities suspended from the ceiling by its neck; it is female, with a penis seemingly tied on. *Fetish Queen* (opposite) has a more attractive woman with five sculptural entities – two of them female, and with stylistic echoes from Congo to tiki to Hans Bellmer's *Doll* – hanging from piercings in their heads. In some ways these drawings relate to Spare's more realistic line in ethnographically-themed works, but now stylized down to these highly sexualized, tribal-dildo entities, like a quintessence of the idea of primitive art ("Objects that are strongly sexed sell well," says a tribal dealer in Paris, while an anthropologist says that for tourists in New Guinea "figures with erect penises are especially popular.") In continuity with the *Portrait of the Artist* of 1907 and the 'Death Posture' frontispiece, these compositions also have a very Spare sense of a self and its objects.

Spare was casting around for another pub venue and seemed to have found one at the Hercules, but it fell through when the landlord's wife decided his work was obscene. The Feathers, opposite St. James's tube station and somewhat off Spare's usual patch, was also open to him, but in the event he went for the Mansion House Tavern on Kennington Park Road, opposite Kennington tube station, in June and July 1952.

Pictures included *Walpurgis Succubi* (no.87) and *Audrey Hepburn* (no.88) – a very Spare conjunction – along with *Anaxagoras*, *Newsboy*, *Anatomy of Ecstasy*, *Werewolf*, *Hermaphrodite*, *Deep Waters*, *Rag and Bone Man*, *Inferiority Complex*, and many others. An unusual feature was the inclusion of a number of sketchbooks with as many as forty-eight drawings in each. These sketchbooks showed "the underlying ideas motivating the artist," Spare wrote, and "Those purchasing these sketchbooks obtain therewith both the copyright and my permission to exploit any of the ideas as their own."

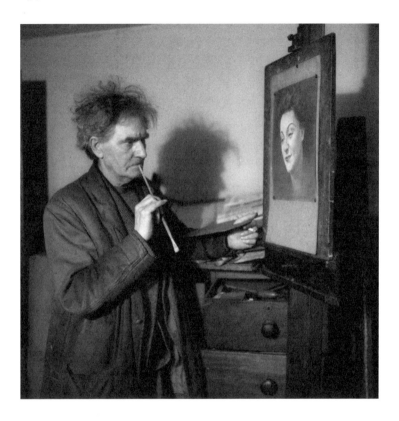

Spare's catalogue essay, 'This and That', complained about the price of framing – more than Spare was charging for the pictures – and reiterated his relation to automatism and surrealism: he had no desire to make any claim to be the first surrealist, he said, despite having suggested certain techniques "*long before* our surrealists were thought of."

Spare had been annoyed by a Salvador Dalí show in the winter of 1951 at Alex, Reid and Lefevre, where Spare himself had shown in years gone by, and he had argued about Dalí with Ken and Steffi, adding him to Crowley as another figure they disagreed about. The newly fashionable Zen Buddhism also annoyed Spare around this time ("the Zenists are the Spivs of the religious world"), and he contrasted it with the virtues of old-style Buddhism and Taoism.

Spare had written in the Temple Bar catalogue 'Apologia' "Why a show in a Tavern? My answer: it is democratic..." and again in the Mansion House catalogue he wrote "No excuse is necessary for a 'Tavern Show' – now almost a fashion – it is convenient both to artist and public, being without the formalities of the more orthodox places." This was probably sincere, but it was only part of what he felt about pub shows; there was more expressed in a February 1954 letter when he thought there was

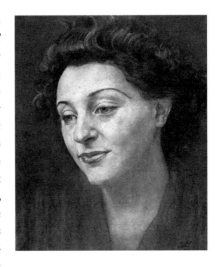

a chance of a show in the West End: "No more bloody pubs for me!"

He never did make it back to the West End, but the post-war pub exhibitions showed a remarkable spread of work, from the Cockney portraits to automatism. Writing to Dennis Bardens after Spare's death, Letchford made an attempt to categorise the range of his portraits. There were the satyrs and satyrized faces: "The Satyr which recurs throughout his work – is himself (his hidden desires) lustful, embracing all forms of sex and perversion with joy." Then there were the siderealized portraits: "a slant on ordinary faces or upon faces which one may look at twice but require the knowledge of people to divine. Homosexuals and lesbians are the predominant types but there are subtle shades of and degrees which Spare looked for."

And not least were the Cockney pictures:

> ...the people he really loved – hard workers, people who suffered like himself with no hope of redemption. He looked for suffering and portrayed it. He had always suffered and sought it out in others. His deep inferiority feelings also made him sympathetic towards the down trodden and suppressed and those who had "fallen by the wayside". He was the Good Samaritan.

The Mansion House show sold well, and Spare himself was the subject of a photo essay for *Picture Post* by the famous photographer Bert Hardy, who had already done photo features on the Blitz, Cockney life and the Elephant and Castle. In the event the piece was spiked and never used, but it produced some memorable images of Spare (see p.234), and Spare did pictures of Hardy and his assistant in turn.

Helped by £200 from Letchford, Spare at last escaped from the basement and moved upstairs at Wynne Road. He bought what was left of the lease on the dilapidated house, while Miss Pain continued to live there and now paid him rent. Rain came through the ceiling on Spare's first night upstairs, so he was driven back down to sleep in the kitchen.

Letchford was meanwhile living in a bedsitter in Bayswater, and now he was going to get married to a girl named Joyce Turner, an artist; she never took to Spare. When Frank told Spare he was getting married, Spare made an excited masturbatory gesture with a bottle of milk he was holding – an odd association for marriage, you might think – before recovering a respectable tone with the advice that "The only stone a man can wear is a star sapphire."

Apart from his Ovaltine-fuelled satyric dreams, Spare's own luck with women had not been good of late. One day in Southwark on his way into the Post Office he saw a beautiful girl with a mass of auburn hair, in the Pre-Raphaelite manner, talking to some other girls outside: "He complimented her upon her beauty and suggested that she should model for him, to be met with such a stream of coarse invective that he forgot to enter the Post Office."

Love raised its difficult head around this time with a friendly barmaid named Betty, whom Spare had drawn for his Temple Bar show. She wore strikingly low-cut dresses and probably worked at the Gladstone, a pub on King and Queen Street. She was only in her twenties but she fell in love with Spare, or so he felt. Then her husband warned Spare not to hang around the pub, and later, says Letchford, "he discovered that the girl had been turned sour against him by her husband's friends." "Saw Betty the other evening," Spare wrote to the Grants in 1952, "very changed."

Spare had weathered a lot of hard knocks and disappointments, and as time went by he took on a new identity: he was now Zos the Stoic. "The Stoic seeks and practises Virtue for its own sake not from fear," he wrote in a book for Letchford: "he takes responsibility for all his actions... Virtue, the effort towards autonomy!"

He wrote to Steffi as "the last Stoic (ZOS)" and in his writings with the Grants he coined the awkward word "Eststoic", which he also used as a picture title. Kenneth very reasonably tried to change it to Ecstoic, summing up the balance of ecstasy and stoicism that he felt characterised Spare, but Spare stuck to Eststoic, which he felt was better "because as implying as from an older stoicism than that of Zeno."

Whatever he called himself, heroic stoicism had become his late stance. Spare had come a long way from the man who thought he could have anything he desired. Undefeated in his basement, moving upstairs into the rain, he was now the man who soldiered on regardless. Apollonius of Tyana had been famed as the greatest of magicians, but at last he prayed – according to *The London Mystery Magazine*[9] – "O ye gods, grant me this: that I shall have little and need nothing."

9. Vol.1 no.6, October 1950, p.92.

Eighteen: An Owl with the Wings of a Bat

Spare was now preparing for his autumn 1953 pub exhibition, at the White Bear on Kennington Park Road. His pictures continued to show the influence of his friendship with the Grants, with works such as *Witchery*, *Walpurgis Vampires* and *Satiated Succubi*. Grant had come up with a magical name for Spare, "Zos vel Thanatos". Spare took to it happily, but it was very much Grant's coinage rather than his: in fact Spare had to ask what it meant, a little cagily: "By the way, translate 'Zos vel Thanatos'. I believe my guess is right but both are elastic words."

It means "Zos or Death", typical of Grant's dark sensibility. Grant had also founded a Spare religion, the Zos Kia Cultus, described by Grant as embodying Spare's idea that any belief, sufficiently believed by the whole being, becomes "vital or organic... it is possible to reify wishes, dreams, desires, etc... The mechanism of this sorcery may be described as an 'as if' potential, latent and fictive, transforming into an 'as now' ecstasis, potent and actual...". Grant's especial influence on Spare was to whip up his interest in witchcraft, orgiastic sabbaths, and lascivious old women.

Talking to Grant, Spare recalled that one night he had boarded a double-decker bus a few miles from where he lived. It was raining and the streets were deserted, but when Spare went upstairs he was surprised to find it was packed. The rain outside and the shining street lamps took on an aura of strangeness and unreality, and he realised that the same uncanny quality seemed to possess his fellow passengers. They were *all women*, he realised, and women, moreover, who seemed to take an "intense though oblique interest... in him, as if inviting him to some secret and unhallowed gathering."

The conductor never came up to take Spare's fare, remarking as he got off at his stop that it wasn't worth coming up just for one. Spare

realised he had somehow stumbled into a party of witches headed for the
Sabbath. In Grant's explanation, which he attributes to Spare, it had been
a moment of *perichoresis*, or an interpenetration of dimensions; a central
idea in the supernatural fiction of Arthur Machen.[1]

Spare had always been interested in trams and buses, and in the
Thirties it was a great pleasure of his to get on a Green Line coach for a
"mystery tour"; an outing to an unknown destination, often in rural Essex.
Spare would reminisce to Letchford about public transport before the war,
which was far better value, and he remembered a small firm whose buses
would stop "*anywhere*".

The central figure in Grant and Spare's shared fantasy of witchcraft was
the old witch, Paterson, who could transform herself from an old hag to
a beautiful woman. There may have been an old woman, perhaps a friend
of Spare's parents, who may have done some fortune telling, but it seems
to be only in the Grant era of Spare's life that she takes on the name
of Paterson.

It is possible that Spare had encountered Ruth Patterson (see p.12)
as a child, but it is also possible that he first encountered her name in local
newspaper reports of her death, aged 102, in January 1942 (she had been
born Ruth Welch in Southwark in 1839) or her hundredth birthday in
1939. *The South London Press* put this on the front page, with the headline
LIVED HERE FOR 100 YEARS, SHE WON'T LEAVE – "NOT
FOR FORTY HITLERS".

Spare fleshed her out in a late interview with Hannen Swaffer:
now she was an unnamed old lady who read the cards and lived to be a
hundred and one years old. She had gipsy blood; she was illiterate; she was
married to a doctor; she was a friend of his parents; she lived in a tough
neighbourhood but was respected by everyone; she was full of childlike
love and kindness; she could predict the future; and he had taken Clifford
Bax and Mabel Beardsley to see her.

1. "I believe that there is a *perichoresis*," says a character sitting in a tavern at the end
of Machen's story 'N', "an interpenetration. It is possible, indeed, that we three are now
sitting among desolate rocks, by bitter streams…And with what companions?"

Kenneth Grant fleshed her out even further: she had been a member of a witch coven in Wales; she was a descendant of Salem witches, in Massachusetts, through whom she was connected to ancient American Indian witchcraft; and her name was Yelg, Yelga or Yelda Patterson: the latter supposedly short for "Ye Elder," and also recalling the obscure word "yelder" in the work of the Reverend Montague Summers, when he writes of "yelder-eyed witches," meaning witches who have the evil eye.

It is generally thought that there was no real witchcraft in Salem (which is the point of Arthur Miller's play about witch-hunting hysteria, *The Crucible*), nor would the Salem community have had much contact with any Native American sorcery, although the idea would suit Grant's desire to suggest links with the fictional world of HP Lovecraft. The idea of a Victorian or Edwardian coven of witches in Wales, or anywhere else, also seems unlikely, because organised witchcraft had barely been invented (or possibly "re-invented") before the 1940s, when a retired civil servant and old colonial hand, Gerald Gardner, concocted it. Partly drawing on the discredited anthropology of Margaret Murray, and his own tantric interests from the East, Gardner invented "Wicca" as a modern pagan religion, claiming to have been initiated by an aristocratic old woman known as Old Dorothy.

Gardner published his influential book *Witchcraft Today* in 1954, and the Grants knew him. More than that, they introduced him to Spare in September of that year and played the two of them off against each other:

> *ZOS and Scire [Gardner] had a fierce argument as to who had been to the Witches Sabbath, what the Witches Sabbath actually was, and so on. Scire drew his magical athame [ceremonial magic dagger] and showed ZOS the strange characters on the hilt. ZOS should have blanched before them but didn't, saying he "knew all them symbols and more"... Zos keeps a "Borneo Dyas"[2] complete with nineteen human hairs sprouting at end, of victims who have died by its blade... This*

2. [Sic] Probably a Borneo Dayak sword, from the head-hunting Dayak people; a bit of Spare's tribal bric-a-brac.

he brandished before Scire, who later gave him various Witch-
Cottage pictures... A screamingly funny interview.

The conversation between Gardner and Spare also came round to "the old
Witch who was a second mother to Zos", whom he now said had lived
to be 109.

"I don't think Dr Gardner has ever met a pucker [sic; pukka] witch
i.e. one who can really perform – nor has he attended a real Sabbath,"
Spare wrote to Ken and Steffi afterwards, "that was very apparent when
I nailed him down." And they wrote back reassuringly "I doubt he's ever
met anybody to come up to the Witch who taught you when young."

Quite what "a real Sabbath" might be like was a very complex
question. Grant drafted, or perhaps helped Spare to draft, an erotically-
charged text called 'The Witches' Sabbath', but Spare's own experiences
were largely dreams. He reported to Grant one night in the pub that
he'd "had a 'Sabbath' dream of vivid power yestere'en and had done some
unmentionable graphic representations thereof." Grant reminded him on
a different occasion, a couple of years later, that he'd said "that you had
either been to a Sabbath or had dreamed an amazing dream of one; you
were going to tell me all about it but we were in a crowded place at the
time and you never told me."

So perhaps the Sabbatic experience can take place in a mind-space,
even a solo mind-space, like an event on the astral plane. Either been to it
or dreamed it, as Grant says. Perhaps it was all the same.

Along with the Zos Kia Cultus, Grant also founded the New Isis Lodge
(or "Nu-Isis Lodge", as Grant specifies it was known to initiates; Nu being
the starry sky in Ancient Egyptian, and Nu-Isis together signifying the
starlit earth, connoting the Lodge's task of communicating with extra-
terrestrial forces such as the planet Isis).[3] Grant founded the Lodge in
1952, although it didn't really get under way until 1955. Like the Zos Kia
Cultus, Spare was happy enough to go along with it: "Shove me down as

3. Not known to astronomers.

an hon. member in any manner you like," he wrote cheerfully to Grant. It is not wholly clear why he specifies "Honorary" membership, but it seems that he didn't want to attend in person.

The Nu-Isis Lodge is the subject of extraordinary stories in Grant's later writing, often involving death and misfortune to female members[4] when rituals go wrong and entities from other dimensions break through, but in fact it is unclear how much they met. There was a Fifties children's writer, Malcolm Saville, whose books about the Lone Pine Club gave rise to a real club of that name for his readers, one of its memorable phrases being "...and we had adventures in our heads." Like the Lone Pine club, the Nu-Isis Lodge had many of their most remarkable adventures in their heads, or in the head of Mr Grant.

If that is the first and most obvious thing to say about the Lodge, the second is that they really did meet; at least up to a point. There were a number of real members, including the English surrealist painter and writer Ithell Colquhoun (although, paradoxically, she seems never to have attended in person) and several female friends of the Grants including Joyce Bernard, who lodged with the Grants and modelled for Spare, and a woman who appears in Grant's work as Clanda, whose real name I believe to have been Barbara Kindred. So Nu-Isis was, in fact, a "working lodge".

The work of Sax Rohmer often features small shops – particularly old book shops or curio shops – as gateways to mystery. There is the Wapping curio shop of Morris Klaw in *The Dream Detective*; the shop of Zazima, with its voodoo masks and shrunken head (pivotal to the plot, as it turns out) in *The Island of Fu Manchu*; and better yet, in *The Mystery of Fu Manchu*, there is an antique dealer's shop on Museum Street, just near the British Museum, with Egyptian statuettes and Indian armour in its shadowy interior, along with a Buddha that is not for sale. Foolishly touching it, the narrator discovers it to be the handle

4 "Olga" disappears into a hole in the ground, "Nerik" goes mad, "Moola" falls from a trapeze into a tank with a swaying mass of tentacles, and "Clanda" is drowned on a sea voyage when the water spirits reclaim her.

that sets a secret door in motion: and suddenly, there, "facing me, *stood Dr. Fu Manchu!*"

One of Grant's comparatively rare forays into honest fiction features a shop on Chancery Lane, the emporium of a Monsieur Auguste Busche who trades in plaster casts of "antique sculptures and fantastic images." It is only when the shop is demolished, shortly after the war, that the foundations reveal a huge stone tank beneath the shop containing the remains of a giant crocodile and some human bones: "The bones were of young women and there were hints of witchcraft and other diableries. But who, or what, in twentieth-century London, would sacrifice to a crocodile?"

As for the Nu-Isis Lodge, Grant tells his readers that the Lodge meeting place had been rigged up under a shop

> in an extensive underground network of apartments which formed the basis of a deceptively small shop in one of the side streets off a main West End thoroughfare.

The Lodge was prepared for a particular kind of "lycanthropic and necromantic sorcery", and readers are asked to imagine a decor – painted by Austin Spare – amounting to

> A miniature though more complex version of the Dashwood caves with – in lieu of the various grottoes – a series of shell shaped cells, like petrified vortices, designed with the sole purpose of attracting into their convolutions the occult energies of Yuggoth ... the place was the epitome of twilight and of those equivocal states of consciousness peculiar to the werewolf, the vampire and the ghoul, whose subtle presences were suggested by...

It seems almost a shame to interrupt Mr Grant in full creative flow, but the interesting thing about this shop is that it really existed. Deceptively small shops which become much larger, like the Narnia wardrobe, sound almost generic as fantasy gateways, but the West End thoroughfare was Baker Street, and the shop was a furrier's owned by an associate of

Grant's at 7a Melcombe Street; now an Islamic bookshop. Enquirers have been told the building has no basement, which seems contradicted by the presence of glass window bricks in the pavement.

Grant tells his readers that the ritual in the furrier's basement went wrong, with an "eruption of black energy" and a woman raving with a dagger in her hand. This was nothing, however, compared to the goings-on in Islington one night in 1955, which took place in the house of an alchemist.

Spare had been giving Gerald Gardner some magical help with deflecting a curse that Gardner feared he might be under. On 27th September 1954 Spare asked for a "token sacrifice" in the form of a cheque for ten shillings ("No more or it spoils it") made out to the Royal Society for the Prevention of Cruelty to Animals, and in return he sent him a stele and a sigil ("This is the sigil you must visualise (as near as possible) whenever the 'subject' enters your mind"), in order to return evil "on the Boomerang principle". It is interesting to notice that Spare had a reputation among other occultists as somebody who could actually 'do the business'; conversely, it seems Gardner recognised he had no ability himself, although he was a pseudo-academic expert.

Up in Islington, magical feuding had broken out between two occult groups. One was Grant's Nu-Isis Lodge, and the other was a coven headed by Gerald Gardner. Gardner believed Grant had poached a talented medium of his, Clanda, an unstable young woman who had entered Gardner's coven hoping to become a Priestess of the Moon, but become disappointed with her progress and defected to the Nu-Isis Lodge.

Gardner then went to Spare for a talisman "to restore stolen property." Spare had no idea that this was to be used, in effect, against his friend Grant. The talisman Spare drew was apparently "a sort of amphibious owl with the wings of a bat and the talons of an eagle."

Islington was a very run-down district in the Fifties, somewhat off the beaten track, and the house where the Lodge was meeting had mouldering walls, overgrown paths, and windows that were never cleaned. It was not lived in, but maintained by the alchemist entirely for magical purposes. The idea of an alchemist in Fifties Islington already seems to

belong in a slightly parallel universe, and Grant's confabulatory webs present him as a character who indulged in necrophilic rituals and on one occasion nearly died after drinking liquid gold. He was nevertheless a real man, David Curwen – the furrier of Melcombe Street – and he later published a pseudonymous textbook on old-style alchemy.[5]

At the Lodge meeting Clanda lay on a massive altar between two heavy candlesticks, which were the only source of light in the room. "Four violet-cowled figures (members of the Lodge) flitted to and fro; the air was thick with incense, mingled with the must of corruption which the old house exhaled."

> *The room was electrically heated; stifling waves of hot air bore aloft the cloying incense sacred to Black Isis, an incense compounded of galbanum, onycha, storax and olibanum, based on a preparation of moon juice. A very potent manifestation of Isis was expected to occur, as the dark aspect of the Goddess was being invoked.*

Clanda lay upon the altar, waiting to become possessed by Black Isis, but things went badly wrong. The temperature in the room dropped, and Clanda imagined a great bird had crashed into the room, taking her out into the night sky and away. She saw the snow-covered rooftops below, as in a flying dream, until the bird began to lose height over a wharf-like structure. She struggled in terror, and suddenly found herself back on the altar.

Nobody is suggesting that Clanda went anywhere physically: it all took place, as they say, "astrally". Grant adds that a slimy, saline substance was left on the windowsill afterwards:

> *an actual deposit of some gelatinous substance, resembling seaweed, pullulated slowly on the window-sill – as if* breathing.

It sounds very Lovecraftian. Asked by an admirer how his writing was going, Grant said "slowly, it needs to get some more slime into it."

5. *In Pursuit of Gold* (Spearman, 1976) by "Lapidus".

Grant was steeped in what have been called "the gurgling mysteries... that dwell in cheap books."[6] He is a writer of what we might have to call *fictional non-fiction* (a genre which bedevils occult writing, and might well be in some way intrinsic to it). Perhaps he deserves wider recognition as an imaginative writer in his own right: the graphic novelist Alan Moore has characterised his work as being as "mystifying as a giant squid in a cocktail dress" and the vision of "a schoolboy gone berserk on brimstone aftershave."

Spare was a gift for Kenneth Grant; a kind of 'found object' for Grant's own artistry and peculiar genius to work on. It is almost too obvious just to say that Grant mythologized and fictionalised the people he knew, such as David Curwen and Spare. He did, of course, but – in discussing opium – Jean Cocteau writes "We all carry within us something folded up like those Japanese flowers made of wood which unfold in water. Opium plays the same role as the water." Perhaps that was the role Kenneth Grant played for Austin Spare.

6. From 'A Yellow Creeper' – an Arthur Machen parody – in Arthur Rickett's *Lost Chords* (AD Innes and Co., 1895): "... you are approaching the gurgling mysteries, the ghastly, unspeakable, shuddering mysteries, that dwell in cheap books. Man alive! However can you pass Smith's bookstall without shrinking appalled in large-nosed, white-eared, terror from the hideosities that abound there?"

Nineteen: Only the Gods...

The White Bear show came around in the winter of 1953. Pictures included *Seance Manifestation*; portraits of Evelyn Waugh, psychologist Eustace Chesser, and Henry Miller, with whom Spare had struck up an enthusiastic correspondence; and various old locals, including *Ex-prizefighter, Ex-docker,* and *Ex-flower girl.* Spare did a portrait of *Mine Own Ghost,* with the half-joking catalogue note:

> *I have long suspected that my ghost (astral body or Ka) often wanders forth... now I know. What I've seen amongst the Tombs you would scarcely believe! I search for something... nothing fortuitous – maybe a new reality? Or the pint of blood owing me from the hospital? Not, like most, their lost absoluteness, perhaps* I *seek the* Humane.

The influence of the Grants was particularly strong in the title *Bess-Mass of Matter* [sic], Besz being an old Golden Dawn word for 'matter.' Spare's particular take on Besz was hermaphroditic flesh, as in a slightly later picture of a hairy, muscle-bound woman entitled *Gynander: Mutation via Besz-Mass.* Like "Zos vel Thanatos", the whole Besz business came from Kenneth Grant, who used the word in his first Spare catalogue essay, and again Spare had to ask him what it meant ("please will you give me a rough definition of the Qlipoth[1] & Bess-Mass [sic]").

"The Besz-mass of matter designates a pullulating mass of bestially directed substance" Grant explained, and Spare in turn explained it to Letchford regarding a later picture called *The Besz-Mass of Flesh,* which

1. An evil aspect of the Qabala; its dark side. It is quite a basic idea to Qabalists, suggesting Spare didn't have any great knowledge of, or interest in, the subject.

was packed with a hideously superfluous excess of muscles and breasts. It was, said Spare, "the be-all and end-all of fuck-all".

The White Bear was an attractive venue, with a garden and summer house at the back, but there was confusion over sending out the publicity notices and the show flopped badly. Hardly anything was sold until Eustace Chesser suddenly arrived at the end in a car with his daughter. Chesser was a famous Harley Street psychiatrist, sexologist and social reformer, author of numerous books from the best-selling and once controversial manual *Love Without Fear* to the literary criticism of *Shelley and Zastrozzi: Self-Revelation of a Neurotic*. He selected about thirty pictures that he considered to be of psychological interest, negotiated a discount for buying in bulk, and drove off again. Having earlier done a drawing entitled *It Was My Soul That Saved Me*, Spare later said to Letchford "It was a psychologist that saved me."

Spare's confidence was dented after the White Bear, but he continued working; as he had told Frank, if you stick at it then "moral courage accrues." As Spare's physical energy began to wane his mental energy seemed to increase, and around this time a new totem animal came to the fore. Where an ageing WB Yeats had turned to rejuvenating injections of "monkey gland" Spare turned to his personal method of atavism, drawing a magical and sigillated pastel in 1953 on the theme "This my wish to obtain the strength of a tiger", from *The Book of Pleasure*.

Tiger or not, Spare was increasingly neglecting himself. His nephew Martin Lapwood had already noticed that when he was working hard, for weeks on end, he seemed to live out of tins, but now he was living on milk straight from the bottle. When Dennis Bardens visited one day he noticed Spare had made a magical stele 'For Health', and he began to wonder if Spare was sick.

Spiritualism had come back into Spare's later output, and a spiritualist named Philip Paul visited him for an interview. "From childhood a victim of bad health," wrote Paul,

he is a creature of space – the limitless horizons of the mind. His preoccupation with the mental has not helped the physical. He is plagued with anaemia and deafness and has now to sit at his easel.

The words seemed to pour out of Spare: he was a stoic; everything was true; his dreams were like nothing he had seen on earth; he had an ambition to paint a tree as it had never been painted before. They joked about spiritualism. "A lot which appears to be fraud is not really fraud at all," Spare said, "but I don't mind the fraud. I have been a crook all my life."

Here on the wall was a portrait of a girl; who was she?

He looks reflectively wan. "A mental visitor from forty years ago. She was the first girl I courted. I was twelve. I painted that picture, then there was a knock on the door. When I opened it, she walked in, out of the past."

Finally it was time to go, to walk out again past "the mean houses". Mr Paul shook "the thin hand" that was offered, and tried to say something; "groping inarticulately for words."

They come at last, unintendedly flippant, advice that he should take greater care of his health. "We can't spare Spare, you know."

Publicity was important, and Spare needed all the interviews he could get. A major chance arrived in 1955, or so it seemed, when the BBC invited Spare to talk on the wireless. The invitation came, indirectly, through the agency of Dennis Bardens, and Spare was to be on the first episode of a pioneering series called *People Talking*, devised and presented by Dennis Mitchell. Spare was excited by this, and he had great hopes for it, asking

8.30 PEOPLE TALKING
See below and 'Both Sides of the Microphone'
(The recorded broadcast in the North of England Home Service of Jan. 25)
Next week: 'Boys in Trouble'

P E O P L E T A L K I N G

A S E R I E S O F F I V E P R O G R A M M E S D E V I S E D
A N D P R E S E N T E D B Y D E N I S M I T C H E L L

1: Unusual *'I believe I've said and done more original things than any other living man'*
Beliefs *'I believe in fun and I don't believe in work'*
 'I believe I could kill anybody in the world by Black Magic'

 Astrology, fairies, charms, flying
 saucers, ghosts and the occult . . . these
 are some of the many unusual subjects
at 8.30 touched on in the programme

the Grants if they would help him to answer the heavy postbag he expected to come in afterwards. He even lent Bardens his "magic bell" so that it could be used in the programme.

The first episode was called 'Unusual Beliefs,' and it was broadcast on Monday 18th April 1955 at 8.30 on the Light Programme channel, just after a drama series called *The Barlowes of Beddington*. We can imagine Spare waiting beside his wireless as the last notes of the *Barlowes* theme tune ended.

A more worldly man than Spare might have been wary even of the title 'Unusual Beliefs', anticipating something like the "Bring an Idiot" parties popular among the smart set in the 1920s. The programme was a disaster, a complete "wash-out", as he told the Grants, and he had been "segmented with a lot of half wits". Spare's words had been sampled, cut about, and generally mutilated. Nor had Spare done himself any favours, rising to the bait when asked if he could kill a man with a curse. He could, he said. And how long would it take? About two weeks, he said. Far from drawing a heavy postbag, a single anonymous member of the public wrote in to the BBC to complain, denouncing Spare as a former associate of Crowley.

Adding injury to insult, they lost his magic bell. Spare was bitterly angry with Bardens, and their friendship never regained its former warmth. There was a ludicrous postscript to this sorry event in one of

the pulpier men's magazines, *True*, in 1959. In an article about Gerald Gardner's witchcraft museum on the Isle of Man, entitled 'Witchcraft's Inner Sanctum,' Daniel Mannix wrote of "an engraved spell prepared in 1954 by a magician named Austin Osman. Osman advertised the charm over the radio as bringing sure death to anyone who offended its possessor." What an evil character he was, this Osman.

Spare managed a show at home in 1954, and had his last show at the Archer Gallery in October 1955. He was still working like ten men, as he told Ken and Steffi, and this was one of his largest shows, with over two hundred and twenty pictures including *Man is a bundle of Ids*, *Traverser of the Aeons*, *Psycho-Somatic Phantasy* and *Death Does Not Part*. Portraits included Sigmund Freud, with Spare's Alphabet of Desire across his forehead, and the surrealist Max Ernst, and there was a picture of *Bernard Shaw in Limbo*. There were a number of stelae, including *For Protection from Evil People*, *General Benedictus and Love of all Things*, *Desire for Vampires and Succubi*, and *Desire for Psycho-Somatic Strength*.

An Exhibition of Paintings and Drawings
by
AUSTIN OSMAN SPARE
to be opened by
HANNEN SWAFFER, Esq.

at 3 p.m. on Tuesday, 25th October, 1955

ARCHER GALLERY
303 WESTBOURNE GROVE, LONDON, W.11 · Park 8761

Open from 25th October to 26th November

Tues.—Sat. 10 a.m.—5 p.m.	*Stations*: Central and District
Sundays 2—5 p.m.	Notting Hill Gate
Closed Mondays	*Buses*: nos. 15 and 52

Spare was no longer able to draw line as he once had and, in accordance with the way that painting is often said to be 'easier' than drawing, pastel work was now more prominent. Spare's late pastels are often extraordinary, some of them showing a multi-coloured chaos of coloured images with the effect of the *affichiste* collage

movement of the early Fifties, catching the look of layerings of torn posters or Paris Metro adverts. In their flow they have some of the qualities both of mental imagery and music. Spare's late output also includes Symbolist-style pictures "of" pieces of music, such as Beethoven's Fifth.

Spiritualist-themed works were also prominent, such as *Death Does Not Part*. The Arab-looking sheeting that drapes and veils some of the figures in these pictures is supposed to be ectoplasm. The series of ghosts or 'sheeted dead' was inspired by a book the Grants lent him, Albert von Schrenk-Notzing's *Phenomena of Materialization*.

Letchford was disappointed with this line of Spare's work, and with his *Ghosts I Have Seen* pictures. He later wrote to Bardens that it was "tied up with his sales talk":

> ...*he had to sell and keep selling and always had a ghost story up his sleeve for newspapermen. Well yes he may have seen ghosts inside his own head – we all have fear. Fear can produce imaginative ghosts. [...]*
>
> *But when I saw a dirty white linen sheet tossed over his lay figure standing beside a big picture of a "ghost" I knew that Spare could manufacture a ghost on the odd occasion.*

Spare had already told Letchford, somewhat ambiguously, "I'm sick of bloody ghosts."

Letchford's final judgment on Spare, unexpectedly, was that he was ultimately "rather a lightweight" (if "a damned good one at best"). It is an odd comment in some ways, since lightness is hardly an attribute of Symbolist art or much of Spare's.

He is also uneven, partly because he was so prolific. Occasionally his late work can be kitsch, and his occult subjects can limit his appeal to a cult audience. The psychic intensity of his work can also be claustrophobic, and in the Thirties a ginger-haired man ran out of one of his exhibitions shouting "Horrible, horrible! Go to Hell!"

Spare could certainly draw, although praise for his draughtsmanship sometimes has an air of consolation about it, and gets repeated unthinkingly until it becomes pious. There are any number of fine draughtsmen who are not household names – Edward Poynter, Gilbert Rogers, Herbert Draper, George Richmond, Gerald Brockhurst, and many others – so the fascination must be elsewhere.

As much as he can seem of his time or even ahead of it, Spare was equally behind it. He was an interstitial figure, "in-between", essentially out of step. He wasn't the last Old Master or the last decadent, nor was he quite the great precursor of Pop, abstract expressionism, surrealist automatism, Lettrism, or appropriative, role-playing art (with his pictures "of" himself as Christ, a woman or Hitler, anticipating Cindy Sherman). And yet – like the principle of "fourfold negation" that he seems to draw on in *The Book of Pleasure* – it's not that he absolutely wasn't a precursor of those things, either.

As for being ahead of his time, it is also noticeable that he often looked belated to contemporaries. It wasn't just his pre-Modernist styles and his plugging away with unfashionable interests such as automatism, but his actual career. Reviewing the post-war Archer Show, Cora Gordon noted that he had "reappeared" after many years. Two decades earlier in 1924, reviewing his Oxford Street show, *The Studio* noted that his work had attracted attention "some years ago" by its originality, but that he had "since been seen less frequently." Going further back into the Edwardian heyday this seems to point towards, the *Burlington Magazine* noted in 1911 that he had attracted attention six or seven years earlier, but since then "the years have not dealt kindly with Mr Spare". His career seems to have been over almost before it began, until he starts to sound like the greatest artist Britain never had.

For all that, when Spare is at his rare best he is superb, and there is no one to touch him. Although much of his work almost defies reproduction, seen in the flesh it has an extraordinary aura about it. Georges Bataille once asked whether any man could love a painting as much as a fetishist loves a shoe. If we can find that man, he might well be a Spare collector.

Spare looked tired at the last Archer Gallery show, where Hannen Swaffer – now seventy-five and also showing his age – stood unsteadily on a chair to make a speech at the opening. They had come a long way

since 1904, when Swaffer had first encountered Spare's work on the Walworth Road. Among the pictures in the show was an unusual late work, *Traverser of the Aeons (Ego)*, which seems to show a vague, misty, almost pixelated-looking face – Spare's face – merging with the starry universe.[2] It apparently began as a parody of Paul Klee, but ends up like a picture of consciousness itself, undefeated and magnificent.

Spare had taken some knocks, but his life had certainly had its moments. There were the hundreds of women he'd had, and the Sabbaths he'd attended. He once saw a satyr in Fleet Street, and chased it through the crowds until he lost sight of it. He'd been the only survivor of a torpedoed troopship, spent the night on top of a pile of corpses in No Man's Land, and he never forgot the sight of an albatross following his ship through the mist in the North Sea. He had studied hieroglyphics at first hand in Egypt, painted Hitler from life, had the friendship and encouragement of Walter Pater, sampled thirty kinds of ice cream during a heat wave in Italy, and marvelled at the freshness of a picture of fruit seen on a frieze at Pompeii. He was such an expert on all aspects of human sexuality that he had been called as an expert witness at the obscenity trial of Radclyffe Hall's lesbian novel *The Well of Loneliness*, and of course he had that letter from Freud praising his work, and deferring to his greater genius.

Spare was a man of paradoxes. Mario Praz described him as a dark, Satanic occultist, while his friends were impressed by his down-to-earth kindness and his love of animals – he was a lifelong RSPCA member, and can be seen wearing his RSPCA badge in photographs. The London journalist HV Morton (as in "HV Morton Finds A Genius") had kept in touch with Spare and after his death he wrote to Letchford: "Poor Spare had all the outward attributes of the stage genius (another Dan

2. A quirky extra touch of meaning, and perhaps bathos, is given by the small, primitively stylized figure at the bottom of the picture with an erection and what looks like a handbag. Letchford describes it "on earth below a tiny nude with libido erect [hurrying] along with his little 'handbag of values'". It might equally be a dancing figure making an offering.

Leno!)" – Dan Leno being the celebrated Cockney music-hall artist and pantomime dame.

At the very least, perhaps, we should include Spare in what Peter Ackroyd has identified as the "Cockney visionary tradition."

It has been said that the history of Western art is really the history of patronage, and it is true that the Renaissance would have been different without the Medici family. A new patron came into Spare's life around now in the shape of Ernest Chapman, a retired hairdresser, who was keen to buy not only pictures but sketchbooks. Spare was exhausted after the last Archer show, but in November he wrote to the Grants that he was looking forward to getting back to the West End at last in 1957.

Spare had made a stele for Letchford and his wife Joyce and given it to them, along with a Buddha, as a wedding present; it depicted Joyce as the goddess Isis and Frank as a satyr. They were now kept very busy running a small toyshop in Battersea called Joytoys, but they managed to go on a short holiday to France, and before they went Spare asked Frank if he could look for any remaining stock of pre-war Conté pastels in little old back-street artists' supply shops in Paris.

On 10th May 1956, Spare's neighbours were surprised to see a large, dark Rolls-Royce draw up outside the house in Wynne Road; the identity of this car remains mysterious. It has been suggested it might have been the Nizam of Hyderabad, one of the world's richest men, who had paid for a squadron of Spitfires during the Second World War, and may now have wished to buy some erotic drawings from Spare. Spare said an Indian prince had visited the White Bear show and wanted to maintain contact through an intermediary. Whoever it was, the car waited for a while and then drove away again.

As soon as he got back from Paris, Letchford called on Spare and banged the heavy, rusted iron doorknocker: "For the first time ever, the crash of the doorknocker brought no response, but echoed through a deserted house." A boy on a bike told him the Rolls-Royce had just been there, and a nearby window cleaner called out "Guv'nor, the old chap's been took away by ambulance."

That evening Dennis Bardens rang to say Spare was in the South Western Hospital, Stockwell; his appendix had burst. Letchford grabbed his old Claud Butler racing bike and set off at once. In the course of visiting he met the "neat figure" of Kenneth Grant, and was struck by his "very luminous eyes." The two men had not previously met.

Spare was very sick, with tubes in place and a substance coming out of his mouth. "This is a stab in the back," he said. He weakly held up his hand which, Grant wrote in his diary that night, "I'm ashamed to say I was loath to take." Another friend, an artist named EAR "Alfred" Larking, was made of stronger stuff, and wiped Spare's mouth with his own handkerchief. Letchford laid his hand over Spare's and said "See you soon," motioning to Grant that they should let him rest; Spare was talking animatedly about ideas for new work.

Spare was glad of his visitors, who returned over the next couple of days, except for Bardens: he hadn't forgiven him for the radio debacle and turned his face away to the wall when he saw him, with what Bardens remembered as an almost animal snarl.

Spare died on the afternoon of 15th May 1956, at ten minutes to two. The Resident Surgical Officer, Dr Vasavada, wrote to Letchford to say that Spare had neglected himself. He had died from peritonitis following a burst appendix, but he was also suffering from anaemia, bronchitis, high blood pressure and gall stones: "His death was very much regretted by the entire hospital staff who could not save him in spite of all their efforts."

Spare left the first choice of fifteen pictures to Letchford and the second choice of ten to Grant, together with all the books and papers at Wynne Road. He was buried together with his father at St Mary's, Ilford, without a separate monument. Hannen Swaffer paid for the funeral.[3] Among the mourners was Connie Smith, Spare's old flame from before the First War.

He received a fairly motley spread of obituaries. "The collecting of his pictures may yet become a cult," said the *Times*, and for other papers he was variously the local artist, the man who defied Hitler, and the strange and gentle genius: "A strange and gentle genius died in a London

3. Hannen Swaffer tried to pay for the funeral, but in the event it was covered by Spare's younger sister Ellen [2023 correction].

hospital this afternoon," the *Evening News* told its readers; "You have probably never heard of Austin Osman Spare. But his should have been a famous name."

It was generally agreed he had simply turned his back on fame and fortune, which was not quite true, although things had certainly turned out very differently from the glowing future anyone might have predicted from the perspective of 1904.

What had done for Spare? Perhaps it was the class system, or lack of education, or a touch of mental illness; or perhaps – as I'd like to think – it was nothing at all: "Only the gods can distinguish failure from success."

In 1968 Miss Pain died and the old house at Wynne Road was left derelict, until the terrace was demolished to make way for a block of council flats. The final word belongs to Gavin Semple, who relates that when Ian Kenyur-Hodgkins, bibliophile, book dealer and picture-framer, visited the house while it was torn open during demolition, he noticed a handful of Spare's 'Surrealist Racing Forecast Cards' scattered here and there about the floor.

> *He did not retrieve them, and they were left amongst the remains of Spare's last home, torn and mouldering, like leaves turned only by the fingers of the wind.*

FINIS ꙮ

CODA: THE AFTERLIFE

"Assuredly, death is the great chance."
– *The Focus of Life*

Obscure and famous at the same time, Spare has long been wavering in a state of near-revival. In 1965 a dealer named Peter Claas showed some Spare pictures in London's Alpine Club Gallery, and the *Burlington Magazine* noted that Claas had "resurrected an unknown English artist named Austin Osman Spare" (an artist who "would have inspired the surrealist movement had he been discovered early enough").

It was harsh to say Spare was unknown when he had been the subject of a show at the Greenwich Gallery only the year before. This had a catalogue essay by Mario Amaya, whose own particular interests were Art Nouveau and Pop (he was soon to be shot and wounded alongside Andy Warhol, when they were attacked by Valerie Solanas) and he described Spare as the first Pop artist:

> *...he obsessively explored with a fetishist's fascination the Body-Building hero and the Strip-Tease heroine, in a group of works of the late thirties and forties that can lay claim to be being the first examples of Pop art in this country. In these sleazy, vulgar pastels, he depicted supra-real "animal" types who had become the idols of a mass-culture society.*

More than that, Amaya thought that in his rapid automatic scribbling Spare "appears to have predicted Abstract Expressionism long before the name Jack [sic] Pollock was heard of in England." Now on a roll with his comparisons, Amaya then decided Spare wasn't just in the business of "early forms of Pop art and crude types of Abstract

Expressionism," but by decorating radio loudspeakers "he flirted with a primitive type of kinetic 'Assemblage' art as well."

Spare's name never quite died out among antiquarian booksellers and the more scholarly picture dealers: among those who collected him was Victor Arwas of Editions Graphique, the Mayfair specialist in Art Nouveau and Deco. The Art Nouveau craze and Beardsley revival of the late Sixties and early Seventies did little for Spare, except for the odd footnote, but in 1973 Ian Kenyur-Hodgkins, founder of the picture framers Sebastian d'Orsai on Kensington Mall, felt that Spare's time had come and he published a facsimile of his *A Book of Automatic Drawings*. It was not a success, and unbound sheets were still circulating years later.

Meanwhile Spare was becoming better known, not to the art world but to people interested in the occult. The "Buy part one, get part two free" encyclopaedia *Man Myth & Magic* (available every Thursday from your newsagent at 4/–) was launched in 1970 with a Spare picture on the cover of the first issue. Anyone old enough to have watched ITV in the early Seventies, back in the days of Benny Hill and *On the Buses*, has probably seen a Spare without knowing it, because a picture of this same devilish head (variously known as *The Vampires are Coming*, its real title in the last Archer Gallery show, or *The Demon Elemental* or *Portrait of an Elemental*) flashed up on screen in the advert for *Man Myth & Magic*.

This was the work of Kenneth Grant, the man who is almost single-handedly responsible for Spare's posthumous fame. He wrote about him in *Man Myth & Magic*, with articles including 'Atavism' and 'The Nightmare World of Austin Spare', and he established an enduring Spare legend with his books *The Magical Revival* (1972) and particularly *Images and Oracles of Austin Osman Spare* (1975) – the book that really launched the Spare mythos. Spare subsequently continued to figure as a somewhat mythologised character in the rest of Grant's output.

Following the works of Grant (and to a lesser extent Francis King, who gave Spare a chapter in his 1970 book *Ritual Magic*) Spare's name spread from the occult to the music scene. Jimmy Page of Led Zeppelin, who was also behind the Equinox occult bookshop in Kensington, put together a major collection, and Spare was particularly taken up by the alternative music community during the early 1980s, with Genesis P-Orridge, Psychick TV, and their associated movement the Temple ov

Psychick Youth, along with the "chaos magic" movement within occultism. The experimental band Coil were also inspired by Spare, and the late John Balance, Coil's leading light, had a fine collection.

Spare made an unlikely re-appearance in the *Tatler* magazine when the Temple Ov Psychick Youth were profiled there in 1984 (the same year that James Birch and Oliver Bradbury put on a Spare show). I saw this *Tatler*, with what I still remember as a dreamlike sensation, in a moonlit greenhouse on the roof of a squatted Georgian building. It reawakened dim memories of Kenneth Grant, and over the next decade or so I would see references to Spare here and there: a poem by Iain Sinclair ("… the New Sexuality […] BECOMING ONE WITH ALL SENSATION […] the annihilation of separate identity through / the mechanics of the Death Posture"); a couple of pictures in an auction catalogue of the decorator David Hicks; and a landmark sale at Christie's South Kensington in 1994, selling the Spare collection of a Texas oilman.

There was a show by dealer Henry Boxer in 1992, celebrating the launch of *The Witches Sabbath* and *Axiomata*. This show, with a beautifully-done keepsake book in the same green as Spare's late Twenties drawing paper, was even more of a landmark because it effectively launched the Spare-specialist firm of Fulgur, headed by Robert Ansell. Ansell had already written a scholarly study of Spare's bookplate work, and together with Gavin Semple his publications took Spare studies to new levels of reliable research and larger cultural awareness. Ansell and Semple have continued to preside over the field with Fulgur publications such as *Zos-Kia, Two Tracts on Cartomancy, Zos Speaks!* and *Borough Satyr*.

Slowly Spare was coming into what might be called the mainstream of the alternative (and now, of course, there are T-shirts). Between 1987 and 2005 there were quite large shows at the Morley Gallery, Marx House in Clerkenwell, and the Maas Gallery. I reviewed one of these for the *Times Literary Supplement* in 1999, only to get a concerned phone call from an editor: "We're just a bit worried in the office," he said; "We're a bit worried you might have made this man up."

Nowadays a moment's googling on the internet would show that I hadn't. Spare has become very famous (for a very obscure figure), although his fame is still greater with occultists and musicians than in the art world. There is a musical coda to his story, and it is all the

more remarkable because it pre-dates his wider dissemination by Kenneth Grant.

Back in 1969, in the days of the King's Road, joss sticks, Beardsley, and boutiques such as I Was Lord Kitchener's Valet, a psychedelic band called Bulldog Breed (not to be confused with any later bands of the same name) recorded a song about Spare, complete with references to Victoriana – all the rage at the time – and the lighting of black candles. "They said he was before his time" runs the chorus,

> *His reproduction out of line*
> *But now he's dead, they wish him well –*
> *Is he in heaven, or come back from hell?*

After which it takes off into a psychedelic fugue.

The band were based in Ilford, where Spare lies buried, and they knew about him because one of them, Rod Harrison, had an aunt who'd actually known him in person; he even had a batch of Spare's pictures in his lodgings by Ilford bus station. Unfortunately he got so badly behind with his rent that he had to do a midnight flit, leaving all the pictures, and they have never been seen again.

NOTE TO THE SECOND EDITION

Since I wrote this book there have been two further Spare exhibitions, at
the Cuming Gallery in South London and the Hidden Noise in Glasgow,
and I am glad to say that the book itself seems to be taking its place in a
consolidation of Spare's reputation.

A second edition is always an opportunity to correct errors and
mention things that have since come to light. My favourite error, if I am
allowed such a thing, is that I described Spare's father-in-law as a keen
naturist when he was actually a keen amateur *naturalist*. This evidently
reached me by a process of Chinese whispers, even though the correct
information was already in my notes and staring me in the face from
Frank Letchford's memoir of Spare.

Reports of Spare's early achievements in Paris and St. Louis
come from Spare himself, and are hard to confirm. Despite her name,
Belinda Blinders (aka Spare's friend Desmond Coke) wrote school*boy*
fiction, not schoolgirl. Oswell Blakeston's novel *For Crying Out Shroud*
is not narrated by the protagonist. Spare's mysterious and possibly non-
existent Indian patron has been rumoured to be the Gaekwar of Baroda as
well as the Nizam of Hyderabad, and, as for the latter, his connection with
British military aircraft is not that he was buying them in 1956, as far as I
know, but that he paid for, i.e. sponsored, a Spitfire squadron in the Second
World War. The film *Night of the Demon* features weather magic when the
magician Karswell whips up a sudden storm by touching his hand to the
bridge of his nose, but not – as I misremembered it – by holding up a spell
to his forehead. These errors have all been quietly corrected in the present
edition; there must be others lurking.

A few things have since come to light or fallen into place. The
idea of distracting the conscious mind so that the unconscious mind could
do its work, as advocated by Spare, was quite widely 'in the air' at the time
and Spare's reference to playing the card game Patience, in the *Book of
Pleasure*, may well be an allusion to Madame Blavatsky. In her later days
in West London, from the 1880s to her death in 1891, she would keep
herself absorbed in playing Patience on a green baize table while absent-
mindedly throwing out pearls of wisdom for her many visitors. Around

the same time August Strindberg similarly believed in putting himself into "a state of unconsciousness, not with drink, but by distractions, games, cards, sleep, novels", and then – without worrying about "results" or "acceptability" – he found "something emerges."[1]

I am still not sure that Spare ever met Mabel Beardsley, but I enjoyed finding Steffi Grant's 1972 reminiscence of his conversation, in the *Times Literary Supplement* letters pages: "He was very fond of her, and remembered her as an ardent exponent of Free Love."[2]

When researching the book I came to think that the practice of making 'conic sections,' related to Spare's anamorphic pictures, was an aspect of solid geometry that was perhaps more widely known in the late nineteenth and early twentieth centuries than it is today, and I still think this. I even came across a reference to conic sections by the writer MP Shiel which seemed to suggest they might once have been a popular pastime, when Shiel notes the futility of writing novels: "I have asked myself 'Why ever didn't he (or she) amuse himself by doing carpentry, or conic sections, puzzles, tennis – something more educating and entertaining...'"[3] However, on discovering that Shiel – self-appointed "King of Redonda", friend of John Gawsworth, and writer of *Prince Zaleski*, *The Purple Cloud* and the early 'Yellow Peril' novel *The Yellow Danger* – knew Spare's friend Oswell Blakeston, I now think that his comment, from 1932, is probably an allusion to Spare himself.

If I wrote the book now I'd say something about Grace Pailthorpe, a British surrealist who bought Spare's pictures. Frank Letchford mentions in passing that he met Dr Pailthorpe and her son, who visited Spare in his basement. In fact it was Pailthorpe and her partner, the painter Reuben Mednikoff, who was about thirty years younger than she was: she'd adopted him as an Oedipal son, and he'd changed his name to Pailthorpe. Pailthorpe was a psychiatrist who pioneered art therapy, and they were an extraordinary pair of British surrealist artists in the Thirties: André Breton

1. Letter to Bengt Lindforss, 1 January 1891, cited in Mary Sandbach's introduction to *Inferno and From an Occult Diary* (Penguin, 1979) p.16
2. *TLS* January 21ˢᵗ 1972
3. MP Shiel in *Ten Contemporaries* ed. John Gawsworth, (Ernest Benn, 1932), p.171

said they were the most surreal artists in Britain[4]. The fact that Breton admired her, and she evidently admired Spare, is another facet of Spare's tenuous relationship to surrealism.

There is also the question of how much Kenneth Grant's New Isis Lodge actually met, which I tried to be positive about in the book. I know I've started at least one Grant enthusiast on a wild goose chase into the question of whether the furrier's basement in Chapter Eighteen really existed, because I wrote that the present shop owners' denial of it (an instance of *taqiyya* to unbelievers, perhaps) "seems contradicted" by the window bricks in the pavement. Without having meant to be arch, this was understatement; I definitely think that the basement really existed, and still does. Since publication, however, the old Argenteum Astrum temple at 124 Victoria Street, which stood proud amid a wasteland of concrete and plate glass, has sadly been knocked down.

Spare continues to be a magnet for myth, rumour, and distortion. Talking with someone in a Glasgow bar about the Glasgow Spare exhibition (which included his self-portrait with Hitler moustache) I was told that the show – apparently – included a bizarre self-portrait of Spare wearing an SS uniform. Better yet, it seems that for security reasons all the pictures were actually copies – except for the opening night, when the real ones were briefly on show.

4. "The best and most truly Surrealist" artists in Britain, according to Breton, with reference to their showing at the 1936 Surrealist Exhibition in London. *Sluice Gates of the Mind: The Collaborative Work of Dr Grace W Pailthorpe and Reuben Mednikoff*, ed Nigel Walsh and Andrew Wilson (Leeds, Leeds City Art Gallery, 1998), p.11.

Note to the Third Edition

It has been over ten years since this book first appeared and Spare's star continues to rise, bringing the recognition that largely eluded him in later life. There is a strange pleasure in immersing yourself in the world of Spare, something I fully indulged in while writing the book, and since then I have been delighted to be in contact (via eBay, of all routes) with a man who had read it four times, and to be told by someone else that when she read it the quality of her dreaming changed.

Yet more details and developments, new at least to me, have surfaced since the Note to the Second Edition (and two larger ones, cartomancy and pornography, follow further below). Among the smaller ones, Spare's wearing a crimson silk sash when he was a young man (pp.21, 22, 80) as remembered by Sylvia Pankhurst, was not just eccentric personal flamboyance but an art-student fashion of the day: Arthur Ransome, in his 1907 book *Bohemia in London*, writes "Our Romantics strut the streets in crimson sashes…".[1]

At the other end of Spare's life, when he knew Kenneth Grant and was only a handshake away from the nebulous world of Grant's Nu-Isis Lodge, Grant's shadowy tales of the Lodge feature the basement of a furrier's shop owned by an alchemist. Twenty-first century enquiries about this basement by Grant and Spare enthusiasts were not always encouraged,[2] but now, down a narrow flight of stairs, the basement is bright, open and accessible as part of a thriving Islamic bookshop.

The basement and the alchemist himself, David Curwen – who wrote on the subject as 'Lapidus' – are further remembered by Stephen Skinner in the beautiful Watkins edition of the 16th century alchemical manuscript *Splendor Solis*. Skinner visited in the 1970s and gives the story of the Nu-Isis basement another layer, this time entirely factual:

1. Arthur Ransome, *Bohemia in London* (Chapman Hall, 1907) p.10.
2. I heard of a very brusque response when I was originally researching the book, but in fairness I have since heard of at least one researcher – who made written contact ahead of his visit, and had the respectability of an overseas university behind him – who was made more welcome.

He introduced himself simply as Lapidus and made me swear
not to reveal his identity. He owned a furrier's shop in London,
close to Baker Street underground station. In the cellars of this
shop he had fitted out a modern alchemist's laboratory and was
following the classics like Pontanus, Artephius and Ali Puli
step by step.... using modern Pyrex cucurbits and flasks... In
turning again to this classic of alchemy, I am reminded of the
sequence of colour changes that Lapidus replicated, including the
stunningly beautiful image of the "peacock" being sublimated on
the walls of the flask...[3]

Inevitably a few more errors have also raised their little grinning heads, along with things I might have done differently or made clearer.[4] Although the etymological overlap and confusion between necromancy, raising the dead, and nigromancy, black magic, is striking and interesting, the primary meaning in *Dr.Faustus* and elsewhere does of course go from necromancy itself to nigromancy as its corruption, and not the other way around.

I've already emphasised – perhaps even laboured – the rise of the unconscious in the late Victorian and Edwardian period. If I were writing the book today, I'd labour it even more. W.B. Yeats, writing about the revival of magic that reached its high point in the 1890s with the Order of the Golden Dawn, and thinking of his former magical comrades such as Macgregor Mathers, remembered: "My friends believed that the dark portion of the mind – the subconscious – had an incalculable power, and even over events. To influence events or one's own mind, one had to draw the attention of that dark portion, to turn it, as it were, in a new direction."[5]

Despite the all-important revelation of the unconscious, and Spare's experimentation with automatic drawing, I was taken aback

3. Stephen Skinner, 'An Introduction to Splendor Solis', *Splendor Solis* (Watkins, 2019) pp.11-12.
4. *Straus* for ostrich is not Latin but German [p.55]; the Arena of Anon was announced not in *Focus of Life* but *Anathema of Zos* [p.177]; and although Hannen Swaffer offered to pay for Spare's funeral, in the event it was probably paid for by his sister Ellen [pp.23, 256]. These have been corrected in the 2023 text.
5. W.B. Yeats, 'The Trembling of the Veil', in *Autobiographies* (Macmillan, 1955) p.372

to see this book cited by another writer (and approvingly) as saying Spare was an influence on surrealism. In fact I was at pains to tease apart the apparent confluence of automatism in Spare and surrealism, because Surrealist automatism was stimulated by psychiatry and psychoanalysis, while Spare's automatism is rooted in an earlier tradition going back to spiritualism. Having said that, occult paradigms ("Enter the Mediums") keep rising up in surrealism like the return of the repressed, so perhaps it is not so ridiculous to see Spare as a precursor of sorts (see pp.114-15; 184-85). As for direct influence, though, I very much doubt there was any, not least because the surrealists, Andre Breton in particular, were keen to find and name forerunners, and Spare's name is never there.[6]

I was wary of taking Spare's own accounts of his life too much at face value, but a likely error still slipped past me regarding the Jewishness of Golder's Green at the time Spare lived there (p.80). This was based on something Spare told Frank Letchford – and the real cargo of the conversation for Spare, talking to his younger friend, was probably his delectation over all the attractive Jewish women who would allegedly parade about in the evenings, who may have been largely fantasy[7] – but I'm assured by a present-day resident with a serious interest in Jewish history that the now celebrated Jewishness of Golder's Green only came later, after the rise of Hitler.

When I first planned this book I was going to make more of Spare's deep tendency to confabulation, considering it on a quasi-philosophical level. I'm glad I didn't, and what saved me was impatience with the endless glib and inconsistent lying of my then literary agent. Some years ago the man in question died, but I'm still glad not to have seemed on side with 'post-truth' developments or the more vapid New

6. With no bias against the English-speaking world, Breton's *First Manifesto* (1924) namechecks Swift, Poe, Shakespeare and Edward Young (poet of *Night Thoughts*). He was also enthusiastic about Gothic novels, William Blake, and artists Pailthorpe and Mednikoff (see pp.263-4). In his *Anthology of Black Humour* (*Anthologie de l'humour noir*, 1940) he finds further kindred spirits in Leonora Carrington, Thomas De Quincey, Lewis Carroll, J.M. Synge and others. If he was aware of Spare I feel he'd have let us know.
7. For Spare to Letchford on Golders Green see Letchford, *Michelangelo in a Teacup* pp.77-79.

Age clichés about everyone creating their own reality. Everyone does create their own reality, but there is still a sense in which Elvis is either dead or he isn't.

In Spare's defence, he didn't lie to swindle anyone or gain advantage, but to impress people. The occasional incongruity between his version and the truth can be funny, and there is certainly a tragicomic strand in Spare's life, but you can also feel the pain of a craving for recognition and esteem. The later Spare was perhaps not quite as philosophically detached from success as we might like to imagine, and there is a melancholy aspect to his writing "Of the Ghetto" under his name on a late self-portrait.[8] It would be very interesting to know what sort of ghetto he felt he was in.

I might have exaggerated the extent to which Spare's marginalisation was due to fine drawing no longer being of paramount importance – a shift that really came later, with the art college revolution of the Fifties and Sixties and the rise of abstract, Pop and conceptual art – which reinforces the inescapable conclusion that the stalling of his career was largely due to his character, and his talent for rubbing people up the wrong way. Clifford Bax, in a 1922 letter about the magazine he co-edited with Spare, *The Golden Hind*, writes "I hope we are going to make a success of this magazine, but Mr Spare seems to upset most people much more than I had expected."[9]

Anyone who writes books now has to expect occasional feedback from candidates for the Dunning-Kruger Award, and one of mercifully few idiotic (not to mention insensitive and tone-deaf) comments was a very truculent complaint that the book was too funny. It is worth remembering where these funny stories generally come from – Spare himself – because it is in their nature that there tend to be no other witnesses. The same feedbacker (it would be dignifying this unfortunate man to call him a reviewer) also complained there was too much about Spare's tall-tale

8. *Self Portrait* (1955; item 221a in the 1955 Archer Gallery show). Bayer Knight collection, London. I am very grateful to David Knight for showing me this.
9. Letter 4.xii.1922 from Clifford Bax to writer Arthur Thrush (1894-1963), which came up in the American book trade circa 2012. I am indebted to William Breeze for bringing this to my attention.

telling, but Spare without his tales wouldn't be Spare (as Oscar Wilde says, "One's real life is so often the life that one does not lead...").[10]

Spare is such an extraordinary artist that he's been dead fifty years – more, literally – and we still don't know what he's going to do next. Recent twists and turns in his posthumous career have included a tarot deck and the discovery of more pornographic drawings, something he was known for in his lifetime (see pp.171- 72). A folio of grotesque drawings closely related to the world of *Ugly Ecstasy* and entitled *Psychopathia Sexualis* has now been published, although it bears only a very notional relation to the book of that title by Krafft-Ebing.[11] The drawings are certainly sexual, although few people would describe them as erotic, and it remains to be seen what effect they will have on Spare's still fluid critical fortunes. As for the tarot, an attractive thing, on one level it is juvenilia, largely copied from the Oswald Wirth deck and uncharacteristic of the mature Spare (he went back to ordinary playing cards, along with cards entirely of his own devising), but meanwhile extraordinary, complex, super-abundant things are happening on the linking edges between the cards.[12]

The previous paperback was announced or blurbed somewhere as "definitive" – one of those forgivably exaggerated things that publishers say – but the book was partly a meditation on the impossibility of definitive biography (particularly of an occultist, whose life is lived so much on the 'inner planes'), and there was a digression on this (p.149-150 and corresponding endnote p.294). Any worthwhile biography is to some extent an artistic creation in its own right, like a novel.

10. 'Miscellanies', *Collected Edition of the Works of Oscar Wilde*, ed. Robert Ross, (1908) vol.14 p.38.
11. *Psychopathia Sexualis* (Fulgur, 2022). Spare was clearly fascinated and inspired by the phrase and borrows it for his title inscription "Psychopathia Sexualis by A.O.S.", although there is no evidence from the drawings that he had read the book. One of the most intriguing things about this folio is his final inscription "In Memoriam Coitus", as if ordinary intercourse was now dead or over for him. Krafft-Ebing's actual book has been atmospherically illustrated by the great American comic artist Robert Crumb, in *Weirdo Comics* no.13 (Berkeley, Last Gasp, 1985).
12. The tarot has been published in book form in Jonathan Allen (ed.) *Lost Envoy* (Strange Attractor, 2016) and will appear in deck form in 2023.

It has been said of the iconographer and scholar of art history Aby Warburg, after whom London's Warburg Institute is named, that he "conceived of the art historian as a necromancer who conjures up the art of the past to give it an enigmatic new life, a strange figural floating."[13] I couldn't claim to be an art historian, but I am glad to have conjured up a figure of Spare, and to have contributed to his enigmatic new life.

London
15.v.2023

13. Brian Dillon, 'Collected Works: Aby Warburg's Mnemosyne Atlas', *Frieze* no. 80 (2004), p.46.

LIST OF ILLUSTRATIONS

Cover image: *Portrait of a Young Woman (Experiments in Relativity)*, pencil and water colour, 1933 (Collection of Ossian Brown)

COLOUR PLATES

1. *Druidesque*, pastel 1955.

2. Untitled album picture related to *The Focus of Life* (early 1920s). A distinctly peculiar-looking woman is bleeding from the vagina, but she has a man's legs and a head of hair we've seen before somewhere [discussed pp.171-2; 180]. This picture is related to Spare's theories of the 'New Sexuality': androgynous, empathetic and ultimately mystical.

3. *The Black Mask* (1904). Spare's early Beardsley style, this example taking the already subversive mode of Beardsley and subverting it further with the mannish face and the lumpish outline of the excessive bustle: it seems to go beyond graceful Victorian artifice to suggest actual steatopygia. The question mark, surely about gender, chimes with the contemporary *Earth Inferno* picture labelled 'The Despair' [described p.36]. Meanwhile the dwarf (also androgynous) can hardly bear to look. (Collection of Jerusalem Press Ltd)

4. *Portrait of a Woman with Red Hair, 'Coquette'*, pencil and watercolour, 1930s. (Collection of John Contreras)

5. *Bette Davis* (1933): another fine example of Spare's 'sidereal' manner, often developed from film star magazines or cigarette cards.

6. *Joan Crawford*, pencil and watercolour 1933.

7. *Stele: For Protection Against Evil People*, pencil and watercolour on plywood, 1955. (Collection of Michael Staley and Caroline Wise)

8. *John Teed*, pencil and watercolour, 1937. (Collection of Ossian Brown)

9. *Reclining Nude*, pastel, c.1920s. (Collection of Ossian Brown)

10. Untitled woman (1939). At the other end of the formal spectrum from his 'sidereal' play with line, these realistic Cockney pastel portraits were a heartfelt part of Spare's work. This one from 1939 was lucky to escape the tragic 1941

loss of many – the usual figure given is three hundred – of its kindred pictures one night in the Blitz. (Collection of John Slater)

11. *Galaxy*, pencil and watercolour, 1932.

12. *Satyr*, pencil and watercolour, early 1930s.

13. *Satyr*, pencil and watercolour, 1932. (Collection of Simon Whittaker)

14. *Reclining Nude*, pencil and crayon c.1930. (Courtesy Maas Gallery)

15. *Redundancy Isle*, ink on board, Archer Gallery (1947) number 92.

16. *Mors Janua Vitae*, ink on board, 1947. (Collection of Ossian Brown)

17. *Vague Familiars* (1910) [discussed pp.83-4, when the real title was unknown] An idealised self-portrait beside a devil figure. The devil's wings are represented both unfurling and at full vertical stretch, anticipating the simultaneous depictions-in-time of the Futurists, like Giacomo Balla's *Dynamism of a Dog on a Leash* (1912), with its moving legs in multiple positions. At the base of the picture, vague animal heads are taking shape in a cloudy jungle of 'automatic' line that defies reproduction; like many of Spare's pictures, it needs to be seen in the flesh. A semi-legible inscription says "consciousness with fluctuating identity indiscriminately associationist incapable of effective resistance". The whole thing should expand our idea of what was going on in British drawing in 1910.

18. The only known colour photograph of Spare, circa 1945, at Wynne Road. The model seems to be Joyce Bernard. Thanks to Ossian Brown for this observation. (Popperfotos / Getty)

19. *Isis Smiles* (1953). Again, the model seems to be Joyce Bernard.

20. *Threshold of the Qliphoth: Drawn for Magical Conation*, pencil, coloured crayon, charcoal and wash on board, 1955. (Collection of Ossian Brown)

21. Self portrait (1955): a stoical Spare, inscribed "Of the ghetto". (Collection of Ruth Bayer and David Knight)

22. *Traverser of the Aeons (Ego)*, from the 'Contexture of Being', pastel, 1955. (Collection of Ossian Brown)

ILLUSTRATIONS IN THE TEXT

p.24 *Chums* vol.XII, no.614, 15th June 1904

p.26 *Tatler* no.151, 18th May 1904

p.45 1907 *Portrait of the Artist* (collection of Jimmy Page)

p.46 Early Spare letterhead

p.47 Jason Hyde

p.52 Pickford Waller bookplate

p.54 *Self Portrait* for Raffalovich (copyright V&A Images/Victoria and Albert Museum, London)

p.66 Northam's advert, from *The Equinox* vol.1 no.4

p.68 Picture of Spare with chalice, from Clifford Bax, *Ideas and People*

p.75 Artists' monograms

p.83 'The Senseless Seven', from *The Starlit Mire*

p.92 Martian script by Hélène Smith, from Breton, *The Automatic Message*

p.93 *Spiritual Study*, 1914-20 (collection of Charles Cholmondeley)

p.99 'The Death Posture' and 'The Death Posture: Preliminary Sensation Symbolized', from *The Book of Pleasure* pp.16 and 58

p.108 'The Death Posture', frontispiece from *The Book of Pleasure*

p.130 *The Negation of Unity is Wisdom*

p.134 'The Primogenial', from *The Focus of Life*

p.140 'The New Eden', from *The Golden Hind* vol.1 no.1

p.145 'Ugly Ecstasy', picture No.1 from *The Book of Ugly Ecstasy*

p.151 Woodcut from Matthew Hopkins *Discovery of Witches* (1664)

p.163 Two anamorphs, 1933 and 1932 (formerly collection of WB Dalton)

p.178 Envelope and Surrealist Forecast Card advert

p.182 List of shops from the 1937 Walworth Road catalogue

p.199 Cancelled cheque 17th March 1948 (author's collection)

p.203 *Satyros* (1933), an earlier instance of satyrization

p.204 *Joan Crawford* (1933, collection of David Knight and Ruth Bayer); together with Joan Crawford and Lon Chaney in *The Unknown* (Tod Browning, 1927). The image is in mirror-reversal to show the resemblance, spotted by David Knight.

p.205 *Judy Garland*

p.214 "I desire intercourse with a vampire" in sigils and alphabet of desire (private collection)

p.222 Sigils for Frank Letchford

p.226 *Lambeth Liz*, (1952, collection of Ossian Brown)

p.231 *Fetish Familiars*

p.232 *Fetish Queen*

p.234 Spare at easel (copyright Bert Hardy/Getty Images)

p.235 *Flower Girl* (1951) from easel opposite, showing sidereal effect in photograph (collection of Charles Cholmondeley)

p.250 *Radio Times*, 15th April 1955

p.251 Archer Gallery invitation October 1955 (author's collection)

Section, chapter, and 'finis' ornaments from Spare's first book *Earth: Inferno.*

ENDNOTES

I have tried to follow the general principle that notes to be read should be footnotes, whereas source notes can be buried quietly at the back of the book. However, I've put source notes concerning auction catalogues under the main text as footnotes, in order to give a sense of following a minor artist through the sale rooms, and I have put some supplementary material into the endnotes: notably Havelock Ellis on narcissism and JFC Fuller on yoga in the notes to Chapter VIII; and The Great Masturbator, Duchamp on artists going underground, Donald Meltzer on dreams as life events, and Ithell Colquhoun on 'inner planes' in the notes to Chapter XI. The possibly apocryphal nature of the opening and closing anecdotes in the Prologue and final chapter has also been noted.

PROLOGUE

The bicycle anecdote is from William Wallace, *The Artist's Books (1905-1927)* (Thame, First Impressions, 1995) p.6. Wallace was told this story by Spare's friend Will Smith, who was probably told by Spare, so it should be considered apocryphal. Spare's father wasn't on duty, as recounted, because he had already retired.

The early praise is widely repeated but hard to pin down. From artists, for example: GF Watts, "Spare has already done enough to justify his fame", quoted by e.g. Hannen Swaffer, 'The Mystery of an Artist', *London Mystery Magazine*, Vol.1 no.5, August 1950, and Kenneth Grant, *Images and Oracles of Austin Osman Spare* (Muller, 1975) p.11; see also Spare's note in the 1949 Temple Bar catalogue; Watts and Sargent "hail Spare as a genius", Wallace, *The Early Work of Austin Osman Spare 1900-1919*, 'Chronology' 1905; Sargent "thought him a 'genius' at seventeen", Dennis Bardens 'Introduction' to Archer Gallery show, 1947.

From contemporary critics and journalists, for example: "His ambition is to be President of the Royal Academy," *South London Press* 7th May 1904; "beyond doubt a genius" *Chums* June 15th 1904; "not been equalled since the days of Aubrey Beardsley", *The World*, 29th October 1907.

"There must be few people in London interested in art…" RED Sketchley, 'Austin O Spare', *Art Journal* 1908 p.50 [c.Jan/Feb].

I: SEATE OF THE BEASTE

Dickens on Smithfield: *Oliver Twist*, Chapter 21.

"a question, whether in theology or philosophy": Boswell, *Life of Johnson* (Oxford, 1953) 15th April, 1778 p.951.

Born after four in the morning (4.04) 30th December 1886: Alan Leo, *A Thousand and One Notable Nativities* (LN Fowler and Co, 1911).

Spare boys would stand: Gavin Semple in conversation 1.v.08 (Austin Spare to Will Smith).

Dickens: "horrible fascination" of Newgate: cited Weinreb and Hibbert, *The London Encyclopaedia* (Macmillan, 1993) p.813, p.563.

"cathedral nave"; "nave and screen," Alec Forshaw and Theo Bergstrom, *Smithfield: Past and Present* (Heinemann, 1980) pp.76; 79.

Denis Hollier on Bataille's "sacred horror" and Zola's "butcher's stall": Hollier, *Against Architecture: the writings of Georges Bataille* (MIT, 1989) pp.5; 12-13.

Animals in fear: Frank Letchford, *Michelangelo in a Teacup: Austin Osman Spare* (Thame, First Impressions, 1995) p.33; dream of animals ibid. p.35.

'Characters for a Murder Plot': 'Foreword' by William Wallace, Letchford p.15.

Ripper, gesture of silence: Robert Ansell on Spare walk, 5.xi.05. The friend was Will Smith.

II: THE DISCOVERY OF WITCHCRAFT

Goldfish man, one-man bands Letchford p.39; penny toys, old clo' men, Geoffrey Fletcher, *London's Pavement Pounders* (Hutchinson, 1967) pp.10; 16.

Soldier, swimming, bike accident, etc. *Chums* interview, 5th June 1904.

Mother: rewards, punishment, frustration Letchford p.163; inability to separate fantasy from reality ibid. 207; never allowed her to kiss him ibid. 37.

Claimed d.o.b. 31st December, e.g. Wallace *Early Work* 'Chronology'; Grant 'The Nightmare World of Austin Spare', *Man Myth and Magic* no.50, giving Spare what he called his "Janus Complex."

"often spoke disparagingly": Kenneth Grant, *Images and Oracles of Austin Osman Spare* (Fulgur, 2003) p.9; "filial affection was transferred": 'Austin Osman Spare 1888-1955' [sic] in Vera Wainwright, *Poems and Masks* (Guernsey, Toucan Press, 1968) p.24.

Materialising thought forms, transformed into alluring woman etc: Grant *Images and Oracles* [henceforth *I&O*] p.10; Grant, 'Nightmare World.'

Yelga or Yelder Paterson: e.g. Grant, *Outer Gateways* (Skoob, 1994) pp.17-18; p.24.

"usually old, usually grotesque" Grant and Spare, *The Witches Sabbath* (Fulgur, 1992) p.5 cf Grant *I&O* p.24.

"lame, blear-eyed": Reginald Scot, *Discoverie of Witchcraft* [1584], cited in 'Old Age and Witchcraft,' *Man Myth and Magic* no.73, p.2051.

"...Jezebel of Rome": celebrated anti-Catholic line from John Moultrie's poem 'The Black Fence.'

Drawing of robed and cowled figures Letchford p.35.

headmaster story ibid. p.173.

learned only to masturbate ibid. p.37.

superstitions: Michael Collins, *The Likes of Us* (Granta, 2005), pp.53-4; 127, 158-9; Thirteen Club pp.58-60.

"I love superstitions…" Oscar Wilde to Mr Blanch, January 1894, *Letters of Oscar Wilde*, ed. Rupert Hart-Davis (Hart-Davis, 1962) p.349.

III: BOY GENIUS

Bessie Mitchell: Letchford p.71.

"happy evenings": 'South London Boy Artist', *South London Press* 7th May 1904.

Powell's in Whitefriars Street: Masonic connection suggested by Robert Ansell, 5.xi.05.

Stained glass windows for Thomas Cowell: Robert Ansell, *The Bookplate Designs of Austin Osman Spare* (Bookplate Society / Keridwen Press, 1988) p.1.

Sir William Blake Richmond and FH Jackson, swathe of prizes: widely recounted in 1904 interviews; National Mathematics Award Ansell *Bookplates* p.1.

"remarkable sense of colour": National Competition Examiners' Report, 1903, cited William Wallace, *The Artist's Books 1905-1927* (Thame, First Impressions, 1995) p. 35.

"belong practically to the realm of colour-prints": Esther Wood, 'National Competition of Art Schools' *The Studio* vol.XXIX, 1903.

" most regrettable in Victorian painting." John Christian, *Symbolists and Decadents* (Thames and Hudson, 1977), caption to Plate Nineteen.

Omar Khayyam and Homer: 1904 interviews, e.g. 'Boy Artist at the R.A.', *Daily Chronicle*, 3rd May 1904. *Chums* paper also mentions an enthusiasm for Thomas Carlyle.

Reading Blavatsky: Gavin Semple has noted the key influence of Blavatsky in *Zos-Kia*, *Two Tracts on Cartomancy*, and *Who Ever Thought Thus?*

"Blavatsky's book answered to deep needs": Peter Washington, *Madame Blavatsky's Baboon* (Secker and Warburg, 1993) p.53.

Wittgenstein on grottoes: Karl Britton, 'Portrait of a Philosopher' in KT Fann *Ludwig Wittgenstein: The Man and his Philosophy* (NY, Dell, 1967) p.62.

Cornelius Agrippa's *Three Books of Occult Philosophy:* Semple, *Two Tracts on Cartomancy* p.21; Eliphas Levi ibid. p.20.

Tennyson: eg Gertrude Williams, *Priestess of the Occult: Madame Blavatsky* (New York, Knopf, 1946) p.11 and Sylvia Cranston, *HPB: The Extraordinary Life and*

Influence of Madame Blavatsky (New York, Tarcher, 1993) p.7.

Watts advises Beardsley to avoid Kensington: Stephen Calloway, *Aubrey Beardsley*, (V&A, 1998) p.37.

Hands and feet from plaster casts: Letchford p.43. Further details of RCA from Sylvia Pankhurst, *The Suffragette* (Gay and Hancock, 1911); Hilary Cunliffe-Charlesworth , 'Sylvia Pankhurst as an Art Student', in *Sylvia Pankhurst: From Artist to Anti-Fascist* eds. Ian Bullock and Richard Pankhurst (Macmillan, 1992); and Richard Pankhurst, *Sylvia Pankhurst: Artist and Crusader* (Paddington Pess, 1979). "…depressing feeling in the College…" Pankhurst cited Cunliffe-Charlesworth p.28. "…it is not very easy to live…" ibid. p.28; five cases of insanity ibid. p.12.

"… resembling a Greek god…" Herbert Budd quoted Grant *I&O* p.11.

"The weirdness of his work in those days…" Pankhurst, Suffragette Movement p.172.

"perhaps her best friend": Richard Pankhurst p.48.

Ellen and Pankhurst: Letchford pp.79; 89.

"one of the finest draughtsmen"; Addis Ababa: Richard Pankhurst op.cit p.48.

"…mainly sexual failures…" 1954 Spare annotation in AM Ludovici, *Enemies of Women*, collection of John Balance, reproduced *Fortean Times* 144 (March 2001) p.38.

William Rossiter: quoted in 'Acculturating them' review by John Henshall *of Art for the People: Culture in the Slums of Victorian Britain* (Dulwich Picture Gallery, 1994) *TLS* 10th June 1994.

"vitality that comes from the street": *Daily Mail* 23rd May 1904.

'Portrait of Hisself' from *Earth: Inferno* p.13.

"…I never forgot": Hannen Swaffer, 'Mystery of an Artist', *London Mystery Magazine*, Vol.1 no.5 (August 1950).

Extraordinary praise: see source notes to Prologue. Augustus John "unsurpassed," Fulgur Press flyer for *Zos Speaks!*, c.1998.

"beyond doubt a genius": *Chums* 5th June 1904.

"too brilliant a genius"; "astonished the art world": *Morning Leader* 4th May 1904.

"President of the Royal Academy"; nursery frieze: *Daily Chronicle* 3rd May 1904.

Too busy for cricket, 'Spirit of War'; buyers do good turn; general discouragement; wastepaper basket: *Chums*.

"Of the great names in art he knows but little. Watts…": *Daily Chronicle* 3rd May. draw in "a trance": Letchford p.49.

Father's eyes story: ibid. p.73.

"I do not wish to commune with journalists": ibid. p.237.

"Austin's disgust and consternation.": ibid. p.41.

"devising a religion of my own": *Daily Chronicle* 3rd May 1904.

"dental sibilant gods": *The Commentaries of AL, being The Equinox Vol V no.1*, by Aleister Crowley and Another (RKP, 1975) footnote p.8.

"Nothing": Louis MacNeice, *Varieties of Parable* (Cambridge University Press, 1965) p.118.

Kia and Blavatsky's Kia-yu: Robert Ansell, Spare Yahoo group [defunct] post of 22.vii.04, with ref to *The Secret Doctrine* (1921 edition) vol.1 p.474.

Pronounced "keer": Gavin Semple 1.v.08, from Letchford.

"this curious religion is an important factor": *Daily Chronicle* 3rd May 1904.

"once picked up a golden skull": George H Bratley, *The Power of Gems and Charms* (London, Gay and Bird, 1907) p.15.

The man from the *Morning Leader* saw something like it: *Morning Leader* 4th May 1904.

still wearing it in the Fifties: Kenneth and Steffi Grant, *Zos Speaks!* (Fulgur, 1999) p.31 (28th June 1949).

Donleavy on "one": *Wrong Information is Being Given Out at Princeton* (Little, Brown, 1998) p.181.

"consumer of religion": *Book of Pleasure* (The Author, 8b Golders Green Parade, 1913) p.7. Henceforth *BoP*.

"Revere the Kia and your mind will become tranquil": *Earth: Inferno* p.18.

IV: A TOUCH OF EVIL

Churchill on Chinese Labour Contract: 22nd February 1906.

'Cartoon of the Day': *Morning Leader* 12th May 1904.

"A Young Socialist Painter," *The New Age* vol.2 no.6 December 1907.

George Orwell, 'W.B. Yeats' in *Critical Essays* (Secker and Warburg, 1946).

"wonder boy" Sandilands cited Letchford p.43.

"worst Art College in Europe": Lethaby cited Letchford pp.43-44.

Mackay on enormous table in 'Austin Osman Spare 1886-1956' included in Ansell, *Borough Satyr* pp.66-71, quotation from p.68.

Spare portrait by Maggie Richardson (d.1958): listed in her *Who's Who* entry (as Mitchell, Mrs George).

"Decadents and Pessimists": GK Chesterton, *Autobiography* (Hutchinson, 1936) p.95.

Rothenstein on Beardsley, *Artists of the Eighteen-Nineties* (Routledge, 1928) p.164.

Mabel Beardsley to Yeats, in Miriam Benkovitz, *Aubrey Beardsley* (Hamish Hamilton, 1981) pp.66-7.

"repellent," "repulsive," "morbid": cited Linda Gertler Zetlin, *Beardsley, Japonisme and the Perversion of the Victorian Ideal* (CUP 1997) p.5.

O'Sullivan, 'On The Kind of Fiction Called Morbid' *The Savoy* no.2 April 1896, reprinted in *The Savoy: Nineties Experiment* ed. Stanley Weintraub (Pennsylvania State University Press, 1966) pp.95-98.

James on the "morbid": *Varieties of Religious Experience* (Longmans, 1925) [1902] pp.162-4.

Soames: all details from 'Enoch Soames' [1912] in *The Bodley Head Max Beerbohm* (Bodley Head, 1970) pp.55-86.

Blavatsky on Earth as Hell in *Voice of the Silence*: connection made by Gavin Semple in 'Once again to Earth…': introduction to Polish edition of *The Book of Pleasure*.

"Strange Desires and Morbid Fancies;" 'Of Myself:'; "REVERE the KIA": *Earth: Inferno* pp.10; 12; 18.

"Iccha" and "sikka" as "will" and "method" in Sanskrit: see Semple, *Two Tracts on Cartomancy*, p.21.

Ikkah the body and Sikah consciousness: *The Arcana of AOS*, 1906, see Sotheby's *The Book as Art Part II*, London 21st November 1995, lot 411.

Visual diary and 'Reunion with Ellen Osman': Christie's South Kensington, *A Collection of Watercolours and Drawings by Austin Osman Spare* 12th May 1994, lot 12.

Black Eagle can be seen as Plate 1, facing p.76, of *Zos Speaks!*, and is mentioned as a "spirit guide" on p.5.

"Red Eagle, White Owl, Grey Feather": Tim d'Arch Smith, *The Books of the Beast* (Leighton Buzzard, Crucible, 1987) p.104.

Yeats "sex and the dead": letter to Olivia Shakespear, cited E Fuller Torrey, *The Roots of Treason; Ezra Pound and the Secrets of St Elizabeth's* (Sidgwick and Jackson, 1984) p.49.

"always talking about cardigans": Hilary Mantel, *Beyond Black*, (Fourth Estate, 2005) p.17.

"all the rabble rout of imposture": Machen, 'The Novel of the White Powder' [1895] in *Tales of Horror and the Supernatural* (Tartarus, 1997) p.53.

"the bingo of the occult world": Tim d'Arch Smith, *The Books of the Beast* p.104.

"all the devils" James Laver, *Museum Piece* (Deutsch, 1963) p.222.

"spiritualists are living sepulchres": *Anathema of Zos* p.15.

"The tables turn. The sleepers speak" Jean Cocteau, *Opium*, (Peter Owen, 1968 [1930]) p.42.

Ethel Wheeler's *Behind The Veil* (David Nutt, 1906); quotations from pp.83, 87.

Connard on Spare as designer: *Daily News* 4th May 1904.

Father and antique markets: Letchford p.189.

Freud's desk: see *Sigmund Freud and Art: His Personal Collection of Antiquities* ed. Lynn Gamwell and Richard Wells (Thames and Hudson, 1989); photograph by Edward Engelman p.28; etching by Max Pollack p.152.

See *André Breton*, three films by Fabrice Maze: *L'Oeil a l'État Sauvage: L'Atelier d'André Breton* (1994); *André Breton Malgré Tout* (2003); *Hotel Drouot le 31 Mars 2003* (2003).

Jason Hyde: a character in the comic *Valiant*; see for example *Valiant Annual 1968* (Fleetway Publications, 1968) p.43.

Wilhelmina Murray in study: *The League of Extraordinary* Gentlemen, Alan Moore and Kevin O'Neill, Vol.II no.3 'And the Dawn Comes Up Like Thunder'.

RH Malden, 'A Collector's Company' [1909] collected in Malden, *Nine Ghosts* (Arnold, 1943).

Letterhead circa 1911: private collection, London.

"not been equalled since the days of Aubrey Beardsley": *The World*, 29th October.

"of equal interest to his fellow artists and to pathologists": *Observer* 3rd November.

"the chief excuse": *The Globe* 30th October.

"Vicegerent of God upon Earth": cited *Zos Speaks!* p.43.

V: THE DARLING OF MAYFAIR

Something Nasty in the Woodshed: quotation from Bonfiglioli, *The Mortdecai Trilogy* (Black Spring, 1991) p.443.

Archer, *The Hieroglyph* (Dennis Archer, 1932) pp.7-9.

"Italian ponce out of work": *Zos Speaks!* p.43.

"…as well or better than Sime": cited in Keith Richmond, 'Discord in the Garden of Janus' in *Artist Occultist Sensualist* eds. Beskin and Bonner (Beskin, 1999), unpaginated.

"a minor cult following that would last his entire life": Ansell, *Borough Satyr*, p.5;

"cult of strangeness": Connolly cited in Jeremy Lewis, *Cyril Connolly: A Life* (Pimlico, 1998) p.88.

"Evil is more potent than good" from Spare text 'Fragmenta' reproduced in Spare and Wainwright *Art and Letter: Word and Sign* (Thame, I-H-O Books, 2003)

Bookplates reproduced in Ansell *Bookplate Designs of Austin Osman Spare* (Bookplate Society / Keridwen Press, 1988) [henceforth *Bookplates*]: 1907 bookplate for Desmond Coke plate 3, p.14; 1908 plate for Waller plate7, p.18; self portrait with broken nose on cover.

Broken nose: cited Letchford p.287.

Lane and golf: *Dictionary of National Biography*.

Spare remembers Chesterton: Letchford p.93.

"Table for six, please": Calloway, *Aubrey Beardsley* p.129.

"most wonderful man I ever met": Spare to Vera Wainwright, circa 1955, in *Dearest Vera* (Fulgur, 2010) p.166.

Gray and Gribble portraits, circa 1910: illustrated in Brocard Sewell, *Footnote to the Nineties: A Memoir of John Gray and Andre Raffalovich* (Cecil and Amelia Woolf, 1968) facing pp.66; 92.

Raffalovich bookplate: illustrated Ansell *Bookplates* plate 14, p.25.

Possibly lodges with Beardsley uncle: Letchford p.69.

Straus bookplate: Ansell *Bookplates* plate 5 p.16.

'Chaos' of 1904: frontispiece of *Austin Osman Spare* (Fulgur/Boxer, 1992) [henceforth Boxer 1992].

Letchford to Bardens: letter of 5th September, 1970. Reproduced in Tony Naylor (ed.) *Existence: Austin Spare 1886-1956* (Thame, I-H-O, 2006) pp.38-42.

sexual relations with elderly women: Grant, *I&O* p.20.

Recommends Edward Carpenter: Letchford p.50

Book of Satyrs inscription in Richmond, 'Discord in the Garden of Janus,' unpaginated and endnote 8.

'The Garden of Janus'; 'The Priestess of Panormita'; 'The Twins' in Crowley, *The Winged Beetle* (privately published, 1910), pp.35-44; 47-54; 98-101.

Spare pleased to receive it: letter of 31ˢᵗ April [sic] 1909 in Harry Ransom Collection.

"Refers to Austin Osman Spare consciously" cited Richmond, 'Discord in the Garden of Janus', unpaginated.

"a very fin-de-siecle atmosphere…. A faintly decadent charm": Madame Teissier du Cros, cited in Sewell, *Footnote to the Nineties* p.59.

"sparks": ibid., and further details from pp.59-61.

throat spray and Congo figure: Letchford p.77.

"peering through thick lenses with his gooseberry green eyes": Letchford p.59.

Spare and Moore in Café Royal; tarts in balcony: ibid.

Soames; Beerbohm op.cit.

"… three *spare* men of our day!": *Enoch Soames: The Critical Heritage*, edited by David Colvin and Ed Maggs (Maggs Bros, 2001). This is accompanied by an artfully bogus Spare picture of Soames entitled 'Crème de Menthe and Nicotine'.

much older woman before he was sixteen; 'Self-Portrait at Age of Eighteen'; Welsh maid; dwarf; hermaphrodite: Grant *I&O* p.11.

'Hermaphroditism': reproduced in Kenneth Grant, *Aleister Crowley and the Hidden God* (Muller, 1973) facing p.118.

"embugger none but monsters, or blackamoors, or deformed persons": *120 days of Sodom* Part III Fourth January item 19.

VI: YOUNG MAN WITH PROSPECTS WANTED

letter to Pickford Waller: Richmond 'Janus' note 30.

famous people in the arts: ibid n.19.

A∴A∴ form: ibid., unpaginated.

"cannot afford the Robe": Semple *Cartomancy* p.19 and Richmond 'Janus' note 13.

test for a later student: Kenneth Grant, *Remembering Aleister Crowley* (Skoob, 1991) p.52.

"can't understand organisation or would have passed": cited Richmond, 'Janus'.

"give up the ghost": Spare to Grant, October 1949, *Zos Speaks!* p.43; "I saw you" and spaghetti: ibid.

T'ang dynasty cakes: Lawrence Bradshaw to Letchford in 1957, cited Letchford p.145.

"What is there to believe in, but in Self?": *BoP* p.1.

'I and my self in Yoga': pen and watercolour, c.1905, reproduced *Borough Satyr* p.27.

"A mystic": 'Logomachy of Zos', dictum 389, *Zos Speaks!* p.186.

"Conscious thinking is the weakest": Highsmith in her Journal, 1940, cited Andrew Wilson, *Beautiful Shadow* (Bloomsbury, 2003) p.70.

James and 1886: *Varieties of Religious Experience* p.233.

James and Janet: see Ann Taves, *Fits, Trances and Visions: Experiencing Religion and Explaining Experience from Wesley to James* (Princeton, 1999) p.418 n.6.

"golden age of the subconscious": Taves op.cit p.418 n.4.

"In spite of unfortunately widespread ignorance of his work...": Breton, *The Automatic Message* (Atlas Press, 1997) [1933] p.17.

"which in the dreamy Subliminal might remain ajar or open.": James, *Varieties* p.242.

"...is of course 'inspiration'": ibid. p.479.

"more": ibid. p.512.

"methods of yoga to produce genius at will": Aleister Crowley, *Confessions* ed. Kenneth Grant and John Symonds (Cape, 1969) [c.1925] p.244.

Crowley meets Maudsley: *Confessions* p.386; "humbug of the supernatural" ibid.

"black tide of mud": CG Jung, *Memories, Dreams, Reflections* (Fontana, 1983) p.173.

"MAGICAL obsession": *BoP* p.41.

"... telesmatic Image of a Force. The Sigil shall then serve thee...": Israel Regardie, *The Golden Dawn* 6th edn., (St.Paul, Minn., Llewellyn, 1989) p.486.

The Studio vol.XXIX 1903.

"Sigils are monograms of thought": *BoP* p.50; sigils also resemble the Edwardian puzzle pastime of "letter knots", some of which can be seen in *Chums*.

Research with Coke: *Zos Speaks!* ('Zoetic Grimoire of Zos') p.233.

Benson: front hall, "a few curiosities, "curious" tapestry, Dance of Death: A.C. Benson, *Hugh* (Smith, Elder and Co., 1915) pp.7-9.

"Whatever it was passed right through him": Grant *I&O* p.12.

Another version: Ian Law 'Austin Osman Spare' in *Divine Draughtsman*, unpaginated.
...woken with the words "Are you there?": Swaffer 'Mystery of an Artist'.

"... Spare had entertained the haunter of his house." Grant *I&O* p.12.

Rain-making anecdote: Grant ibid. pp11-12.

"bloody silly thing to get by magic what could be got more effortlessly..." 24th
September 1954, *Zos Speaks!* p.95.

RCA Board of Education Enquiry: details from 'Sylvia Pankhurst as an Art Student'
in *Sylvia Pankhurst: from Artist to Anti-Fascist*.

Romantic ambitions towards Sibyl Waller: Gavin Semple 1.v.08.

Connie Smith: see Letchford p.85, where she figures in later life as wife of CS Jagger.

"well known for his heterosexual excesses...": Richmond, 'Janus' n.47.

"unworldly, naive, and perhaps virginal"; apparition of girl; "thought of a permanent
alliance with a lady...": Letchford p.69.

Mrs Shaw story: Letchford p.75; Ansell dates it to 1909: *Borough Satyr* p.6.

Self-portrait in oils: reproduced *Divine Draughtsman* plate 4; discussed *Borough Satyr*
p.6.

St. George's Registry Office: Letchford p.75; Semple agrees.

Marriage Letchford 75-86: cake and "hysterics" p.75; dandyism p.75; incompatible p.79;
ailments "under tension" p.77; spending too much time with younger men p.85.

"Men fall only in order to rise": Letchford p.79, although Spare gave a very different
account of Golders Green to the Grants, claiming he left "when the Jews came": *Zos
Speaks!* p.18.

Inscribed copy of *Satyrs* to Mrs Shaw, August 1911: in possession of Maggs Bros.,
London in 2008.

Self-portrait of himself with Eily: reproduced *Borough Satyr* p.6.

plain woman with a good body: Letchford p.85.

VII: NECROMANTIC SIGNS

"Blake's most fantastic inventions are sane, normal and bourgeois": *Observer* 15th
October 1911.

Press invitations: *Borough Satyr* p.9 n.23.

Missing sections: *BoP* note below 'Introduction'.

symbol of justice known to the Romans: *BoP* p.3 note.

"God, religions, faith, morals, woman, etc": *BoP* 'Definitions'.

"Virtue" equals "Pure Art": ibid.

Rycroft, *A Critical Dictionary of Psychoanalysis* (Penguin, 1972) p.16.

"disappointed before Wisdom can root itself": John Blofeld, *City of Lingering Splendour* (Hutchinson, 1961) p.183.

"wait for a belief to be subtracted": *BoP* p.37.

"illustrations that you think would do for No.10 of *The Equinox*" Richmond 'Janus' note 34.

"unemployed dandies of the Brothels": *BoP* p.2.

"no magic to intensify the normal": *BoP* p.3.

"Self condemned in their disgusting fatness": *BoP* p.3.

"Our asylums are crowded, the stage is over-run!": *BoP* p.2.

"A bat first grew wings and of the proper kind…": *BoP* p.48.

Downe: Letchford p.205.

"The Egyptians": *BoP* p.52.

"Sigils are the means of guiding and uniting": *BoP* p.50.

"no theatricals or humbug": *BoP* p.50.

"sex principle": *BoP* p.56; *Zos Speaks!* p.107.

Orghast: see Craig Raine, *In Defence of T.S.Eliot* (Picador, 2000) p.2.

"own Arcana": *Focus of Life* p.15.

"sacred alphabet of the mysteries that each one of us contains": Semple, *Who Ever Thought Thus?* p.7.

Serge Leclaire on "jubilatory formula": Anika Lemaire, *Jacques Lacan* (RKP, 1979) Ch.XI 'The Elementary Signifiers of the Unconscious' p.143.

"Fraud and Junk": *Zos Speaks!* p.23; "Patho-psychology has birthed another Frankenstein…" – *Axiomata* dictum 1; "pathopsychology": *Dearest Vera* p.166.

"born and bred among the founders of 'modern' schools": *Dearest Vera* p.166.

"Automatic drawing is a cure for insanity": BoP p.56.

"a secret you don't know you're keeping": cited Kathleen Tynan, *The Life of Kenneth Tynan* (Weidenfeld, 1987) p.188.

"Magical obsession is that state when the mind is illuminated by sub-conscious activity": *BoP* p.41.

"Obsession known as or related to insanity": *BoP* p.41.

"fight on his side against this thing that is obsessing him": RH Benson, *The Necromancers* (Hutchinson, 1909) p.277. This sense of obsession was also familiar in Golden Dawn circles.

Benson and "evil spirits": *Zos Speaks!* endnote 150.

Obsessional produces a parody of a religion: Freud, *Totem and Taboo* [SE.XIII.73].

VIII: STRANGE PLEASURES

"intrinsic non-existence at the heart of entity": Gavin Semple, introduction to CJ Chibnall, *The Book of Pleasure in Plain English* (Hemel Hempstead, Winged Feet, 2009) p.ii.

abaissement du niveau mental: see *A Critical Dictionary of Jungian Analysis* ed. Samuels, Shorter and Plaut (RKP, 1986).

"many means of attaining this state of vacuity": *BoP* p.51.

"incest twixt the body and the soul": Richard Le Gallienne 'The Decadent to his Soul,' *English Poems* (John Lane, 1892).

Narcissism: Havelock Ellis writes in *Studies in the Psychology of Sex* IV. III. 187 (1905) "I have referred to the developed forms of this kind of self-contemplation… and in this connection have alluded to the fable of Narcissus, whence Näcke has since devised the term Narcissism for this group of phenomena." See also Havelock Ellis, *Auto-Erotism* (1900), in *Studies in the Psychology of Sex* vol.I.

Montaigne, "silk-smooth slide": Yi-Fu Tuan, *Passing Strange and Wonderful: Aesthetics, Nature and Culture* (Washington, Island Press, 1993) p.9.

George Blake "being dead": *Daily Telegraph Fifth Book of Obituaries* (Macmillan, 1999) obituary of Kenneth de Courcy.

"Amor intellectualis quo Murphy se ipsum amat": Samuel Beckett, *Murphy* (Routledge, 1938), epigraph to Chapter Six; "so pleasant that pleasant was not the word": ibid.

"wombtomb" "twilight mummyfoetus": Samuel Beckett, *A Dream of Fair to Middling Women*, (Dublin, Black Cat, 1992) p.44.

"... the sleeper is not truly alone, but 'sleeps with' his introjected good object..." analyst Mark Kanzer cited in Michael Balint, *The Basic Fault* (Tavistock, 1968) p.50.

Freud on "oceanic feeling": *Civilization and its Discontents* [SE.XXI.72-3].

"Man implies Woman, I transcend these by the Hermaphrodite": *BoP* p.17.

"Poor though I be": *BoP* p.59; "nectar of all-beneficent and gratuitous ecstasy" *BoP* p.38; "syllabub of sun and moon" *BoP* p.38.

"thumb in the light of a moonbeam": *BoP* p.56.

JFC Fuller, *Yoga: A Study of the Mystical Philosophy of the Brahmins and the Buddhists* (Rider, 1933) [1925]: internal music pp.136-37; transferring of attention and consciousness to a single part of the body in *dharana*, e.g. pp.90; 92.

"identification with this Atman (Emerson's 'Oversoul') p. 23.

"God, immortality, freedom, are appearances and not realities..." p.25.

"super-consciousness (Samadhi)... will consume him back into the Atman from which he came"; "Yoga consists in withdrawing the organs of sense from the objects of sense, and... concentrating them on the Atman..." pp.33-34.

Atman equivalents: Tao, Augoeides, Holy Guardian Angel, Genius, Watcher etc – note on p.34. Fuller also writes: "... we become magicians, begetters of illusion, and then, if we allow ourselves to become obsessed by them, a time comes when these illusions will master us, when the children we have begotten will rise up and dethrone us, and we shall be drowned in the waters that now we can no longer control..." pp.124-5.

unsold copies in the Thirties: Robert Ansell, 5.xi.05.

D'Offay: Letchford p.67.

"Spare was at one time a pupil of Fra.P..." annotation to Crowley's copy, cited Richmond 'Janus' [unpaginated].

"Black Magic" and "Black Brothers," see Crowley, *Magick in Theory and Practice* ed. John Symonds and Kenneth Grant (RKP, 1973) [1929] pp.295-96.

Spare's letter from Freud: Letchford p.55.

"one of the most significant revelations of subconscious mechanisms": Kenneth Grant, Introduction to *The Book of Pleasure* (93 Publishing, 1975).

TLS review of *BoP*: 6th November 1913, p.516.

"... little statues and images helped stabilise the evanescent idea...": HD [Hilda Doolittle] *Tribute to Freud* expanded edition (Oxford, Carcanet, 1985) p.175. HD was a friend of Spare's friend Blakeston.

"The reality of a thought... assumes the characteristic of a material object" Victor Tausk, 'Philosophy and Psychoanalytic Philosophy' in *Sexuality War and Schizophrenia* ed. Paul Roazen (New Brunswick, Transaction, 1991) p.86.

Ralph Steadman, *Sigmund Freud* (London, Paddington Press, 1979): Freud examines a joke pp.54-55.

"The love of such beings by a Magus": Eliphas Levi, *The Magical Ritual of the Sanctum Regnum* (London, George Redway, 1896) p.35. Better known in Crowley's paraphrase "The love of the magus for such things is insensate, and may destroy him," quoted by Kenneth Grant in *The Magical Revival* (Muller, 1972) p.166.

IX: "WHAT DIRE OFFENCES RISE..."

Frederick Carter on his subjects: Richard Grenville Clark, *Frederick Carter A.R.E. 1883-1967* (Guildford, Apocalypse Press, 1998) p.24.

"automatic writing, hysteria ... these contemporary interests": ibid. p.17.

Samuel Hynes: ibid. p.17.

Book of Pleasure inspired by love for Eily: Ansell, *Borough Satyr* p.6.

"May the idea of God perish and with it women": *BoP* p.31.

Carter had already published on automatic writing: 'A Theory of Automatic Writing', *The Arts*, vol.1 no.1 April 1914.

André Breton, "pure psychic automatism" in 'First Surrealist Manifesto' [1924] in *Manifestos of Surrealism*, trans. Richard Seaver and Helen Lane (Ann Arbor, Michigan University Press, 1969).

"Menthes or the subconscious self?": 'Automatic Drawing' by 'Scrutator,' *The Occult Review* Vol.XI, Jan-June 1910 p.194.

Times Literary Supplement review of *Form* no.1: 29th June 1916 p.306.

"*Form* is a very horrible publication... what do you call a man who makes love to himself?": Shaw, 7th January 1917. Colby College Library, Maine.

"clever draughtsman": Ricketts papers 1916-1917. no.61717 vol.V, British Library: letter to Yeats p.216.

"I think this picture vulgar": cited in Colin Smythe, 'W.B.Yeats, Austin Spare and *Eight Poems*' *Yeats Annual 12*, p.257.

"The red woman is a brute": cited in Allan Wade, *A Bibliography of the Writings of W.B.Yeats* (Rupert Hart-Davis, 1958) p.120.

Art Nouveau "common": Jane Ridley, *The Architect and his Wife: A Life of Edwin Lutyens* (Chatto, 2002) p.177.

"I am not responsible for this pretentious publication": cited Smyth op.cit p.258.

"this foolish picture": ibid. p.259.

"not enough to eat": ibid p.256.

"I know next to nothing about *Form*... he has talent": cited Letchford p.93.

"a sort of *Dial*"; "poor Spare's beastly paper": Ricketts papers 1916-1917. no.61717 vol.V, British Library; letters to Yeats p.216 and Lowinsky p.221.

Peter Warlock (Philip Heseltine) letter: *The Collected Letters of Peter Warlock*, ed. Barry Smith (Woodbridge, Boydell Press, 2005) Vol.III p.568; see also Cecil Gray, *Peter Warlock: A Memoir of Philip Heseltine* (Cape, 1934) pp.192-193.

"everything that an intellectual of the day was liable to wince at most": John Gross, *The Rise and Fall of the Man of Letters* (Weidenfeld and Nicholson, 1969) p.240.

Plagiarism: see A.R.Naylor, *Stealing The Fire From Heaven* (Thame, I-H-O Books, 2002).

"original flying saucers": Archer show 1955 items 67-69. These were magically intended, and to be thrown away over a scrapyard wall, for example – and broken.

"stratum of the Zeitgeist": 'On Mediumship' in *William James on Psychical Research*, eds. Gardner Murphy and Robert O Ballou (Chatto, 1961).

Correspondence between Spare and Carter: Thirty four letters from Spare, item no. 152 in Roy Davids Ltd. *Catalogue IV: The Artist as Portrait* (2000).

Guthrie, "This bit of paper recalls Spare": cited Ansell, *Bookplates* p.7.

"His goodness and practical sympathy": cited Letchford p.97.

The Little Flowers of St Francis: advertised at the back of *Form*, April 1916. "the saint I like best" to Vera Wainwright, Bloomsbury Book Auctions 20th June 2005 lot 182.

Egypt Letchford p.69; No-Man's Land ibid. p.103; torpedoed troopship ibid. p.103.

"white lies": Letchford p.87.

"sports fund," Naples: ibid. p.99.

Colonel Solomon Solomon: ibid. p.103.

Mr Chignell: ibid. p.85.

Strand Palace Hotel: ibid. 85.

"practice celibacy thereafter"; Letchford p.107.

"We are most anxious": letter of 25th November 1919 from Lady Norman of Women's Work Sub-Committee. Imperial War Museum.

Flora Murray to Colonel Brereton, cited in Jennian F Geddes, 'Artistic Integrity and Feminist Spin: a spat at the Endell Street Military Hospital, *The Burlington Magazine* CXLVII (Sept 2005) p.617.

"What we would ask you to do would be to cut the floor off": Lady Norman to Spare, 22nd May 1920, cited Geddes op.cit. p.618.

"fondly imagined that what good there might be": Spare to Lady Norman, 29th May 1920, ibid.

"made to appear 'ludicrous' by certain modern artists": Spare to Lady Norman letter of 29th May 1920, Imperial War Museum.

"unlikely that Spare would have invented the presence of sterilising drums.": Geddes p.618.

"hoping that all my work is dead and buried": Letchford p.261.

X: A SWINE WITH SWINE

Spare in bed with model story: variants Letchford p.179; Grant *I&O* p.18.

"kipper for dinner today!": Spare letter to Pickford Waller, c.1919, offered on eBay 2006.

"Freda Spare": her existence under this name is only my conjecture, based upon Spare's picture entitled "Freda Spare".

London General Omnibus Company: Letchford p.117.

"lady friend who married a patron": Letchford p.117; "young man" Letchford p.121.

wife of Jagger: Letchford p.85.

Edwardians and "Life": see Jonathan Rose, *The Edwardian Temperament 1895-1919* (Ohio University Press,1986); Hulme cited p.74.

"good to think": Claude Levi-Strauss, *Totemism* (Boston, Beacon Press, 1963) p.89.

"someone of better judgement stole it": Dennis Bardens, 'In A Lonely Wood Astray', introduction to Spare, *The Focus of Life* (Thame, I-H-O, 2000) p.16.

"couple playing with each other": Letchford p.135.

Frost, Brooke and Lawrence in Barbara Hooper, *Time to Stand and Stare* [WH Davies biography] (Peter Owen, 2004): pp.94; 100, 93.

"for and by the common people does it live": Editorial, *Form* No.1.

Spare on Havelock Ellis's *Psychology of Sex*: Letchford p.57.

Spare and Ellis sit facing each other: ibid.

JFC Fuller, 'The Black Arts' *Form* vol.2 no.2 pp.57-66, quotation from 66.

"horrible but fascinating magazine": Shaw cited Letchford p.163.

Clifford Bax on Spare: 'Sex in Art' chapter of *Ideas and People* (Lovat Dickson, 1936): "queer amalgams of primitive magic and primitive sexuality..."; "what an odd and charming person..." p.35; "barrack-like... a penny and ha'penny... esquire" p.37; "subconscious desires"; "subconscious desire is to be poor!" p.38.

Wireless tinkering: Letchford p.55.

TLS review of *Golden Hind* no.1: 9th November 1922 pp.730-31.

"backviews of massive nude females"; "The Golden Behind": Bax op.cit. p.36.

"a queer fish": Stephen Pochin to present writer 4.vii.10.

"an artist whose work attracted much attention some years ago": *The Studio* Vol.88, July-Dec 1924, p.98.

"bubbling over with excitement"; Liberty's; Gloucester visit: Grace Rogers, 'Austin Osman Spare,' *The Goth*, vol.6, December 1991.

TLS review of *Golden Hind* penultimate issue (Vol.2 no.7 April 1924): 22nd May 1924 p.326.

"silk hats, hansom-cabs, drawing rooms and permanent marriages": Bax, *Ideas and People* p.35.

"a staunch friend": Clifford Bax *Inland Far* (Heinemann, 1925) p.292.

"seldom that anybody happens to be passing the Borough": Bax, *Ideas and People*, p.37.

"a swine with swine": Grace Rogers, 'Austin Osman Spare' *The Goth*, vol.6, December 1991.

XI: NEVER ALONE

Beckett House and petty thieving: Grace Rogers op.cit.

Neighbours: Letchford p.133.

Grace Rogers's visit, and Spare's philosophy of dream: Rogers op.cit.

"gluttonous future!"; "lamentable apotheosis of self?"; "pleasures between ego and self?"; "MAN HAS WILLED MAN!" *Anathema of Zos: The Sermon to the Hypocrites* pp.11, 8, 16.

Reitlinger wouldn't sell his Spares: Letchford p.135; remembered Spare as shy: ibid. "sine curves" – "Sine curve calligraphy / signatures and sigils / of / Austin Osman Spare" - penultimate page of *Automatic Drawings*. This calligraphy also figures in a number of twentieth-century pen adverts.

"daemonic doodling": Ian Law, Introduction to *A Book of Automatic Drawings* (Catalpa Press, 1972).

Austin Spare, *The Valley of Fear* (Fulgur, 2008).

'The New Eden': plate twelve – the final plate – in *A Book of Automatic Drawings*.

"Down among the lost people…" WH Auden, 'In Memory of Sigmund Freud', *Collected Poems* ed. Edward Mendelson (Faber, 1976) p.216.

"this difficult life;" "knows how to spend": *Automatic Drawings*, final and penultimate pages.

Spare on local women; "Only I, who have deliberately stamped on the aesthetic idea of love": Rogers in *The Goth*, Vol.6, December 1991.

"he who transmutes the ugly into a new aesthetic has something beyond fear": Spare and Grant, 'The Zoetic Grimoire of Zos,' *Zos Speaks!* p.219.

"a rare ecstasy results which generates great magical potential": Grant *I&O* p.23.

"Taoist ascetics retiring to the wilderness perhaps rather to develop sex than to deny it": IA Richards, *Mencius on the Mind*, (Kegan Paul, Trench and Trubner, 1932) p.74.

"Spare bastards all over London": former member of Typhonian Order of the Temple of the Orient 17.viii.99; "around the middle of his marriage": Gavin Semple 20.iii.07.

prostitute and fish and chips: Letchford p.95; prostitute and sandwiches: *Zos Speaks!* p.46.

"Let this be thy one excuse": *Focus of Life*; variants in Grant *I&O* pp.21; 51.

Re "chocolate grinding": one of the things we can say about Spare's masturbatory practices is that they were highly self-conscious: he refers to himself in some notes, circa 1945, as "the great masturbator," an echo of Dalí's famous 1929 painting of the same title (*Fragmentum*, p.7). He further seems to have used auto-erotic abstinence as a magical technique. "One must retain - to give birth to will", he writes in *Focus of Life*, and this idea may be lurking behind comments such as "I give up smoking… or something like that" (p.193 above, cf starving of lesser desires p.138, strength of frustration p.173). On the other hand, regarding Spare's sexual life, he also makes the somewhat cryptic observation "Never yet has procreation with another been satisfactory." (*Focus of Life* p.13).

"Dionysian repertory company": Paul Bailey, *Sugar Cane* (Bloomsbury, 1993) p.17.

Duchamp on artist going underground: "... above all you know what happens when the art dealers say to you, "Ah! If you make ten pictures for me in this style, I will sell as many as you want of them." Then – well this wasn't at all my interest or my amusement, so I didn't do it.... Then it was like this, I went to a conference. A round table which took place in Philadelphia, where I was asked, "Where are we going?" Me, I simply said, "The great fortune of tomorrow will hide itself. Will go underground." In English it's better than in French – "Will go underground." It'll be necessary that it dies before being known. Me, in my opinion, if there is an important fellow [i.e. artist] from now in a century or two--well! he will have hidden himself all his life in order to escape the influence of the market..." – "Will Go Underground" – interview on RTBF [1965] with Marcel Duchamp by Jean Neyers, trans. Sarah Skinner Kilborne, in *Tout-Fait: The Marcel Duchamp Studies Online Journal* vol.2 issue 4 (January 2002).

"In our solitariness, great depths are sometimes sounded": cited Grant, *I&O* p.18.

"I have lived for months a hermit's life": cited Hannen Swaffer, *Adventures with Inspiration* p.13.

Donald Meltzer on Freud's dreams as "life-events": "[For Freud, dreams] are to be taken as of evidential interest but not as life-events. But can one escape the impression that, say, "the dream of Irma's injection" was an event in Freud's life and deeply disturbed him, not just for the light it shed on his character but because it happened?"... "We cannot contentedly leave this outline of the theory of dream-life without some comment on the momentous importance that certain dreams have in people's lives. Schreber's dream of being a woman in intercourse, the Wolf-man's dream of the wolves in the tree, may illustrate perfectly those haunting dreams which form the nucleus of severe psycho-pathological developments.
 But there are dreams, as Emily Bronte said, "which go through one's life like wine through water", enriching one's vision of the world with an intoxication of emotional colouring as never before. Or is it a heady vision that was once apprehended and lost, awaiting a dream to reinstate its dominion in the aesthetic relation to the world? When such a dream has visited our sleeping soul, how can we ever again doubt that dreams are "events" in our lives? In this dream world there is determined the great option between an optimistic and a pessimistic view, not only of our own lives, but of Life." Donald Meltzer, *Dream-Life: A Re-examination of the Psychoanalytic Theory and Technique* (Clunie Press, 1984) pp.12; 94-5.

"Dream is a second life": opening line of *Aurelia, The Dream and Life* [1855] in Gerard de Nerval, *Selected Writings* (Penguin Classics, 1999) p.265.

Dreams and Adventures in Sleep ("Being a Psychology Symbolised by Automatic Drawings... April-May 1925"): four pages accompany Grace Rogers on 'Symbology and Aesthetics in Relation to the work of Austin O. Spare' *Artwork*, vol.2, 1925.

Biography of occultist on 'inner planes': Ithell Colquhoun asked an alchemist named Edward Garstin why there had been no biography of Macgregor Mathers: "He replied that the writing of it would be an impossible task since the most important events of an occultist's life take place on the inner planes and are therefore inaccessible to any but the one experiencing them..." Colquhoun, *Sword of Wisdom* (Spearman, 1975) p.60.

"I thank the Gods that be – I see myself as no other seeth me": Spare Christmas card circa 1955, ("Salutations from the Nadir") reproduced *Dearest Vera* p.80; and another in *Zos Speaks!* pp.147-48.

Yeats: "there is for every man some one scene, some one adventure, some one picture, that is the image of his secret life"; "a single vision would have come to him again and again, a vision of a boat drifting down a broad river": cited Peter Ackroyd, *Thames: Sacred River* (Chatto, 2007) p.344. From Yeats's *A Vision*, and 'The Philosophy of Shelley's Poetry'.

"like a page torn from some necromancer's dreambook": a phrase found on the jacket of a forgotten thriller, Leonard Gribble, *Striptease Macabre* (Herbert Jenkins, 1967).

"By turning my head quickly and involuntarily I can always see my alta-ego [sic], familiars or gang of elementals that partly constitute my being": quoted by Bardens, 'Introduction' to 1947 Archer Gallery show.

"Lonely!": Kenneth Grant, introduction to *The Book of Pleasure* (93 Publishing, 1975).

"unconscious cerebration": "our Familiar is a great deal more than a walking dictionary": Frances Power Cobbe *Darwinism in Moral and Other Essays* (London, Williams and Norgate, 1872) p.312. Reprinted from 'Unconscious Cerebration,' *Macmillan's Magazine*, November 1870. The phrase "unconscious cerebration" had been coined Dr William Carpenter (1813-1885).

"single-handed product of some Brownie, some Familiar": Robert Louis Stevenson: 'A Chapter on Dreams' *Works* vol.16 (Chatto, 1912) p.187.

"agents" as "little mental homunculi" – Steven Poole, *Trigger Happy* (Fourth Estate, 2000) p.115.

"autonomous complexes," "mediumistic phenomena," "daemons" as "autonomous partial systems": see Jung, 'Commentary' to *The Secret of the Golden Flower* ed. Richard Wilhelm (London, Kegan Paul, Trench, Trubner and Co, 1938) pp.108-113.

doodled face-forms on cards: examples from the 'Arena of Anon' illustrated in Semple, *Two Tracts on Cartomancy*, pp.10; 18.

"degenerate and crank": Nigel Burwood, 'Introduction' to *Austin Osman Spare* (Bradbury and Birch catalogue, 1984).

Waugh to Harold Acton: *Letters of Evelyn Waugh*, ed. Mark Amory (Weidenfeld and Nicolson 1995) p.23.

Viola Bankes visit: all details from Viola Bankes, *Why Not?* (Jarrolds, 1934) pp.257-8.

"I left school at 13"; "that extraordinary genius Austin Osman Spare.": Warren Retlaw [Walter Warren], *The Youth and The Sage* (self published, 1927) [c.1928] 'Foreword'.

"all green and idols": Robert Hichens, *Felix* (Methuen, 1902) p.232.

"whether as works of art or as material for the psycho-analyst": *Times*, 5th March 1927, p.10.

"they all knew how the rich lived." Hugh Massingham, *I Took Off My Tie* (Methuen, 1936) p.26. Spare told Letchford he knew Massingham.

"very nearly if not quite as Swafferish": Aldous Huxley, letter to J.Glyn Roberts 19th July 1933 – *Aldous Huxley: Selected Letters* ed. James Sexton, (Chicago, Ivan R. Dee, 2007) p.286.

Swaffer's 1927 *Express* piece is adapted into *Adventures with Inspiration* pp.9-13: all quotations from this source. Original piece reprinted in Ansell, *Borough Satyr*, 'Artist as Agent of the Unseen' pp.48-9.

'PRICES, - And Reasons for a Guinea Exhibition': reproduced in Retlaw, *The Youth and the Sage* (Thame, I-H-O, 2003) pp.78-9.

"I understand how the dinosaurs felt" Keith Vaughan, *Journals 1939-1977* (John Murray, 1989) p.140.

"an overlooked genius (since 1922)!... I simply neglected myself. I've never claimed to be more than an erotic Blake!": 1953 letter to Letchford cited Letchford p.127.

Gas oven: Spare to Swaffer, *Daily Herald*, 7th April 1932.

XII: EXPERIMENTS IN RELATIVITY

Empty years: *Zos Speaks!* p.18.

"deep incursions into psychic realms": Semple, *Cartomancy* p.9.

"subconscious and its denizens": Ansell, note to item 39 in Boxer 1992.

Dancers with trees and moon: for these sabbatic outdoor groups consider e.g. *Incident at the Witches Sabbath* Lot 62, Christies 5th May 1994; *Moonrack*, Lot 70 ibid.; *Untitled* mono plate 16, *Divine Draughtsman*; *Pan Satyros* in *Zos Speaks!* plate 9

"worshipped nature and the abundance of nature" Yeats cited in Stephen Coote, *WB Yeats: A Life* (Hodder and Stoughton, 1997) p.134.

Anamorphs: see Jurgis Baltrusaitis, *Anamorphic Art* (Cambridge, Chadwyck-Healey Ltd, 1977).

"associated with a genius and with artists of the top flight" Baltrusaitis op.cit. p.33

El Greco: Letchford p.273.

"I witnessed the severance of my automatons – elementals that appeared distortions of space." – title 9 in 'The Journey of the Soul Through Death to Rebirth', advertised at the back of *The Anathema of Zos*, p.19.

Reviewed in *Times*: 19th November 1930 p.12.

Trocadero cinema as "huge ferro-concrete refuge from the cares and troubles of modern life..." Norman Collins, *London Belongs to Me* [1945] cited Collins, *The Likes of Us* p.107.

"Maybe it was like those dreams": Ernest Hemingway, *For Whom the Bell Tolls* (Cape, 1941) p.133.

Rules for Sitters: unidentified 1934 newspaper cutting, courtesy Stephen Pochin.

"I shall not go to the Spare show" George Bernard Shaw to GS Sandilands, 4th May 1932, offered for sale by Heritage Auction Galleries, Texas, 24th October 2007, Lot 30327.

"Woolworthized £5 exhibition" Shaw letter to *Times*, 29th January 1940; "Woolworth theatre" Shaw letter to Charles Cochran n.d., *The Letters of Bernard Shaw to the Times* ed. Ronald Ford (Dublin, Irish Academic Press, 2007) pp.222; 297.

"unsuited for domestic decoration": Shaw to Sandilands 4th May 1932.

"he's the best artist alive today": Dennis Bardens 'In a Lonely Wood, Astray', introduction to *The Focus of Life* (I-H-O, 2000) p.10. All further details of Bardens and Neuburg visit from this source.

"technique of implanting symbols of wishes and desires into the subconscious mind";

"personally devised cryptology": ibid.

"Shall we put another record on?" Will Smith: Robert Ansell 5.xi.05.

"I'm bloody well DYING", rain story: account of Edward Carrick in Semple, *Cartomancy* p.11.

"streak of sadism in the Borough clans": Letchford 243.

Told Clifford Bax how to fight: Bax, *Ideas and People* p.39.

local cruelty to animals: ibid. pp.37-8.

Oswell from Osbert Sitwell: Clive Harper, 'Foreword' to Oswell Blakeston, *Austin Spare: Black Magician* (Thame, I-H-O, 2007).

"quick eye for the bizarre and the outrageous": ibid.

Blakeston, 'An Initiate Speaks,' [1933] in *Austin Spare: Black Magician* pp.15-27.

Blakeston, 'Magicians in London' [1950] in *Austin Spare:Black Magician* pp.33-44, Spare 40ff.

"The black-magic stuff is pretty off, though, isn't it?": Blakeston, *For Crying Out*

Shroud (Hutchinson, 1969) p.156; "a woman will look round now" p.158. "D.P. has taken a fancy to you": *Austin Spare: Black Magician* p.44.

"a small but regular income from such works" Naylor, fn.p.86, *Art and Letter: Word and Sign*.

Grant-era works: reproduced in *Zos Speaks!* and *Images and Oracles*, including 'Erotica of Zos'.

Album recently surfaced: shown to present writer by Julian Machin, 5.v.09.

Forster owned at least one other Spare: an Art Nouveau-ish concoction of heads and nudes manifesting in swirling plant forms, again shown to present writer by Julian Machin.

Forster, 'The Story of a Panic': see e.g. Nicola Beaumont, *Morgan* (Hodder and Stoughton, 1993) pp.112-13.

Forster and "smut": see Jonathan Gathorne-Hardy, *Kinsey: Sex The Measure of all Things* (Chatto, 1998) pp.324-25.

"Does not every initiate take the flight into Egypt": Blakeston, 'An Initiate Speaks,' *Austin Spare: Black Magician* p.27.

"I do not merely make the request": Spare to A.W.Austen, in 'Artist Faces Starvation for Inspired Drawings', *Psychic News* no.27, 1932.

"related to a denial so that the strength of the frustration joins…": Blakeston review of 1955 Archer Gallery show, *Art News and Review*, 12th November 1955, reproduced *Black Magician* pp.91-2.

"superstitious practice": Letchford p.177.

Friendship with William Argent: details from 'Fine Art and Antiques', Lawrence's Auctioneers, Crewkerne, 15th February 2001. Argent collection lots 361-375.

Annotated *Picture of Dorian Gray* (Paris, Charles, Carrington, 1908): collection of Charles Peltz.

XIII: FATHER OF SURREALISM

"plunging down deeply into the human mind": Dalí in Ian Gibson, *The Shameful Life of Salvador Dalí* (Faber, 1997) p.358.

"Surrealism is catching on wonderfully in London… awakening the hidden atavisms": Dalí ibid.

"giving life to inanimate objects": Paul Nash, The Life of the Inanimate Object, *Country Life* 1st May 1937 p.496.

"Surrealists are subtle to marshal under their banner": Oswell Blakeston, 'Austin

Osman Spare' in *Austin Osman Spare: Exhibition of Paintings Autumn 1936*.
"your surrealist AO Spare": 1936 birthday card to Ada Pain, item 22 in Boxer 1992.
used to pick winners with a pin: Letchford 127.

"I should have to trail him about": cited Semple, *Cartomancy* p.12.

passing a cross-eyed woman in the street – in fact two cross-eyed women, who smiled
at him – undated notes offered for sale by Caduceus Books [catalogue undated, but
including items from Gerald Yorke collection] p.21.

Gambling a form of oracle: Peter Fuller, 'Gambling; A Secular "Religion" for the
Obsessional Neurotic' in Fuller and Halliday, eds., *The Psychology of Gambling* (Allen
Lane, 1974).

"After memorising the portion in pencil": reproduced Semple, *Cartomancy* p.29.

"a roaring success" – Bardens to Tony Naylor, cited by Clive Harper, 'Off Course and
Of Course', St. Bride's Event 14.5.2005.

"secret truth of numbers"; "one neither wins nor loses": Pierre Cabane, *Dialogues with
Marcel Duchamp* (Thames and Hudson, 1971) p.116.

"Artists throughout history are like the gamblers of Monte Carlo": see Ecke Bonk,
Marcel Duchamp: The Portable Museum (Thames and Hudson, 1989) p.18.

Hitler portrait story: see Letchford pp.191 and 253; Hannen Swaffer, 'Mystery of an
Artist' *London Mystery Magazine* Vol.1 no.5, August 1950; Roy Curtis Bramwell, 'A
Personal Recollection' in *Artist Occultist Sensualist:* Ansell, *Borough Satyr* p.15.

"Only from negations can I wholesomely conceive you": as reported by Hannen
Swaffer in 'The Mystery of an Artist', *London Mystery Magazine* vol.1 no.5, August
1950.

Orwell on Hitler and Christ: cited in DJ Taylor, *Orwell: The Biography* (Chatto,
2003) p.59.

Spare attempts to photograph himself as Christ: Letchford p.241.

Letchford's first visit: Letchford p.171.

"wonderful old Austin": Letchford p.227.

"Awe-stin": Semple, *Study for a Portrait of Frank Letchford* (Fulgur, 2002) p.25.

naive until 1936: Letchford p.237.

Hubert Nicholson: Nicholson, *Half My Days and Nights* (Heinemann, 1941) pp.215-16.

'Father of Surrealism – He's a Cockney!': *Daily Sketch*, 25 February, 1938.

"what remained of mediumistic communication once we had freed it from the insane
metaphysical implications": Andre Breton, *Conversations: The Autobiography of*

Surrealism , trans. Mark Polizzotti (New York, Paragon, 1993) p.64.

"opening out of the Ego to (*what is called*) any external influence": *BoP* p.41.

"What is Art Nouveau...?" Breton, 'The Automatic Message' in *What is Surrealism? Selected Writings* ed. Franklin Rosemont (Pluto Press, 1978) p.104.

"the first text-book on how to be a surrealist and why": Blakeston, Walworth Road catalogue 1936.

"autism (egocentricity)": Breton, 'The Treatment of Mental Disease and Surrealism,' in the 'Surrealism and Madness' section of *This Quarter*, Surrealist Number, vol.V no.1 (September 1932) p.115.

"the conversion of the being into a jewel": Breton, 'Surrealism, Yesterday, Today and Tomorrow' *This Quarter* p.27.

"spivs, higglers, tapsters, billiard-cue markers and taxi drivers": HV Morton in Letchford p.171.

"These remarkably lively ladies": Letchford p.175; washerwoman p.245; wanted, as charwomen and cleaners p.175; digging them out of their hovels p.241.

newspaper sellers, "fast disappearing": Letchford p.179.

thought of opening a hostel for tramps: Letchford p.183.

"I look about for character... That picture on the wall is the picture of a costermonger": *Chums* 15th June 1904.

"...difficult lives of those who surrounded him": Ansell, *Borough Satyr* p.12.

Spare and Letchford evening walks: Letchford pp.181-3.

"wars come and go, but Art lives on for ever": Letchford p.183.

XIV: HITLER'S REVENGE

Graded C3: Letchford, p.183.

Camouflage, see Letchford 185; 199.

Lionel Hale, 'The Invisible Man; A New Theory for Camouflage' *News Chronicle* 20th February 1940.

Spare's success stories: Letchford p.187; "or so he said" ibid.

Letchford remembers "tarts": Letchford p.189.

Letchford sees "bazaars, Jain temples": Semple, *Study for a Portrait of Frank Letchford* p.11.

Neuburg suggests Vera Wainwright should visit Spare: *Dearest Vera* p.13.
"in trying to avoid them he bumped into living people" Bardens, 'In a Lonely Wood Astray' p.24.

First bomb through studio mentioned in Smith, 'Spare and Southwark', Temple Bar catalogue, 1949.

Beer and matches as omens: or so he told Grant in 1949: *Zos Speaks!* p.46.

Spare's permit to be on Collier's roof was among the papers blowing around when the house at Wynne Road was demolished: Roy Curtis-Bramwell in *Artist Occutist Sensualist*.

"not only for art but also for the social history of Southwark": Letchford p.195.

Spare in hostel: Letchford p.97.

Donald Bowen: writing in addition to Spare's obituary, *Times* 18th May 1956 p.13.

Spitalfields, clay figures: Letchford p.199.

"In search of a new aesthetic: effort to recover memory": Letchford p.201.

"silent, dazed, almost a ghost": ibid. p.203.

"Not that Austin was *demonstrative*": ibid.

Vera's letters to Spare: see *Art and Letter: Word and Sign*.

Spare barters pictures for suit: Letchford p.203.

Magazine plans and suggested contributors: Bloomsbury Book Auctions 20th June 2005, lot 182, a collection of Spare and Wainwright material: "dramatic subjects that can be expressed in the head and hands mainly;" "The saint I like best is St.Francis but doesn't lend..."; 'more terrible the better" etc.

"I conclude that you are on the threshold of sainthood..." *Poetry and Art*, one of an unnumbered three volume set concerning Spare and Wainwright (Tony Naylor, 2008) [59 copies; not seen – quotation from Caduceus books mailing Spring 2008].

"PS supposing it does not go beyond 'very close friendship'" Wainwright to Spare 3rd August 1944, *Art and Letter* p.158.

"Finally, I would like to express my admiration": 'Acknowledgments', Vera Wainwright, *Poems and Masks* (Guernsey, Toucan Press, 1968) p.6.

"Human relationships are very mysterious": cited Letchford p.207.

FAMOUS ARTIST, BLITZ VICTIM, BLAMES FATE: unidentified newspaper cutting sent by Spare to Letchford and reproduced Letchford p.316.

"offered to kill Hitler by Black Magic": Bardens diary entry 6th January 1942, reproduced *Existence* p.51.

"one of the saddest and most distressing periods of his life": Bardens 'In a Lonely Wood' p.25.

"near to being a nervous wreck… indelible memories of the blitz": Bardens p.213.

"Laboriously, painfully, he was trying to regain the use of his muscles by exercises": Bardens op.cit pp.24-5.

'Adventures in Limbo,' 'Enthosthorasis,' 'The Static Alignments,' 'A Book of Satyrs': Bonhams, 20thC British Art, 11th July 2006, lots 11-13.

Young people "fine mediums for the obsession": Spare paraphrased in Letchford p.211.

"moral courage" ("*constant*, not sporadic"): ibid. p.217.

Working "like a demon": Letchford p.223; "with demoniac energy": Bardens, 'Lonely Wood' p.26.

XV: THE COMEBACK

Docker with National Teeth: Temple Bar show, 1949, item 92.

"Never more talk of democracy" introduction to White Bear 1953 show, 'About It And About' [sic], re no.108 *The birth of a hydra*.

"Individualist": introduction to 1952 Mansion House catalogue.

Small shops: Letchford p.249; material quality declining ibid p.241; craftsmanship and earnings 247; tarmac, silver, space travel: 277, 247, 281; fares, pot cupboards: p.241; boat-race trophy: Letchford p.249.

like a tramp: ibid. p.215; newspaper in place of plates ibid p.213; "altering the doctor's prescription" ibid. p.213.

gamelan show: ibid. p.215.

"Darling of Mayfair": Nigel Burwood in Bradbury and Birch catalogue, 1984.

Letchford's Bombay transvestites story: ibid. p.245.

"output seemed superhuman": Bardens, 'Lonely Wood' p.26.

Ethel Morris: details from *Times* obituary 7th November 1957; camp bed Letchford p.227.

Letchford's father: Letchford pp.223-5.

Food parcels, tin of salmon: ibid. p.229.

'London Commentary,' Cora Gordon, *The Studio* vol.135 Jan-June 1948 p.94.

Priestess and her God : Letchford p.227.

"suggestion of sexual mischief": Ansell, *Borough Satyr*, p.46.

"Dreamer of dreams or observer of film stars": John Russell Taylor, reviewing Morley Gallery show, *Times* 15th September 1987.

scrapbook of film star photographs from Frank Letchford's sister: Chronology, 1946, in Wallace *Later Work*.

Meets James Mason: Letchford p.243.

"Para-automatecismus" thesis: Letchford p.215.

"You are the Master, I the pupil": Semple, *Study for a Portrait of Frank Letchford* p.17.

"confidence, health and strength seeped back": Letchford p.233.

Spare and Letchford plan 'Modern Art Versus Classicism': Letchford p.207.

The basement apport story: Francis King, *Ritual Magic in England* (Spearman, 1970) ch.22.

King a fantasist: Tim D'Arch Smith, *The Times Deceas'd* (Settrington, Stone Trough Books, 2003) pp.119-20.

XVI: "INTERCOURSE WITH A VAMPIRE"

"a god-like figure": Herbert Budd in Steffi Grant, 'Introduction', *Zos Speaks!* p.13.

"literally speechless"; Steffi's first visit: ibid.

Kenneth Grant and army: Grant, *Remembering Aleister Crowley* (Skoob, 1991) p.v.

"Being watery and Luna": ibid. p.21.

"foul London and Ilford atmosphere": ibid. p.30.

blue cups: *Zos Speaks!* pp.15; 33.

"one of the greatest living draughtsmen": ibid. p.30.

"'len o'clock" ... "all them symbols"; "mental": ibid. pp.95; 42.

Harry Lime Theme: ibid. p.14.

Imperial Russian Stout: ibid. pp.47; 79.

"dirtiest bitch I know"; "on the job at once!!"; "expecting it", "so tight": ibid. pp.85; 47; 51; 45.

"less than a penny": ibid. p.46.

"fatally premature birth"; maid, dwarf, hermaphrodite: Grant *I&O* p.11.

married twice; Norman Birkett: *Zos Speaks!* p.37.

"hundreds of women he has ridden": ibid. p.36.

Blind girl: ibid. p.46.

"Bearded lady" and "Self-portrait at 18 years" reproduced *Zos Speaks!* p.90.

"tongueing it": ibid. p.36.

Penis experiment: ibid. p.120.

Ovaltine aphrodisiac: ibid. p.71.

"old bitch – sound practice if you have imagination": *I&O* p.47.

"copulating the ether": *Zos Speaks!* p 119.

"fat, ugly barmaid": ibid. p.33.

"nice fat arse": ibid. p.47.

"woman for social congress"; "Stalin"; "intercourse with a vampire": ibid. pp.235-36.

"same as any *real* event": ibid. p.117.

"Of course I meant 'Succubi'": ibid. p.122.

'Doctrine and Credo' from Zoetic Grimoire: ibid. p.220.

"Arabesque of a 'thing' in thought thinking" : card reproduced in Semple, *Study for a Portrait of Frank Letchford* p.29.

"the Formula of Plotinus" or "Giving Life to the Autistic by Virgin Earthenware... Genii of the Brazen Vessel": *Zos Speaks!* p. 223 cf p.37.

"real meaning of the word Urning": ibid. p.37.

"whose love she had not managed to win": Breton, *Conversations*, p.108; "the mind's compensation for the heart's defeat.": ibid.

Choronzonic Caesar: Temple Bar cat.28; *Yantra of Yearning*: Temple Bar cat. 29: *Corybantic Ennui*: Mansion House cat.15.

"sentientesquely": *Zos Speaks!* p.128; "enormon," "stectatorially" ibid. p.123.

"precention" ibid. p.129.

"Enthosthorasis": e.g. 1937 Walworth Road cat.38.

"'Touch & go'?": *Zos Speaks!* p.136.

"A certain famous writer to whom I showed a page or so": ibid. p.122.

Book of the Dead; Rohmer; Vaihinger: ibid. pp.33; 33; 157-8.

"By Belief in a concept, either true or false": ibid. p.103.

Inn and wine story: Grant *I&O* p.35.

Two dabblers story: ibid. pp.21-22.

Cult of Ku story: Grant, *Hecate's Fountain* (Skoob, 1992) pp.14-21, cf *Cults of the Shadow* (Muller, 1975) pp.202-3, *Outside the Circles of Time* (Muller, 1980) p.69ff.

"vowel sounds as in Sanskrit": *Zos Speaks!* p.111.

"Key to it… destroyed in the Blitz": ibid. p.93.

"could still guess a good deal"; "could be by another person": ibid. p.102.

"like looking into an empty bucket!": Spare introduction, 'This and That,' Mansion House catalogue 1952.

"psycho-maths-astro factors": 1940 letter, Letchford 189; "Fairy Tales" and "bollocks": 1939 letter, ibid. p.183.

sigils and heraldry, 1953 letter to Letchford cited Wallace, *The Artists Books* p.285 n.1.

"This is the only work on sigils": envelope illustrated in Semple, *Study for a Portrait of Frank Letchford* p.33.

"'Behaviour' is the whole thing in every direction": Letchford p.267.

yoga not social: 1947 letter cited Wallace *Artist's Books* p.263: "Yoga has no contexture within the true function of life – which is – fuller life, beauty, pleasure by every social means."

"The greatest disaster of love": Logomachy of Zos dictum 227, *Zos Speaks!* p.176.

XVII: THE STOIC

Civil List: Letchford p.249.

"*somewhere to work*": Spare to Vera Wainwright, undated, *Dearest Vera* pp.161-2.

Spare and Letchford shop: Letchford p.235.

"knows Tom Driberg intimately": *Zos Speaks!* p.40.

pandered too much to "normal": ibid. p.103.

"sensual leer and bleary eyes": Letchford p.255.

Yorke invitation: *Zos Speaks!* pp.283-4; "I can only do portraits in the quiet of my own rooms": ibid. p.284.

Gavin Todhunter: see Ansell, 'Introduction' *The Book of Ugly Ecstasy* (Fulgur, 1996).

two hundred and fifty guineas: Letchford p.253; "Sorry" ibid.

'Mind to Mind and How' "by a Sorcerer": in Semple, *Two Tracts on Cartomancy* pp.31-37.

Hall "mental": *Zos Speaks!* p.59.

Spare goes back to art college: see *Zos Speaks!* pp.19-20.

"Medusine masque looming in the corner": Semple, *Study for a Portrait of Frank Letchford* p.18.

London Bridge Auctions: Letchford, 'Memories of a Friendship' in *Artist Occultist Sensualist.*

"spirits, the unconscious… they are all the same thing": Picasso quoted in André Malraux, *Picasso's Mask*, trans. J Guicharnaud (Macdonald and Jane's, 1976) pp.10-11, see also Hal Foster, 'The Primitive Unconscious of Modern Art' *October* 34 (Autumn, 1985) pp.45-70.

"night side of man": André Malraux quoted in Sally Price, *Primitive Art in Civilized Prices* (Chicago University Press, 1989) p.37.

"Witch Mother": Grant *I&O* p.46.

"Objects that are strongly sexed sell well"; "figures with erect penises": Price op.cit p.47.

"Those purchasing these sketchbooks obtain therewith": Spare note to items 101-112 Mansion House Tavern 1952.

annoyed by Dalí show: see *Zos Speaks!* p.77.

"the Zenists are the Spivs": note reproduced Semple, *Study for a Portrait* p.30.

"No more bloody pubs for me!": *Zos Speaks!* p.84.

"Satyr which recurs": Letchford to Bardens, 5 September 1970, possession of present writer.

Spare moves upstairs: Letchford p.267.

bottle of milk, "star sapphire": ibid. p.269.

"such a stream of coarse invective that he forgot to enter the Post Office": ibid. p.223. Betty: Letchford p.265; *Zos Speaks!* p.79.

"The Stoic seeks and practises Virtue": reproduced in Semple, *Study for a Portrait* p.31.

"the last Stoic (ZOS)": *Zos Speaks!* p.35.

"Eststoic"; "… an older stoicism than that of Zeno": ibid. pp.113; 114 and note.

"O ye Gods, Grant me this": *London Mystery Magazine*, vol.1 no.6 p.92.

XVIII: AN OWL WITH THE WINGS OF A BAT

"By the way, translate 'Zos vel Thanatos'": *Zos Speaks!* p.66.

"an 'as if' potential, latent and fictive, transforming into an 'as now' ecstasis": Grant in *Zos Speaks!* p.155.

Bus journey story: Grant *I&O* pp.23-4.

"mystery tour": Letchford pp.73-4.

"*anywhere*": ibid. p.281.

Patterson newspapers e.g. LIVED HERE FOR 100 YEARS, *South London Press*, 24th November 1939, front page; AGED 102, *South London Press*, 27th January 1942.

Fleshed her out for Hannen Swaffer: 'The Mystery of an Artist', *London Mystery Magazine* vol.1 no.5 August 1950.

Paterson becomes a running figure in Grant's tales: e.g. in *Cults of the Shadow* (Muller, 1975) a "self-confessed witch who embodied the sorceries of a cult so ancient that it was old in Egypt's infancy"p.202.

"yelder-eyed witches": Montague Summers, *The Werewolf* (Kegan Paul, 1933) p.29.

Gerald Gardner and "Wicca": see e.g. Ronald Hutton, *The Triumph of the Moon*.

"ZOS and Scire [Gardner] had a fierce argument as to who had been to the Witches Sabbath": *Zos Speaks!* p.95.

"second mother to Zos," aged 109: ibid. p.95.

"I don't think Dr Gardner has ever met a pucker witch": ibid. p.97.

"the Witch who taught you when young": ibid. p.98.

"had a 'Sabbath' dream of vivid power yestere'en": ibid. p.52.

"either been to a Sabbath or had dreamed an amazing dream of one": ibid p.121.

"Shove me down as an hon. Member": ibid. p.81.

Death and misfortune: Moola falls from a trapeze into a tank with a swaying mass of tentacles, *Hecate's Fountain*, pp.156-7; "Li" dies in a plane crash perhaps caused by elementals *op.cit.* p.9, and Nerik goes mad p.106, Olga disappears into abyss p.182; Clanda is drowned by water spirits, in Grant, 'Water Witch', *Man Myth and Magic* no.65.

Barbara Kindred: conversation with former member of Typhonian OTO, 17.viii.99.

"facing me, *stood Dr. Fu Manchu!*" *The Mystery of Fu Manchu* [1913], *The Fu Manchu Omnibus* vol.1 (Allison and Busby, 1998) p.343.

"sacrifice to a crocodile?": Grant, *Against the Light: A Nightside Narrative* (Starfire, 1993) pp.23-4.

Nu-Isis lodge under shop, "in an extensive underground network of apartments": *Hecate's Fountain* pp.10-12.

"eruption of black energy": ibid. p.11.

"token sacrifice" of ten shillings: Spare to Gardner, *Zos Speaks!* p.98.

Clanda story: e.g. Grant *I&O* pp.30-33; "a sort of amphibious owl with the wings of a bat and the talons of an eagle" p.33.

"needs to get some more slime into it." Grant cited in Dave Evans, *The History of British Magick After Crowley* (no place given, Hidden Publishing, 2007) p.328.

"...squid in a cocktail dress;" "... brimstone aftershave." – Alan Moore, 'Beyond our Ken: a review of *Against the Light: A Nightside Narrative*' in Joel Birocco (ed.) *Kaos* 14, 2002 [internet journal].

"We all carry within us something folded up like those Japanese flowers" Jean Cocteau, *Opium* (Peter Owen 1968) p.58.

XIX: ONLY THE GODS...

Henry Miller: e.g. *Zos Speaks!* p.82; Semple *Letchford* p.19; *Borough Satyr* p.16, with portrait of Miller reproduced.

"have long suspected that my ghost (astral body or Ka) often wanders forth": White Bear catalogue.

"please will you give me a rough definition of the Qlipoth & Bess-Mass": *Zos Speaks!* p.135.

"the be-all and end-all of fuck-all": Letchford p.287.

"a psychologist that saved me"; ibid, p.263.

"moral courage accrues": ibid. p. 217.

New totem animal: *Elemental Materialisation* [sic], 1953 (*Divine Draughtsman* plate 17) – probably the same picture as *Elemental Materializing*, Archer Gallery cat.48, and on the theme of "I Desire the Strength of My Tigers", or "This is my Wish, to Obtain the Strength of a Tiger" cf *BoP* p.50.

Bardens notices stele for health ("O Isis! Endow me with Health"): 'In a Lonely Wood' p.29.

"A lot which appears to be fraud is not really fraud at all": Philip Paul 'Psychic Artist Enables You to See Beethoven's Fifth Symphony' *Two Worlds*, 1954, reprinted *Borough Satyr* pp.59-59.

BBC radio: see *Zos Speaks!* pp.132-134; "segmented with a lot of half wits" 133.

"Osman advertised the charm over the radio": Daniel Mannix, Witchcraft's Inner Sanctum,' *True* vol.40 no.267, August 1959, pp.34-5, 77-80.

working like ten men: *Zos Speaks!* p.139.

Schrenk-Notzing's *Phenomena of Materialization*: ibid. p.284 n.116.

Ghosts "tied up with his sales talk": Bardens to Letchford, letter 5th September 1970.

"sick of bloody ghosts": Letchford p.183.

"rather a lightweight": Letchford to Bardens 5th September 1970.

"Horrible, horrible! Go to Hell!": *Dearest Vera* p.13.

"reappeared": Cora Gordon, 'London Commentary,' *The Studio* vol.135 Jan-June 1948 p.94.

"seen less frequently": *The Studio* vol.88 (July-Dec 1924) p.98.

"the years have not dealt kindly": *Burlington Magazine* Vol.XIX June 1911 p.177.

"I defy any lover of painting to love a picture as much as a fetishist loves a shoe." Bataille, 'The Modern Spirit and the Play of Transpositions' from *Documents* no.8 (1929) in Ades (2006) p.242; cf Bataille (1968) p.200.

Archer Gallery opening: *Zos Speaks!* p.142; Letchford p.285.

Klee pastiche: Letchford p.273.

Hundreds of women, Sabbaths, Radclyffe Hall: to the Grants, in *Zos Speaks!*; satyr in Fleet Street, friendship of Walter Pater: to Vera Wainwright, in *Dearest Vera*; torpedoed troopship, No Man's Land, albatross, hieroglyphics, ice cream, Pompeii: to Letchford and others, in *Michelangelo in a Teacup*; painted Hitler from life: to journalists and others; letter from Freud: to both Grant and Letchford in Letchford op.cit. and Grant's introduction to *The Book of Pleasure*.

RSPCA badge in photographs: e.g. frontis. *AOS: A Celebration* ed. Staley and Wise (Thame, I-H-O, 2006).

"English Satanic occultist": Mario Praz, *The Romantic Agony* (OUP, 1933) p.396 n.59.

"another Dan Leno!", HV Morton to Letchford: Letchford p.171.

West End gallery: *Zos Speaks!* p.155.

Wedding, Buddha: Letchford p.269; stele p.279; illustrated Letchford p.242.

Conté pastels, final visit to Wynne Road: Letchford p.289; Letchford, 'Memories of a Friendship', in *Artist Occultist Sensualist*; Semple *Portrait* p.21; more on Rolls-Royce e.g. *AOS: A Celebration* p.25.

"neat figure" of Kenneth Grant: Letchford p.289; "very luminous eyes" Semple, *Portrait* p.21.

"stab in the back"; "loath to take": *Zos Speaks!* p.149; Alfred Larking ibid. p.150.

"See you soon"; new ideas: Letchford p.289.

Bardens and almost animal snarl: Robert Ansell 14.v.05.

"The collecting of his pictures may yet become a cult" *Times* 16th May 1956; 'He refused to paint Hitler' *Daily Express* 16th May 1956 and 'He refused Hitler' *News Chronicle* 16th May 1956; "The Ilford artist who snubbed Hitler" *Ilford Pictorial* 24th May 1956; "A strange and gentle genius died in a London hospital this afternoon…" *Evening News* 15th May 1956.

"Only the gods can distinguish success from failure." This quotation lay unsourced in my notes for over ten years but I now know it to be from Chekhov's letters, and probably better translated "You have to be a god to distinguish the successes from the failures without making a mistake." Letter to AS Suvorin, November, 1888, in Michael Henry Heim (ed.) *Letters of Anton Chekhov* (Bodley Head, 1973) p.122.

"He did not retrieve them, and they were left amongst the remains of Spare's last home…": Semple, *Two Tracts on Cartomancy* p.15. I wanted to end on this not only because it hits the perfect note, with an air almost of William Burroughs's "last awning flaps on the pier," but also out of respect to those who have researched Spare before me. It is no disrespect to them if I say Spare was not only a confabulator but a magnet for mythologisation, and it looks as if Kenyur-Hodgkins in fact gathered up as much as he could carry from the basement (particularly cancelled cheques, which he included in his edition of *Automatic Drawings*).

CODA: THE AFTERLIFE

'Current and Forthcoming Exhibitions', *Burlington Magazine* Vol.CVII no.747 (June, 1965) p 330.

Mario Amaya, catalogue essay in *Austin Osman Spare: Paintings and Drawings*, The Greenwich Gallery, London, 23rd July-12th August, 1964.

Martin Cropper, 'Patchwork Cult: The Temple ov Psychick Youth', *Tatler* vol.279 no.3 (March, 1984).

"... the New Sexuality [...] BECOMING ONE WITH ALL SENSATION [...] the annihilation of separate identity through / the mechanics of the Death Posture": Iain Sinclair, *Suicide Bridge* (Albion Village Press, 1979).

Britwell House: Sold by Direction of Mr David and the Lady Pamela Hicks, Sotheby's, 20th-22nd March, 1979.

A Collection of Watercolours and Drawings by Austin Osman Spare, Christie's South Kensington 12th May 1994.

'Austin Osman Spare', Bulldog Breed, *Made in England* (Deram, 1969).

"I inherited a lot of prints and sketches of Austin's work, but with the passage of time they were lost (I think I left them in a bedsit in Ilford just round from the Bus station, 1969!) [...] most of my equipment had been stolen and I suffered a setback financially (as musicians do). I did a runner 'cos I couldn't pay the rent!": Rod Harrison on Spare Yahoo group; contribution now preserved on Fulgur website.

BIBLIOGRAPHY

Clive Harper's bibliography is one of the indispensable works on Spare. It currently comprises:
Revised Notes Towards A Bibliography of Austin Osman Spare (Edmonds WA, Holmes, n.d. [1999])
Supplement to the Second Revised Version of Notes Towards a Bibliography of Austin Osman Spare (published privately, 2005)
Son of Supplement to the Second Edition of the Revised Version of Notes Towards a Bibliography of Austin Osman Spare (published privately, n.d. [2005])
Not forgetting:
Corrigendum Slip for the Son of Supplement to the Second Edition of the Revised Version of the Notes Towards a Bibliography of Austin Osman Spare [distributed at AOS: A Celebration, London, 14th May 2006]

There is also a bibliography of Kenneth Grant:
Kenneth Grant: A Bibliography – from 1948, compiled by Henrik Bogdan (Gotebord, Academia Esoterica, 2003)

WORKS BY SPARE
Earth: Inferno (the author, Co-Operative Printing Society Ltd, 1905)
A Book of Satyrs (Co-Operative Printing Society Ltd, 1907)
The Book of Pleasure (Self-Love): The Psychology of Ecstasy (The Author, 8B Golders Green Parade, 1913)
The Focus of Life (The Morland Press, 1921)
Anathema of Zos: The Sermon to the Hypocrites (The Author, 58 Blythswood Road Goodmayes, 1927)
Form: A Quarterly of the Arts, ed. with Francis Marsden Vol.1 nos.1-2 (1916-1917)
Form: A Quarterly of the Arts, ed. with W.H. Davies Vol.1 nos.1-3 (1921-22)
The Golden Hind, ed. with Clifford Bax Vol.1 nos.1-4; Vol.2 nos. 5-8 (1922-24)
A Book of Automatic Drawings (Catalpa Press, 1972)
Axiomata and The Witches' Sabbath (Fulgur, 1992)
The Book of Ugly Ecstasy (Fulgur, 1996)
Two Tracts on Cartomancy (Fulgur, 1997)
Zos Speaks! ed. Kenneth and Steffi Grant (Fulgur, 1998)
Fragmentum ed. Mark Smith (published privately, 2002)
The Valley Of Fear (Fulgur, 2008)
Dearest Vera ed. Kenneth and Steffi Grant (Fulgur, 2010)

EXHIBITION CATALOGUES
Bruton Galleries, *Black and White Drawings* (1907)
Baillie Gallery, *The Modern World* (1911)
Baillie Gallery, *Paintings and Drawings* (1912)
Ryder Gallery, *Pleasure and Obsession* (1912)
Baillie Gallery (1914)
Exhibition of the Society of Independent Artists [at] Thos. Parsons and Sons, 315 & 317 Oxford Street (1924)

St. George's Gallery, *Psychic Drawings and others of Magical and Occult Manifestations* (1927)
Lefevre Galleries, *Drawings and Watercolours* (1929)
Godfrey Phillips Galleries, *Water-Colours and Drawings* (1930)
Storran Gallery [as agents; exhibition 56a Walworth Road] (1936) [essay Blakeston]
56a Walworth Road, *Exhibition of Paintings* (1937) [essay Sandilands]
56a Walworth Road, *Exhibition of Paintings* (1938) [essay Bardens]
Archer Gallery, *Exhibition of Paintings* (1947) [essay Bardens]
Temple Bar, *Exhibition of Paintings* (public house, 1949) [essays Grant, Quinn, Smith, Spare]
Mansion House Tavern, *Exhibition of Paintings* (public house, 1952) [essay Spare]
White Bear, *Exhibition of Paintings* (public house, 1953) [essay Spare]
Archer Gallery, *Paintings and Drawings* (1955) [essay Grant]
Greenwich Gallery (1964) [essay Amaya]
Taranman Gallery, *Exhibition of Paintings, Pastels and Drawings* (1974)
Oliver Bradbury and James Birch Fine Art (1984) [essay Burwood]
Morley College Gallery, *The Divine Draughtsman*, ed. Geraldine Beskin and John Bonner (1987)
Henry Boxer, *Austin Osman Spare: an exhibition to celebrate the launch of The Witches Sabbath and Axiomata* (Fulgur, 1992)
Marx House, *Artist Occultist Sensualist*, ed. Geraldine Beskin and John Bonner (1999)

SELECTED AUCTION CATALOGUES
A Collection of Watercolours and Drawings by Austin Osman Spare, 12 May 1994, Christie's South Kensington [lots 1-128]
The Book as Art: Modern Illustrated Books and Fine Bindings, Part II, 21 November 1995, Sotheby's New Bond Street [lots 409-412 including illuminated manuscript grimoires from 1905-6]
Fine Art and Antiques, 15 February 2001, Lawrences of Crewkerne [lots 361-375 from WS Argent collection]
Twentieth Century British Art, 26 July 2001, Christie's South Kensington [lots 43-49 from Thomas Lumsden collection]

BOOKS & ARTICLES
Agape: The Occult Review (Vol.1 no.4) [Spare issue] (Bath, 1973)
Ansell, Robert, *The Bookplate Designs of Austin Osman Spare* (Bookplate Society / Keridwen Press, 1988)
Ansell, Robert, 'Borough Satyr: The Life of Austin Osman Spare' *Cent magazine* (Simon Costin issue, 2003)
Ansell, Robert, *Borough Satyr* (Fulgur, 2005)
Antiquities Including an English Private Collection of Ancient Gems Parts I and II, Christie's South Kensington, 13 May and 29 October 2003
Archer, Ethel, *The Hieroglyph* (Denis Archer, 1932)
[Arnaud] *Prises de Terre: Potlatch pour Noel Arnaud* (Toulouse, Palais des Arts, 1997)
'Artist Who Paints In His Sleep, The' *Psychic News*, 5 November 1955
'Artists in their Studios: The Boy Exhibitor at the Royal Academy' *Tatler*, May 18, 1904
Arwas, Victor, *Alastair* (Thames and Hudson, 1979)
Austen, AW 'Artist Faces Starvation for Inspired Drawings' *Psychic News* no.27, 1932
Baker, Phil, 'Get Sidereal', *Times Literary Supplement* 20 August 1999

Baker, Phil, 'Stroke of Genius,' *Fortean Times* 144 (March 2001)

Baker, Phil, 'Austin Osman Spare', *New Oxford Dictionary of National Biography* (OUP 2004)

Balint, Michael, *The Basic Fault* (Tavistock Press, 1968)

Baltrusaitis, Jurgis, *Anamorphic Art* (Cambridge, Chadwyck-Healey Ltd, 1977)

Bankes, Viola, *Why Not?* (Jarrolds, 1934)

Bardens, Dennis, 'No Man Shall Understand' [in Naylor 2006]

Bardens, Dennis, 'Diary Entry January 6th 1942' [in Naylor 2006]

Bardens, Dennis, 'In A Lonely Wood, Astray' introduction to Spare, *The Focus of Life* (Thame, I-H-O, 2000)

Bataille, Georges, *Visions of Excess* (Manchester, MUP, 1985)

Bataille, Georges, *Inner Experience* (New York, SUNY, 1988)

[Bataille] Ades, Dawn, *Undercover Surrealism: Picasso, Miro, Masson and the Vision of Georges Bataille* (Hayward Gallery, 2006)

Bax, Clifford, *Inland Far* (Heinemann, 1925)

Bax, Clifford, *Ideas and People* (Lovat Dickson, 1936)

Beaumont, Nicola, *Morgan* (Hodder and Stoughton, 1993)

Beckett, Samuel, *A Dream of Fair to Middling Women* (Dublin, Black Cat, 1992)

Beerbohm, Max, *The Bodley Head Max Beerbohm* (Bodley Head, 1970)

Benson, AC, *Hugh* (Smith, Elder and Co., 1915)

Benson, RH, *The Necromancers* (Hutchinson, 1909)

Birocco, Joel, 'Grant's and Letchford's Versions of Austin Spare' *KAOS* 14 (2002)

[Blakeston, Oswell] as 'Simon,' *Murder Among Friends* (Wishart, 1933)

Blakeston, Oswell, Introduction to 1936 Storran / Walworth Road show

Blakeston, Oswell, 'Magicians in London' in *The Uncertain Element* ed. Kay Dick (Jarrolds, 1951)

Blakeston, Oswell, 'Magician' *Art News and Reviews* Vol.2, no.21 12 Nov 1955

Blakeston, Oswell, *For Crying Out Shroud* (Hutchinson, 1969)

Blakeston, Oswell, ed. AR Naylor, *Austin Osman Spare: Black Magician* [posthumous compilation] ed. Clive Harper (Thame, I-H-O Books, 2007)

Blavatsky, Helena, *Isis Unveiled* (New York, JW Bouton, 1877)

Blavatsky, Helena, *The Secret Doctrine* (Theosophical University Press, 1888)

Blofeld, John, *City of Lingering Splendour* (Hutchinson, 1961)

Bonfiglioli, Kyril, *The Mortdecai Trilogy* (Black Spring, 1991)

Bratley, George H, *The Power of Gems and Charms* (Gay and Bird, 1907)

Breton, Andre, 'Surrealism and Madness' *This Quarter* vol.V no.1 Surrealist Number (September, 1932)

Breton, André, *Manifestoes of Surrealism* (Ann Arbor, Michigan University Press, 1969)

Breton, André, *What is Surrealism? Selected Writings* ed. Franklin Rosemont (Pluto Press, 1978)

Breton, André, *Conversations: The Autobiography of Surrealism*, trans. Mark Polizzotti (New York, Paragon, 1993)

Breton, André, *The Automatic Message* (Atlas Press, 1997)

Calloway, Stephen, *Aubrey Beardsley* (V&A 1998)

Chesterton, GK, *Autobiography* (Hutchinson, 1936)

Chibnall, CJ, *The Book of Pleasure in Plain English* (Hemel Hempstead, Winged Feet, 2009)

Christian, John, *Symbolists and Decadents* (Thames and Hudson, 1977)

Clark, Richard Grenville, *Frederick Carter A.R.E. 1883-1967: A Study of His Etchings* (Apocalypse Press, 1998)

Cobbe, Frances Power, 'Unconscious Cerebration,' *Macmillan's Magazine*, November 1870

'Cockney Portrait Gallery' *World of Art Illustrated* vol.1 no.2 Feb 1939

Collins, Michael, *The Likes of Us* (Granta, 2004)

Colquhoun, Ithell, 'Heaven and Earth: Portrait of a Magician', *The London Broadsheet*, 1955 [reprinted Ansell, *Borough Satyr*]

Colvin, David, and Ed Maggs, eds. *Enoch Soames: The Critical Heritage* (Maggs, 2001)

Compton, Ann, *The Sculpture of Charles Sargeant Jagger* (Much Hadham, Henry Moore Foundation, 2004)

Coote, Stephen, *WB Yeats* (Hodder and Stoughton, 1997)

Cropper, Martin, 'Patchwork Cult: The Temple of Psychic Youth', *Tatler* March 1984

Crowley, Aleister, *Confessions*, ed. Kenneth Grant and John Symonds (Cape, 1969)

Crowley, Aleister, *Magick in Theory and Practice* ed. John Symonds and Kenneth Grant (RKP, 1973)

Crowley, Aleister, *The Winged Beetle* (privately published, 1910)

Curtis-Bramwell, Roy, 'A Personal Recollection' in *Artist Occult Sensualist*

Curwen, David [as Lapidus], *In Pursuit of Gold* (Spearman, 1976)

Dalí, Salvador, *OUI: The Paranoid-Critical Revolution: Writings 1927-1933* ed. Robert Descharnes (Boston, Exact Change, 1998)

Doolittle, Hilda [as 'HD'], *Tribute to Freud* (Oxford, Carcanet, 1985)

Drury, Nevill, and Stephen Skinner, *The Search for Abraxas* (Spearman, 1972)

Duchamp, Marcel, and Pierre Cabane, *Dialogues with Marcel Duchamp* (Thames and Hudson, 1971)

[Duchamp] Ecke Bonk, *Marcel Duchamp: The Portable Museum* (Thames and Hudson, 1989) p.18

Duchamp, Marcel, "Will Go Underground," interview with Jean Neyers, in *Tout-Fait: The Marcel Duchamp Studies Online Journal* vol.2 issue 4 (January 2002)

Ellis, Havelock, *Studies in the Psychology of Sex*, six vols. (Philadelphia, Davis and Co., 1900-1920)

Errigo, Angela M., 'Austin Osman Spare: Magical Artist', *Fate and Fortune* no.8, 1974

Fann, KT, *Ludwig Wittgenstein: The Man and his Philosophy* (NY, Dell, 1967)

Feng, HY, and JK Shryock, 'The Black Magic in China Known as Ku' *Journal of the American Oriental Society*, Vol. 55, No. 1 (March, 1935)

Fergusson, James, 'How many copies did Spare print of Eight Poems?' [re Maggs catalogue 1247] in *The Bookdealer*, no.1349, 5 March 1998

Fletcher, Geoffrey, *The London Nobody Knows* (Hutchinson, 1962)

Fletcher, Geoffrey, *London's Pavement Pounders* (Hutchinson, 1967)

Forshaw, Alec, and Theo Bergstrom, *Smithfield: Past and Present* (Heinemann, 1980)

Freud, Sigmund, On Narcissism: An Introduction [1914] *Standard Edition* vol.XIV

Freud, Sigmund, Totem and Taboo [1912-13] *Standard Edition* vol.XIII

Freud, Sigmund, Civilisation and its Discontents [1929] *Standard Edition* vol.XXI

[Freud] *Sigmund Freud and Art: His Personal Collection of Antiquities* ed. Lynn Gamwell and Richard Wells (Thames and Hudson, 1989)

Fuller, JFC, *Yoga: A Study of the Mystical Philosophy of the Brahmins and the Buddhists* (Rider, 1933) [1925]

Fuller, JFC, 'The Black Arts', *Form* Vol.2 no.2 (December 1921)

Fuller, Peter, 'Gambling; A Secular "Religion" for the Obsessional Neurotic' in Fuller and Halliday, eds., *The Psychology of Gambling* (Allen Lane, 1974)

Gardner, Gerald, *Witchcraft Today* (Rider, 1954)

Geddes, Jennian F, 'Artistic Integrity and Feminist Spin: A Spat at the Endell Street Military Hospital,' *Burlington Magazine* vol.CXLVII no.1230, September 2005
Gibson, Ian, *The Shameful Life of Salvador Dalí* (Faber, 1997)
Gough, Paul, *A Terrible Beauty: War, Art and Imagination 1914-1918* (Bristol, Sansom, 2009)
Gould, Veronica Franklin, *The Vision of GF Watts* (Compton, Watts Gallery, 2004)
Gould, Veronica Franklin, *GF Watts: The Last Great Victorian* (Yale, 2004)
Grant, Kenneth, Temple Bar catalogue essay (1949)
Grant, Kenneth, Archer Gallery catalogue essay (1955)
Grant, Kenneth, *Austin Osman Spare: An Introduction to his Psycho-magical Philosophy* (London, The Carfax Monographs, 1961) reprinted *Hidden Lore*, (1991)
Grant, Kenneth, 'Atavism' *Man Myth and Magic* no.6 [1970]
Grant, Kenneth, 'Nightmare World of Austin Spare,' *Man Myth and Magic* no.50 [1971]
Grant, Kenneth, 'Water Witch,' *Man Myth and Magic* no.65 [1971]
Grant, Kenneth, 'Dreaming Out of Space' [on Lovecraft] *Man Myth and Magic* no.84 [1971]
Grant, Kenneth, *The Magical Revival* (Muller, 1972)
Grant, Kenneth, *Aleister Crowley and the Hidden God* (Muller, 1973)
Grant, Kenneth, 'Austin Osman Spare' in *The Encyclopaedia of the Unexplained* ed. Richard Cavendish (RKP, 1974)
Grant, Kenneth, Introduction to *The Book of Pleasure* (Montreal, 93 Publishing, 1975)
Grant, Kenneth, *Cults of the Shadow* (Muller, 1975)
Grant, Kenneth, *Images and Oracles of Austin Osman Spare* (Muller, 1975)
Grant, Kenneth, *Nightside of Eden* (Muller, 1977)
Grant, Kenneth, *Outside the Circles of Time* (Muller, 1980)
Grant, Kenneth, *Hidden Lore* [the Carfax Monographs] (Skoob, 1989)
Grant, Kenneth, *Remembering Aleister Crowley* (Skoob, 1991)
Grant, Kenneth, *Hecate's Fountain* (Skoob, 1992)
Grant, Kenneth, *Outer Gateways* (Skoob, 1994)
Grant, Kenneth, *Against the Light: A Nightside Narrative* (Starfire, 1997)
Grant, Kenneth, and Steffi, *Zos Speaks!* (Fulgur, 1998)
Grant, Kenneth, *Beyond the Mauve Zone* (Starfire, 1999)
Grant, Kenneth, *Snakewand and The Darker Strain* (Starfire, 2000)
Grant, Kenneth, *The Ninth Arch* (Starfire, 2002)
Graves, Algernon, *The Royal Academy of Arts: A Complete Dictionary of Contributors* (Henry Graves, 1906)
Gray, Cecil, *Peter Warlock: A Memoir of Philip Heseltine* (Cape, 1934)
Gray, Tony, *A Peculiar Man: A Life of George Moore* (Sinclair-Stevenson, 1996)
Hine, Phil, *Condensed Chaos: an Introduction to Chaos Magic* (Tempe, Arizona, New Falcon, 1995)
Holmes, Jeremy, *Narcissism* (Icon, 2001)
Hooper, Barbara, *Time to Stand and Stare* [W.H.Davies biography] (Peter Owen, 2004)
Horne, Alan, *Dictionary of Twentieth Century British Book Illustrators* (Antique Collectors Club, 1994)
Houfe, Simon, *Dictionary of British Book Illustrators and Caricaturists* (Antique Collectors Club, 1978)
Houfe, Simon, *Fin de Siècle* (Barrie and Jenkins, 1992)
Howe, Ellic, *Magicians of the Golden Dawn: A Documentary History of a Magical Order 1887-1923* (Routledge Kegan Paul, 1972)
Hutchinson, Henry Neville, *Living Races of Mankind* (Hutchinson, 1900)

Hutton, Ronald, *The Triumph of the Moon* (OUP, 2000)
James, William, *Varieties of Religious Experience* (Longmans 1925) [1902]
[James] *William James on Psychical Research*, eds. Gardner Murphy and Robert O. Ballou (Chatto, 1961)
Jarrolds' Dictionary of Difficult Words (Jarrolds, 1948) [1938]
Jullian, Philippe, *Dreamers of Decadence: Symbolist Painters of the Eighteen-Nineties* (Pall Mall, 1971)
Jung, Carl, *Memories, Dreams, Reflections* (Fontana, 1983)
Jung, Carl, 'Commentary' to *The Secret of the Golden Flower* ed. Richard Wilhelm (London, Kegan Paul, Trench, Trubner and Co., 1938)
[Kenyur-Hodgkins] Ian Hodgkins and Co., Catalogue Seventeen, c.1979 [items 218-256]
King, Francis, *Ritual Magic in England* (Spearman, 1970)
King, Francis, *Astral Projection, Ritual Magic and Alchemy, by SL MacGregor Mathers and others* (Spearman, 1971)
King, Francis, *Magic* (Thames and Hudson, 1975)
Laplanche, Jean, and Pontalis, J-B., *The Language of Psycho-Analysis* (Hogarth Press, 1973)
Laver, James, *Museum Piece* (Deutsch, 1963)
Laver, James, 'Austin Osman Spare', *Dictionary of National Biography 1951-60* (OUP 1971)
Law, Ian, 'Austin Osman Spare' [in *The Divine Draughtsman* 1987]
Leo, Alan, *One Thousand and One Notable Nativities* (Fowler, 1911)
Letchford, Frank, 'Obsession with a Magician', *White Stuff* no.5 1977
Letchford, Frank, 'The Search for a Guru', *Skoob Occult Review* no.3 (1990)
Letchford, Frank, *Michelangelo in a Teacup [Inferno to Zos vol.III]* (Thame, First Impressions, 1996)
Letchford, Frank, 'Memories of a Friendship' [in *Artist, Occultist, Sensualist* 1999]
Letchford, Frank, Letters to Dennis Bardens [in Naylor 2006]
Levi, Eliphas, *The Magical Ritual of the Sanctum Regnum* (London, George Redway, 1896)
Machen, Arthur, *The Cosy Room and Other Stories* (Rich and Cowan, 1936)
Mackey, Haydn, 'Austin Osman Spare, 1886-1956' [broadcast script, printed Ansell *Borough Satyr*]
MacNeice, Louis, *Varieties of Parable* (Cambridge University Press, 1965)
Malden, RH, *Nine Ghosts* (Arnold, 1943)
Man, Myth and Magic (Purnell, 1971-2)
Mannix, Daniel, 'Witchcraft's Inner Sanctum,' *True* vol.40 no.267, August 1959
Massingham, Hugh, *I Took Off My Tie* (Heinemann, 1936)
Meltzer, Donald, *Dream-Life: A Re-examination of the Psychoanalytic Theory and Technique* (Clunie Press, 1984)
Moore, Alan, 'Beyond Our Ken' [review of Grant's *Against the Light*] in Biroco, Joel (ed.) *Kaos 14* (Kaos-Babalon Press, 2002)
Nahum, Peter *Monograms of Victorian and Edwardian Artists* (Victoria Square Press, 1976)
Nash, Paul, 'The Life of the Inanimate Object', *Country Life* May 1st 1937
Naylor, Tony, *Stealing the Fire From Heaven* (Thame, I-H-O Books, 2002)
Naylor, Tony, ed., *Mystery of an Artist; Austin Osman Spare* (Thame, I-H-O Books, 2002)
Naylor, Tony, ed., *Existence* (Thame, I-H-O Books, 2006)
Nechtavatal, Joseph, 'Artist and Familiars', *Blast* no.1, 1999 [not seen] and on net
Nerval, Gerard de, *Selected Writings* (Penguin, 1999)
Neuburg, Victor, *The Triumph of Pan* (Equinox, 1910)
Nicholson, Hubert, *Half My Days and Nights* (Heinemann, 1941)

Ozenfant, Amedee, *Foundations of Modern Art* (John Rodker, 1931)

Pankhurst, Richard, *Sylvia Pankhurst: Artist and Crusader* (Paddington Press, 1979)

Pankhurst, Sylvia, *The Suffragette Movement* (Longman, Green and Co. 1931)

Paul, Philip, 'Psychic Artist Enables you to see Beethoven's Fifth Symphony', *Two Worlds*, 1954 [reprinted Ansell, *Borough Satyr*]

Pilkington, Mark, 'From Atavism to Zos: Spare's Magic and Philosophy,' *Fortean Times* 144 March 2001

'Poor Painter with Cats' *Leader Magazine*, January 1948

Poole, Steven, *Trigger Happy* (Fourth Estate, 2000)

Praz, Mario, *The Romantic Agony* (Oxford, OUP 1933)

Price, Sally, *Primitive Art in Civilized Places* (University of Chicago, 1989)

Raine, Craig, *In Defence of T.S.Eliot* (Picador, 2000)

Rasula, Jed, and McCaffery, Steve, *Imagining Language: An Anthology* (MIT, 1998)

Regardie, Israel *The Golden Dawn* (St.Paul, Minn., Llewellyn, 1989)

Retlaw, Warren [Walter Warren], *The Youth and The Sage* (The author, 1927) [1928]

Retlaw, Warren [Walter Warren], *The Youth and the Sage* (Thame, I-H-O, 2003)

Richmond, Keith, 'Discord in the Garden of Janus' [in *Artist Occultist Sensualist*]

Rickett, Arthur, *Lost Chords: Some Emotions without Morals* (A.D.Innes, 1895)

Rogers, Grace, 'Symbology in Aesthetics in Relation to the Art of Austin O Spare', *Artwork*, Vol.2 no.5, Oct-Dec 1925

Rogers, Grace 'Austin Osman Spare' [posthumous notes about] in *The Goth*, Vol.6 [i.e. issue 6], 1991

Rogers, Grace, Austin Osman Spare [reminiscences in Naylor 2006, pp.67-68]

Rohmer, Sax, *The Romance of Sorcery* (Methuen, 1914)

Rohmer, Sax, *The Mystery of Dr Fu-Manchu* [1913] in *The Fu-Manchu Omnibus* vol.1 (Allison and Busby, 1998) p.343

Rohmer, Sax, *The Fu-Manchu Omnibus* [vols.1-5] (Allison and Busby 1995-2001)

Rose, Jonathan, *The Edwardian Temperament 1895-1919* (Ohio University Press, 1986)

Scot, Reginald, *The Discoverie of Witchcraft*, with an introduction by Montague Summers (John Rodker, 1930) [1584]

Scrutator, 'Automatic Drawing' *The Occult Review* Vol.XI, (Jan-June 1910)

Searle, Ronald, and Kaye Webb, *Looking at London* (News Chronicle, 1953)

Semple, Gavin, 'Zos: The New Flesh of Desire' *Starfire* vol.1.no.5 (1994)

Semple, Gavin, *Zos-Kia* (Fulgur, 1995)

Semple, Gavin, 'A Few Leaves from the Devil's Picture Book' in Spare / Semple, *Two Tracts on Cartomancy* (Fulgur, 1997)

Semple, Gavin, *Study for a Portrait of Frank Letchford* (Fulgur, 2002)

Semple, Gavin, '*Whoever Thought Thus?: Some Perspectives on the Philosophy of the Book of Pleasure*' (Fulgur, 2004)

Semple, Gavin, 'Introduction' to *The Book of Pleasure in Plain English* [Chibnall, 2009]

Sewell, Brocard, *Footnote to the Nineties: A Memoir of John Gray and Andre Raffalovich* (Cecil and Amelia Woolf, 1968)

Sewell, Brocard, *In the Dorian Mode: A Life of John Gray 1866-1934* (Padstow, Tabb House, 1983)

Shah, Sunny, *An Edwardian Blake* (Mandrake, 1996)

Shaw, George Bernard, *The Letters of George Bernard Shaw to the Times* ed. Ronald Ford (Dublin, Irish Academic Press, 2007)

Sinclair, Iain, *Suicide Bridge* (Albion Village Press, 1979)

Sitwell, Osbert, *Left Hand, Right Hand* (five vols) (Macmillan, 1945-50)

Sketchley, RED, 'Austin O Spare', *Art Journal* 1908 [c.Jan/Feb]

Smith, John, 'Spare and Southwark' in Temple Bar Catalogue, 1949 [reproduced Ansell *Borough Satyr*]

Smith, Tim d'Arch, *The Books of the Beast* (Crucible, 1987)

Smith, Tim d'Arch, *The Times Deceas'd* (Stone Trough, 2003)

Smythe, Colin, 'W.B. Yeats, Austin Spare and Eight Poems', *The Yeats Annual* no.12

Snell, Lionel [as Lemuel Johnstone] 'Spare Parts', *Agape* vol.1 no.4 1973

Snell, Lionel, 'Exploring Spare's Magic,' *The Divine Draughtsman* [catalogue 1987]

Staley, Michael, and Wise, Caroline, eds. *AOS: A Celebration 14ᵗʰ May 2006* (Thame, I-H-O, 2006)

Steadman, Ralph, *Sigmund Freud* (Paddington Press, 1979)

Stevenson, Robert Louis, 'A Chapter on Dreams' *The Works of Robert Louis Stevenson* ed. Andrew Lang vol.16 (Chatto, 1912)

Straus, Ralph, 'Austin Osman Spare: A Note on his Work,' *Booklover's Magazine* 1909, reprinted Ansell, *Borough Satyr*

Swaffer, Hannen *Adventures with Inspiration* (Morley and Mitchell, 1929)

Swaffer, Hannen, 'The Mystery of an Artist,' *London Mystery Magazine* vol.1 no.5 (August 1950)

Tausk, Victor, *Sexuality, War and Schizophrenia: Collected Psychoanalytic Papers* (New Brunswick, Transaction, 1991)

Taves, Mary Ann, *Fits, Trances and Visions: Experiencing Religion and Explaining Experience from Wesley to James* (Princeton, 1999)

Tegtmeier, Ralph [as Frater U.D.], *Practical Sigil Magic* (St Paul, Minnesota, Llewellyn, 1990)

Tuan, Yi Fu *Passing Strange and Wonderful: Aesthetics, Nature and Culture* (Washington, Island Press, 1993)

Vaihinger, Hans, *The Philosophy of 'As If'* trans. C.K.Ogden (Routledge, Kegan Paul, 1949) [1924]

Wainwright, Vera, ed. AR Naylor, *Art and Letter: Word and Sign* [correspondence with Spare] (Thame, I-H-O Books, 2003)

Wallace, William, *The Early Work of Austin Osman Spare* (Catalpa Press, 1987)

Wallace, William, *The Later Work of Austin Osman Spare* (Catalpa Press, 1989)

Wallace, William, *The Artist's Books* [Inferno to Zos vo.II] (Thame, First Impressions, 1996)

Warlock, Peter [Philip Heseltine], *The Collected Letters of Peter Warlock*, ed. Barry Smith (Woodbridge, Boydell Press, 2005)

Washington, Peter, *Madame Blavatsky's Baboon* (Secker and Warburg, 1993)

Waugh, Evelyn, *The Letters of Evelyn Waugh*, ed. Mark Amory (Weidenfeld and Nicolson 1995)

Wilton, Andrew, and Robert Upstone eds. *The Age of Rossetti, Burne-Jones and Watts: Symbolism in Britain 1860-1910* (Tate, 1997)

Witchard, Anne Veronica, *Thomas Burke's Dark Chinoiserie: Limehouse Nights and the Queer Spell of Chinatown* (Aldershot, Ashgate, 2009)

Wood, Esther, 'National Competition of Art Schools', *The Studio* vol.XXIX 1903

'Young Socialist Painter, A' *The New Age*, vol.II no.6 (December 1907)

INDEX

Abramelin, 105
abstract expressionism, 253, 258
Ackroyd, Peter, 255
Acton, Harold, 153
Adler, Alfred, 95
Advaita Vedanta, 103
'Adventures in Limbo' (Spare
sketchbook), 197
Agrippa, Cornelius, 19, 74
Alastair (Hans Henning Voigt), 139
Alex, Reid and Lefevre, 158-159, 162,
176, 234
Alphabet of Desire (Spare), 92, 94,
214, 221-222, 251
Amaya, Mario, 206, 258
Ambassadors, The (Holbein), 162
anamorphs, anamorphism, 162, 163,
164, see also sidereals, 'Experiments in
Relativity'
Anathema of Zos (Spare), 144, 155,
159, 164
Anderson, Dr Garrett, 125, 126
Ansell, Robert, 161, 204, 227, 260
Apollo, 157
Apollonius of Tyana, 46, 237
'Apologia' (Spare), 235
arcana, 94, 95, 150
Arcana of AOS, The (Spare), 28, 29, 135
Archer, Ethel 49-50, 66, 227
Archer Gallery, 201-2, 209, 250, 252,
253, 254, 258
Archives de l'Anthropologie Criminelle,
56
Arena of Anon (Spare), 178
Argenteum Astrum, 65, 68, 77, 103,
104
Argent, William, 173
Arnaud, Noel, 94
Artaud, Antonin, 196
*Art Journal,*1
Art Nouveau, 10, 118, 135, 141, 185,
258, 259

Arwas, Victor, 259
"As If" principle (Vaihinger), 217, 218
Asmodeus, 208
Assemblage art, 259
astral light, 161
astral plane, 20, 162, 241
atavism, x, 90, 176, 181, 219, 226, 248
atman, 70, 104
Auden, WH, 146
Augustine, Saint, 131
Austen, John, 124, 139, 194
Autobiography of a Supertramp (Davies),
136
automata, automatisms, 72, 73, 109,
151, 173
automatism, automatic phenomena
113-15, 72, 73, 84, 95, 104, 107, 111,
119, 144, 145, 158, 176, 178, 183, 185,
207, 229, 235, 254, 259; drawing 84,
95, 103, 104, 107, 112, 114, 115, 116,
145, 158, 184
'Automatic Drawing' (Scrutator), 115
Automatic Drawings, A Book of (Spare),
48, 146, 147, 259
Automatic Message, The (Breton), 71,
185
Axiomata (Spare), 260
Ayer, AJ, 208
Azazel, 28
Azrael, 28

Baillie Gallery (see also Bruton), 79,
84, 85, 111
Baker, Chet, 195
Baker Street, 94, 229, 243
Balance, John, 260
Balint, Michael, 102
Baltrusaitis, George, 163
Bankes, Viola, 154, 155
Barbanell, Maurice, 203
Bardens, Dennis, 166-8 and passim
Barlowes of Beddington, The, 250
Barry, James, 117
Bartholomew Fair (Jonson), 3
'Base Materialism and Gnosticism'
(Bataille), 228

159, 185, 252
Synett, L, 121

Tabard Street, 138
Taoism, 28, 30, 104,148, 152, 234
Tatler (magazine), 25, 164, 260
Tausk, Victor, 109
Taylor, John Russell, 204
Teed, John, 164
Temple ov Psychick Youth, 260
Tennyson, Alfred Lord, 19
Tharpe, Runia, 167
Thaumaturgus Opticus (Niceron), 162
Theosophy, 18, 19, 20, 30, 31, 35, 38, 55, 70
'This and That' (Spare), 234
Thomas, Dylan, 167, 169
Three Books of Occult Philosophy (Agrippa), 19
Thus Spake Zarathustra (Nietzsche), 144
Tibet, 20, 50, 103, 141
Times Literary Supplement, 106, 115, 260
Titanic, 85
Titian, 117
Todhunter, Gavin, 227
totem, 135, 248
Toulouse-Lautrec, Henri de, 154
Towards a Sexualization of the Alphabet (Arnaud), 94
Trafalgar Square, 157
tribal art, 44, 46, 62, 82, 135, 141, 143, 161, 209, 231, 232, 240
Triumph of Pan, The (Neuburg), 66
True (magazine), 251
Tudor Street, 35
Twelve Poems (Squire), 120
'Twins, The' (Crowley), 59
Two Tracts on Cartomancy (Semple and Spare), 260
Tynan, Kenneth, 95
Typographia, 121

unconscious, 71-4, 36, 86, 89, 91, 94, 95, 96, 99, 113, 144, 150, 151, 153, 165, 171, 176, 182, 219, 228, 229, 231

'unconscious cerebration' (Carpenter), 151
Universal Woman, 37
Unusual Beliefs (BBC), 250
Uranisme et unisexualité (Raffalovich), 60
Urning, 216

Vaihinger, Hans, 165, 217, 218
Valley of Fear, The (Spare), 146
vampire (see also succubus), 214
Varieties of Religious Experience (James), 33, 67, 71
Vasavada, Dr., 256
Vaughan, Keith, 160
Victoria and Albert Museum, 55, 80
Victoria Street, 66, 111
Vivekananda, 73
Voice of the Silence, The (Blavatsky), 19
void (see also Kia, Sunyata), 28, 70, 98, 103
vulture, 7, 22, 28, 30, 191

Wainwright, Vera 190-194, 224
Walker, Kenneth, 229
Waller, Pickford, 50-51, 52, 56, 61, 65, 78, 79, 80, 85, 107, 121, 128, 160
Waller, Sybil, 79, 121
Walworth Road, 22, 166, 167, 173, 175, 182, 183, 190, 191, 225, 254
Wapping, 242
Wardour Street, 129
Warhol, Andy, 258
Warlock, Peter, 119
Warren Gallery, 172
Warren, Walter, 155, 156, 166
Washington, Peter, 18
Watts, George Frederick, 1, 18, 20, 25, 42, 56, 79, 134, 159, 197
Watts, Mrs Alaric, 115
Waugh, Evelyn, 153, 247
Waverton Street, 77
Well of Loneliness, The (Hall), 254
Westbourne Grove, 201
Wheatley, Dennis, 56, 207, 214, 225
Wheeler, Ethel, 41

Wheeler, Herbert E, Ltd., 111
Whistler, James, 51
Whitefriars Street, 16
Whitehead, Alfred North, 95
Wicca, 240
Wilde, Oscar, 14, 25, 50, 53, 54, 55, 60, 117, 174
Wilkinson, Russell, 82
Winged Beetle, The (Crowley), 59
wireless (see radio)
Witchcraft's Inner Sanctum (Mannix), 251
Witchcraft Today (Gardner), 240
Witches Sabbath, The (Grant and Spare), 240, 242, 260
Wittgenstein, Ludwig, 19
Wizard of Oz, The, 205
Women's Hospital Corps, 124
Women's Work Committee, 124
Woolf, Virginia, 159
Woolworth's, 166, 167, 180, 185, 184
World, The (periodical), 47
Wounded Centaur (Lippi), 162
Wynne Road, 192, 195, 236, 255, 256, 257

Yeats, WB, 19, 28, 31, 33, 39, 65, 112, 115, 117, 118, 119, 150, 162
Yellow Book, The, 33, 36, 53, 111, 115
'Yellow Creeper, A' (Rickett), 246
Yoga, 70, 73, 104, 222-23
Yoga (Fuller),104
York Road, 165
Yorke, Gerald, 226, 227
Youth and The Sage, The (Retlaw), 155

Zanoni (Bulwer Lytton), 27
Zen, 234
Zeno, 237
'Zoetic Grimoire of Zos' (Grant and Spare), 214
Zohar, 28, 80
Zoists, 27
Zoist, The, 27
Zola, Emile, 7, 62
Zoretti, 28

Zoroaster, 28, 41
Zos, x, xi, 27, 28, 38, 98, 100, 144, 155, 164, 173, 205, 213, 214, 236-241, 246, 260
Zosimos, 28
Zos Kia Cultus, 238, 241, 242
Zos-Kia (Semple), 173, 260
Zos Speaks! (Grant and Spare), 260

ACKNOWLEDGMENTS

I am very grateful to Spare scholars Gavin Semple and Robert Ansell for their friendship and encouragement. Gavin was also kind enough to read the text and make valuable suggestions. Any errors – and inevitably something will have crept in – are of course my sole responsibility. I'd further like to acknowledge and indeed celebrate the work of Frank Letchford and Kenneth Grant in presenting their very different versions of Spare. I've been much cheered by Alan Moore's generous and enthusiastic introduction. The staff of the London Library and the National Art Library (V&A) have been unfailingly helpful. Last but not least I'd like to salute Mark Pilkington and Jamie Sutcliffe at Strange Attractor Press for having the vision to publish this somewhat peculiar book in these mainstream and corporate times.

A host of excellent people have earned my gratitude along the way, including the late John Balance, Richard Bancroft, Danielle Barnett, James Birch, Joel Biroco, Henry Boxer, Alastair Brotchie, Ossian Brown, Chris Chibnall, Charles Cholmondeley, John Contreras, Leila Dear, Neil Dineen, Geoffrey Elborn, Ben Fernee, Steffi Grant, Clive Harper, Michael Holroyd, Ali Hutchinson, Nadia Katz-Wise, Ellis Kelleher, David Knight, Gary Lachman, Mark Le Fanu, Rupert Maas, Julian Machin, Aden McConville, Gareth Medway, Steve Moore, Frances Morgan, Tony Naylor, Gavin O'Keefe, Reggie Oliver, Liz Parratt, Nick Pearson, Charles Peltz, Stephen Pochin, Kate Poole, Steve Poulacheris, William Redwood, Ian Sayer, Iain Sinclair, Mark E Smith [the silversmith, not the musician], Mick Staley, John Stewart, Robert Wallis, Carl Williams, Caroline Wise, Viktor Wynd. And I'm grateful to Sheena, for being herself.

Strange Attractor Press MMXXIII